RUSSIAN DECORATIVE ARTS

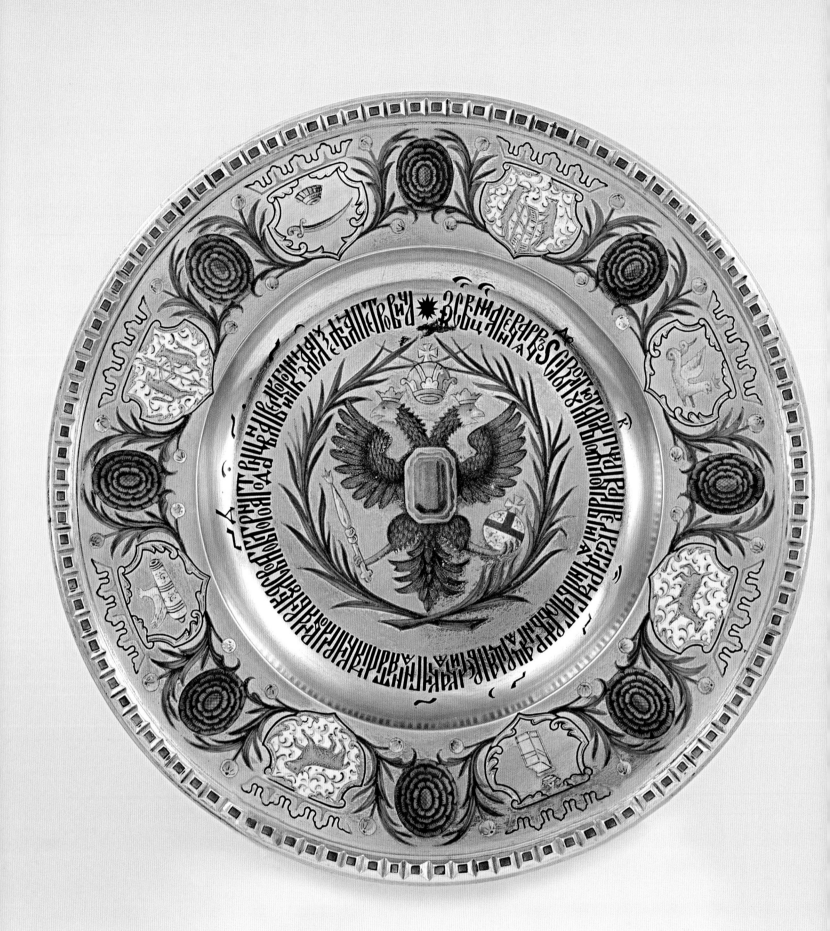

RUSSIAN DECORATIVE ARTS

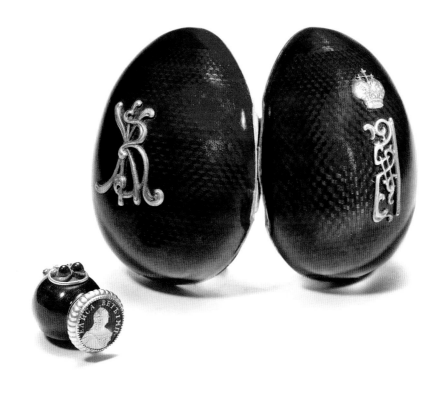

Cynthia Coleman Sparke

ANTIQUE COLLECTORS' CLUB

Frontispiece: An Imperial Presentation silver and enamel tray by Pavel Ovchinnikov, Moscow, 1882. This tray was presented to Queen Olga of Greece by Tsar Alexander III of Russia on the occasion of his 1883 Coronation. It is a copy of a seventeenth-century gold plate presented to Grand Duke Alexei Petrovich by his grandmother, Natalia Naryshkina, in 1694. Diam. 16.3 cm.
THE MCFERRIN COLLECTION, C&M PHOTOGRAPHERS

Title Page: Coin-mounted scent bottle made to fit inside the larger hinged egg, Fabergé, St Petersburg, c.1890 (see page 62 for further details).
BONHAMS/MRS ALEXANDRA MARTIN-ZAKHEIM

British Library Cataloguing-in-Publication Data
A catalogue record for this book is available from the British Library

FSC
www.fsc.org
MIX
Paper from responsible sources
FSC® C104723

Printed in China
for the Antique Collectors' Club Ltd., Woodbridge, Suffolk

CONTENTS

For Andrew, Alex and Emily – N.L.G.

ROMANOV DYNASTY REIGN DATES

Consorts took Russian names upon conversion to Orthodoxy; both variants are listed here.

1613–1645: Tsar Mikhail I, founder of the Romanov dynasty, married Princess Maria Dolgorukova followed by Eudoxia Streshneva.

1645–1676: Tsar Alexei I, married Maria Miloslavskaya followed by Nataliya Naryshkina.

1676–1682: Tsar Feodor III, married Agaphia Gruszewska followed by Marfa Apraxina.

1682–1696: Tsar Ivan V (joint ruler with Peter I 'the Great'), married to Praskovia Saltykova.

1696–1725: Tsar Peter I (Peter the Great, Emperor of All Russia), married Eudoxia Lupukhina followed by Marfa Skavronskaya who became Catherine I. (From 1721 onwards, the Russian Tsar was proclaimed Emperor of All Russia. Tsar Peter I became the first Emperor of All Russia.)

1725–1727: Catherine I, Empress of All Russia, second wife of Peter I.

1727–1730: Peter II, Emperor of All Russia, unmarried.

1730–1740: Anna Ivanovna, Empress of All Russia, married to Frederick Wilhelm, Duke of Courland.

1740–1741: Ivan VI, Emperor of All Russia, unmarried.

1741–1762: Elizabeth, Empress of All Russia, married to Alexei Razumovsky.

1762: Peter III, Emperor of All Russia, married to Princess Sophie Friederika Augusta of Anhalt-Zerbst who became Catherine II.

1762–1796: Catherine II (Catherine the Great), Empress of All Russia.

1796–1801: Paul I, Emperor of All Russia, married to Princess Wilhelmina Louisa of Hesse-Darmstadt (later Natalia Alexeievna), then to Princess Sophie Dorothea of Württemberg who became Maria Feodorovna.

1801–1825: Alexander I, Emperor of All Russia, married to Princess Louise of Baden who became Elizabeth Alexeievna.

1825–1855: Nicholas I, Emperor of All Russia, married to Princess Charlotte of Prussia who became Alexandra Feodorovna.

1855–1881: Alexander II, Emperor of All Russia, married to Princess Marie of Hesse who became Maria Alexandrovna.

1881–1894: Alexander III, Emperor of All Russia, married to Princess Dagmar of Denmark who became Maria Feodorovna

1894–1917: Nicholas II, Emperor of All Russia, married to Princess Alix of Hesse who became Alexandra Feodorovna.

ACKNOWLEDGEMENTS

The majority of the illustrations for this book were provided by Bonhams auctioneers. I was fortunate early on to share a lift with chairman Robert Brooks who listened politely to a spontaneous pitch for my idea and helped me line up the necessary in-house advocates for this project. Without the patient support of Nathan Brown at DTP and the unflagging enthusiasm of my own department – Sophie Law, Ksenija Krapivina and Evgenia Teslyuk – the manuscript could not have reached completion.

I am enormously grateful to the former colleagues and collectors who generously permitted the use of the images within these covers. My appreciation is extended both to those who consented to being named and those who chose to remain anonymous.

The text was inspired by many of these same friends and colleagues worldwide who shared their knowledge so generously with me over the years. I am especially indebted to John Benjamin, whose gracious mentoring and friendship has been invaluable, not least for introducing me to his publishers and guiding me through the process. I would also like to mention Alice Milica Ilich and Anne Odom who inspired me to commit to this field and to Géza von Habsburg who advised me to consider escaping it.

I am in debt to Diana Steel of the Antique Collectors' Club, who saw the manuscript's potential; to the unflappable Anna Morton who painstakingly edited the text; and to Sandra Pond who brought the images to life with her layout. Closer to home, I would like to extend my grateful thanks to Eric Coleman, Marisa Dal Pan, Nancy d'Albert and Vanina Marsot for their loyalty and support throughout this latest project.

My peculiar fascination with Russian works of art is a family trait that can be traced back to my grandparents, Georgette and Edmond, who assembled and preserved a collection of Russian objects against substantial odds. My own obsession was sparked by my parents, Nadine and Fred, who displayed fragile objects on a particular round table when I was a small child and strictly forbade me to touch them. Later, their foreign postings included tours in Moscow where they nurtured my interest, taught me to enquire about art on museum walls and to walk the flea markets. I am endlessly indebted to them for fostering my earliest interest in what continues to be an endlessly rewarding career.

Cynthia Coleman Sparke

INTRODUCTION

THE GLITTERING TERCENTENARY CELEBRATIONS of 1913 in St Petersburg are often cited as the pinnacle of pre-Revolutionary Russian decadence. A series of receptions and grand balls marking the 300 years of Romanov rule showcased an astonishing display of wealth manifested in the glittering jewels and accessories of those in attendance. With the palace interiors serving as a backdrop to the jubilee, the crystal, porcelain and silver tableware of the Tsarist era would never be so lavishly displayed again.

The anniversary inspired a large volume of objects by many Russian makers incorporating the 1613–1913 dates. These varied from modest mugs, badges, scarves and cufflinks to jewelled cases for pills, snuff, dance cards and cigarettes. At the most extravagant end of the spectrum, the legendary firm of Fabergé was famously commissioned by Nicholas II (1894-1917) to create a jewelled egg that he would present to his wife, Alexandra Feodorovna, for Easter. This period was the pinnacle of a glittering life at court which had begun to suffer during the Russo-Japanese War of 1904–5, and which would be annihilated by the First World War and subsequent Revolution.

Nearly a century later, it is effectively the material culture of this Romanov heyday that drives the highly successful Russian decorative arts market. Ever since the collapse of the Soviet Union, Russia's new ultra-rich have been clamouring to buy back their lost heritage. Works by jewellers and silversmiths to the Tsars are particularly sought after today as status symbols. The huge appetite for a limited supply of surviving goods pushes auction prices to dizzying heights. Add to that an increasingly sophisticated pool of buyers who are uncompromising on condition and provenance, and you have ever-stiffening competition for the consignments described in glossy auction catalogues.

Opposite. 1. Imperial presentation brooch of gold, platinum, diamonds and rubies. Fabergé, St Petersburg, 1913. This would have been commissioned to mark the Tercentenary Anniversary of Romanov succession.
FABERGÉ MUSEUM BADEN-BADEN

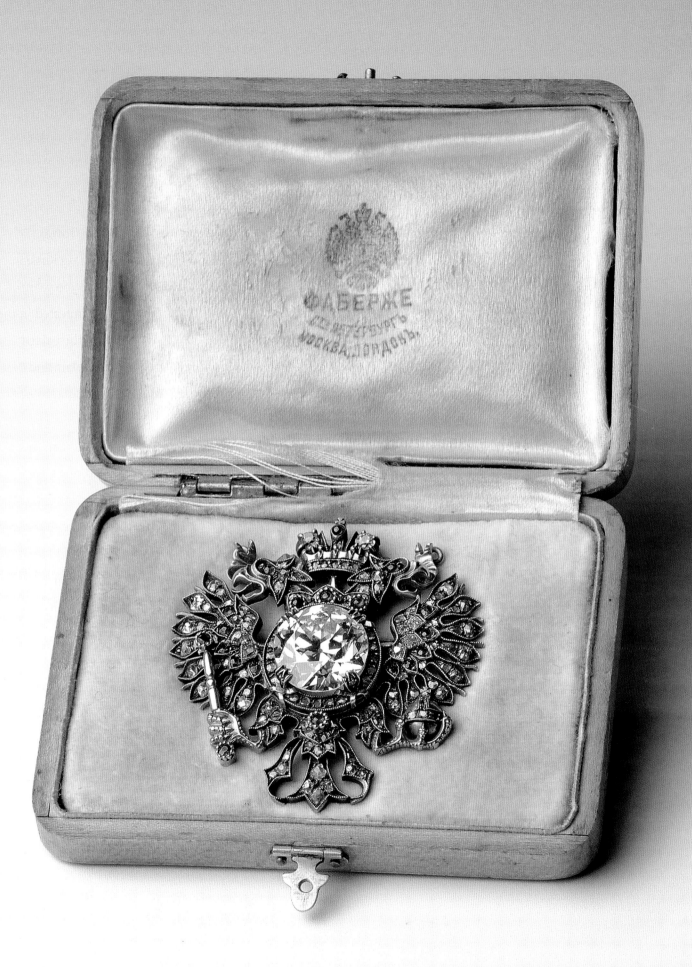

With a large proportion of auctioned lots being repatriated to Russia, which in turn prohibits the export of antiques, it is not surprising that Moscow has become an important holding centre for the Russian decorative arts market. Sales in New York also stimulate the market, but London is its epicentre. As is customary, each auction house holds a preview exhibit with free entry offering the very best opportunity to handle the maximum number of Fabergé items which are on view but not tangible in public collections such as the Victoria and Albert Museum.

With most buyers, at the time of writing, coming from Russia and Ukraine, either émigré or those based in the former Soviet Union, the Russian department at Bonhams caters to a perception of regional identity, and when that territory emerges into wealth, it seeks to acquire the heritage it was long denied. In general, collectors are interested in the material culture of their home be it the Crimea, Arkhangelsk, or the Baltics.

Most of the decorative arts on offer at any given Russian sale will date from the nineteenth to early twentieth centuries. Pieces produced in the former Russian capital of St Petersburg evoke, in English terms, the trappings of Edwardian society – they speak of life at court, foreign sophistication, and relate to the output of Cartier or Tiffany, contemporaries of Fabergé. Generally, items crafted in Moscow evoke woodworking and embroidery, boyar princes and fairy-tale maidens depicted in enamel jewelled caskets, and traditional drinking vessels called *kovshes* appealing to the self-made merchants of the industrial era.

The market for pre-Revolutionary decorative arts touches a wide audience, from Hermitage Museum curators in St Petersburg to pre-dawn bargain-hunters at the *marchés aux puces* (flea markets) in Paris. Purchasers in this sector (be they dealers or private collectors) tend to cross-buy; a Kievan cigarette case one day, a Muscovite brooch or a St Petersburg silver candlestick the next. Generally, they buy the nationality rather than a specific medium or subject. It is precisely this premise of buying into a geographical territory that led me to consider writing such a broad introduction to collecting Russian decorative arts.

Having periodically lived in Russia while I was growing up, and being surrounded by a family of Russian art collectors, I was programmed to work in the field. That said, I hope that twenty-five years of handling bibelots and working in the privileged atmosphere of international auction rooms have not resulted in my taking on the blasé affectations that are all too common in my field.

So, what about the valuation inquiries I have received over the years from people who were not force-fed antiques from birth and came to be interested in the subject of their own accord? There is a wealth of nuanced research out there for each subtopic, but I also felt that the sustained interest in the Russian sector of the antiques market called for a more accessible guide to this field.

When I was working in the Russian department at Christie's in New York, a lady I met in the viewing rooms had brought along a jade egg to be valued. She questioned the fact that I was dismissing it from being the work of Fabergé until I pointed to the label at the base marked 'made in Hong Kong' to support my appraisal. It makes for an amusing anecdote, as do some of the inquiries I receive relating to offerings on online auction sites. The fact remains that one's knowledge of a subject has to begin somewhere and I would suggest that the following chapters provide a springboard into an astonishingly rich and diverse subject.

AUTHOR'S NOTE

Where no Latin spelling of a Cyrillic word has been adopted into common English usage, I have deferred to the Library of Congress system of transliteration.

The spellings of the names of Fabergé's Finnish workmasters are based on the latest available research drawn from each workmaster's original birth certificate. It is hoped that there will be a general trend of reverting to their given names rather than the anglicised forms that seem to have stuck in more recent years.[1]

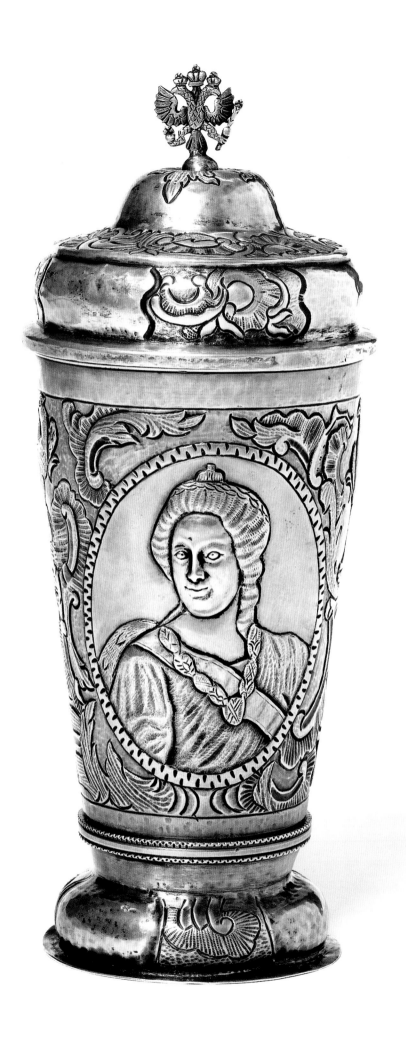

PRECIOUS METAL

AS ANY MUSCOVITE schoolchild will know, the Kremlin Armoury Museum is a popular destination for class outings. Contained within are the actual ermine-lined robes, jewelled regalia and golden thrones of infamous tsars and empresses. Visiting as a graduate student, I approached the diplomatic gifts and ornate tableware in the museum fund as crucial documents in the evolution of Russian material culture. However, if truth be told, the objects never failed to delight the inner schoolgirl as storybook illustrations come to life.

A closer look at the Kremlin Armoury Museum's holdings provides us with a series of timelines tracing the aesthetic evolution of goldsmithing, as well as offering insight into the laws governing the production and trade of gold and silver. As objects created from precious metal which served as the basis for currency, regulations governing the intrinsic value of these metalworks were strictly enforced from early on.

The Seventeenth Century

Russian seventeenth-century goldsmithing was centred in Moscow. At first, traditional forms drawn from provincial woodwork and translated into precious metal were enriched with engraving and applied sparingly with stones or pearls. The most common vessel shapes were the *kovsh* (resembling a dipping ladle), *bratina*-type compressed bowls, and the

3. A silver *kovsh* by Ovchinnikov, St Petersburg, 1908–1917. Length 20cm.
BONHAMS

Opposite. 2. A silver cup and cover, marked 'B.A.', Moscow, eighteenth century. The tapering body is chased and embossed with fauna and rocaille cartouches surrounding a reserve with a bust portrait of Empress Elizabeth. The domed cover is surmounted by an Imperial Eagle finial. Height 55cm.
BONHAMS

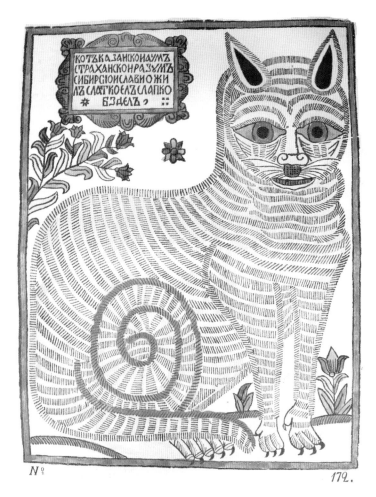

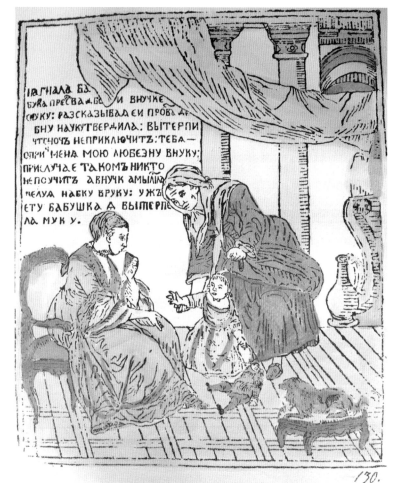

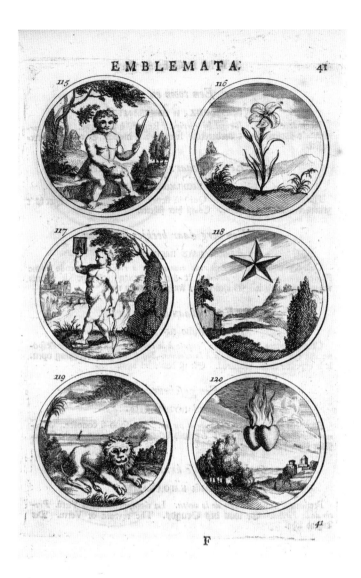

charka — a shallow bowl with a small handle reminiscent of a *tastevin*. As the century progressed, polychrome enamel work began to cover the entire surface of an object, drawing heavily from floral motifs.

The depiction of figures drew upon print sources such as the popular *lubki*, which had evolved from the old Russian woodcuts used to produce pictorial stories akin to comic strips. Further afield, the illustrated bible published in seventeenth-century Amsterdam by Visscher and referred to, using the Latinisation of the author's name, as the 'Piscator Bible' provided additional models. During the eighteenth century, another Western prototype was disseminated throughout Russia at the instigation of Peter the Great (1696–1725). *Symbols and Emblems*, published in Amsterdam by Daniel de la Feuille from 1705, was expanded to include Russian language text contextualising Classical figures and ornamental motifs from the Italian Renaissance which were familiar to Western Europeans but groundbreaking for Russian artists trained in the East.[1]

Opposite. 4. *Russkie Narodnye Kartinki,* D.A. Rovinsky, c.1881, plates 130, 172, 235. Three examples of the *lubok* or popular print, characterised by simple graphics and narratives. *Lubki* were cheap to produce and therefore accessible to a wider public. The image of the cat illustrates the power of the *lubok* as a tool of political satire, as the reader would have understood the references to Peter the Great's appearance, titles and Western pretensions.

5. *Symbola et Emblemata*, Daniel de La Feuille, Amsterdam, 1705, page 41.

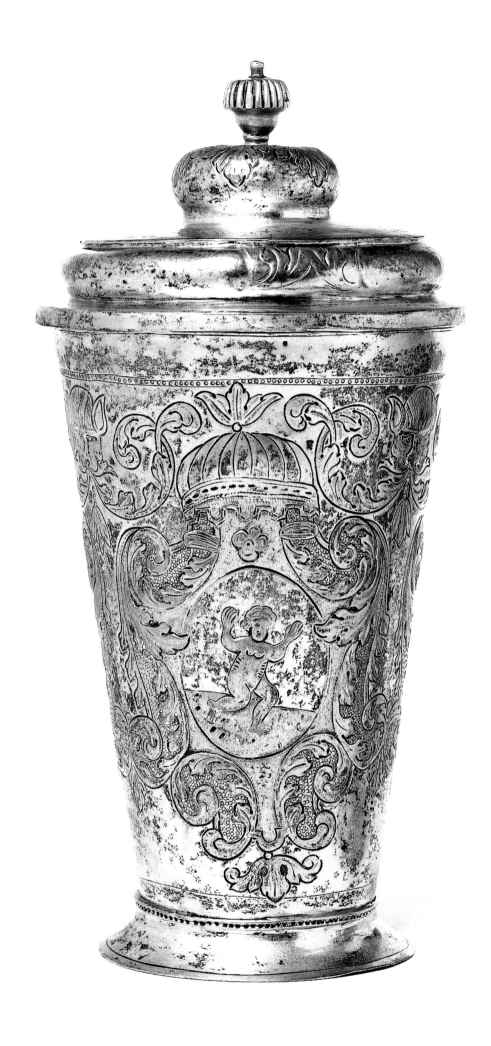

The Eighteenth Century

From around 1720 onwards, the allegories integrated into goldwork often relate directly to the vignettes in such print sources, but also bear the hallmarks of seventeenth-century German taste. This is because many of the foreign masters drawn to the opportunities in Peter the Great's new capital had originally trained in Germany; logically enough, they then produced work bearing this influence. From about 1740 onwards, a somewhat cumbersome interpretation of Rococo was produced and this continued until the last quarter of the eighteenth century when Classicism took hold.[2]

6. Two silver beakers, Moscow, c.1745. Height 23.5cm (left); 17cm (right).
BONHAMS

Court patronage encouraged masters to look to Western Europe for their design inspiration, but as craftsmen adapted their wares to suit their clientele, they ceased to be considered as mere copyists. The longstanding Western notion that Russian decorative art is simply a derivative poor cousin of Western prototypes is flawed and outdated. By the same logic, exquisite Swiss snuff boxes, inspired by Paris, would be seen as inferior

plagiarisms. It can be said, therefore, that it was precisely the distance between the Russian masters and the European capitals that offered them some freedom from the prescriptive design restrictions to which Western masters adhered. The creative output in St Petersburg may have been larger in scale, bolder in colour or more pronounced in relief and weight, but it was authentically Russian.

7. A silver sugar coffer and bowl. The coffer is of bombé form with meandering Rococo ornament and the maker's mark: 'A.Ch' (Cyrillic), Moscow c.1760. The bowl is decorated with leaf tips and linear Classical ornament, marked 'M.Ts.S.' (Cyrillic), Moscow, 1794. Coffer width 19.7cm; bowl height 29cm.
BONHAMS

Above left. 8. A parcel-gilt and niello box, late eighteenth century. Applied with a medallion of Catherine the Great and the reverse commemorating the coronation of 1762. Diameter 8.9cm. BONHAMS

Above right. 9 A silver and niello portrait medallion snuff box, Moscow, c.1800. The lid is applied with a medal commemorating the 1776 marriage of Grand Duke Paul, later Paul I, and Sophia Dorothea of Württemberg. Diameter 8.5cm. BONHAMS

The Nineteenth Century

French taste continued to find favour right through to the Napoleonic wars. The wreaths, winged creatures and military trophies drawn from the wide repertory of Classical motifs lent themselves well to celebrating Russia's victory over France in 1812. Subsequently, with the reign of Nicholas I (1825–1855) and his Prussian born wife, the decorative arts evolved into Germanic Romanticism and Biedermeier, then Gothic,

10. A silver-gilt portrait medallion box, maker's mark: 'V. P.' (Cyrillic), Moscow, early nineteenth century. The lid is set with a portrait medallion of Alexander I, its reverse commemorating the 1801 coronation. Diameter 9.5cm. BONHAMS

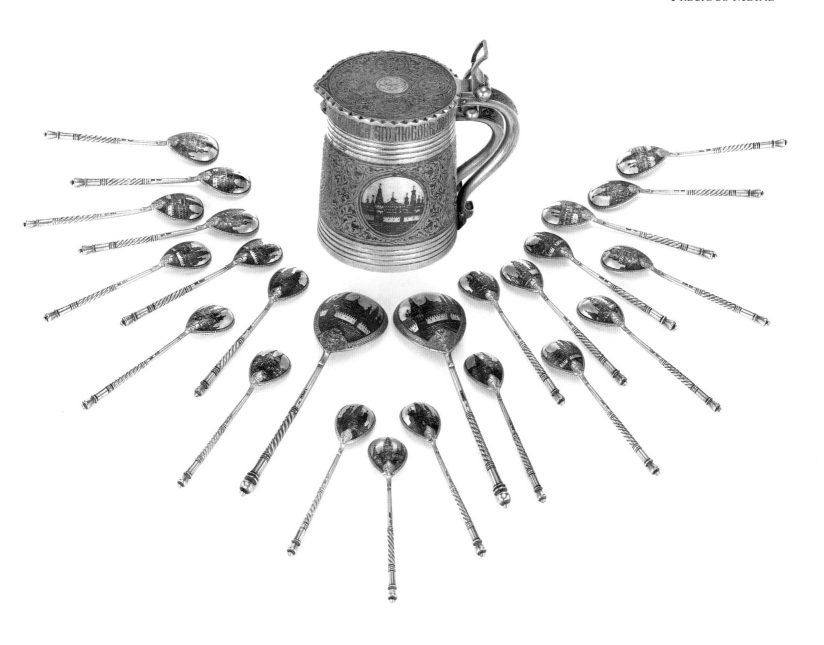

11. A series of silver parcel-gilt and niello spoons together with a tankard. Maria Semenova, Moscow, c.1893. Tankard height 13.7cm; length of longest spoon 17cm.
BONHAMS

Renaissance and Baroque Revivals.³ The nineteenth-century trend towards historical revival gave renewed life to the pre-Petrine motifs of the sixteenth and seventeenth centuries. This nationalistic backlash was particularly embraced in Moscow by wealthy industrialists.

The technique of niello work, which had reached its peak in eighteenth-century Veliky Ustyug in northern Russia, was revisited. Using a black compound to fill in engraved patterns on a metal surface, small pieces such as religious medallions and snuff boxes enriched with genre scenes were produced. From 1780 onwards, detailed topographical views, maps and statistical tables were used to embellish pieces. Snuff boxes of this type are particularly prized at auction for their meticulous depictions. In

the nineteenth century, niello scenes were incorporated into various dining implements, including those for tea and drinking. Typically, a central roundel featuring an architectural scene such as a Kremlin fortress, national monument or cathedral was surrounded by ornamental strapwork ranging from the crisply geometric foliate style to the meandering Eastern taste incorporating ogee forms. The application of a gold wash, termed gilding, served to further enrich the object's entire surface. When gilt was applied to chosen sections to specifically highlight details, this was referred to as parcel, i.e. partial, gilding.

The highest prices for niello work are achieved at auction for complete tea sets in fitted cases. Composite sets, those created from parts by various makers and gathered together to form the implements of a traditional service, sell at a relative discount, while spare teaspoons and small pieces separated from an original set abound and are priced accordingly.

12. A silver, parcel-gilt, niello money box, maker's mark: 'BC', Moscow, 1870. Shaped as a casket, each side with view of Moscow, the domed, hinged cover bearing the Russian adage 'He who saves money will live without need'. Length 11.8cm.
BONHAMS AND IAKOBACHVILI COLLECTION

Opposite top. 13. A group of silver parcel-gilt and niello objects, Moscow, late eighteenth to early nineteenth century. Height of cross 11.5cm.
BONHAMS

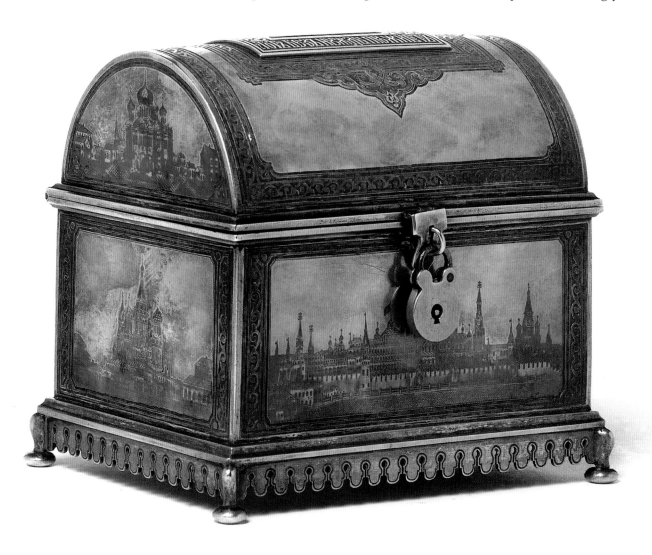

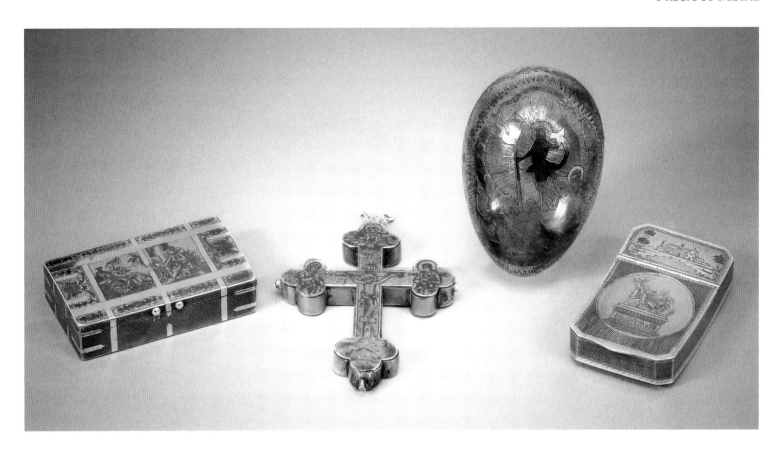

Niello cigarette cases incorporating hunting, falconry, peasant or troika scenes were made in large quantities. At one end of the spectrum, we still see examples enriched with meandering repoussé and chased strapwork, completely or partly gilt for added contrast and produced by the higher end workshops. At the lower end are examples in base metal stamped with a basic troika scene and decorative surround.

Below left. 14. Niello silver-gilt snuff box, probably Moscow, eighteenth century. The hinged cover and sides with pastoral scenes against sunburst gilt ground. Length 8.2cm.
BONHAMS AND IAKOBACHVILI COLLECTION

Below right. 15. Silver parcel-gilt and niello snuff box, maker's mark: 'A.I.', Moscow, 1819. Commemorating the Peace of Europe, the lid engraved with the allied leaders. Width 8.8cm.
BONHAMS

16. Parcel-gilt silver caviar serving set, Grachev, St Petersburg, 1884–1908, comprising a covered glass-lined bowl decorated to suggest a barrel overlaid with embroidered cloth, together with six spoons. Underplate diameter 17.3cm.

BONHAMS/COLLECTION MIRABAUD

If architectural forms were explored by vignettes in nielloed silver, another popular nineteenth-century style focused on the actual materials used in traditional Russian craft. The simulation of birch bark, wickerwork and embroidery was sometimes vaguely suggested in the chasing of an object, at other times it was a deliberately *trompe l'oeil* reference to contemporary cigar boxes encircled by tax bands or woven bread baskets surmounted by linen napkins.

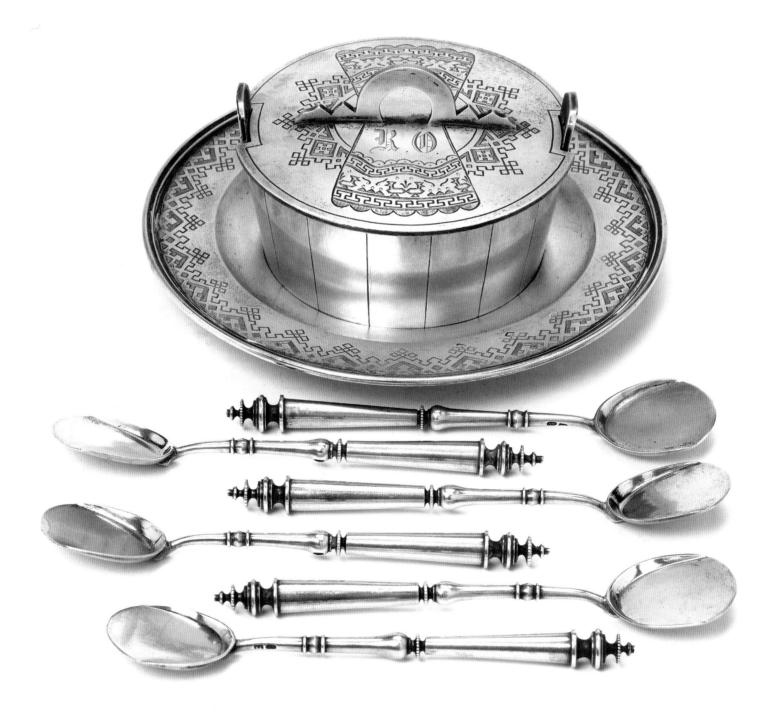

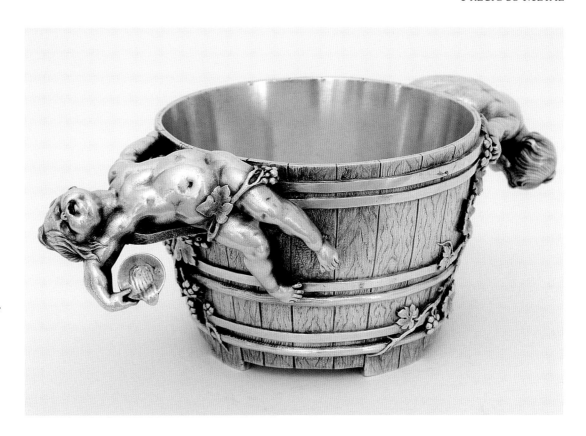

17. Silver barrel-shaped punch-bowl, Bolin, Moscow, 1895, with realistically chased sides emulating wood grain.

FABERGÉ MUSEUM BADEN-BADEN

Below. 18. Silver parcel-gilt *trompe l'oeil* cigar box, Samuel Arndt, St Petersburg, c.1900. Finely engraved to simulate wood complete with tax bands and labels. Width 22.3cm.

BONHAMS/FABERGÉ MUSEUM BADEN-BADEN

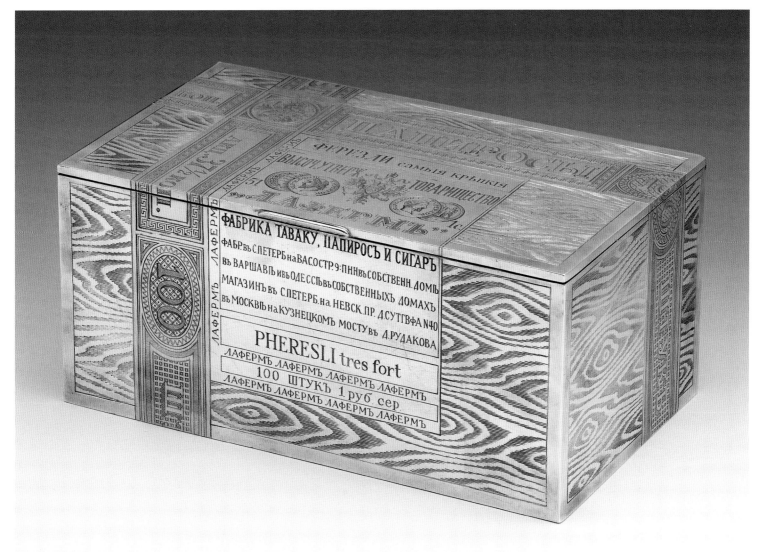

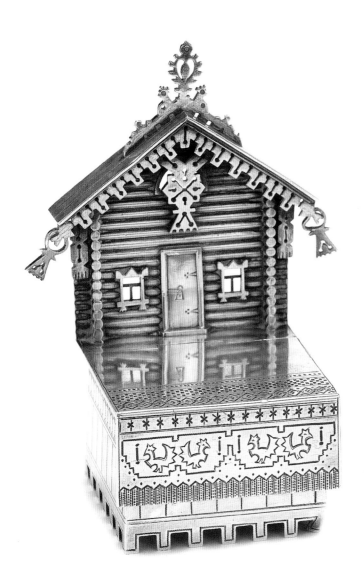

19. Two *trompe l'oeil* silver-gilt salt cellars, nineteenth century. The first is formed as a customary salt throne with a hinged seat applied with an apron of simulated embroidery, the back in the form of a traditional *izba* (a typical Russian log house); the second is formed as a loaf of bread placed on a cloth-lined saucer, the lid surmounted by a further hinged throne. The bread and salt tradition welcomes guests. Height of largest 12.5cm.

BONHAMS/JOHN ATZBACH

Opposite. 20. A silver gilt and jade clock by Ovchinnikov, Moscow, 1880s. Weight approx. 16kg, height approx. 40cm.

FABERGÉ MUSEUM BADEN-BADEN

These styles were applied to endless objects: traditional salt thrones, coachman's gloves, bast shoes, ashtrays formed as troikas, and cake baskets seemingly woven from birch wicker. Buyers could not help but be amused and delighted with these items and their references to Russia's traditional heritage. These pieces were successfully displayed in international exhibitions and found a welcoming public abroad that was eager to buy into this image of Russia.

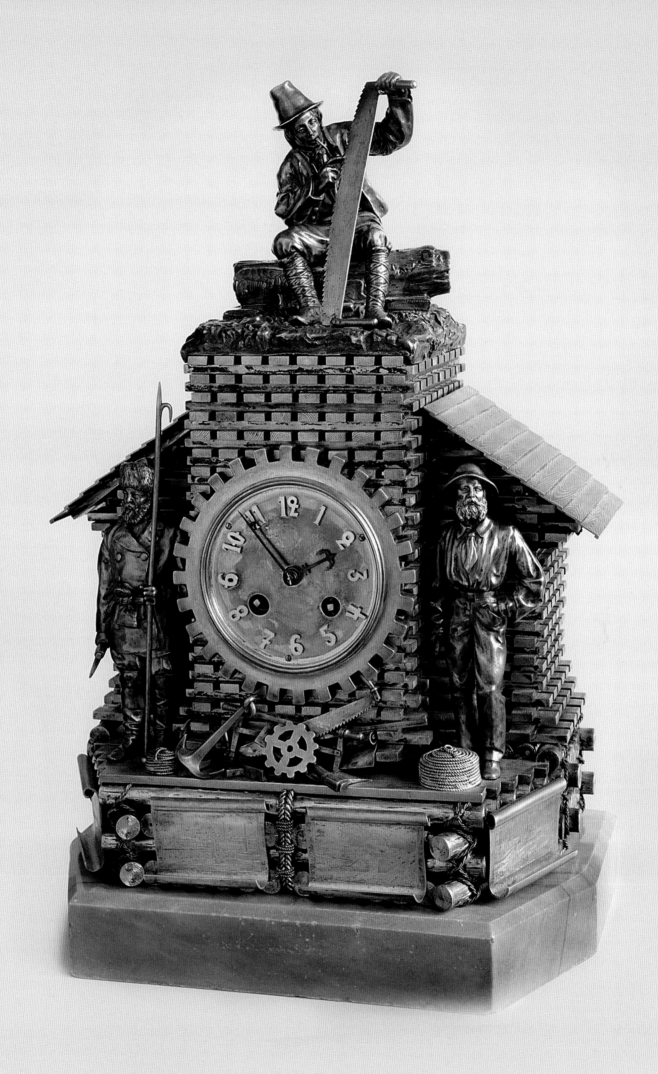

21. A Fabergé shaped oval
silver dish, Moscow, 1893.
Repoussé and chased with
rocaille scrolling and raised
upon three leaf supports, in
the Louis XV taste. Length
18cm.

BONHAMS/FABERGÉ MUSEUM BADEN-
BADEN

22. A Fabergé silver egg-
shaped box, Moscow, c.1890.
The hinged covers finely
repoussé and chased with
rocaille scrolling. Length
15cm.

BONHAMS

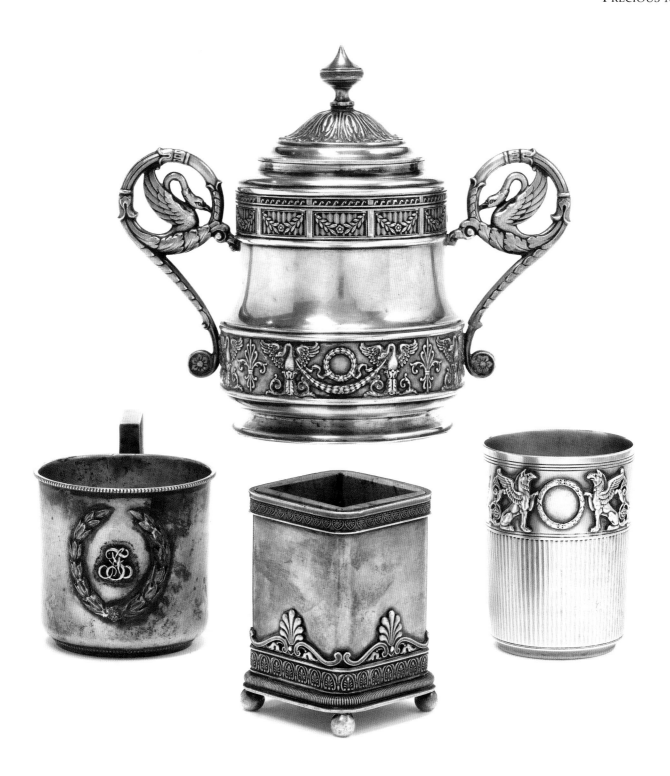

In parallel, St Petersburg espoused a revival of Western decorative arts techniques, namely eighteenth century enamelling in the French Court taste. Under Louis XV, this was synonymous with the Rococo style characterised by shell-like motifs, foliate scrolls or sea spray to imbue rhythm and asymmetric movement to an inanimate object. The Louis XVI style evolved as a reaction to the earlier exuberance by embracing more sober, rectilinear compositions. These were inspired by Ancient Greece and Rome. Fabergé famously reinterpreted these earlier themes into his firm's signature style.

23. A Khlebnikov sugar bowl together with Fabergé pen holder and cups, c.1900. These objects in the Louis XVI style draw their ornamental vocabulary from Classical motifs. All silver. Height of tallest 16cm.
BONHAMS/COLLECTION MIRABAUD

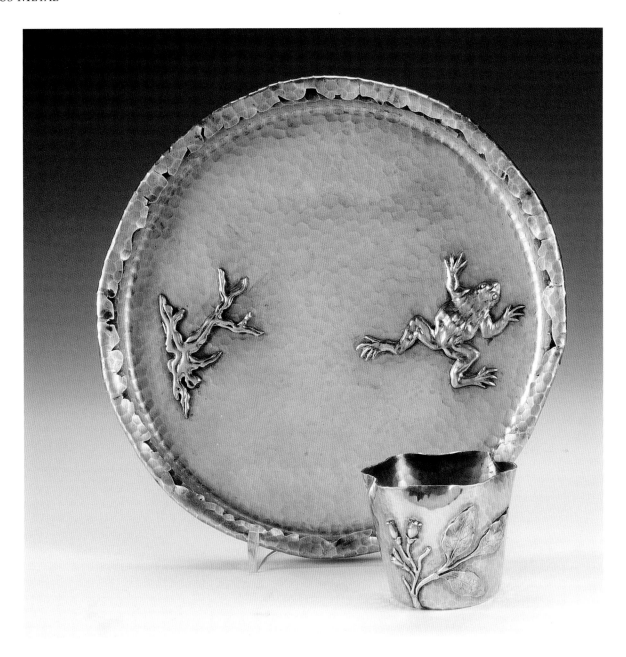

The Twentieth Century

24. A *trompe l'oeil* silver tray and beaker, Karl Albrecht, St Petersburg, 1882. The tray simulating a lily pad and applied with repoussé, and chased, Japanese-influenced silver-gilt frog and pond weed; the cup en-suite illustrating the Art Nouveau taste in Russian silver. Tray diameter 22cm.

BONHAMS/FABERGÉ MUSEUM BADEN-BADEN

The early years of the twentieth century saw the languid forms of Art Nouveau take hold. Referred to as the 'Style Modern' and embodied in the *Mir Iskusstva* group, the movement sought to counteract the mass production made possible by the Machine Age and drew inspiration from nature rather than continually reinterpreting the historical past. The profusion of scrolling foliate ornament was then followed by a backlash of restraint and geometric symmetry that foretold the Art Deco style. The first tentative steps in this trajectory were made around 1910, although the First World War and ensuing shortages quickly redistributed the supply of precious metals for luxury goods.

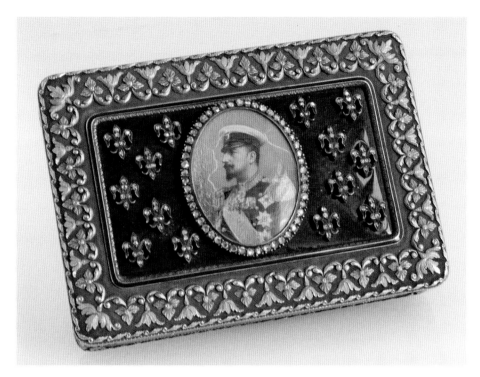

Techniques

As pure gold is too pliant to be of practical use on its own, a metal must be alloyed to it in order to strengthen it. The addition of copper lends a red hue, while silver results in green gold, and nickel in white gold. When used in proximity to one another in a single piece, the play on yellow, red, green and white gold is termed *quatre-couleur* or varicoloured gold. Russian goldsmiths understood the practicalities and design possibilities

25. Enamelled and varicoloured gold presentation box with a portrait miniature by Zehngraf of King Ferdinand I of Bulgaria. The Swiss box, c.1820, displays the play between gold colours in the details of the cast tulips in the border to great effect. Width 8.7cm.

FABERGÉ MUSEUM BADEN-BADEN

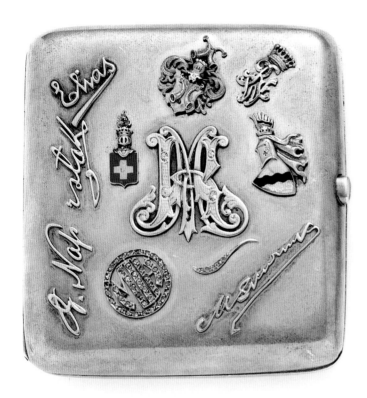

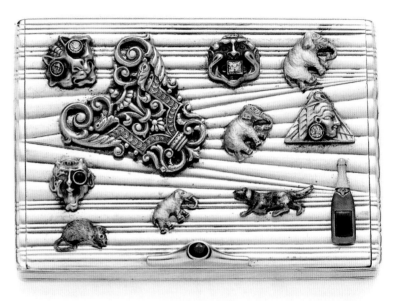

afforded by this alchemy. Fabergé, in particular, capitalised on the ability to create relief and perspective by highlighting details of a trailing ribbon tied loosely around a contrasting wreath or the petals of varying flora emanating from a garland.

When snuff gave way to cigarettes in the nineteenth century, fashionable Russians clamoured for pocket-sized accessories to store and offer their cigarettes with flourish. Smoking cut across economic

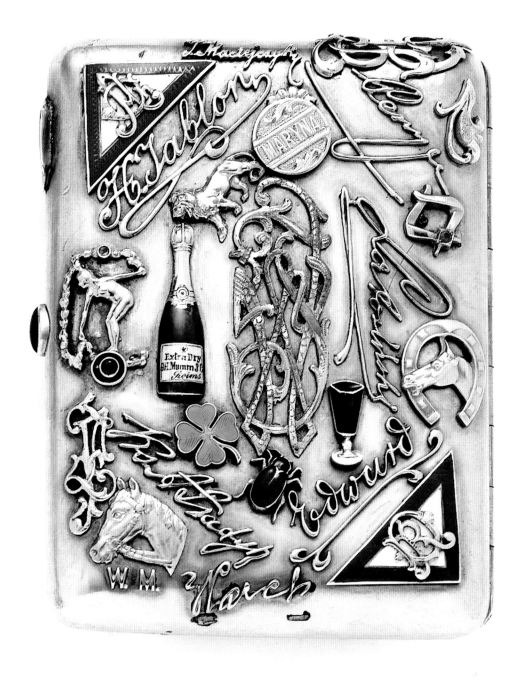

and geographical boundaries and so the little cigarette cases survive in large quantities and varying qualities. Of course, the elegant proffering from an aristocratic wrist, and the snapping shut from a seamless hinge were all part of the ritual, as had been the passing around of a lit tinder cord between officers.

26. Three silver cigarette cases applied with souvenirs and signatures, c.1900, together with a silver coin holder formed as a pendant with radiating ribbed covers, Marshak, Moscow, c.1890. Height of largest 10.2cm.
BONHAMS

27. A silver and jewelled cigarette case, St Petersburg, 1908–1917, illustrating the textured *samorodok* technique. Length 10.2cm.
BONHAMS

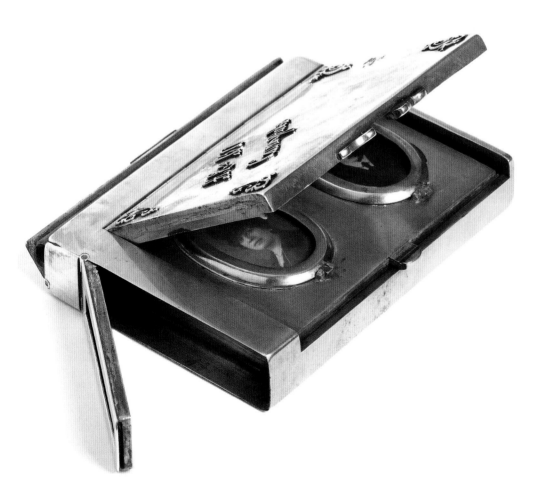

28. A silver cigarette case, maker's mark: 'IF' (Cyrillic), Moscow, 1899–1908. Hinged to reveal separate photo, tinder and pencil compartments. 11 x 8cm.
BONHAMS/IAKOBACHVILI COLLECTION

Nowadays, surviving examples are often reeded or ribbed and applied with souvenirs or monograms to personalise them. Although most commonly comprising one principal section for cigarettes, a great many examples survive with compartments for matches, space for a tinder cord, or even false lids for erotic or sentimental images.

The play on gold tones could also be amplified by polishing a surface or leaving it matt. This could add an effect of depth and contrast to a crisply worked piece. Another common idiosyncrasy of Russian craftsmen was the *samorodok* technique whereby a silver or gold object was heated almost to the point of melting before being plunged into water, causing the metal to retract on itself and form a random pattern resembling nuggets or animal hide. This rugged, topographical surface lent itself well to the cigarette cases of the male realm.

29. Varicoloured gold and gem-set cigarette case, Beilin & Son, St Petersburg, 1908–1917. In addition to using various alloys to dye the gold elements, this box demonstrates how varying matt and textured gold gives added relief to the design elements. Length 9.5cm.
FABERGÉ MUSEUM BADEN-BADEN

Assaying and Hallmarking

As mentioned, working pliable silver and gold into durable objects requires the addition of an alloy to bolster the strength of the precious metal. Historically, the specific makeup of the materials was of grave importance, particularly before paper money became the norm when gold and silver coins were used as currency and traded according to their intrinsic cost. As the proportion of metals used is not obvious to the naked eye, and also because there were strong incentives to dissimulate the true value of these portable commodities, it was crucial to develop an accepted system of grading for the makeup of a piece. The striking of a hallmark or other symbol noting the purity of a metal helps to identify its provenance and value if it is to be sold, traded or taxed.

The crafting and selling of precious metals in seventeenth-century Russia took place in a row of approved workshops located on the principal market squares in Moscow and the provinces. Admission to this association required craftsmen and dealers to adhere to the Tsar's edicts and for a sample of work to be approved. Aldermen were charged with controlling or assaying the metal content and ensuring that pieces were sold with proper identifying stamps.

Purity marks for Russian silver were used from about 1650 and appeared as city symbols because the master had to have the composition of an object tested in order to apply this form of certification to a work. Maker and assay marks were added in the 1680s.[4] Running parallel to this was the output of workshops that were tied either to Imperial, church or private patronage and which did not answer to the edicts governing the popular Silver Rows.

This traditional system was altered in the eighteenth century as the policies of Peter the Great stimulated trade and encouraged foreign craftsmen to settle in his newly founded city of St Petersburg. With the Tsar's reforms in 1700 came decrees controlling the use of makers and city marks. The aldermen verified that the minimum standard allowed had been used and taxed the silversmith accordingly.[5]

Opposite. 30. Twenty-fifth anniversary clock. Silver, gold, onyx and diamonds. Fabergé, workmaster Mikhail Perkhin, St Petersburg, 1891. One of the largest works of art ever produced by Fabergé and an astonishing tribute to Baroque art, the clock was a fitting silver wedding anniversary present to Alexander III and Maria Feodorovna on behalf of their extended family members. Height 68.5cm.
FABERGÉ MUSEUM BADEN-BADEN

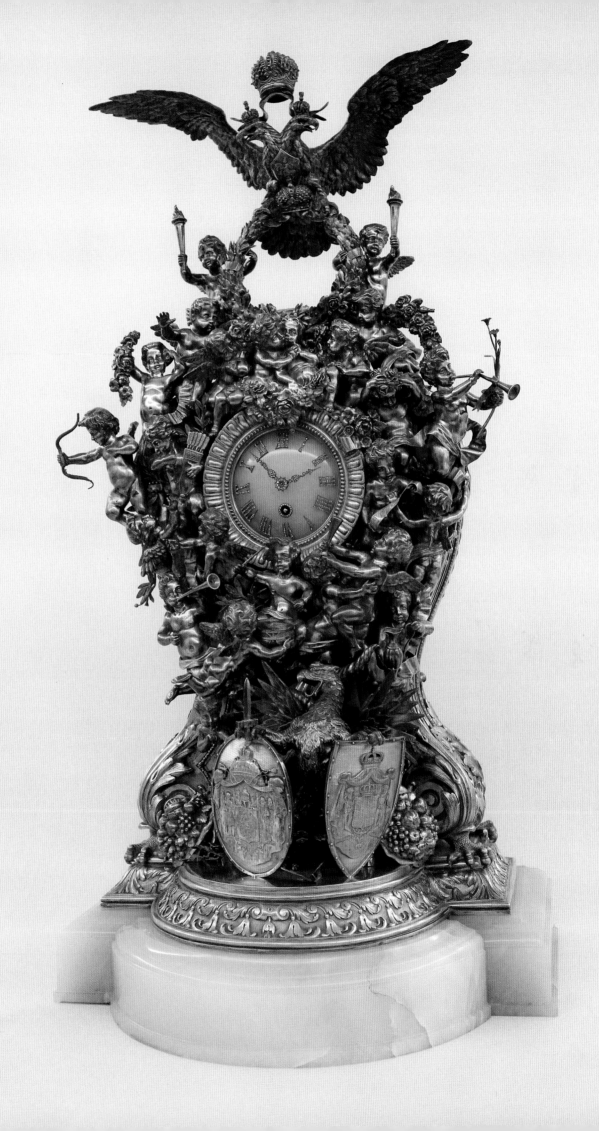

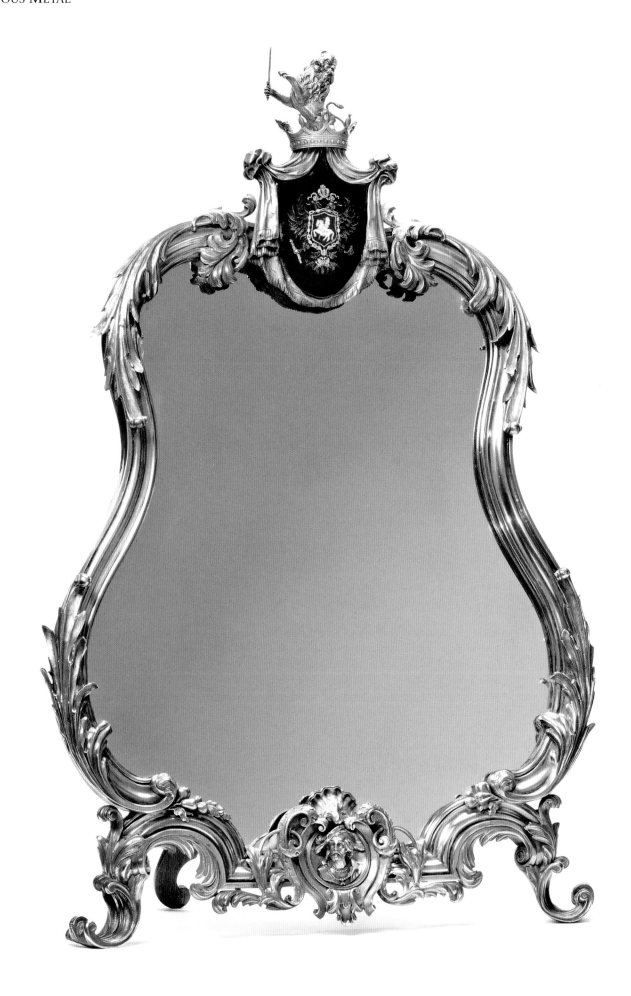

These efforts at standardising the system were by no means fail-safe. As silversmiths tried to avoid paying duty based on silver content, they too side-stepped the formal hallmarking system, so it should not be assumed necessarily that an unmarked piece was produced by Imperial request in the Kremlin workshops. Many of the hallmarks that do appear are indecipherable and although M.M. Postnikova-Loseva catalogued a staggering number of stamps in her ground-breaking dictionary of hallmarks, there remains a large body of work created by unrecorded makers.[6] Still, by process of elimination, where there are maker's initials with details of the silver standard and city, we are often able to extrapolate dating.

Peter the Great introduced additional Western-style amendments to the craft of goldsmithing in the 1720s, and these were modelled on the German guild system. As a result, a two-tier arrangement evolved into separate Russian and foreign guilds. The reign of Catherine the Great (1762–1796) saw further reforms and by the late eighteenth century, a workshop could only be operated by a 'master' – a status achieved after serving specific terms as an apprentice and journeyman, as well as the successful presentation of a 'master piece'. The level of master in turn carried voting rights for nominating aldermen, so the status was coveted and, following death, passed legally to the master's widow.[7]

Opposite. 31. A silver dressing-table mirror by Sazikov bearing the Imperial Warrant, Moscow, 1849. The sheer size of this mirror gives it additional cachet at auction. Height 75cm.
BONHAMS/FABERGÉ MUSEUM BADEN-BADEN

32. A gold cylindrical box, set with blue chalcedony cabochons at either end with bands of rose-cut diamonds. Fabergé, workmaster Hjalmar Armfelt, St Petersburg, 1899–1908. Length 5.4cm.
BONHAMS/PRIVATE COLLECTION

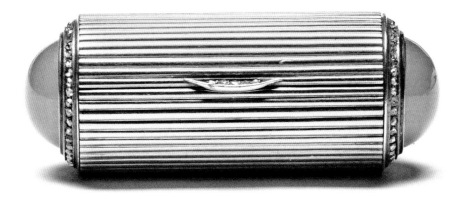

33. The mark on a silver item of the Moscow assay master 'AC' in 1894.

FABERGÉ MUSEUM BADEN-BADEN

34. The mark on a silver item of St George, the mounted horseman slaying a dragon – the symbol for Moscow, together with the 1894 mark for Assay master A.A.

FABERGÉ MUSEUM BADEN-BADEN

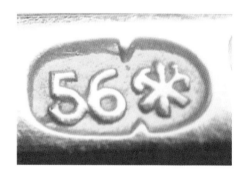

35. 56 zolotnik gold and the crossed anchors of St Petersburg, before 1899.

FABERGÉ MUSEUM BADEN-BADEN

From 1731 until 1792, the lowest silver standard was set at 72 and the highest at 77. In 1792, the minimum silver quantity was reset at 84 zolotniki meaning that there were 84 parts of pure silver out of 96. By 1854, the silver standards were set at 84, 88 and 91, with the latter reserved principally for items earmarked for export.[8]

> 1 gold zolotnik: ½ carat
>
> 96 zolotniks: pure silver or 24 carat gold
>
> 56 zolotnik gold corresponded to 14 carat
>
> 72 zolotnik gold corresponded to 18 carat and was used for export items
>
> 91 zolotnik silver: measured as parts per thousand of standard silver in the West (947/1000), corresponding to sterling silver and used in rare cases where an item was intended for export to the English market. 88 and 84 zolotniks were commonly used and equivalent to 875/1000 and 916/1000 standard silver

These metal standards are commonly found on precious metal objects that are regularly traded in today's market. Other information distilled within oblong cartouches points to date and place of origin. For example, the assayer's initials appear over the date on pieces made during the late eighteenth to nineteenth century. It is worth mentioning that the absence of a metal mark is plausible. This commonly occurs in platinum-mounted objects as this material was exempt from hallmarking.

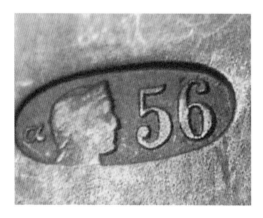

36. Gold item bearing the female profile in traditional head-dress. This symbol indicates a date mark for 1899–1908 if facing left, or 1908–1917 if facing right. On the left can also be seen the delta loop, as shown here beside the 56 zolotnik gold standard, the symbol of St Petersburg.

FABERGÉ MUSEUM BADEN-BADEN

It is crucial to familiarise oneself with the markings on Russian silver as

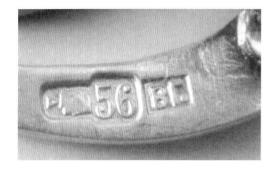

37. The triangular alpha mark for Moscow on a gold item. Also shown are the maker's mark and 56 zolotnik stamp.

FABERGÉ MUSEUM BADEN-BADEN

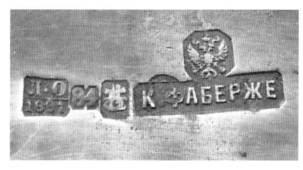

38. Fabergé mark in silver with the crowned eagle as an Imperial Warrant, indicating the firm were official purveyors to the Imperial Court for Moscow. Further to the left are the Moscow marks of St George slaying the dragon, the 84 standard, assay master L.O. and the date 1897.

FABERGÉ MUSEUM BADEN-BADEN

39. The hallmark for the Fabergé head workmaster in St Petersburg, Henrik Wigström (1903–1918).

FABERGÉ MUSEUM BADEN-BADEN

40. An example of a scratch inventory number together with the crossed anchors of St Petersburg and the 88 silver standard, before 1899.

41. The hallmark, in silver, for the family firm of Bolin, together with the 88 silver standard (Kokoshnik facing left for 1899-1908), assay master Ivan Lebedkin and craftsman Konstantin Linke.

FABERGÉ MUSEUM BADEN-BADEN

they can point to the authenticity of a work. A sound knowledge of principle maker's marks will help to identify what the trade refers to as a 'bad marriage', either between disparate silver parts such as bodies, handles and lids joined together haphazardly or random tea implements thrown together in a purpose-built presentation case intending to deceive potential clients. These practises are distinct from the perfectly plausible commercial decisions undertaken by companies outsourcing parts of a silver service to various workshops and uniting them, employing the retailer's hallmark and presenting them within a branded fitted case. Spuriously marked objects often attribute a maker to the wrong city or date, so once the condition and craftsmanship has passed muster with a potential buyer, it is crucial to check that hallmarks are plausible. In St Petersburg, for example, by the last quarter of the nineteenth century, the silver standard shared an oval cell with the crossed anchors of the city symbol. The equivalent Moscow stamp was the figure of St George slaying the dragon. The principal makers and hallmarks should be learned by heart.

42. The hallmark in gold for the Fabergé head workmaster in St Petersburg, Mikhail Perkhin (1886–1903), shown together with the crossed anchors for St Petersburg before 1899 and the mark for 56 zolotnik gold. By cross-referencing the anchors and the master's active dates we can narrow the piece further to 1866-1898.

FABERGÉ MUSEUM BADEN-BADEN

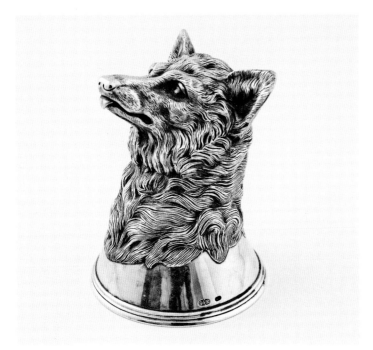

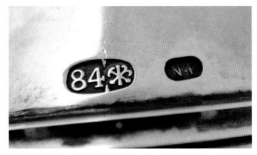

44. Detail of plate 43. The hallmark N.P for Nicholls & Plincke with the crossed anchors for St Petersburg, before 1899, and the 84 zolotnik silver mark.

FABERGÉ MUSEUM BADEN-BADEN

43. Silver stirrup cup, Nicholls & Plincke, St Petersburg, before 1899. One of a large series of cups modelled as hunting animals and traditionally used to toast from the saddle. Height 7.3cm.

FABERGÉ MUSEUM BADEN-BADEN

45. Gold vesta case. Fabergé, workmaster August Holmström, St Petersburg, c.1890. The reeded body with hinged lid opening at the cabochon ruby and rose-cut diamond pushpiece to reveal a match compartment with a striker on the base. Length 4.6cm.

BONHAMS/PRIVATE COLLECTION

There has been a great deal of debate over the exact dating of hallmarks in the last years of the nineteenth century, when a female profile with a peasant head-dress – or *kokoshnik* – replaced the city mark. It is now accepted practice to consider the late nineteenth-century to early twentieth-century use of this female *kokoshnik* stamp in tandem with the principal assay master's initials as follows: from 1899 to 1908 the *kokoshnik* faces the viewer's left. When found in conjunction with the Cyrillic I L, the hallmark points to the Moscow assayer Ivan Lebedkin; from 1899–1904 the initials A.P. stand for the St Petersburg assayer Alexander Romanov. These overlap somewhat with the Cyrillic initials Ya L used for St Petersburg objects assayed between 1899 and 1908 by Yakov Lyapunov. By 1908, the *kokoshnik* on the stamp has turned to face the viewer's right, and the assay initials are replaced until about 1920 by Greek initials: Alpha for St Petersburg and Delta for Moscow.[9]

ИЛ: Moscow, 1899-1908

АР: St Petersburg, 1899-1904

ЯЛ: St Petersburg, 1904-1908

α: St Petersburg, 1908-1917

Δ: Moscow, 1908-1917

Goldsmiths who enjoyed Imperial patronage and who supplied the court directly continued to operate outside of guild and hallmarking restrictions. This privileged appointment entitled the holder to integrate a symbol of

the Imperial warrant, the double-headed eagle, into the firm's hallmarking system. Purveyors to the court created items of exceedingly high quality and are sought after by collectors today. Amongst them, the most important silver firm in the mid-nineteenth century was the English-managed Magasin Anglais Nicholls & Plincke in St Petersburg. They were known for their finely worked heavy silver pieces ranging from monumental candelabra down to stirrup cups realistically modelled as wild game. Their close competition included the firms of Morozov, Khlebnikov, Ovchinnikov, Sazikov and Grachev, sometime collectively nicknamed the 'Ovs'.

It was due to the technical advances of the industrial era that larger factories appeared. With increasingly mechanised production permitting larger output, the successful business model based on higher turnover overtook the smaller, more traditional workshops. Those who survived the initial cull retaliated by banding together to form artels or working cooperatives. Over twenty of these are documented, with some producing goods that are more collectable today than others. Their output was retailed either through larger firms or through dealers, so one might find an artel object with St Petersburg marks in a seemingly unrelated silk-lined retailer's case. The First Silver Artel and the Third Artel supplied the firm of Fabergé with silver and finely enamelled objects respectively. In terms of buying power, their value is elevated when stamped both by the artel and with the Fabergé hallmarks.

Above. 46. Fabergé silver cane handle with hinged cigarette compartment, August Holmström, St Petersburg, 1899–1908. Beneath it is a gem-set silver retractable pencil holder, maker's mark: 'AR', St Petersburg, pre-1899. Handle length 10.5cm.
BONHAMS/PRIVATE COLLECTION

47. Jewelled gold match case by Fabergé, Gabriel Nykänen, St Petersburg, c.1890 opening to reveal match compartment and striking surface. Height 4.2cm.
BONHAMS/ANDREY CHERVICHENKO

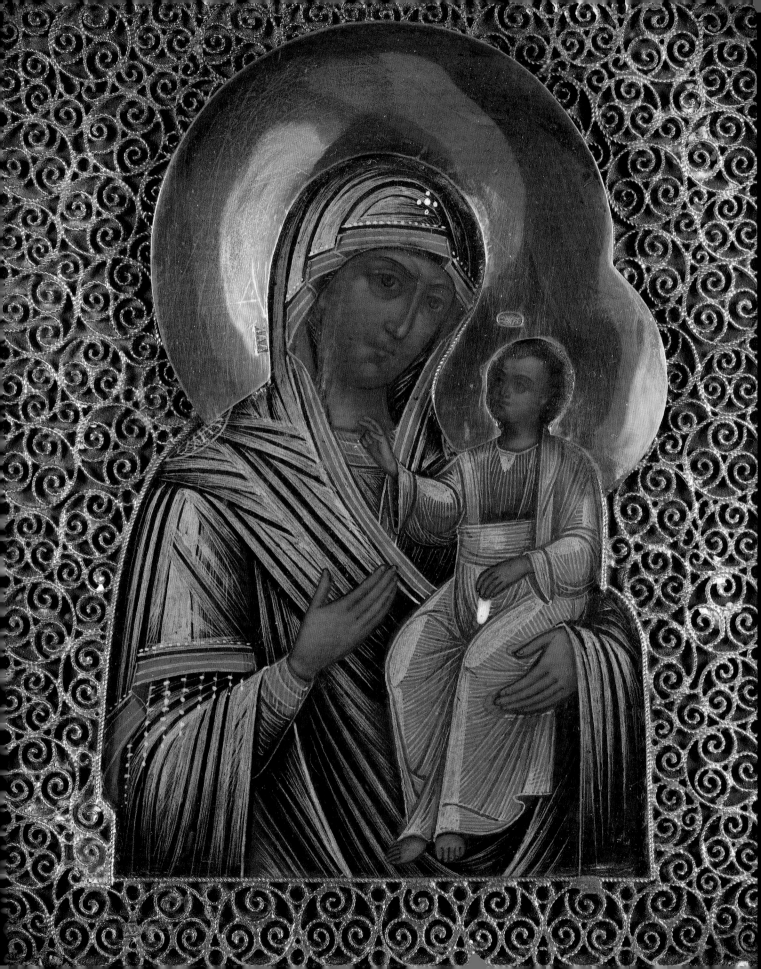

ENAMEL

THE EVOLUTION OF ENAMELWORK from eleventh-century Kievan Rus to twentieth-century revolutionary Moscow drew on Byzantine roots and then wove Western European influences into its ornamental vocabulary. It reflected Russia's own position at the crossroads of trade routes between the East and West. Indeed, enamelwork was a manifestation of the prominence of cities that were later wiped out by political instability. Most of the principal enamel techniques represented on the Russian auction market today have their roots in examples discovered during archaeological excavations. Tenth- to thirteenth-century *finift*-type enamel evolved stylistically from Byzantium, which inspired both Russian and Western European interpretations of the earlier enamel crafts.

Enamelling is a method of adhering a coloured glass compound to a metal base. When this is achieved by incising the surface of the metal and filling the vacant channels with enamel, it is generally referred to as champlevé. The effect is flush across the piece as the enamel decoration is

Above. 49. Salts by various makers, c.1890, showing the champlevé technique in designs inspired by embroidered textile. The tea glass holder dating from the same period is a typical Eastern European form and often appears at auction missing its original glass liner. All silver. Height of tea glass holder 14cm; diameter of largest salt 5cm.
BONHAMS

Opposite. 48. This silver oklad, produced in Moscow, 1899–1908, is enriched with elaborate filigree work. 13.5 x 11cm.
BONHAMS/ANDREY CHERVICHENKO

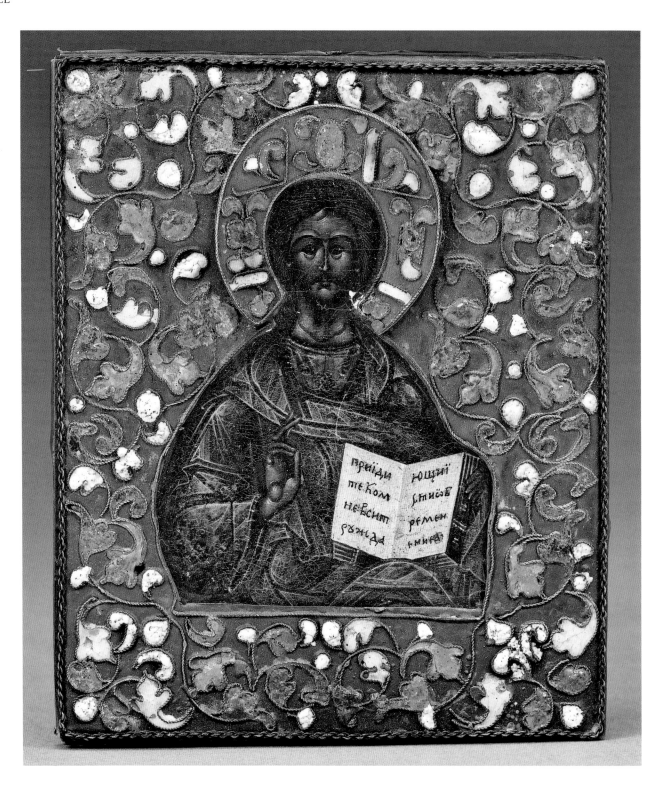

50. Miniature icon of Christ Pantocrator with an enamelled oklad, nineteenth century.
12 x 10cm.

inset. In the Russian market, this method commonly survives in the form of small objects such as salt thrones and bowls. The technique lends itself particularly well to being enriched with decoration borrowed from embroidered textiles.

In instances where the metal base is built up by soldering wire into a pattern of foliate cells or cloisons and then filled with varicoloured

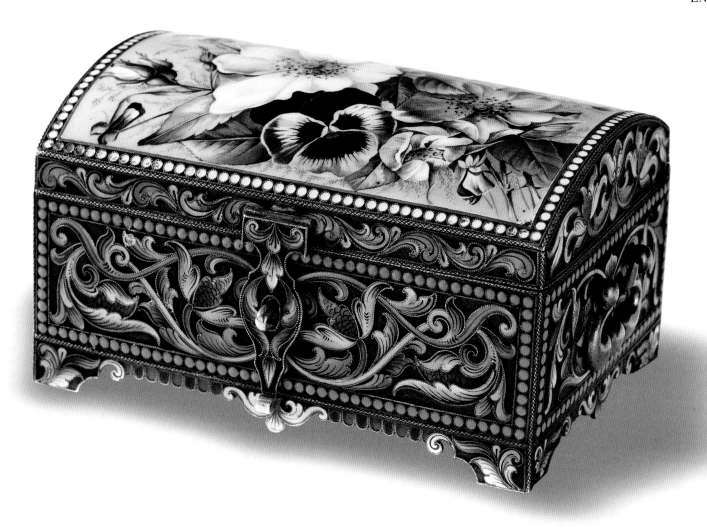

enamel, the technique is generically termed cloisonné. Technically, what is being referred to in auction catalogues is actually filigree enamel, as twisted wirework borders are usually employed. The meandering floral motifs are sometimes further detailed by painting the striations and veins of a leaf with cross-hatching, also employed on individual petals, and thus termed shaded enamelling. This lends an effect of relief and movement to enamel work. Pieces produced in the workshops of Maria Semenova, for example, have a static quality, an energy that feels tangible and is beyond the capabilities of imitators. Here the scrolling foliate ornament meanders and entwines in a lively manner that is rendered dull and flat in spurious versions.

Auction catalogues viewed online offer the opportunity for 'zooming in' and closely studying the individual petals and floral motifs. It is advisable for potential collectors to study the hatching and the grainy quality of the pigment until it forms an imprint in the mind's eye.

51. Silver-gilt and shaded enamel casket by Maria Semenova, Moscow, 1899–1908. The twisted wirework borders, floral plaque and beading are characteristic of this maker. Note the exuberant scrolling foliate motifs and the delicate shading of the petals. Length 12.5cm.
BONHAMS/ALEX AEROV

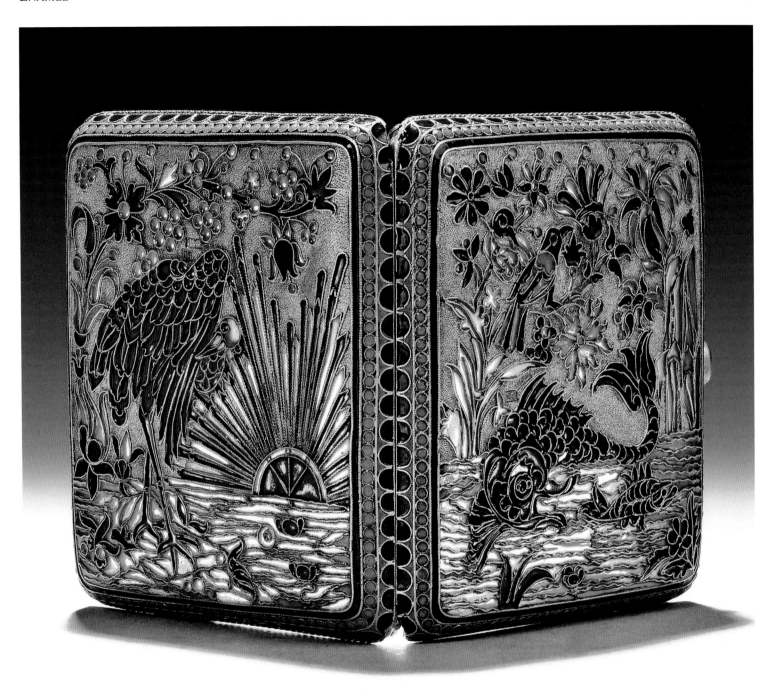

52. Late nineteenth-century silver cigarette case enamelled on one panel with a bird against a sunset and on the other a stylised carp.
9.2 x 8cm.

Opposite above. 53. Silver *plique-à-jour charka* probably by Ovchinnikov, late nineteenth century. Height 10.8cm.

Opposite below. 54. Silver and jewelled pictorial *kovsh* set with enamel plaque painted with a Russian beauty, Nemirov-Kolodkin, Moscow, 1908–1917. Length 32cm.

A cell without a backing that then is filled with coloured enamel and allows light through, as would a stained glass window, is known as *plique-à-jour*.

When cloisonné enamel is fitted with a painted plaque of a floral design or a scene from a fairytale, this has come to be listed in auction catalogues as *en-plein*. Strictly speaking, however, this is not accurate, as it is often simply a miniature painting that has been inset into a larger piece.

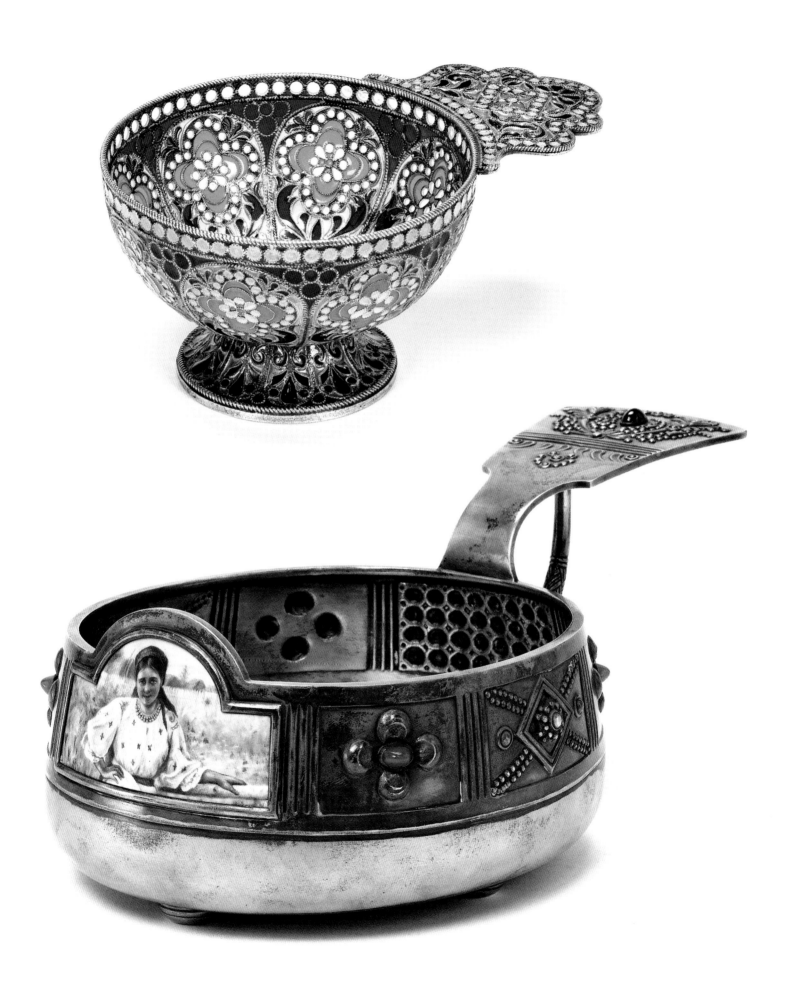

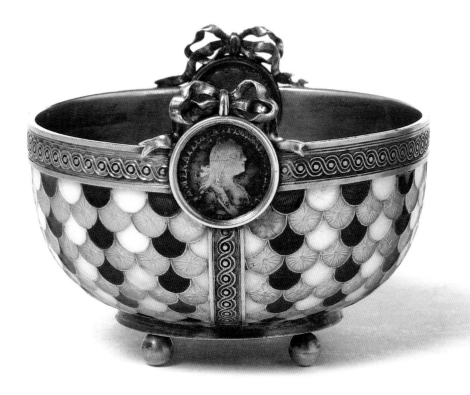

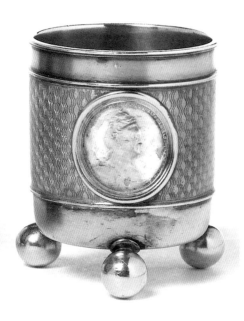

Top of page. 55. Two enamel and silver-gilt pieces by Antti Nevalainen for Fabergé, St Petersburg, c.1900. Both are inset with Russian coins, a characteristic device of this workmaster. Width of bowl 7.8cm.
BONHAMS

56. Fabergé silver-gilt cigarette case and locket showing moiré and sunburst engine-turning respectively. Moscow and St Petersburg, 1899–1917. Length of locket 6.7cm; width of cigarette case 8.5cm.
BONHAMS/FABERGÉ MUSEUM BADEN-BADEN (CASE)/
THE FISCHER FOUNDATION (LOCKET)

Guilloché enamel, a laborious process commonly associated with, but not limited to, the Fabergé workshops, occurs when the metal surface is incised, usually by engine-turning. The resulting repetition of patterns such as waves, zigzags and rays is then fired with successive layers of translucent enamel allowing a pattern to emerge, such as moiré silk or fish scales, which then play with light. The skill involved in re-applying and firing layers of enamel at temperatures of around 700 degrees centigrade without compromising the flux or metal surface was demanding of even the most experienced

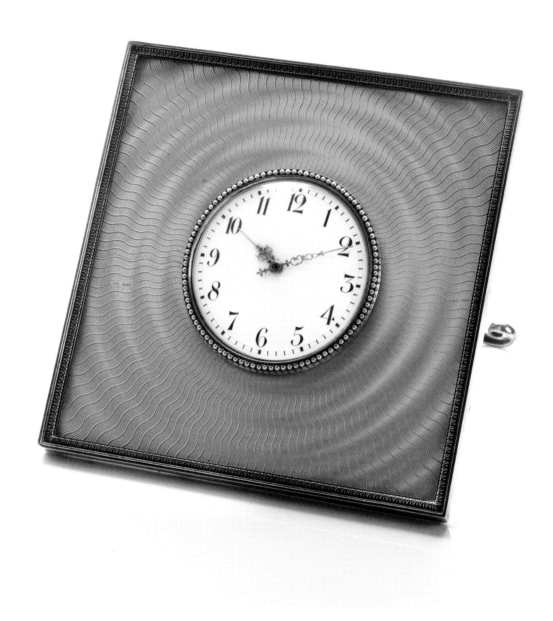

craftsmen. Once the baking process was complete, a piece then required careful polishing in order to smooth down any irregularities. This is why fine enamel pieces are such a pleasure, not only to the eyes but also to the touch.

This optical effect was exploited to great effect in the presentation of guilloché enamel items such as naval awards. When handling the piece to better admire the dedication inscription, the smallest movement of the hand would cause the wavy engine-turned ground to capture the light, giving the object a life and vibrancy that would have delighted the receptor. Similarly, a pink box intended for the inner sanctum of an enfilade of feminine apartments would be engine-turned with a moiré ribbon effect, or the aperture of a clock might be encircled with an energetic sunburst motif. It is often when these details are at cross purposes with the intended use of the item that inner alarms should be tripped off.

57. Silver-mounted seed-pearl and enamel clock, Fabergé, workmaster Henrik Wigström, St Petersburg, 1908–1917. The celadon translucent enamel over sunburst engine turning produces a lively undulating effect. 11 x 11cm.
BONHAMS/FABERGÉ MUSEUM BADEN-BADEN

58. Enamelled and jewelled silver-gilt cigarette case by Britzin, St Petersburg, 1908–1917. Length 9.5cm.
BONHAMS/IAKOBACHVILI COLLECTION

Opposite. 60. Parcel-gilt and enamel bucket by Morozov, St Petersburg, 1899–1908. The body has finely painted views of St Petersburg against a red ground. Height with handle 20cm.
BONHAMS

Below. 59. A group of silver- and gold-mounted St Petersburg Fabergé objects from the rose-coloured feminine realm flanking a match strike suitable for a masculine study. Pencil holder by Perkhin, c.1890, length 7cm. Match strike/holder by Nevalainen, 1899-1908, 9cm tall. Cigarette case by Hollming, 1908-1917, 7.7cm. long.
BONHAMS

A delicate rose-patterned snuff box purporting to be the gift from a group of burly officers to their commander is possible, of course, but unlikely. In much the same way, grandchildren probably would not club together to buy Grandmamma a gun-metal cigar box or daddy a lipstick holder. Equally, lovers do not usually make a habit of presenting one another with ashtrays or vodka glasses. Collectors must look at the plausibility of the provenance and supporting attribution impassively, as an element of logic must prevail when examining pieces doctored with altered dedication inscriptions or far-fetched provenance documentation.

An overview of techniques should mention the cold enamel painted scenes, often against red ground, that appear from time to time at auction. Meticulously rendered troika scenes and cityscapes rarely survive unscathed, which elevates the price of examples in good condition.

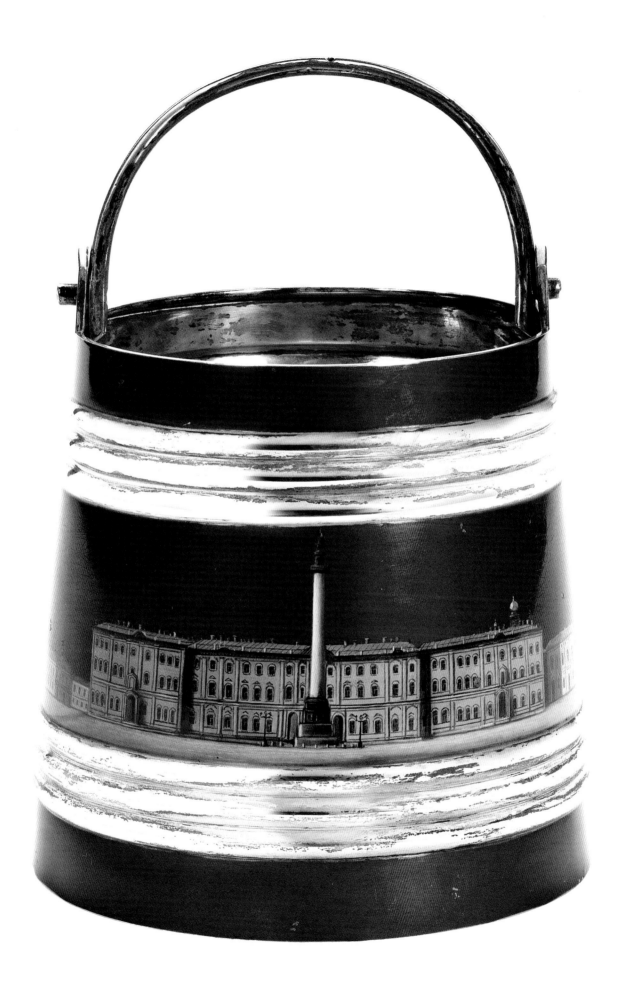

Finally, enamelled steel beakers with transfer-printed motifs, known to have been issued to the public to toast the coronation of Nicholas II and Alexandra, survive in great numbers to present day. This gesture by the organisers was to have an unexpected outcome, however, as when it was rumoured that the free mead was running out, panic spread. The resulting stampede in the Khodinka fields tarnished the festivities and the large death toll cast an ominous shadow over the last Romanov coronation. These days, regular inquiries regarding Khodinka cups stream into the Russian Department at Bonhams.

Historically, enamelling was an expensive technique when applied to gold or to silver and therefore its use was limited to special commissions for the wealthy, rather than being suitable for mass production. As the usage and popularity of enamel were tied to the fortunes of the most prosperous cities, it flourished in eleventh-century Kievan Rus and then all but disappeared during the Mongol invasion of the thirteenth century. Once Moscow emerged from the Tartar yoke, enamelware resurfaced, though not in its earlier Kievan champlevé form. In the sixteenth century, Greek-influenced cloisonné style work was produced in Moscow to meet the growing needs of church and palace patronage, eager to assert a message of internal stability, wealth and power. Precious metals enriched with enamel, combined with repoussé and chasing, then further set with stones, showcased the technical mastery of the Moscow craftsmen.

With the election of Mikhail as the first Romanov Tsar in 1613, political stability encouraged the arts to flourish in the capital city and drew masters from the Russian north as well as from abroad. This melting pot resulted in a particular style of work that was influenced by the aesthetic vocabulary of Western Europe and the Middle East, but which is firmly associated with Moscow. As well as supplying the Kremlin Armoury with its most lavish commissions, the taste for these enamels trickled through the Silver Rows. Thus, in market squares across Moscow and the provinces, the taste for colourful cloisonné enamel was translated into a relatively affordable variety of small objects from buttons to pill boxes and brooches.

61. Enamel cigarette case by Britzin,
St Petersburg, 1908–1917, together with a
coronation beaker demonstrating the wide
spectrum of enamel techniques. Length of case
8.2cm, height of beaker 10.5cm.
BONHAMS/GREGORY KHUTORSKY ANTIQUES

Once Moscow was established as the epicentre of court and religious life, other cities benefited from the economic and political stability of the late seventeenth century. Solvychegodsk was the seat of the famous Stroganov family who were also powerful patrons of the arts. The location in northern Russia on the main trading route between the strategic White Sea port of Arkhangelsk further north and the capital in Moscow further south attracted foreign merchants. With them came Western design which was then incorporated into the enamel ware of Solvychegodsk, sometimes referred to as 'Usolsk', a derivation of the old name of the town. These wares, while perhaps not as technically sophisticated as those made in the capital, are pleasing in their own right – characterised by boldly coloured flora and fauna painted onto bright white ground. References to imported engraved sources as interpreted by the craftsmen can be seen in the cross-hatched treatment of foliate motifs.[1]

In the late seventeenth century, when Solvychegodsk began to decline, the prominence of the nearby town of Veliky Ustyug increased. It too benefited from a wealth of trade opportunities and foreign settlers. The enamel items from this region are more rustic than those discussed above and rarely survived in good condition, but they do appear from time to time, mainly as drinking vessels and teapots. In the case of these, a large area of copper is covered in enamel, often blue. Before the last firing, it is then applied with a silver stamped appliqué depicting genre scenes within floral borders.[2] Far fewer examples of the provincial output of Solvychegodsk and Veliky Ustyug survive making them highly collectable.

A stylistic schism occurred when Peter the Great moved artisans to his new capital city of St Petersburg in 1712. As part of his programme of aggressive modernisation and expansion, the court thereafter sought to emulate the great capitals of Western Europe in every possible way. Catherine the Great (Catherine II) picked up the mantle of Westernisation and further galvanised the transformation of what was a northern marshy territory into a network of lavish palaces and broad boulevards along the Neva river, which came to be known the as 'The Venice of the North'.

Eighteenth-century society in St Petersburg embraced the fashionable styles and techniques produced by the Western European artisans who were drawn to the new capital. Portrait miniatures painted on enamel

62. Enamel and copper snuff box, Solvychegodsk, nineteenth century. Length 6.7cm.

depicting the sitter in the latest fashion were then incorporated into boxes and watches. The fashion for taking snuff swept in from Europe and by the mid eighteenth century, Russia was producing small boxes for this purpose.

These exquisite objects often incorporated a portrait miniature in a central reserve, surrounded by the latest French trend for guilloché work, in which a translucent layer of enamel-covered engine-turned ground revealing a delicate pattern.

These snuff boxes, produced by the great makers such as the Swiss-born Ador, continued to be presented by Russian rulers and so became associated with the Russian court. Enamelling was also incorporated into the military and civil awards which were bestowed upon the most distinguished citizens, thus under-lining the ties between this craft and St Petersburg. Before the House of Fabergé revived the guilloché technique, it was firms such as Keibel, Eduard, and Kordes which were synonymous with the highest achievements in Russian enamelwork.

The Russian Revival

During the second half of the nineteenth century, Russia responded to growing industrialisation with a search on the part of the intelligentsia and artists for an aesthetic language that would herald Russia's glorious past. This introspective quest became known as the Russian Revival and translated itself into literature, fine and decorative arts as well as architecture.

63. Imperial presentation gold, jewelled and enamelled snuff box set with Rockshtul miniature of Alexander II, Keibel, St Petersburg, 1873–1874. Length 9.8cm.
FABERGÉ MUSEUM BADEN-BADEN

64. Imperial presentation gold, jewelled and enamelled snuff box set with miniature of Nicholas II, Koechli, St Petersburg, c.1890. 9.5 x 7cm.
FABERGÉ MUSEUM BADEN-BADEN

Russian ornament borrowed heavily over the years from Byzantium, Western Europe, China and a myriad of other influences afforded by its positioning along major routes of trade. The Revival itself underwent a variety of changes, beginning with court taste in St Petersburg during the reign of Nicholas I (1825–1855). However, it quickly became associated with Moscow and was a factor in the re-establishment of that city as an artistic centre. It is said to have played a major role in providing a foundation of the modern art movement in Russia in the twentieth century.

The endless debate over the validity of any true national style in Russia and ignorant dismissal of the ornament employed as merely derivative is to miss the point entirely. Since Russia was situated at a cultural crossroads between Eastern and Western influences, the decorative arts she produced reflected the ornaments of many cultures. It was this freedom to draw upon a variety of foreign styles that gave Russian enamel work its very own distinctive flavour.

In order to understand how ornament was interpreted by late nineteenth- and early twentieth-century craftspeople, we look to its documentary roots. Fedor Grigorevich Solntsev was pivotal in the establishment of the Russian Revival style. In 1830, he was sent to Moscow by the director of the Imperial Academy of Art, Aleksei Olenin, to copy works of Russian antiquity in the Kremlin Armoury. Solntsev was instructed to draw weapons, sabres, military and court dress as well as church and court plate. These drawings were then sent to Nicholas I, who took a particular interest in this work. In 1836, Solntsev was sent for again. This time, he was to provide designs for the restoration of the Terem Palace which had been occupied by Napoleon's troops in 1812 and was badly damaged.[3]

More than 3000 drawings were made by Solntsev and about 500 of them were published in six volumes between 1846 and 1853, under the title *Drevnosti Rossiskogo Gosudarstva* ('Antiquities of the Russian State'). When Olenin sent Solntsev to Moscow, it had been Olenin's intention to provide these studies as a source for future artists. This was clearly successful as the drawings seem to have been put to almost immediate use by Ignaty Sazikov,

Opposite. 65. The title page from *Drevnosti Rossiskogo Gosudarstva* ('Antiquities of the Russian State') 1849–1853. This monumental catalogue of Russian antiquities and works of art was financed by Tsar Nicholas I and supervised by Count S.G. Stroganov using the original illustrations of F.G. Solntsev. This was considered a pivotal step in the road to re-discovery for Russia's craftspeople and remains today an invaluable reference source.

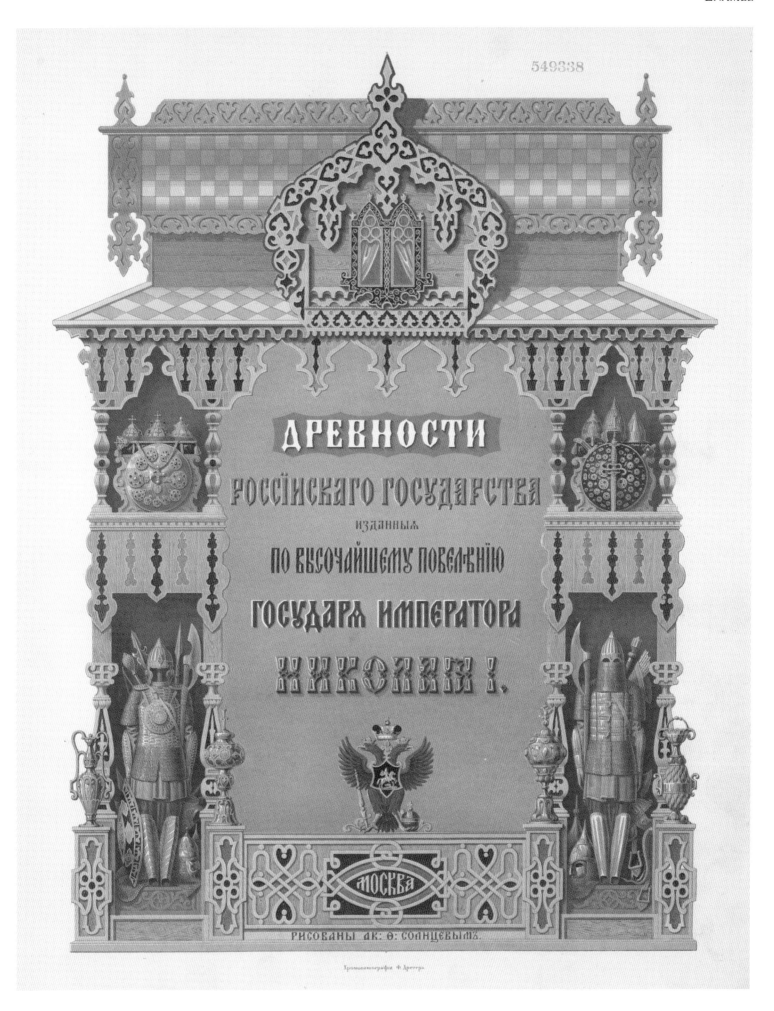

549338

ДРЕВНОСТИ

РОССІЙСКАГО ГОСУДАРСТВА

изданныя

ПО ВЫСОЧАЙШЕМУ ПОВЕЛѢНІЮ

ГОСУДАРЯ ИМПЕРАТОРА

НИКОЛАЯ I.

МОСКВА

РИСОВАНЫ АК: Ѳ: СОЛНЦЕВЫМЪ.

Хромолитографія Ф. Дрегера.

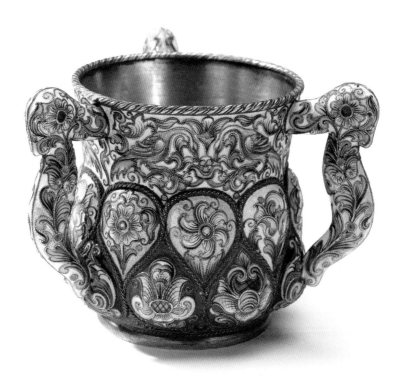

66. On this three-handled silver cup, twisted ropework borders delineate shaded enamelled floral sections and a band of stylised birds, Moscow, c.1900. Height 7.5cm.
BONHAMS/JOHN ATZBACH

Opposite. 67. Silver and enamel tankard, Ovchinnikov, Moscow, c.1889. The floral panels set within arched wirework sections supported by columns and interlacing strapwork bands. These were favourite motifs drawn from the Turkish seventeenth-century prototypes published in Solntsev's 'Antiquities of the Russian State'. Height 16cm.
BONHAMS

the Moscow silversmith who took over his father's workshop in 1830. Sazikov was a major exhibitor at the Great Exhibition at the Crystal Palace in London in 1851. Many of his pieces were illustrated in the official catalogue, almost all of them in the Old Russian style.[4] The similarity between Sazikov's work of the 1850s–1870s and the types of objects illustrated by Solntsev is quite evident in the former's use of interlace, Russian inscriptions in the Byzantine style, as well as troikas and folk figures.

That enamellers such as Pavel Ovchinnikov drew directly from Solntsev's drawings was known from a tankard which was copied from one included in the 'Antiquities', an object thought to be of Eastern origin. The silversmiths of the late nineteenth century had a long tradition of silver and enamel ware from which to draw. It would appear, however, that the first link to that tradition was through the drawings of Solntsev and not to the objects directly.

The Great Exhibition had an impact in other ways as it highlighted the effect that industrialisation was having on decorative and applied arts from abroad. In response, demand increased for the preservation of the traditional techniques used to produce these applied arts. In Britain, the South Kensington Museum (later the Victoria and Albert Museum) was founded almost immediately after the exhibition to house and display the

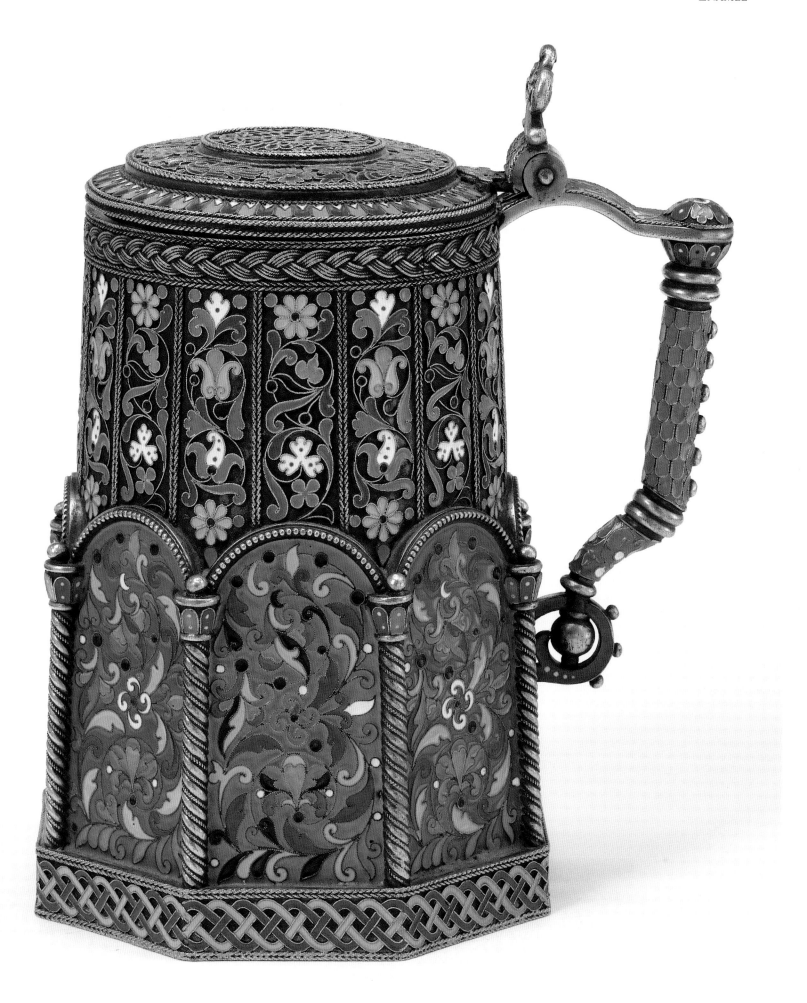

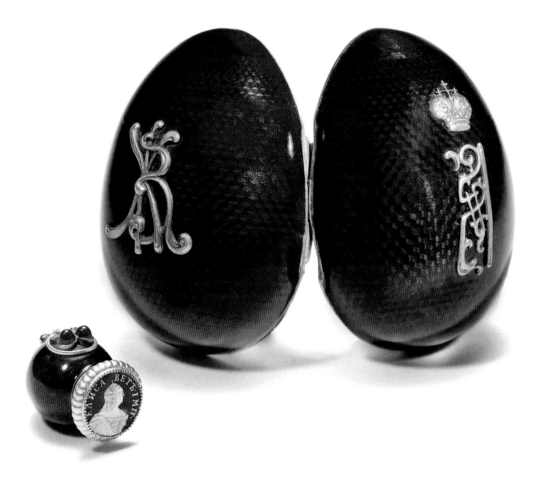

68. This coin-mounted, gold and jewelled scent bottle by the Fabergé workmaster Mikhail Perkhin, St Petersburg, c.1890, was fitted into the larger hinged guilloché enamel egg, which was lined with silk and marked in Cyrillic for the Stroganov Institute for Technical Design. Its director, Victor Butovski, had published a compilation of Russian ornament and advocated a return to the country's stylistic roots. Various Fabergé designers trained at the school, as did the sons of Feodor Rückert before joining their father's studio. Height of egg 6.5cm.

BONHAMS/MRS ALEXANDRA MARTIN-ZAKHEIM

Opposite. 69. Amongst the seminal publications to inspire the Russian Revival was Victor Butovski's *Histoire de l'Ornement Russe du Xe au XVIe Siecle d'apres les Manuscrits*, first published in 1870. The hundreds of medieval ornamental motifs reproduced within this work galvanised a return to native motifs in Russian enamelwork.

COURTESY OF HILLWOOD ESTATE, MUSEUM & GARDENS ARCHIVES/ART LIBRARY

best examples of contemporary applied art as well as historical pieces. This movement had its counterpart in Russia in the form of the Stroganov Institute for Technical Design. Founded in 1860 by combining two existing schools and a museum, it opened in 1863. Sergei Stroganov, the leading force behind the project, was also in charge of the commission that published Solntsev's drawings. The main purpose of the institute was to furnish manufacturers with technically trained artists and artisans.[5]

In addition to technical training, the institute played a crucial role in the dissemination of design during the following decades. Besides Solntsev, two other ornament sources served as conduits: ancient religious manuscripts and folk motifs. In 1870, the director of the Stroganov Institute, Victor Butovski, published a two-volume work on Russian ornament. This was based on studies which were being pursued at the school on Old Russian manuscripts in particular, but also on wall paintings and architectural details in churches. In 1872, Vladimir Stasov published a similar pattern book of folk motifs, many of which were incorporated in the designs of Moscow enamels, particularly in the 1880s.

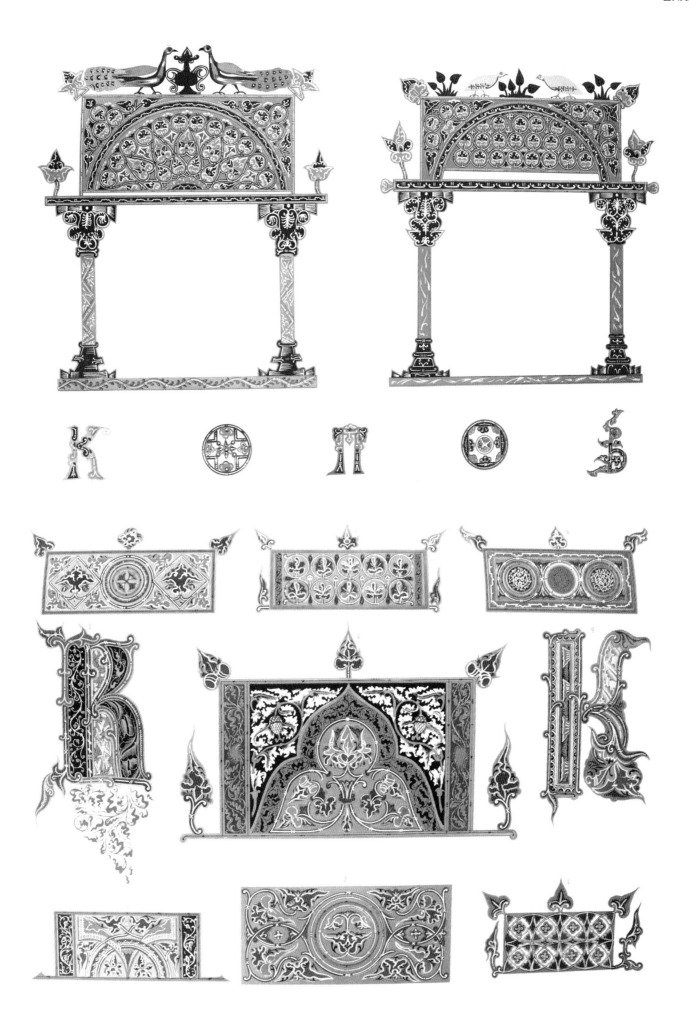

70. Silver-gilt and enamel cigarette cases by Ovchinnikov and Khlebnikov, Moscow, 1875–1880, in the Russian Revival taste. Length of middle/largest 11.5cm.
BONHAMS

71. A collection of miniature silver *kovshes* by various makers, Moscow, early twentieth century. Some handles formed as stylised birds. Length of largest 8.2cm.
BONHAMS

The Old Russian style of the 1870s is characterised by a particular colour scheme: blue, turquoise and white, with touches of red. This is particularly evident in objects produced in the silver workshops outside the Kremlin in Moscow. The enamel did not usually cover the entire surface. Instead, the enamelled sections were raised above the stippled, gilded surface, and the wire-delineated colours. This type of enamelling, with the same colour scheme, became perhaps the most widely produced

in the nineteenth century, and by the turn of the century it had become somewhat repetitive. Bread and salt dishes of this sort, however, remained a favoured presentation gift and they recalled the traditional ceremony of welcoming a new bride and groom into their first home. The pages of illustrated periodicals are full of occasions when gifts such as these were presented to foreign guests. It is clear that these Moscow works represented something uniquely Russian and were desirable abroad because they were thought to be unusual.[6]

72. This playful silver, jewelled and enamel bowl hallmarked Fabergé, Moscow, 1899–1908, is enriched with floral motifs and flanked by handles rising to stylised bird heads set with cabochon garnets. Length 8cm.

By the 1880s, the firm of Ovchinnikov seems to have incorporated the work of the northern Russian enamellers of Solvychegodsk, the seat of the Stroganov family. None of the enamels made in the seventeenth century appear in Solntsev's work on antiquities, although there must have been examples in the Armoury at that time. What Ovchinnikov, and eventually others, adopted from these enamels was a lighter palette and a

73. Silver parcel-gilt and enamel presentation dish marking the Coronation of Alexander III by Ovchinnikov, Moscow, 1882. Diameter 54cm.
FABERGÉ MUSEUM BADEN-BADEN

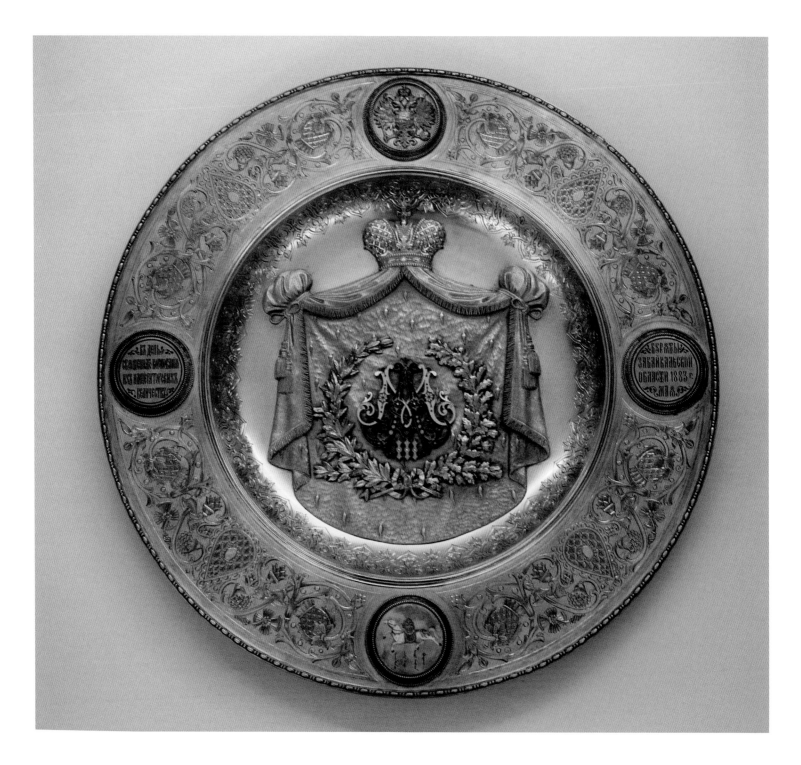

style which in today's market is referred to as 'shaded enamel'. The wires no longer separated single colours, but a complete flower or leaf instead. The enamel within the wires was then painted to emulate the striated details. Also characteristic of these enamels was the fact that they featured folk motifs and people – subjects which did not appear on the high court enamels made earlier in the Kremlin Armoury. Images such as the Sirins and birds on either side of a tree of life were not original to the Solvychegodsk enamel, but in some cases can be traced back to Kievan times. However, the mythical creatures portrayed by the later Moscow enamellers do seem to have been inspired by the Solvychegodsk works.

Feodor Rückert, considered nowadays as the shaded enamelling laureate of the late Imperial period, ran an independent workshop in Moscow which supplied various retailers including Fabergé. His maker's marks are sometimes found in combination with those of the eminent retailer, but they are also often seen in conjunction with other houses or on their own.

74. Silver-gilt and shaded enamel salt throne by Feodor Rückert, Moscow, 1908–1917. This design, with hinged seat section opening to reveal storage for salt, derives from a traditional wooden form. Height 8cm. A detail is shown on the left.

BONHAMS/ANDREY CHERVICHENKO

In addition to supplying Fabergé, Rückert produced objects for numerous other retailers. In the case of the box in plates 75 and 76, it appears that the gold and silver merchant Ivan Vasilievich Shchekleev, who traded in Moscow and Kharkov, sold this Russian casket. The casket once again underlined Feodor Rückert's mastery in linking the colour palette and motifs depicted in the enamel frame with those in the central plaque. Note the stylised enamel renderings of snow flurries echoing the effect of the horse's hooves on winter ground.

Rückert's most expensive works today represent the crossroads between flat and decorative art. The virtuosity of the pictorial boxes he excelled in

75. Detail of plate 76.
BONHAMS/MAXIM REVYAKIN

creating lay in the combination of colour and technique, such as shaded and *en-plein* enamelling. Additional touches of lustre glaze borrowed from ceramic techniques further enriched details such as floral stamens. To then tie the enamelwork sections together visually, the colours of the shaded cells were mixed with deliberate care to echo the scene depicted on the central plaque.

Rückert's mastery of wirework went beyond simply defining cloisons and became a decorative expression of its own, highlighting the stylised flowers in the foreground and creating a geometric backdrop. This was further enriched with characteristic spiral motifs borrowed from pre-Petrine joinery.

76. Silver-gilt shaded enamel jewellery box, Feodor Rückert, Moscow, 1908–1917. Note that the surrounding stylised flowers pick up the colours of the winter scene. The coiled wirework was also a typical device of Rückert's. Length 12.5cm. (See also detail opposite.)
BONHAMS/MAXIM REVYAKIN

The central plaques were often vignettes drawn from known paintings by established artists such as Konstantin Makovsky. After 1908, Rückert's style became increasingly influenced by Art Nouveau as interpreted through the prism of neo-Russian taste. He drew his vernacular from textured ornament on wood carvings, stylised foliage in Bilibin illustrations, as well as the onion domes, *kokoshniks* and boyar accoutrements that were so symbolic of Russia. Because Rückert was familiar with the decorative arts output of the artistic colonies at Abramtsevo and Talashkino, he drew on these influences to marry exuberant frameworks together with plaques

Above. 78. Jewelled champlevé enamelled gold cigarette case by Bok, St Petersburg, 1899–1908. Length 9cm.
BONHAMS/FABERGÉ MUSEUM BADEN-BADEN

Opposite. 77. A silver-gilt, enamel and jewelled coin purse probably by Kuzmichev and with Tiffany marks, Moscow, c.1880. Antip Kuzmichev's work was retailed in New York through Tiffany and Co. Height 5.9cm.
BONHAMS/TIFFANY & COMPANY ARCHIVES. ACCESSION NUMBER B2011.13

Below. 79. Silver, enamel and gem-set pill box, Bolin, Moscow, 1908–1917. Length 8cm.
BONHAMS/COLLECTION MIRABAUD

that depicted the same popular imagery that proved so successful in the lacquer works of Lukutin and Vishnyakov.

As with some of the other firms in the late Imperial period that gained prominence through international exhibitions, retailers abroad such as Liberty of London and Tiffany & Co. in New York embraced the 'Russianness' novelty factor encapsulated in Moscow enamelwares.

80. Silver-gilt, enamel and gem-set pill box, Bolin, workmaster Konstantin Linke, St Petersburg, 1899–1908. Length 9.5cm.
BONHAMS/FABERGÉ MUSEUM BADEN-BADEN

Opposite. 81. Silver-gilt and cloisonné enamel *kovsh*, Khlebnikov, Moscow, 1899–1908. Length 35cm.
BONHAMS/IAKOBACHVILI COLLECTION

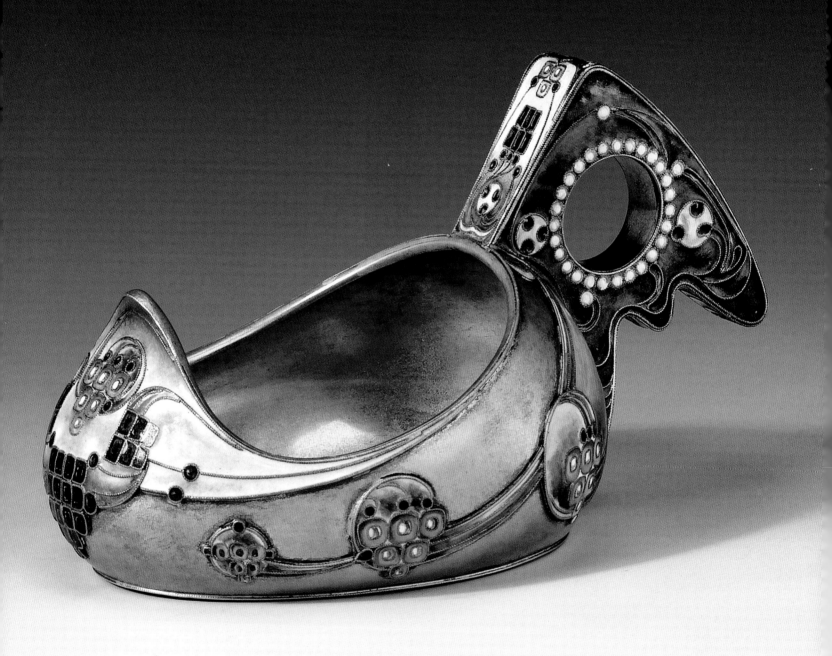

Opposite. 83. An elaborate silver-gilt and champlevé enamel tea glass holder, St Petersburg c.1880, inspired by a traditional wooden *izba*, the sides applied with enamelled aphorisms. Height with glass 15cm.
BONHAMS

Below. 82. Silver-gilt and shaded enamel tazza by Orest Kurlyukov, Moscow, 1899–1908. Width including handles 38.3cm.
BONHAMS/COLLECTION MIRABAUD

Tiffany's had an agent based in Russia from the mid nineteenth century whose role was to keep the store supplied with items by prominent makers such as Antip Kuzmichev. The Chicago World's Fair of 1893 further consolidated the popularity of these Russian Revival enamels in the US, and items bearing both the Russian maker's mark and the signature of Tiffany & Co. sell for a premium (see plate 77).

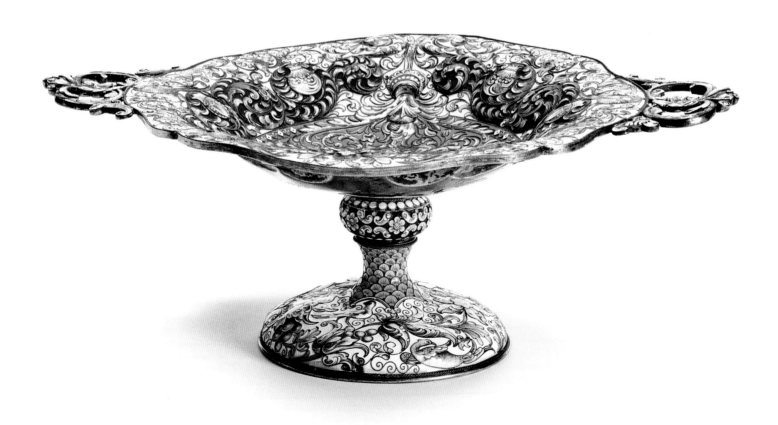

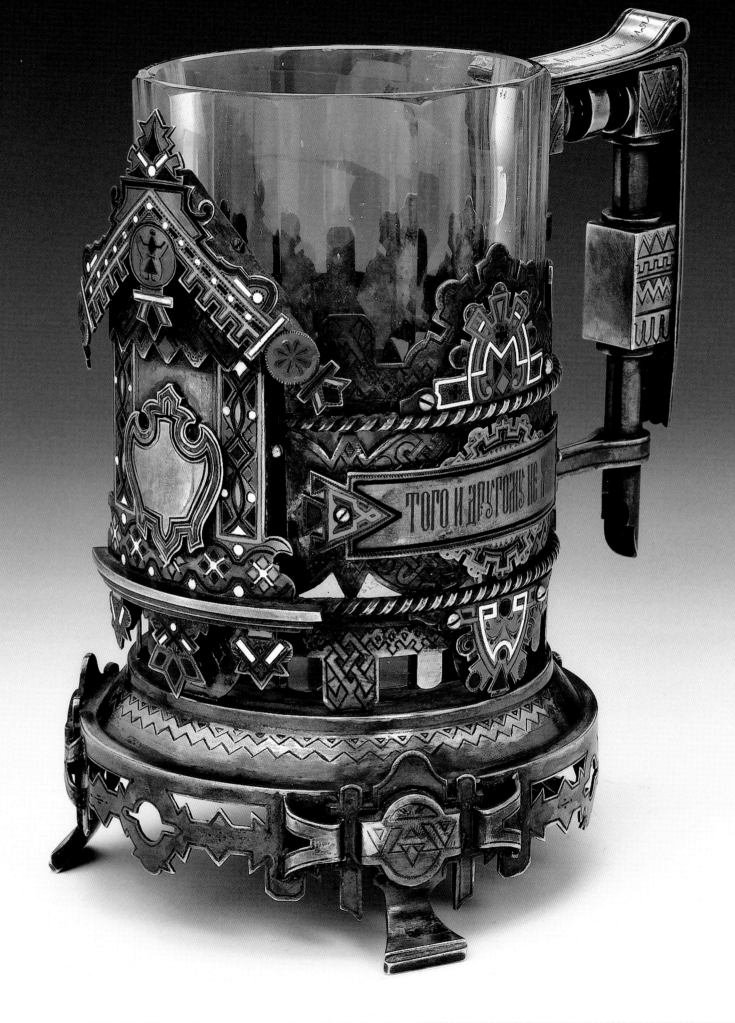

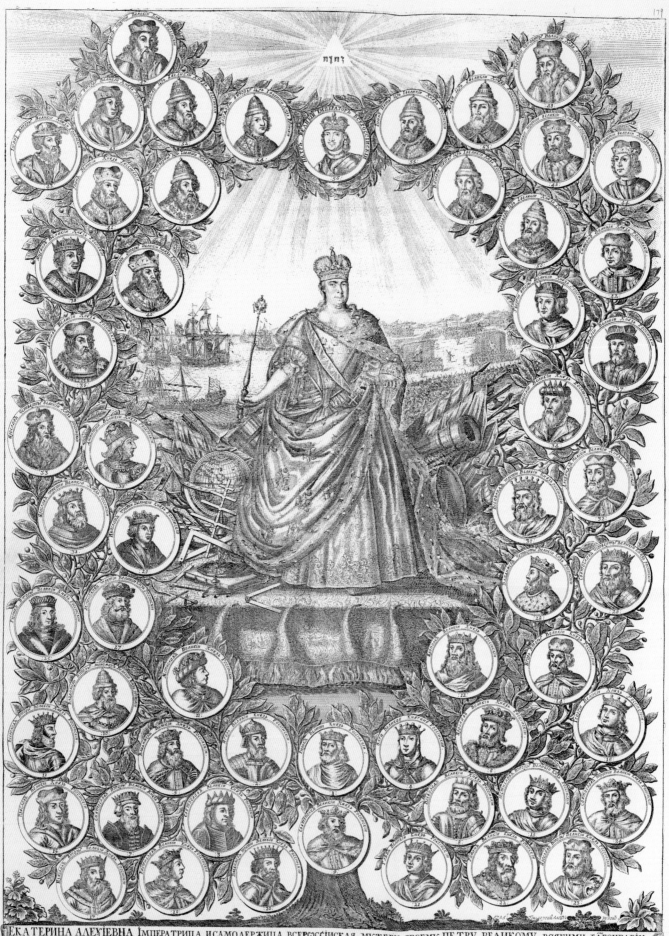

ЕКАТЕРИНА АЛЕУЇЕВНА ЇМПЕРАТРИЦА ИСАМОДЕРЖИЦА ВСЕРОССЇИСКАЯ . МУЖЕВИ СВОЕМУ ПЕТРУ ВЕЛИКОМУ ВСЯКИМИ БЛГОНРАВІИ
БЕЗПРИКЛАДНѢ УГОДИВШАЯ . И ОНЕГО ЗАВЕЛИКОДУШНЫЯ ВВОЕННЫ СНИМЪ ПОХОДА ТРУДЫ ЇПОДВИГИ МУЖЕСКІИ ДХЪ ИМѢТИ СВИДѢТЕЛСТВОВАНАЯ
ИНЕВЪОБЫЧНУЮ ЧЕСТЬ . НОВНАСЛѢДЇЕ . ДЕРЖАВЫ ПРЕСЛАВНО ВѢНЧАННАЯ . ПО ОШЕСТВІИ ЕГО ВВѢЧНАЯ СВЕЛИКОЮ РОССІАНЪ ПЕЧАДЇЮ . СКШПЕТРО
ЕГО СВЕЛИКЇ ПХЪЖЕ ОБРАДОВАНІЕМЪ ПРИЕМШАЯ . ВТОРАЯ ВРОССІИ ОЛГА . ДОСТОИНАЯ ТОЛИКАГО МОНАРХА НАСЛѢДНИЦА .

Chapter 3
JEWELLERY

THE DESIGNING AND wearing of jewels serves as a microcosm of wealth and status. A sparkling solitaire on the manicured hand of the newly engaged still speaks volumes in our society today. As a symbol of tradition, affluence and prestige, we extrapolate a great deal from the choice of a classic ring from Tiffany's over a collaborative commission (i.e. between client and crafts-person) or the inheritance of a family piece.

Within the Russian context, of the relatively little pre-Revolutionary jewellery that survives to this day, much was updated or broken up and cannot offer insight into original designs. We therefore depend rather heavily on documentary evidence supported by the very few extant examples which either appear on the market or are conserved behind museum glass to illustrate the development of this art form. As highly politicised symbols of power, the crown, orb and sceptre mirror the changing needs of the successive monarchs who were crowned in them. Contemporary official portraits of rulers reveal how these items were worn in conjunction with jewels reflecting the tastes of the period. By researching the meaning and use of regalia in eighteenth- and nineteenth-century Russian coronation albums and jewellery inventories, considering surviving portraits and photographs for later years, a stylistic evolution in Russian jewellery design can also be traced to supplement our understanding of surviving pieces.

Opposite. 84. Empress Catherine I of Russia, surrounded by portrait medallions of Russian Tsars, engraved in 1725 by Alexei Zubov.
SLAVIC AND BALTIC DIVISION, THE NEW YORK PUBLIC LIBRARY, ASTOR, LENOX AND TILDEN FOUNDATIONS

85. A gold, platinum and diamond brooch, Fabergé, 1899–1908; with a gold locket, 1908–1917. Both in the Art Nouveau taste enriched with languid blossoms. Brooch length 6.9cm; locket length with loop 4cm.
BONHAMS

In Russia, as in the West, the coronation as Tsar marked the monarch's right to absolute rule. It was a solemn, almost mystical ceremony, which served as divine acknowledgment of a ruler's power. The consecration of a prince was the ceremony's most serious moment and drew its inspiration from the Bible. The expression 'Christened by God' was used during the ceremony to convey that the sovereign received his power by divine grace, rather than through judicial law or the people's will.[1]

Peter the Great adopted the more secular title of Emperor in 1721, thirty-two years after his coronation as Tsar. The title of Tsar had evolved from the word 'Caesar' and was associated with absolute rule and Byzantine traditions in Russia. Peter I was intrigued by the enlightened despotism that was preached, and sometimes practised, in Europe's Age of Reason. Furthermore, having defeated the Swedes at Poltava in 1709, Russia was finally established as a great European power.[2] The ruler therefore set about reforming his people and bringing them into line with everything he felt was European, including the introduction of Western dress at court.

The tight bodice and revealing *décolleté* tapering to a bell shape skirt replaced the costume of the previous century. Wealthy nobles ordered from Paris and London, while popular Russian magazines disseminated trends down through the social ranks to those who could not witness court life themselves. The reforms, prescriptive of trimmings and fabric colours as well as ornament, attracted an influx of itinerant purveyors from the West who were drawn to the spending power of St Petersburg. This in turn drew manufacturers from France, Germany, Switzerland and Great Britain to establish more permanent workshops in the new capital.[3]

Not to be outdone by foreign know-how, diamond cutting factories were established in the new capital from as early as 1721.[4] In past centuries, stone cutting was virtually non-existent in Russia with gems being shaped and polished rather than faceted, resulting in a more or less regular rounded cabochon shape. This technique, employed from antiquity and through Byzantium, came to be widely favoured.[5] Gems were set into

Opposite. 86. Detail from an engraving showing Peter I and Catherine I in Western dress, 1717.

87. Demantoid garnet, the most valuable variety of the garnet family. The stone was mined in the Ural Mountains and prized for its green colour.
BONHAMS

icons and jewellery. By the fourteenth and fifteenth centuries, setting multiple coloured stones in alternation with filigree motifs was popular.[6] It was only further into the eighteenth century that Peter the Great's new city became a huge market for Western-style jewellery to complement the modern gowns and breeches de rigueur at court. A multitude of brooches, watches, snuff boxes, rings and earrings were required and demand generated supply.

The Tsar's reforms spread to updating titles of rank, including his own. He did not require the traditional solemn consecration when his title changed to Emperor. Since he had already been crowned Tsar in 1682, he felt secure that the lawfulness and divinity of his power were unshakeable.[7] His second wife, Catherine (b.1684), came from a family with peasant origins from Estonia. Her low rank and foreign roots were unusual for a Russian royal bride as traditionally one would have been chosen from the most prominent families in the land. This irregular situation necessitated an official affirmation of Catherine's legitimacy as consort. The new Western title that Peter adopted provided a perfect occasion to consecrate her. In addition, the event would serve to publicise his lavishly Western court to foreign guests.

The consecration of Catherine I (1725-1727) was the first Imperial coronation and the first ever of a woman in Russia.[8] Peter the Great composed an elaborate event which borrowed from the processions, announcements and banquets he had witnessed in the West. He planned to shift the focus away from the Eastern orthodox religious ceremony and turn the coronation into a far more secular event.[9] A new crown of gilded silver and precious stones was modelled upon those of the byzantine emperors. It consisted of two hemispheres, symbolising the unity of the eastern and western parts of the Roman Empire.

Catherine's regalia became the traditional form for all subsequent coronations and was widely reproduced in engravings. The gilded frame of the crown was preserved once the gemstones had been extracted for another use, and it is now kept with the orb and sceptre in the Kremlin Armoury. The greatest reserve of Russian jewellery in the world, the Armoury

contains, in particular, one of the most complete collections of eighteenth-century gemstone treasures, comparable to the Green Vault in Dresden.[10]

Despite the fact that some very rare and magnificent pieces have survived to the present day, one of the fundamental problems encountered when trying to trace the evolution of jewellery is that gemstones were regularly re-set according to changing fashions. For this reason, comparatively little eighteenth-century jewellery survives. In addition, Russian pieces can only rarely be attributed to a particular master because early jewellery and ornaments were exempt from hallmarking obligations.[11] We are therefore fortunate to have detailed written descriptions of the gemstones in the crown in addition to the actual frame. Furthermore, numerous illustrations of it can be seen on different portraits of Catherine I.[12] These are not wholly reliable, however, as such portraits may well have been idealised if they were commissioned by the sitter or the court for propagandistic purposes. In addition, they are often lacking in detail, or exist only as black and white engravings, making it difficult for us to reconstruct the craftsmanship and bright impact that the jewels would have had at the time.

Perhaps the most striking piece worn by Catherine I was the clasp of diamonds which fastened her ermine mantel. It was remarkably executed in St Petersburg by the German jeweller Rockentin. The foreign master is likely to have moved to St Petersburg along with a wave of craftsmen brought over by Peter the Great to help Westernise Russia. It was these foreign jewellers who would have known about 'Greek-cut diamonds', the Russian term for table-cut stones[13] featuring rectangular or square tables with sides cut obliquely and ending in a pyramid below. Catherine I's coronation regalia predate the development in the mid eighteenth century of the multi-faceted 'brilliant-cut' diamonds.[14] Therefore, Peter I may have anticipated the need for a foreign craftsman, knowledgeable in the latest techniques, to cut the diamonds for the clasp, aware that such a commission would have been likely to overwhelm a Kremlin jeweller.

A Russian craftsman should have been able to handle such a commission, given the fact that he would have been exposed to a variety of stones –

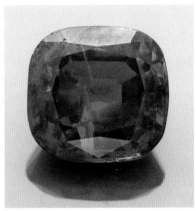

88. Alexandrite, the chrysoberyl variety named after Alexander II when discovered in the Ural Mountains. Its colour varies from green to red depending on lighting conditions.
BONHAMS

89. Amethyst, the highly valued violet-coloured quartz long believed to have talismanic properties.
BONHAMS

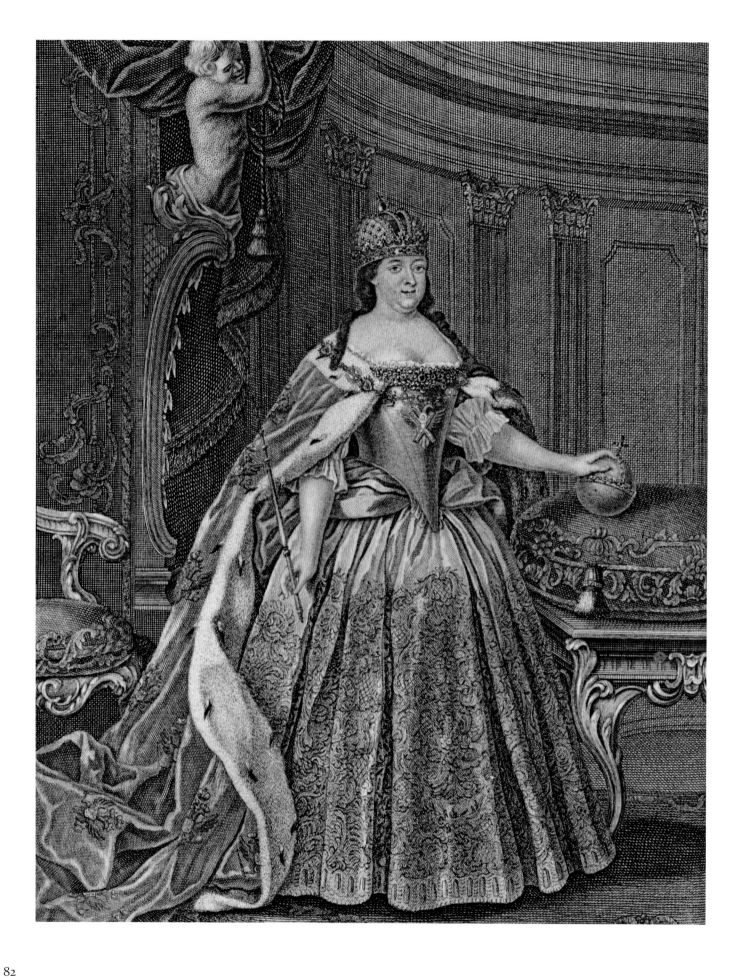

Russia's territories were in close proximity with the sources of several kinds of precious stones, such as India and China, and their caravans supplied the Muscovite courts. However, during the seventeenth century in Russia, precious stones had been used mainly in ecclesiastical robes and utensils, as well as for secular vessels. It was not until the eighteenth century that improved stone-cutting techniques and Western fashions introduced the taste for wearing jewellery for personal adornment, so perhaps this accounts for the lack of Russian craftsmen considered capable of more elaborate stone cutting.[15] The two rulers who followed Catherine I – Empresses Anna and Elizabeth – established the foundations of Russia's fame in jewellery.

Peter the Great's successor was his niece Anna Ivanovna (b.1693, d.1740), whose coronation took place in 1730. The title page of the Coronation Album shows a full-length portrait of Empress Anna by the engraver Christian Wortman after a painting of 1721 by Louis Caravaque. In addition to having commissioned a replacement crown set with gems from the preceding one belonging to Catherine I, the clasp of the mantle and the orb appear to have been new. Anna is depicted in some portraits wearing the so-called 'large' crown, which is currently preserved in the Armoury and whose appellation differentiates it from smaller crowns which were ordered for less formal occasions.[16] In this 'large' crown, two openwork hemispheres flank a central arch surmounted by a cross. Even for ceremonial appearances in public, Anna and all subsequent empresses used small crowns which we only know from portraits. Each was considered the personal property of the individual. After her death, Anna's small crowns were remade or broken up and the stones were distributed amongst her heirs.[17]

During the 1730s, a great number of German goldsmiths settled in St Petersburg, bringing their artistic influences with them. This, in turn, created a growing demand for their superior wares characterised by embossed designs raised against hammered grounds to create strong relief. Their jewellery was then enhanced with diamonds rather than coloured stones fixed

Opposite. 90. Detail of a plaque engraved by Christian Albert Wortmann after a Caravaque portrait from the Coronation Album of Empress Anna, 1730.
SLAVIC AND BALTIC DIVISION, THE NEW YORK PUBLIC LIBRARY, ASTOR, LENOX AND TILDEN FOUNDATIONS

deeply in bezels – either echoing the embossed curvature or encircling the focal point of the object.[18] Favourite motifs for lids of snuff boxes included medals, hunting scenes or landscapes linked to graphic prototypes.[19]

Opposite. 91. Portrait of Empress Elizabeth Petrovna. Oil Painting after Aleksei Antropov, Russia, post-1753. Height 31.5in. Width 26in.
HILLWOOD ESTATE, MUSEUM & GARDENS; PHOTO BY ED OWEN

The daughter of Peter the Great, Elizabeth Petrovna (1741–1761), was next in line to the throne, and her coronation took place with unparalleled pomp on 25 April 1742. Following the discovery of gold deposits in Yekaterinberg in the Urals in 1745, both the goldsmith's trade and the Russian economy were stimulated by the use of native materials. The predominance of German goldsmiths was replaced by an influx of French masters by the second half of the century. With them came the taste for asymmetrical compositions incorporating scrolling foliate motifs or fantastical shells and sea spray executed in coloured stones.

Such exuberant Rococo jewellery was in vogue between 1730 and 1760. The fireworks and masquerades which were popular entertainments at Elizabeth's court can be seen as reflected in the symmetrical, polychrome flower sprays and bouquets of contemporary jewellery designs worn pinned to the bodice.[20] From around 1750, coloured stones, notably emeralds and sapphires, gained in popularity over diamonds and could be combined with coloured semi-precious stones.

In common with much European jewellery design, settings were invariably enclosed at the back so that light could not be transmitted through the gems themselves. This led to a popular technique consisting of backing diamonds and precious gems with tin foil to make them appear to have greater intensity of colour, or even to deceive.

Jewellery was chosen with great care to complement the particular fashions of clothing and accessories. It could not be considered as separate from the overall costume of the wearer. Official portraits of the Empress, such as the one where she is depicted with her left hand draped over foreign crowns, sometimes show her wearing hair-pins, earrings, aigrettes, brooches, clasps, jewelled buttons and braids. While the hair

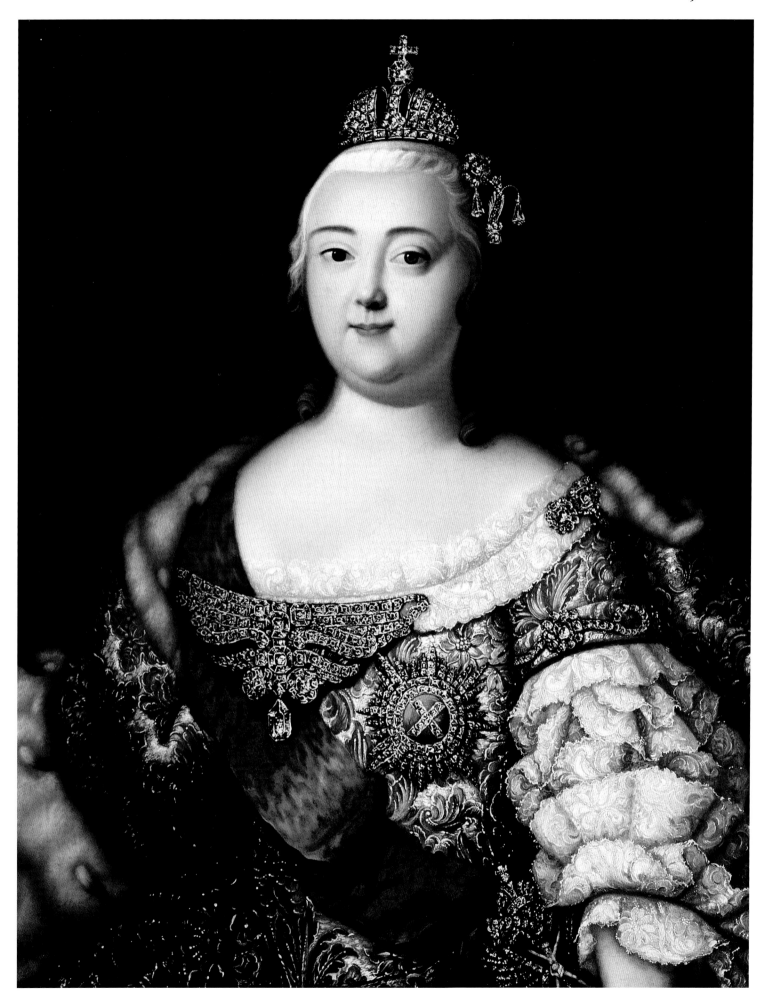

92. Gold, silver, diamond and sapphire hatpin. Russia, third quarter of the eighteenth century. Belonged to Catherine II from 1780. Similar examples are in the collection of the Diamond Fund of Russia.

FABERGÉ MUSEUM BADEN-BADEN

Opposite. 93. Portrait of Catherine the Great attributed to Dmitri Levitsky, St Petersburg, c.1788. Height 106in. Width 73in.

HILLWOOD ESTATE, MUSEUM & GARDENS; PHOTO BY ED OWEN

and clothing appear to have been ornate, Russians did not seem to wear tiaras or necklaces at court at this stage.[21] It may well be that the upper echelons found these items too reminiscent of the headdresses and rows of beads which adorned peasant costume.

The memoirs of the court jeweller Jérémie Pauzié provide an invaluable source for this period.[22] Between 1729 and 1764, he described caravans which brought raw precious stones from China and the Far East to St Petersburg for cutting. This would seem to indicate that a larger supply of diamonds was available and, therefore, more affordable.

As the customer base for jewellery broadened, the middle classes attempted to emulate their wealthier countrymen. Such social mobility demanded the necessary accoutrements, and rising crime rates inspired a viable and affordable alternative to valuable gems. The lavish appetite for jewellery in Russian society helped to promote the use of coloured glass paste jewellery to create the illusion of brilliance. This, being in keeping with the paste jewels of the German goldsmith Georg Friedrich Strass which were all the rage in Paris, was considered acceptable at court.[23]

Elizabeth's heir, Peter III (1762) was not actually crowned after her death in 1761. His estranged consort, Catherine II (1762–1796), staged a coup d'état and had herself crowned three months later, in 1762. Similarly, but not to be confused with Catherine I, Catherine II had married into the Russian throne and had no legitimate hereditary claim to the position of Empress. Catherine II (also known as Catherine the Great), born a minor German princess, had usurped the powerful title and was just as anxious to establish the legitimacy of her rule. The very makeup of her crown incorporated Peter the Great's design for Catherine I's, bearing a diamond presented by the merchants to Elizabeth as well as a ruby acquired by the son of Tsar Mikhail I, founder of the Romanov dynasty. It was a technical and symbolic tour de force.

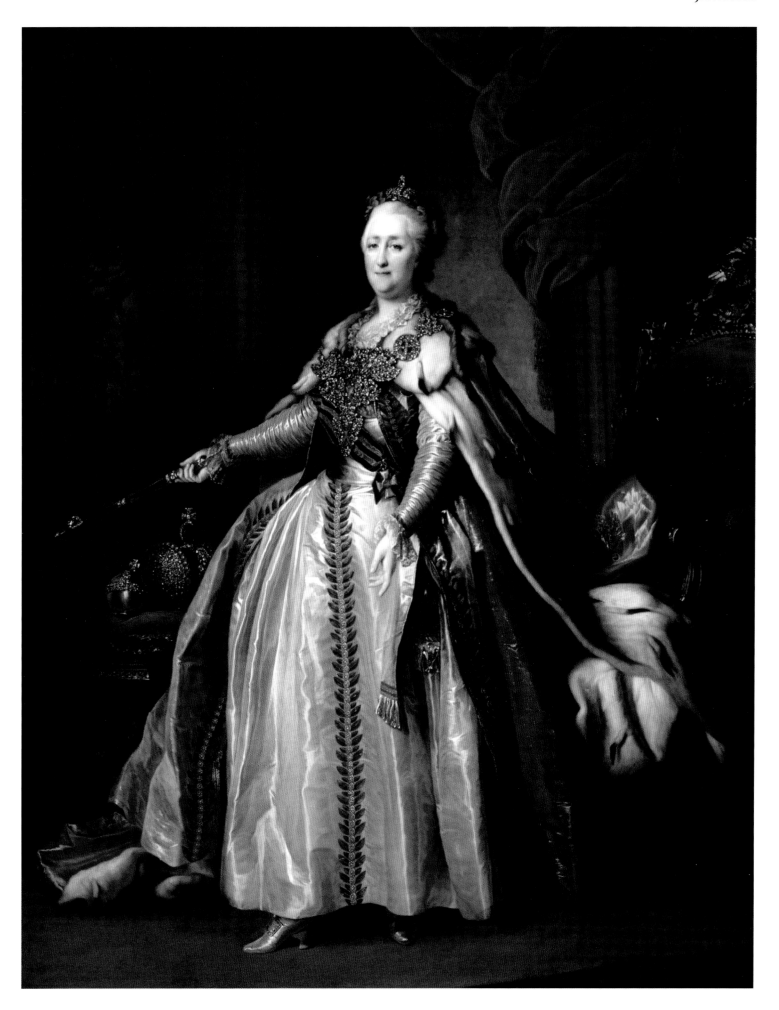

Like most of the ruling houses in Europe, lavish displays of diamonds became synonymous with social prestige at the Russian court. Catherine the Great, who well understood the need to display her rank and power, wrote to Voltaire in 1772 that she was negotiating the purchase of '*un diamant de la grosseur d'un oeuf*' ('a diamond the size of an egg'), weighing about 195 carats.[24] This stone was famously presented to her instead by Prince Orlov on her saint's day and now carries his name. This peerless gem entered the treasure of the Russian court in 1774, and since then has decorated the top of the sceptre.

Another passion of Catherine's appears to have been collecting snuff boxes. Not only did she take tobacco grown at Tsarskoe Selo, her countryside residence, but these miniature treasures bearing monograms or portraits were favourite gifts. Exuberant rocaille forms were superseded by more austere shapes featuring lapidary décor. Pseudo-antique motifs of sober laurel wreaths, festoons and restrained garlands in coloured enamelling or varicoloured gold dominated. The embossed relief gave way to smooth surfaces enriched with brilliant-cut diamonds then pearls, cameos and intaglios found favour over coloured stones.[25]

Despite the French Revolution and subsequent rupture of Franco-Russian relations, Parisian fashions continued to seep into St Petersburg and influenced the appearance of clothing and jewellery. In the 1790s, the tendency towards Classicism was clearly marked by a shift away from the light-hearted scrolling motifs of the Rococo toward sober rectilinear lines and allegorical purpose embraced by the *mode a l'antique* which filtered in from Paris.

The political upheavals of these years found their expression in themes of virtue and sacrifice developed in the style seen earlier in the century at the newly discovered remains of Pompeii. This was still the era of the Grand Tour and the rediscovery of ancient civilisations thoroughly permeated the arts. With Napoleon Bonaparte acting rather like a lightning conductor for Neo-classicism due to his successful campaigns in Egypt and Italy, the style was spread far and wide. Judging from the engravings of the day, bangles and combs were the dominant jewellery

forms as the high-waisted dresses of the period were largely worn uncluttered by excessive ornament.[26]

Paul I (1796–1801), the son of Peter III and Catherine the Great, assumed the throne upon his mother's death in 1796. He was the first Russian Tsar and Emperor to be crowned together with his wife, Empress Maria Feodorovna.

It is due to the reforms of Paul I that the Russian coronation procedure acquired its final form. Paul had been brilliantly educated and was eager to be active in government. Instead, his mother, Catherine II, had refused to involve him in state affairs. She humiliated him by being stingy towards her own son and famously generous to her legendary 'favourites'. Paul had therefore been estranged from his mother and hostile towards her courtiers.[27] A year into his rule, he issued a decree limiting the rights of succession to male monarchs. When Paul I invested himself with the royal regalia during the coronation, he donned over his uniform an ancient royal robe, the dalmatic (an ecclesiastical vestment with wide sleeves worn by bishops on certain occasions), intended only for males. In so doing Paul I was stressing the rule of primogeniture introduced by him to crown emperors only. The coronation mantle was placed on Emperor Paul over the dalmatic.

94. Cameo silhouette portraits caved in agate-onyx by Empress Maria Feodorovna showing a profile of her husband, Paul I, as Grand Duke and two of their sons, the Grand Dukes Alexander and Konstantin, c.1790. The Empress was an accomplished artist, engraver and stone-cutter producing portraits of her intimate family as personal gifts. Smallest 3 x 5cm.
BONHAMS

95. This watercolour portrait of the Baroness de Meyendorf was executed in the 1820s by an unknown artist. The sitter wears a gold muff chain looped twice at the neck and suspending a lorgnette. Her drop earrings are of filigree work termed *cannetille* and at the height of fashion at this time. Height 20.5cm, width 16cm.

HILLWOOD ESTATE, MUSEUM & GARDENS; PHOTO BY ED OWEN

A few months after the murder of Paul I in 1801, the widowed Empress Maria Feodorovna took part in the coronation of her son Alexander I (1801–1825). As the Empire style emerged in the first years of the nineteenth century, other coloured stones besides diamonds, rubies, sapphires and emeralds gained favour at court. Hardstone cameos and intaglios in diamond-set frames were worn as diadems, brooches and bracelets.[28] The general production of jewellery benefited from the discovery of significant gemstone deposits in the Ural mountains at the beginning of the century.[29]

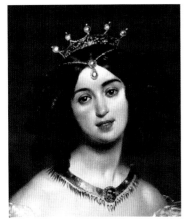

In particular, emeralds, amethysts, aquamarines, topazes and turquoises were mined. They lent themselves well to the tide of romantic interpretations of the meanings of stones in the 1820s. It became customary to set stones together to form an acronym with their initials. For example, the first letters of the words ruby, emerald, garnet, amethyst, ruby and diamond would result in a coded message of 'regard'. The rise of historicism under Nicholas I witnessed the entrance of the neo-Gothic style which swept through the whole of Europe at the time.[30]

96. The Countess Samoilova by Karl Briullov, 1832–1834. The artist painted his intimate friend at the end of his sojourn in Italy following his monumental work *Last Day at Pompeii*. Her jewellery shows the Neo-classical influence fashionable in the 1820s and 1830s. Details of the jewels are shown on the left. Height 268cm, width 200cm.

From about 1840 onwards, the Russian Revival style inspired jewellery combining gold, enamel and precious stones in traditional designs. Sometimes, the use of enamels and gems gave colour and impact to a piece of jewellery as well as a somewhat awkward sense of heaviness. The lasting impression was often that of size or audacity rather than the quality of the materials used. The three most important jewellery firms of the second half of the nineteenth century embraced this taste and benefited from Imperial patronage. They were Bolin, Hahn and Fabergé.[31] Official gifts, commemorative objects and countless other items were commissioned from these houses.

Left. 97. A jewelled gold bracelet, Samuel Arndt, St Petersburg, nineteenth century. Length when open 19.5cm.
BONHAMS/GREGORY KHUTORSKY ANTIQUES

Above. 98. A porcelain plaque with a portrait of Sophie Petrovna Svyechina in traditional costume after François-Joseph Kinson, c.1820s. Her father was a close advisor to Catherine II so she was brought up at court, eventually becoming a lady-in-waiting to Maria Feodorovna. 25.2 x 20.2cm.
BONHAMS

99. A miniature on ivory of a lady by British portraitist Christina Robertson during her stay in St Petersburg, 1841. The broad bracelet is entirely in keeping with the 1840s and shows that this aristocratic sitter was very much at the height of fashion. 24.8 x 19cm.

HILLWOOD ESTATE, MUSEUM & GARDENS; PHOTO BY ED OWEN

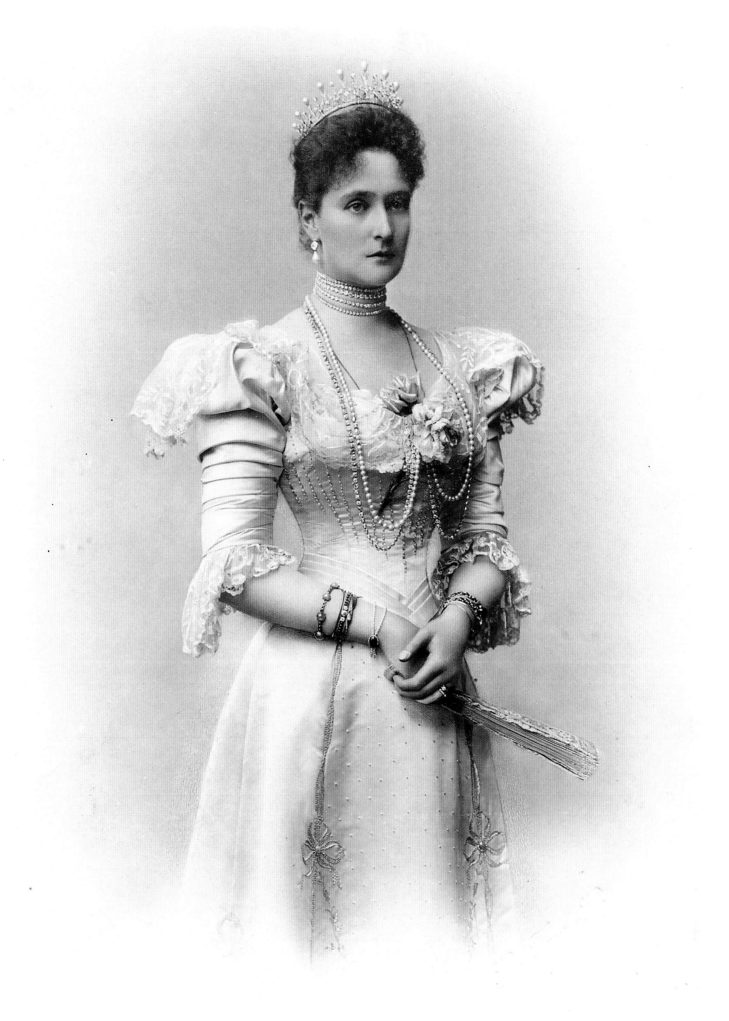

These firms were modern collectives of mechanised workshops. Very few independent makers survived, as the demand for jewellery at home and for export abroad was fuelled by the elaborate international exhibitions. The decorative arts were given a platform in pan-Russian exhibitions and the World Fairs of Paris, London, Stockholm and Chicago.[32] Links with foreign firms such as Tiffany's illustrate the high regard afforded to the applied arts in Russia during the second half of the nineteenth century.

By the middle of the nineteenth century, the merchant class emerged as a self-assured buying force with an appetite for jewellery that did not simply mimic trends at court. Bourgeois society of the 1860s demanded earrings, brooches and pendants in the Russian Revival taste, drawing from the filigree enamelwork of centuries past. The fashion for short-sleeved or sleeveless *décolleté* ball gowns of the 1870s to 1890s was complemented by parures of necklaces, ear ornaments and matching brooches with broad bracelets worn over long kid-gloves.[33]

Opposite. 100. An Imperial presentation photograph of Alexandra Feodorovna by Gan & Co. depicting the Empress wearing multiple strands of pearls and bracelets; c.1898, 29.7 x 18.8cm.
BONHAMS

101. A platinum, diamond and pearl brooch, Fabergé, St Petersburg, c.1890. Of openwork quatrefoil design set at intervals with pearls; within original fitted case. Width 5cm.
BONHAMS/FABERGÉ MUSEUM BADEN-BADEN

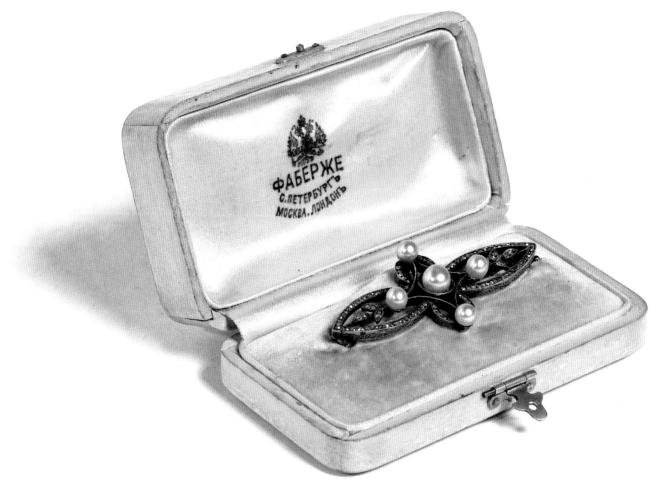

Above left. 102. Two jewelled silver and gold miniature pendant eggs. St Petesrburg, c.1890. Height of largest 2.4cm.
BONHAMS/COLLECTION MIRABAUD

Above right. 103. Gold mounted gem-set enamel cufflinks formed as sphinxes in the Egyptian Revival taste. Tillander, St Petersburg, before 1899.
FABERGÉ MUSEUM BADEN-BADEN

Opposite. 104. A jewelled gold brooch, Bolin, St Petersburg, c.1900. Width 4.2cm.
BONHAMS/GREGORY KHUTORSKY ANTIQUES

The next two coronations in the Russian chronology, that of Alexander II in 1855 and Alexander III in 1883, were as solemn and magnificent as the preceding ones and followed the earlier rituals. The anointment of Nicholas II in 1896 marked the last coronation in Russian history. That year, the firm of Hahn was commissioned to create one of the small Imperial crowns. It was designed after the original by Louis-David Duval, which had been worn by Empresses since the reign of Paul I (1796-1801). For the coronation of Nicholas II, the Duval version was worn by his mother, the Dowager Empress Maria Feodorovna. The replica was worn by his consort Alexandra Feodorovna.[34] In keeping with tradition, Emperor Nicholas II was crowned with the grand Imperial gown which had been used at every coronation since the time of Catherine the Great. A new velvet cap was made to be worn under the crown in order to accommodate a scar which Nicholas had received while in Japan.[35] His

Above. 105. A diamond-set gold and silver bracelet. Fabergé, workmaster August Holmström, St Petersburg, c.1900. This bracelet belonged to the Nobel family of Russian-Swedish oil barons who became prominent Fabergé patrons. Length 17.1cm.

BONHAMS

Opposite. 106. An early twentieth-century gold-mounted diamond pendant-brooch, Bolin, St Petersburg. Length 6.1cm.

BONHAMS

ill-fated rule ended with his forced abdication in 1918. Fortunately, despite the chaos of the Russian Revolution, the regalia used at the last coronation survived.

With so few existing examples of Russian jewellery available to collectors, auction houses have expanded their offerings by including rare books and manuscripts that relate to the subject. In 2011, Bonhams sold the personal jewellery inventory of Nicholas II's sister, the Grand Duchess Xenia Alexandrovna (1875-1960). These itemised records of 925 gifts received between 1880 and 1912 provide a fascinating insight into the personal wealth of the Romanovs, their individual tastes and family relationships. The albums illuminate the manner in which important occasions were marked, and offer crucial links for proving the attribution and provenance of so many pieces which were later gifted, sold on by the Grand Duchess or seized by the Soviet authorities.

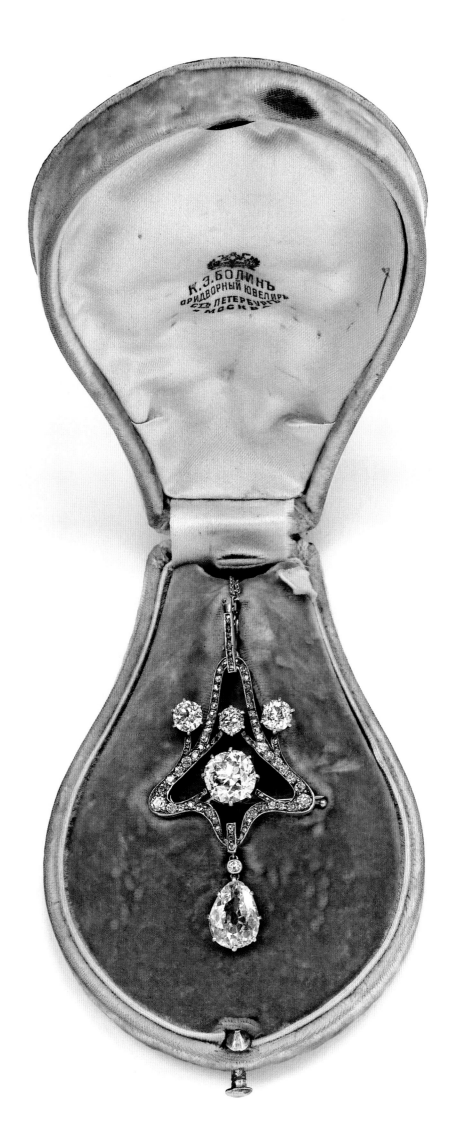

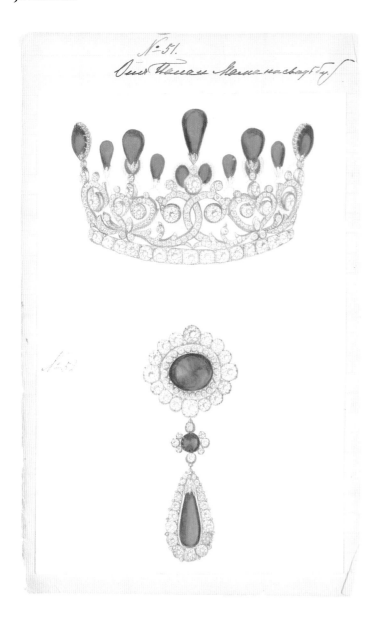

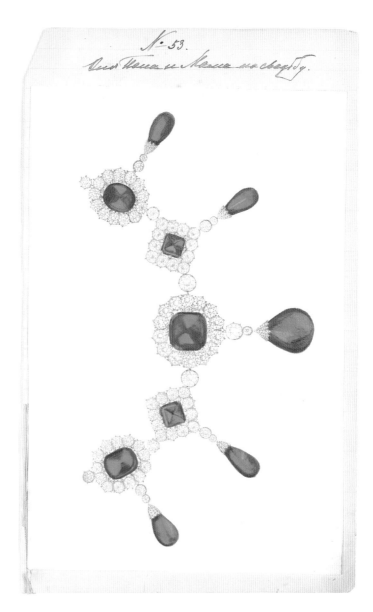

Above. 107. Two extracts from the personal jewellery inventory of Grand Duchess Xenia, illustrating an emerald and diamond parure designed by Nicholls and Ewing, c.1894.
BONHAMS

Because she was the daughter of a reigning monarch, Xenia's wedding celebration in 1894 was one of the last occasions when the Crown commissioned jewellery from the treasury. Alexander III (1881-1894) ordered four complete parures well before the wedding, visiting the repository of the Imperial Cabinet to select emeralds. The role of this administrative institution was to oversee the care of Imperial jewels, and to pay for purchases ordered by the Tsar, as well as goods supplied to the court. Here were stored the most beautiful loose stones collected over the years by various Tsars and which belonged to the treasury. Following the Imperial visit, Fabergé, Bolin and Ewing were each commissioned to design a parure for the wedding from which the Tsar would make the final selection.

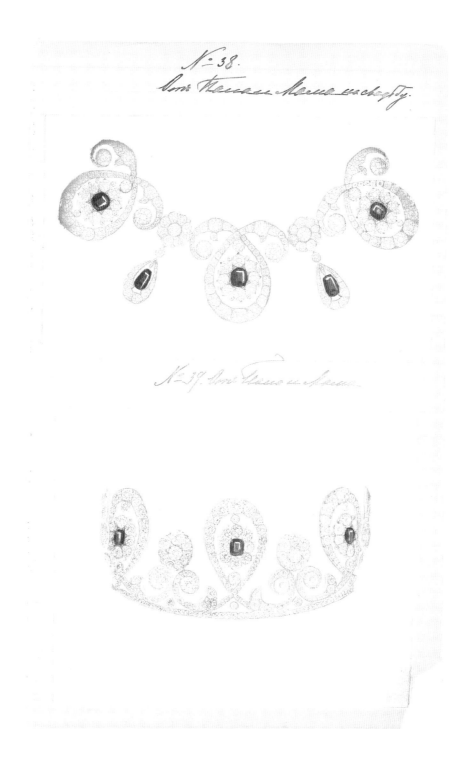

Nicholls and Ewing of Nevsky Prospect created an astonishing parure of emeralds and diamonds consisting of: a necklace formed as a series of oval and rectangular cabochon emeralds, each surrounded by circular-cut diamonds, from each of which hung a pear-shaped cabochon emerald; a coronet of floral design entirely set with diamonds supporting pear-shaped cabochon emeralds; and a large brooch with cabochon emeralds mounted in a double ring of diamonds, which could also be used as a centrepiece in the necklace (see N.51-52). The inscription for N.51-52 in the album reads 'from Mama and Papa for the wedding'.

108. Extract from the personal jewellery inventory of Grand Duchess Xenia, c.1894. The ruby and diamond parure was designed by Bolin in collaboration with Ewing, incorporating stones stored in the Imperial Cabinet.
BONHAMS

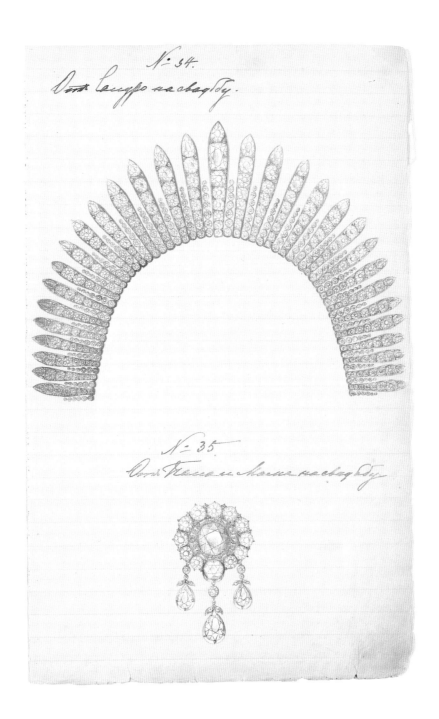

109. Extract from the personal jewellery inventory of Grand Duchess Xenia, c.1894. The groom presented Xenia with this necklace by Bolin to be worn alternately as a tiara. Shown underneath is a diamond brooch, also by Bolin, given to the bride by her parents, Alexander III and Maria Feodorovna.

BONHAMS

At the same time, Bolin worked on an important commission from Xenia's mother, Maria Feodorovna, to create a parure consisting of a tiara, necklace and large brooch in diamonds and rubies (N.37-39). The stones, which were particularly rare and carefully matched in colour, also came from the repository of the Imperial Cabinet. Their selection was entrusted to Bolin with the collaboration of Ewing.

In addition, the Tsar and Tsarina presented their daughter with two large diamond *rivière* necklaces and a wonderful tiara also created by Bolin, entirely decorated with *briolette*-cut diamonds which quivered with every movement of the head. There was also a diamond brooch that included

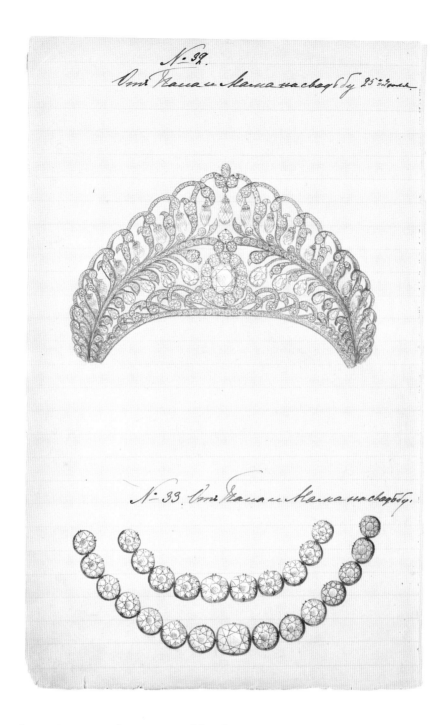

110. Extract from the personal jewellery inventory of Grand Duchess Xenia, c.1894. The tiara and two large diamond necklaces created by Bolin were presented by the bride's parents, Alexander III and Maria Feodorovna.
BONHAMS

three pear-shaped diamonds reminiscent of some owned by the Empress (N. 35). Her parents' gifts were completed by a parure of cabochon sapphires and diamonds, which are not yet attributed to any particular atelier, and a five-stranded pearl *collier de chien* with a large button pearl clasp.

The groom, nicknamed Sandro, presented a splendid diamond *collier Russe* (N. 34) by Bolin which could also be worn as a tiara. It was accompanied by a brooch with a naturalistic design of two vine leaves in diamonds which supported a drop cabochon emerald. The brooch (N. 36) was later given by Xenia to her daughter, Irina, when she married Prince Felix Yusupov in 1914.

Above left. 111. Fabergé moonstone, gold and diamond brooch, workmaster August Hollming, St Petersburg, 1908–1917. 19 x 12mm.
WARTSKI, LONDON

Above right. 112. Extract from the personal jewellery inventory of Grand Duchess Xenia, c.1894. Although lacking attribution to a particular jeweller, moss agate plaques in diamond surrounds were a favourite device of Fabergé's, suggesting the firm's hand if not their signature. Below, sections likely to be from a bracelet and necklace reflect the more modest items of jewellery included in the inventory. These sometimes suggest the wealth of the donor or their relationship to Xenia, and offer insight into the Grand Duchess as a fashionable young woman dressing to please herself rather than to comply with the grandeur of an official occasion.
BONHAMS

In a framed image of Grand Duchess Xenia at the boyar costume ball of 1903, she is portrayed wearing jewellery received for her wedding. Around the neck, her two diamond *rivière* necklaces are arranged as *collier de chien* with a string of large white oriental pearls in the centre. Also visible is the *collier Russe* given by Sandro. Her emerald and diamond necklace has a large emerald and diamond brooch as centrepiece. The cabochon emeralds from the tiara in the parure with the necklace are sewn to her headdress. Other precious stones enrich the embroidery on the brocade of her dress.

Further entries in the albums, while less lavish, provide crucial insight into what was in vogue at the turn of the century and illustrate forms which were no longer in use, such as the chatelaine and adornment set into elaborate coiffures. While St Petersburg looked to Western Europe

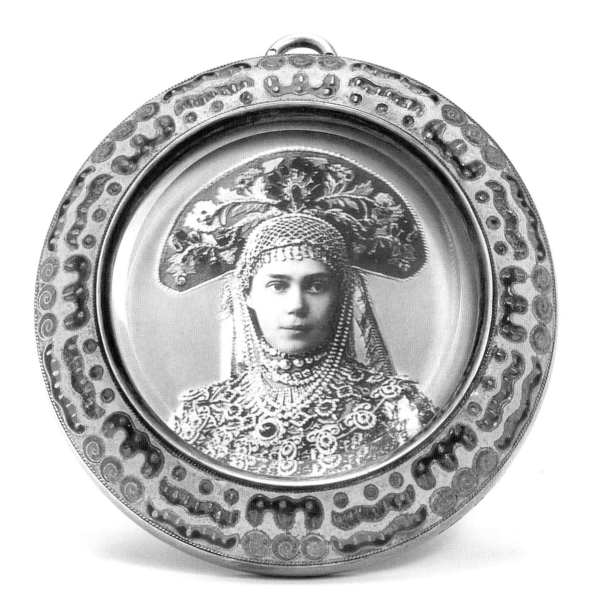

113. Shaded enamel and silver-gilt frame by Feodor Rückert, Moscow, 1908–1917. The image of Grand Duchess Xenia in seventeenth-century dress shows several pieces of her wedding jewellery integrated into her costume. Height 7.2cm.
BONHAMS

Below. 114. Pair of gold-mounted moss-agate cufflinks, maker's mark: 'J.W.' (Latin), St Petersburg, 1899–1908.
BONHAMS/GREGORY KHUTORSKY ANTIQUES

for stylistic influences, the personal jewels of the Grand Duchess show designs that were interpreted through the prism of Russian taste. Red gold was favoured over the yellowish hues and was often densely set with cabochon sapphires, rubies or emeralds. These were more often represented than faceted stones. Semi-precious stones such as moonstones and Mecca-stones are in evidence, as are those typical of the Russian territories such as demantoid garnets and Alexandrite (see p.81), named after Alexander II. The term Mecca-stone seems to have been a Fabergé appellation for a foil-backed mauve chalcedony agate which tinted the stone, depending on the light, from rose to powder blue. The most famous of the transparent gems from the Urals and southern Siberia was deep-purple amethyst. Dentritic agates with moss-like inclusions were also favoured.

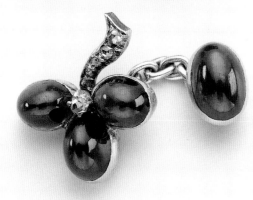

115. Pair of gold, cabochon sapphire and diamond-set ladies cufflinks, Bolin, early twentieth-century. Formed as trefoil flowers with diamond-set stems. Length 2.4cm.
BONHAMS/FABERGÉ MUSEUM BADEN-BADEN

Diamonds were not given quite the same billing as in other cultures. Brilliant-cut stones seem to have been reserved for more important pieces, while rose-cut diamonds appear to have been characteristically used to flank enamel or surround a cabochon stone. The device of mounting a precious stone against a pierced trellis was common and repeated in countless brooches.

Pearls were considered particularly valuable and are only present in a few of the illustrations. In a rare instance amongst the notations, Grand Duchess Xenia expands her pencil entry for a necklace by carefully recording the number of pearls per row.

Alongside the extravagant wedding emeralds and prized pearls are dozens of entries featuring enamel techniques. These were valued for their technical mastery and were synonymous with Fabergé. Cloisonné is noticeably absent and champlevé is incorporated into a design for a brooch in the form of a flag. The lavish hues of translucent enamel over engine-turned ground speak to the unmistakable signature of Fabergé guilloché work.

116. Gold, platinum, amethyst, diamond and guilloché enamel brooch. Fabergé, St Petersburg, 1908–1917, with scratched inventory numbers 1599 and 84557. This octagonal gem-set frame with guilloché border is centrally set with a cushion-cut amethyst. Width 4.5cm.
BONHAMS/FABERGÉ MUSEUM BADEN-BADEN

117. Gold, silver and enamel brooch with diamonds, rubies and pearls, in the form of a bee, Bolin, Moscow, 1908–1817. 4.9 x 3.3cm.

118. Gold mounted diamond and aquamarine Art Nouveau brooch by Morozov, St Petersburg, 1908–1917.

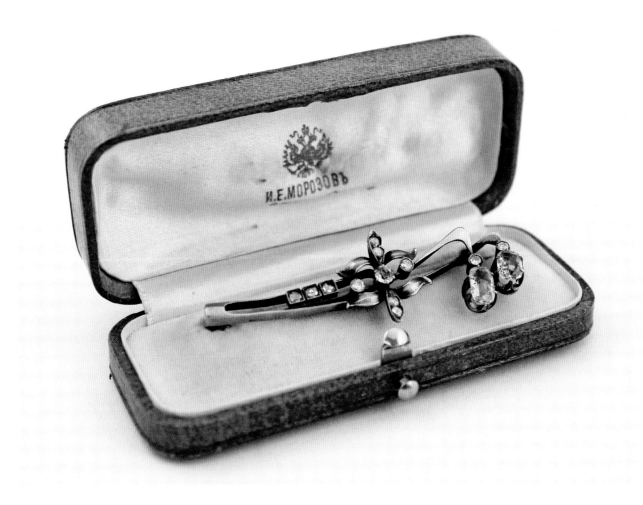

119. Fabergé Imperial presentation gold tercentenary ring, Alfred Thielemann, St Petersburg, 1908–1917. The central eagle is flanked by the dates 1613 and 1913. Width 3.2cm.
BONHAMS

120. Fabergé jewelled gold and enamel Imperial presentation brooch, Alfred Thielemann, 1908–1917. The eagle rests above opaque white enamel fretwork hung with ribbon-tied gold laurel swags. Width 5cm.
BONHAMS

As the dates recorded in the albums progress, so too do the stylistic influences as Art Nouveau takes hold. The taste for languid forms inspired by plants and animals travelled into Russia from Darmstadt when a Jungendstil colony was founded there in 1899 and gained an international foothold during the Paris Exposition Universelle in 1900. The tercentenary celebrations marking the 300 years of Romanov rule inspired a flurry of jewellery designs enriched with dynastic symbols. Soon after, the First World War broke out and small brooches and pendants were created for well-born ladies supporting the war effort with simple red crosses against a white ground. Still further into the inventory, the Art Deco style is represented in the rectilinear geometry of early twentieth-century design which made a brief appearance before the Revolution of 1917.

Both inventories show that the Grand Duchess appreciated the symbolism of jewellery. Her interest in the language of stones is evidenced by opening notes in the smaller album attributing birthstones

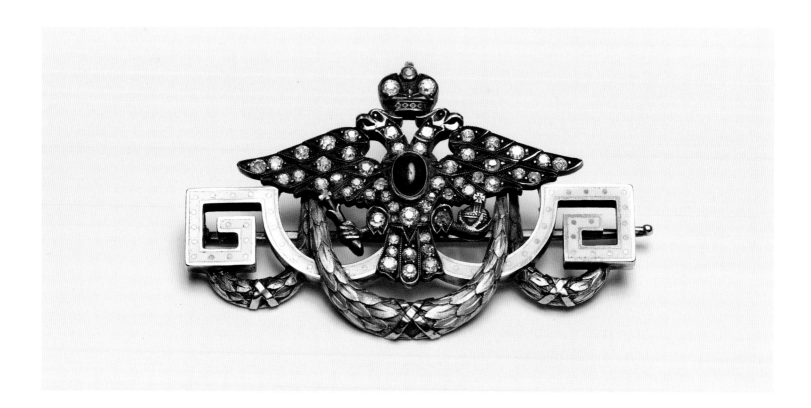

to their respective months. Designs drawn from such diverse sources as the Monomack Cap, Imperial Eagle, royal standard and crowned ciphers support the Imperial provenance but auspicious, romantic metaphors as well as others such as the horseshoe, clover, swastika, owl and elephant show that Xenia was fully in step with the fashion of her times. Private in-jokes and references employ bibelots as couriers. A curiously shaped object presented by 'Georgi' resembling a potato may well serve as a sort of visual shorthand for the secret society which counted Xenia and her brother among its members.[36]

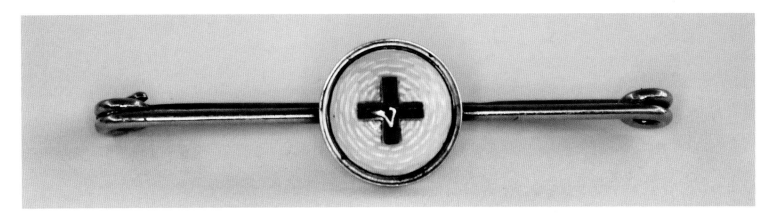

Further archival research could positively attribute many of the detailed renderings to known suppliers to the court. Links with Bolin, Chaumet, Cartier, Ewing, Tillander, Koechli and Hahn are likely to be found. However, even in the absence of documented confirmation, the signature style of many of the illustrations bear the distinctive imprint of Fabergé. The famous house was tasked with resetting and creating parures in a variety of stones, ranging from the most exquisite diamond and emerald tiara to the simplest of miniature pendant eggs.

Another document commanding high prices is a copy of the famous 'Fersman Catalogue', which in 1925–1926, inventoried the nationalised jewel collection of the Russian Imperial Family. This comprehensive document, compiled by the noted gemologist A.E. Fersman (1883–1945), is crucial to us, as some of the crown jewels were sold by the Soviet state in the following year to procure foreign currency. The introduction,

122. Gold and enamel Red Cross bar brooch. Britzin, St Petersburg, 1908–1917. Width 4.7cm.
FABERGÉ MUSEUM BADEN-BADEN

Top of page. 121. Gold-mounted diamond Art Deco pendant, Fabergé, St Petersburg, 1900-1917.
FABERGÉ MUSEUM BADEN-BADEN

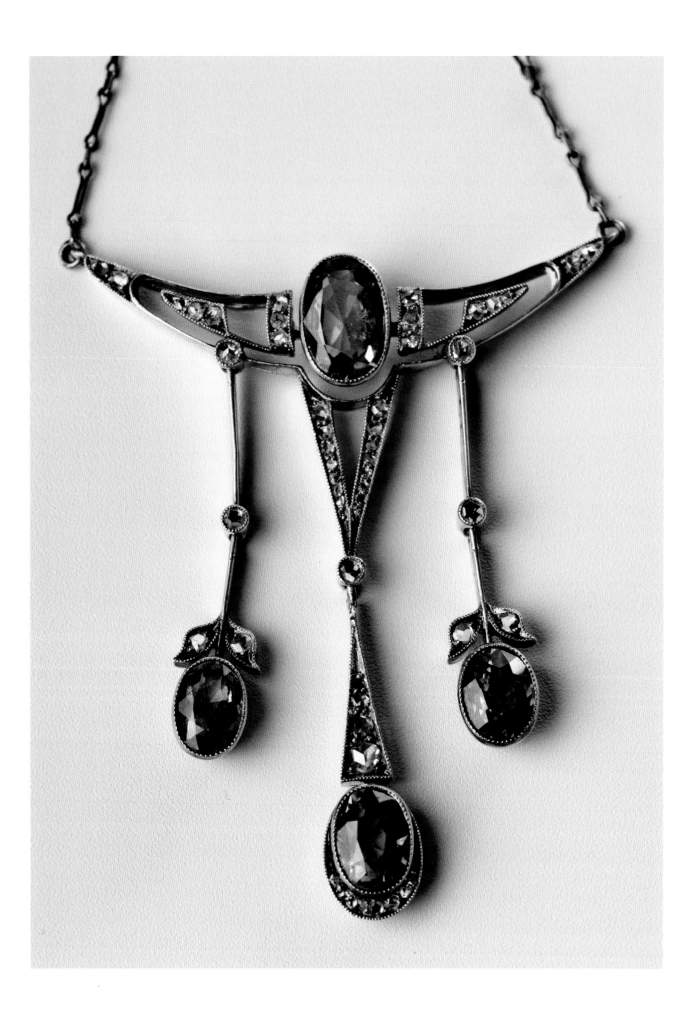

written by a military functionary, G.D. Basilevich (1889–1939), sets the tone for the contents of the catalogue: following 'months of stubborn fight for liberty it became necessary to rebuild the shattered national economy and gather the People's assets all over our country'. The pre-eminent source of 'assets' was the Romanov heirlooms. The author describes the selfless aims of a committee dedicated to showing the people how misled they had been by their 'crowned enemies', the Romanovs.[37]

At the time of the Russian Revolution, the Imperial jewels were stored in St Petersburg. A few years later, they were transferred to Moscow: 'nine huge strong-boxes crammed with gems (and, strange to say, without a single inventory to them) were brought to light from the recesses of the Moscow "Armory Hall" and placed at once in the Safe-Keeping of the People's representatives.'[38] Fersman was appointed to catalogue the contents of the Imperial chests. The propagandistic language supports the anti-monarchic sentiment of the writers. The word 'People' is capitalised whereas terms such as 'imperial', 'tsar', and so on are not. The motivation for publishing this catalogue seems to have been two-fold. Firstly, it was intended to shed light on the supposedly odious taste of the former ruling family, and to discredit it:

> Heaps of precious articles, kept for the private use of the members of the imperial household, were discovered in various other boxes…; they all bear the imperial arms. Among precious watches, breloques, drageoirs, snuffboxes, etc., we discovered a gold cigarette case, personal property of Alexander III which was filled with small photos of a very dubious sort. But what shocked even the few … was the final discovery of jewelled 'icons' bearing features of the Romanovs (!); at the sight of the strange … images our workmen could not but express their disgust.[39]

Secondly, the contents of these vaults were valued 'with true patriotic zeal' and with a view to selling selected items abroad for much needed foreign currency.[40] Following the aftermath of World War I, the newly established

Opposite. 123. Gold, silver, sapphire and diamond necklace. Fabergé, workmaster Albert Holmström, Petrograd, 1914–1915. The firm experimented with Art Deco styles just before its closure. 4.5 x 2cm.
FABERGÉ MUSEUM BADEN-BADEN

124. A page from *Russia's Treasure of Diamonds and Precious Stones* compiled by A. Fersman in 1925, showing Imperial jewels being catalogued with a view to selling them abroad to raise foreign currency.

Soviet Union found itself in a financial crisis. Despite the fact that the market value of the items was known to be far less than their historic value, just one third of the contents of the vaults were published by Fersman. He retained pieces that he considered to be of 'great value and historical fame' in 1925. The other items were deemed too unimportant such as 'minor specimens ... loose stones ... and quaint ... trinkets'. These were sent to Berlin for unpublicised sales to interested dealers.[41]

As a result of the later sales from these vaults by the Soviet government, the Coronation Albums, the Fersman Catalogue, and the published eyewitness accounts by jewellers and courters serve as invaluable records of the most precious contents at the time of the Russian Revolution. It is only through the comparative study of these primary sources and increasing cooperation from curators and archivists based in Russia, that we can effectively trace the evolution of Russian Imperial jewellery to gain an understanding of design, coronation regalia and traditional usage.

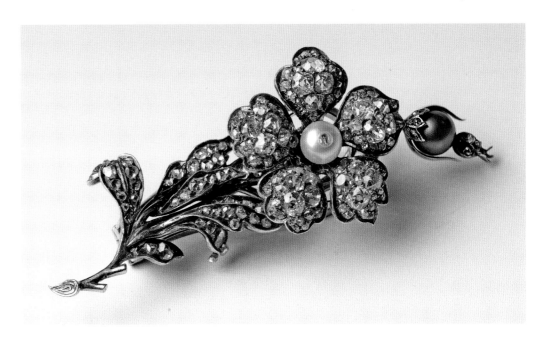

125. Gold and silver jewelled floral brooch with petals set *en-tremblant*, Fabergé, workmaster Henrik Wigström, St Petersburg, 1908–1917. Wire coils attached to the back of certain sections lend a life-like trembling motion as the jewel is moved. This was particularly associated with the eighteenth-century fashion for naturalistic effects. 7 x 2.7cm.
FABERGÉ MUSEUM BADEN-BADEN

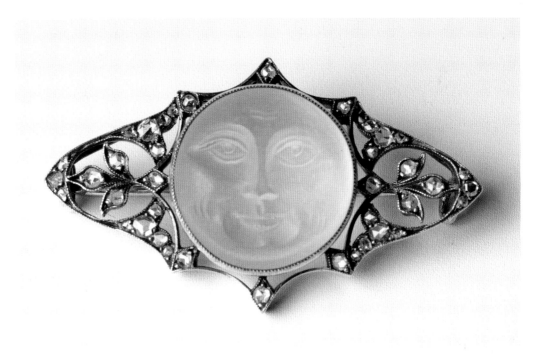

126. Gold, silver, diamond and matt rock crystal 'Man in the Moon' brooch. Fabergé, A. Hollming, St Petersburg, 1908–1917. 4.2 x 2.5cm.
FABERGÉ MUSEUM BADEN-BADEN

127. A typically Russian red gold bracelet set at intervals with alternating diamonds and cabochon sapphires, St Petersburg, 1899-1908. Length 17.8cm, bearing the monogram 'A.B.'.
FABERGÉ MUSEUM BADEN-BADEN

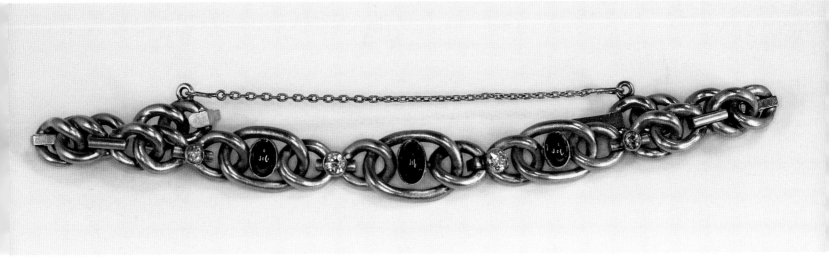

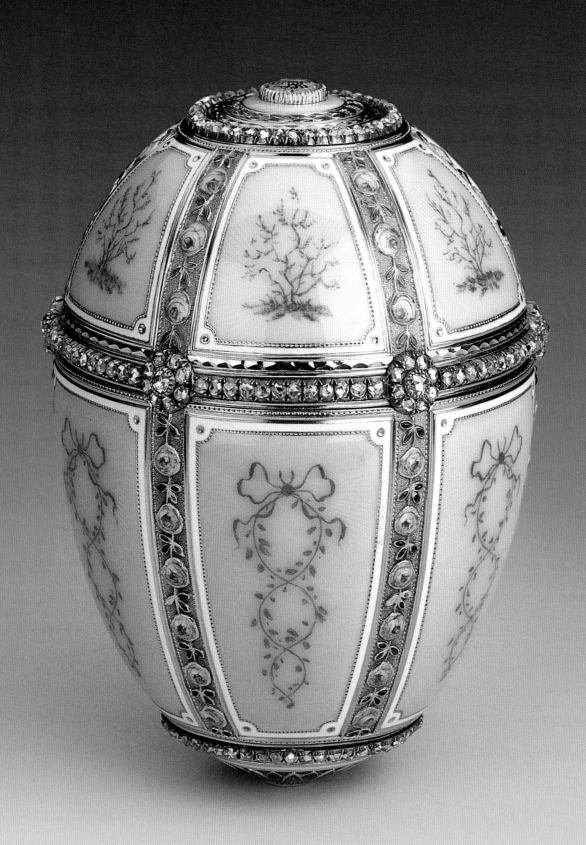

Chapter 4

FABERGÉ

THE HISTORY OF THE House of Fabergé cannot be discussed without mentioning Nicholas II and his consort Alexandra Feodorovna, as the firm was inextricably linked with that of the last rulers of Russia. Beginning with her earliest days at the Russian court, Princess Alix, as she was still known in 1894, had been presented with a necklace designed by Karl Fabergé from her future father-in-law, Alexander III. It was purportedly worth 250,000 rubles (equivalent to several million dollars in today's terms) and was the single largest transaction the firm ever had with the Imperial Family.[1] While we do not have any description of this lavish gift, we know that in the same year, Nicholas commissioned a pearl and diamond necklace as a betrothal present for which he paid a comparatively modest 166,500 rubles.[2]

Although these important commissions must have caused a stir in 1894, today we consider the creations by Fabergé which revolve around the theme of Easter to be his most famous. In the Russian Orthodox tradition, the paschal celebration included the exchange of three kisses and a miniature pendant egg, a symbol of resurrection. As the most important religious festival in the Julian calendar, Easter was characterised in part by the kind of exchange of gifts associated today

Opposite. 128. The Kelch twelve-panel egg. Gold, enamel and diamonds. Fabergé, workmaster Mikhail Perkhin, St Petersburg, 1899, 9.5 x 7.0cm.

Above. Detail from a gold, silver-gilt and nephrite frame by Fabergé, 1899-1908. See plate 185.

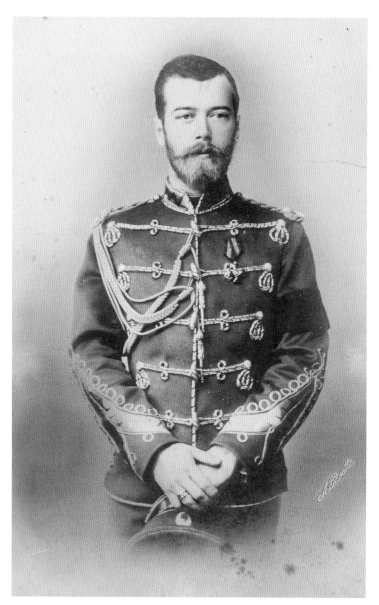

129. Photograph of Emperor Nicholas II wearing his Hussar uniform, c.1895.
BONHAMS

130. Photograph of Empress Alexandra Feodorovna wearing a tightly corsetted gown with dropped sleeves and the *kokoshnik* head-dress prescribed by Court dress, c.1895.
BONHAMS

with Christmas in the West. The egg pendants were crafted from a variety of materials ranging from modestly carved wood examples to the extremely common, more elaborate faceted glass versions. The firm of Peter Karl Fabergé (known as Karl) came to epitomise the excess of the Romanovs with its lavishly jewelled interpretations of the traditional Easter egg. Following an annual custom begun in 1885 by his father, Alexander III, Nicholas II presented both his mother and his wife with an Easter egg each year from 1895 until 1916.[3]

The wealthiest patrons of Fabergé sought to emulate this Imperial tradition and the firm fulfilled orders for the wealthy industrialists who could afford such vanity. Beginning in 1898, Alexander Kelch, a wealthy nobleman with mining interests, who is likely to have supplied Fabergé with raw materials,

commissioned seven Easter eggs produced in Mikhail Perkin's workshop. The Twelve Panel Egg of 1899, now in the Royal Collection, is divided into sections, a device also employed in the Danish Palaces Egg and the Twelve Monogram Egg commissioned earlier for the Imperial Family. Alexander and Varvara Kelch eventually separated and King George V purchased the Twelve Panel Egg as a Christmas present for Queen Mary in 1933 from Wartski.

While commissions of this magnitude reach the market extremely rarely, the more modest pendant eggs do appear regularly and are in the more affordable realms. Often enamelled in rich colours, they are identified by the quality of the workmanship and hallmarks as well as the tiny suspension hoops. The Russian version of add-a-pearl or charm bracelets is

131. Karl Fabergé sorting stones, c.1905.
WARTSKI, LONDON

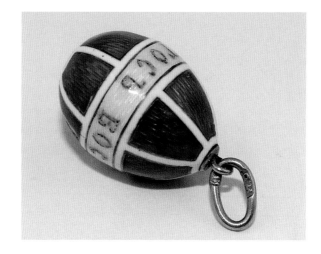

132. A miniature gold and enamel pendant egg. Fabergé, St Petersburg, 1899–1908. Enriched with the traditional Easter greeting 'Christ is Risen'. Length without loop 1.5cm.
FABERGÉ MUSEUM BADEN-BADEN

133. A Fabergé *trompe l'oeil* gold box simulating basketweave, workmaster Erik Kollin, St Petersburg, c.1890. Width 4.5cm.
BONHAMS/ANDREY CHERVICHNEKO

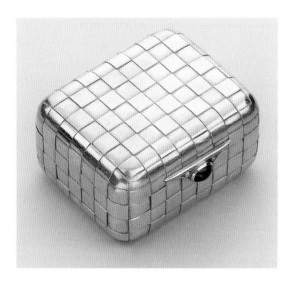

the egg necklace comprising multiple strands of pendant eggs which were earned over a lifetime of Easter gifts to elderly recipients. Close examination allows specialists to weed out the Fabergé examples from the more pedestrian glass or wooden pendants that tend to make up necklaces.

For now, we have a basic understanding of the jeweller's early history which has been widely published. The firm's founder, Gustave Fabergé, was a descendant of French Huguenots who came to settle in St Petersburg and opened a small jewellery firm there in 1842. It was Gustave's eldest son, Karl, born in 1846, who would be responsible for the firm's meteoric rise in the nineteenth century. In the 1860s, as Karl Fabergé was completing his commercial training in Europe, moving back to Russia from Paris to take over his father's firm, he was entering an immense market which had long been receptive to foreign influences.[4] By 1884, Karl Fabergé had already been appraising and restoring jewellery in the Imperial Collection for fifteen years. In doing so, he must have had ample opportunity to study some of the finest European jewels from the Imperial vaults and this would have given him a substantial advantage in comparison with the training of his contemporaries. Letters supporting Fabergé's application for the title of Purveyor to the Imperial Court disclosed that he had not invoiced the court for the appraisal and restoration services rendered, and suggested that he deserved formal recognition for his labours. As Karl Fabergé worked to ingratiate himself by answering to every whim of his Imperial Russian patrons, he obviously understood the immense gains that their approval would bring him. Fabergé's workmasters successfully fulfilled royal commissions, earning the firm the title of Purveyor in 1885. Five years later,

134. A gold chain suspending miniature egg pendants by various makers, late nineteenth century, largest egg 2.3cm.

BONHAMS

Fabergé was named Goldsmith by Special Appointment to the Imperial Crown.[5] Every object produced in the workshops thereafter was struck with the Imperial double-headed eagle in addition to the company name. This result encouraged the buying public to think of the distinguished firm as being clearly linked to the Imperial Family.

135. This informal family photograph with Queen Louise of Denmark at the centre underscores the close kinship across Europe's ruling houses. She and King Christian IX, known as 'Europe's Father-in-law', had six children, four of whom ascended to thrones either as monarchs or consorts of Russia, the United Kingdom, Greece and Denmark.
BONHAMS

In 1890, all the official gifts sent abroad with Grand Duke Nicholas were supplied by the House of Fabergé. As the firm's most important patrons, the Romanovs, who were closely related to the royal houses of Europe in the late nineteenth century, brought Fabergé many new, illustrious clients. Intermarriages between ruling houses produced a feeling of solidarity with the result that Fabergé objects were often exchanged as official gifts, and foreign diplomats travelling to Russia would bring back souvenirs from the firm. During the heyday of Fabergé's career, at the beginning of the twentieth century, five European reigning monarchs were grandchildren of Queen Victoria of Great Britain and, therefore, first cousins: Kaiser Wilhelm II, King George V of the United Kingdom, Grand Duke Louis of Hesse, Duke Carl Eduard of Saxe-Coburg, and Queen Victoria Eugenia of Spain. The Emperor of Russia was related to the kings of Great Britain, Greece, Denmark, and Norway.[6] All of these royal and princely relations were either clients or recipients of Fabergé objects, catapulting the firm into a position where they were one of the foremost in the world.

The Russian rulers' diplomatic relations helped to spread Fabergé's reputation even further afield. In 1898, Alexandra Feodorovna invited Fabergé to appraise gifts presented to her by the wife of Liu Yu the Chinese Ambassador. She then reciprocated with a pair of five light candelabra decorated with dragons' heads by Fabergé. Additional important commissions from East Asia came in 1904 from King Chulalongcorn of Siam whose son, Prince Chakrabong, had been educated and married in St Petersburg and was well aware of the firm's

Above left. 136. Silver-gilt and enamel bell push, Fabergé, Moscow, c.1900, length 5.5cm.
BONHAMS/FABERGÉ MUSEUM BADEN-BADEN

Above right. 137. Silver-gilt and enamel bell push, Fabergé, Moscow, c.1900, length 6cm.
BONHAMS/FABERGÉ MUSEUM BADEN-BADEN

Above. 138. Silver-gilt and enamel bell push, Fabergé, Moscow, c.1900, length 6cm.
BONHAMS/FABERGÉ MUSEUM BADEN-BADEN

139. Gold-mounted ivory bridge set by Fabergé, workmaster Mikhail Perkhin, St Petersburg, 1899–1908. 36 x 23cm.
FABERGÉ MUSEUM BADEN-BADEN

140. An enamelled and jewelled nephrite figure of a Buddha. Attributed to Fabergé, St Petersburg, late nineteenth century. Height 18cm, weight 2.3kg.

FABERGÉ MUSEUM BADEN-BADEN

production. It was for the Siamese court that Fabergé produced Buddha-type figures, some with articulated heads and arms. The French firm of Cartier also designed Buddha figures similar enough to cause mis-attribution, such as an example in the Royal Collection. It was gifted to Queen Mary and, while previously believed to have been by Fabergé, has recently been considered to have been made by Cartier sometime between 1900 and 1910. As scholarship and access to archival documentation evolve, attributions will continue to be challenged and even overturned. Fabergé's

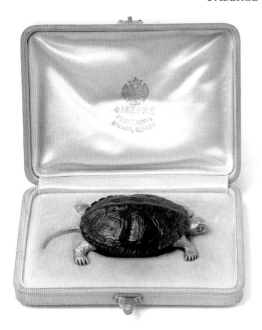

141. Imperial gold-mounted turtle, Fabergé, St Petersburg, 1890–1903. The naturalistically carved jasper, chosen specifically to emulate the animal's shell, is further enhanced with finely chased head, feet and tail. This piece was originally in the collection of Grand Duchess Xenia and was later sold from the Livadia Palace in 1932, length 7cm.
WARTSKI, LONDON

delightfully carved hardstone animals were also in great demand by the Siamese who dedicated each year to a different animal.[7] In this way, the Russian leaders helped to extend the firm's fame to the Far East.

For the Imperial Purveyor to the Court, every private family occasion became an opportunity for Fabergé to create special order items.[8] These could range from his most famous commissions, the Imperial Easter eggs, to monogrammed cufflinks. For the Romanovs, Fabergé produced jewellery, gold boxes, personal accessories such as cane handles, as well as desk and table items, pencil holders, and bonbonnières, relying on exquisite craftsmanship and designs, rather than expensive materials, to set his work apart. Later, Fabergé added carved flowers to his repertoire of hardstone animals and figurines which were equally popular with the Imperial Family.[9] If every birthday, christening, wedding, coronation, Christmas, and Easter gift was to be stamped Fabergé, the sheer numbers of these smaller commissions must have been astonishing. It makes one realise that the body of works which survives today is minute in comparison.

142. A gold-mounted and jewelled enamel parasol handle. Fabergé, workmaster Henrik Wigström, St Petersburg, before 1899. Length 4.4cm.
BONHAMS/JOHN ATZBACH

Fabergé oversaw designs but was not a workmaster himself which is why we do not find his initials on items, only the mark of his firm. He was a patriarchal figure who oversaw all facets of his centralised operation including advertising and distribution.[10] The standards of quality control were exacting, as detailed in illustrated price lists of goods created to reach even the most far-flung provincial clients. These complimentary catalogues stated that the House of Fabergé created vast stocks of new

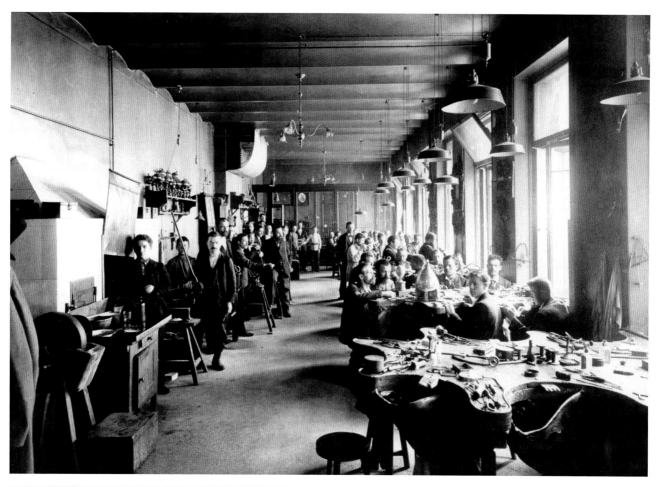

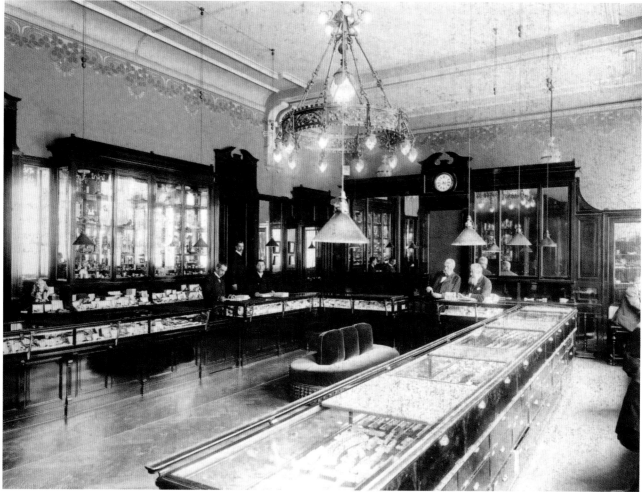

goods every year and only sold those in perfect condition. Faulty, unsold or unfashionable pieces were not tolerated and efficiencies were established to destroy items that did not meet the stringent criteria. Prices were not unreasonably marked up and a variety of goods were offered to suit most pockets. By incorporating modest materials such as palisander or birchwood, cork and metal, the firm would be accessible to buyers of more limited means.[11]

Opposite above. 143. The Fabergé workshop of Mikhail Perkhin in St Petersburg, c.1903.
FABERGÉ MUSEUM BADEN-BADEN

Opposite below. 144. The Fabergé salesroom in St Petersburg.
FABERGÉ MUSEUM BADEN-BADEN

Above. 145. Fabergé's premises in St Petersburg, c.1900.
FABERGÉ MUSEUM BADEN-BADEN

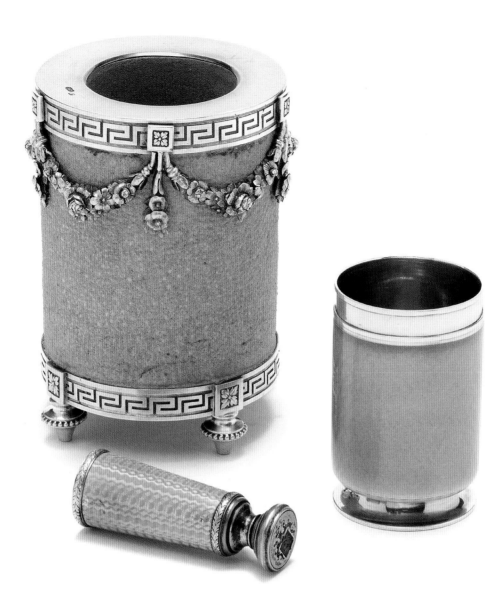

146. A group of objects attributed to Fabergé, c.1900, illustrating a variety of materials and forms, from desk to smoking accessories in gold-mounted guilloché enamel right down to basic sandstone. Height of match holder 10.5cm.
BONHAMS

Opposite. 147. A parcel-gilt and wood clock in the Louis XVI taste. Fabergé, workmaster Viktor Aarne, St Petersburg, 1897, with scratch inventory number 5756. According to the original invoice preserved at the Russian State Archives in St Petersburg, the clock was amongst twelve pieces purchased by the Dowager Empress from Fabergé on 17 April, 1897. This supports the notion that Fabergé's wooden output was possibly more affordable due to the lack of precious materials integrated into the design, but was no less cherished by the highest echelons of society who were hardly financially constrained. Height 22cm.
BONHAMS/FABERGÉ MUSEUM BADEN-BADEN

This interplay between noble and common materials was present from the very first contact with a Fabergé object. Just as blue boxes of a certain hue are synonymous with Tiffany and Co., or crimson cases with gold tooling suggest a Cartier trinket, the Fabergé firm had a characteristic fitted box made generally of light hollywood (see plates 141 and 151). Apart from Imperial commissions housed in Moroccan leather cases stamped with gold Imperial ciphers, or rare velvet-lined ovoid containers conforming to Easter presentations, most items were placed in a disarmingly simple rectangular hinged case which opened with a particular trefoil clasp. The makers of these fitted cases were accomplished carpenters and upholsterers plying their trade in diminutive formats. Finns were recognised in St Petersburg as the best case makers, with two members of the Käki family, Anders and Simon, working exclusively for Fabergé.[12] The boxes usually had canted corners and bevelled edges but no other adornment, which almost heightened the anticipation of receiving such a

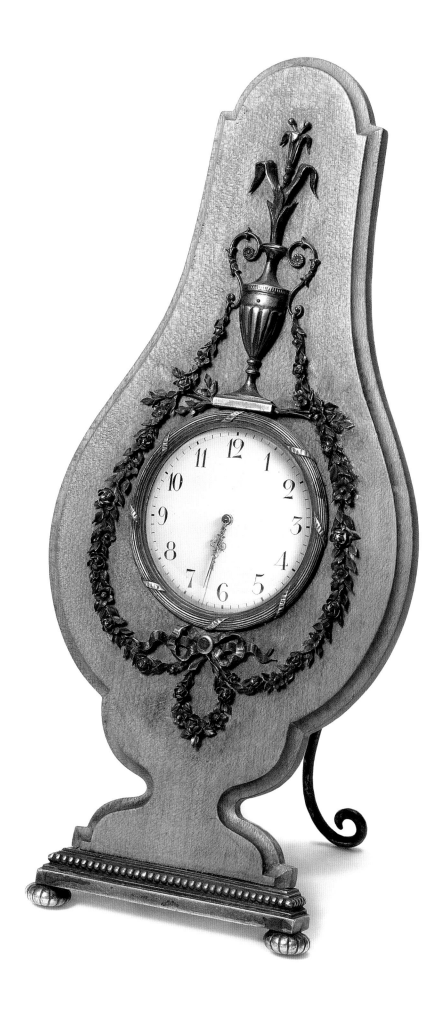

148. Silver-mounted wooden frame, illustrating the fashion c.1900 for simple frames enriched with mounts. It is thought that at Fabergé, these were sometimes originally painted as traces of pigment are occasionally found on these rather pared-down objects. Height 9.9cm.

gift. Convention dictated that bracelets and watches were housed within long boxes, necklaces in square ones and rings in hexagonal fitted cases.[13] At this point in a presentation, the receptor could have absolutely no idea of the shape, size or value of what was contained within. This settled the eyes for a few moments before the opening of the box revealed a perfectly crafted marvel nestled amidst a cream velvet-covered base. The inside cover of the box was silk-lined and stamped with the firm's branding identifying the particular branch that had retailed the object. Thousands

upon thousands of these cases were produced as the firm expanded from
St Petersburg to Moscow, Odessa, Kiev and eventually London.

Fabergé's system for handling a growing company mirrored, in a way, the
Imperial Household, whose numbers and demands were also rising. As
the Household became larger and more bureaucratised, the various
suppliers of goods had to become far more centralised in their operations
and they diversified their production in order to keep up with the times.
Small workshops began to band together to form large manufactures or
factories to meet the demands of their Imperial patrons.

149. A silver-mounted and enamel wooden frame.
Fabergé, workmaster Henrik Wigström,
St Petersburg, 1908–1917. The use of birch with
characteristic enamel and classical mounts was a
common device of the firm which did not rely solely
on precious materials to win acclaim. Height 22.1cm.
BONHAMS/ANDREY CHERVICHENKO

As his fame spread, Fabergé joined the uppermost category of masters such as the jewellery firms of Bolin, Hahn and Koechli who were not subject to guild restrictions. Those masters, who were employed exclusively to fulfill Imperial commissions, dealt with the Court Office which negotiated the drawing to be used, the metal required, and the master's fee.[14] Fabergé was therefore amongst those who enjoyed a more privileged relationship with the Imperial Family. Von Habsburg points out that while Alexander III had participated with Fabergé over the designs of the eggs the Tsar presented yearly to his consort, Nicholas II apparently left the entire creative evolution to the craftsmen so that the firm enjoyed virtually total artistic freedom.[15] As Fabergé's fame grew, he was able to bypass the Court Office and seemingly kept the entire world in suspense

151. Silver-mounted enamel clock. Fabergé, workmaster Mikhail Perkhin, St Petersburg, 1899–1908, with scratch inventory number 8557. The upright case enriched with translucent mauve enamel was the last Empress' favourite colour. The success of this clock at auction was largely due to its impeccable provenance, documented in the *Berwickshire News* of 1903 as a wedding present from The Hon. Lady Miller to Laura Fordyce Buchan. It was consigned by a descendant and therefore kept its unbroken line of pedigree for almost 100 years. Height 12.7cm.
BONHAMS/PRIVATE COLLECTION

Opposite. 150. Fabergé silver-mounted wooden frame, workmaster Hjalmar Armfelt, St Petersburg, c.1900. Height 24.7cm.
WARTSKI, LONDON

152. Fabergé silver-gilt and cloisonné enamel frame, Moscow, 1908–1917. The aperture is enriched with stylised foliage in the Art Nouveau style. Diameter 9.2cm.

as they awaited the unveiling of his next Easter egg:

> While the public and even the Imperial Family might speculate as to the nature of the next egg, no amount of pressure could force Fabergé to divulge his plans. 'Your Majesty will be satisfied', he might answer … or to a particularly curious client, he is said to have answered 'next year's eggs will be square'.[16]

Fabergé capitalised on his advantageous relationship with the Court Office; however, he never seems to have lost sight of his station. A tender note sent by the Dowager Empress to her son, Nicholas II, reveals how cherished Fabergé and his pieces were. After almost a full year's work, he

153. Silver-gilt and guilloché enamel *kovsh* by Fabergé, workmaster Antti Nevalainen, St Petersburg, 1899–1908. Length 9cm.

154. Silver and guilloché enamel *kovsh* by Fabergé, workmaster Antti Nevalainen, St Petersburg, 1899–1908. The bowl is set with an Empress Elizabeth coin. Length 10cm.

155. Fabergé silver-mounted oak *kovsh*, Moscow, 1899–1908. The bowl is enriched with traditional Slavic motifs and set with cabochon garnets and moonstone. Length 15.2cm.

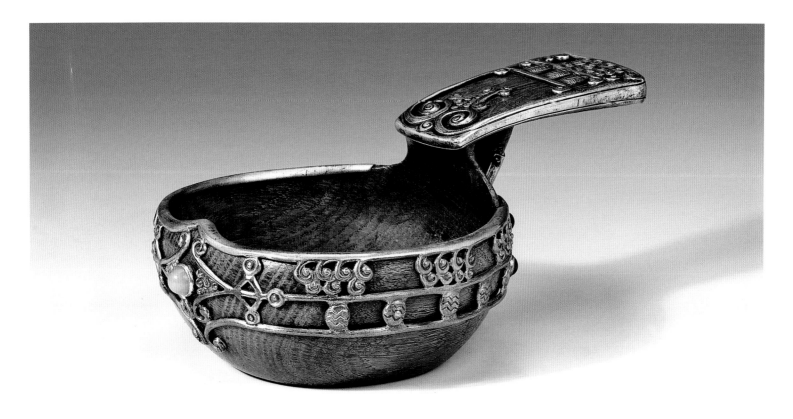

personally brought the long-awaited Easter egg to Maria Feodorovna on behalf of the Tsar in time for Easter. The delighted Dowager Empress immediately returned her son's Easter greetings:

> Christ had indeed arisen! I kiss you with all my heart for your dear cards and lovely egg with miniatures, which dear old Fabergé brought himself. It is beautiful. It is so sad not to be together. I wish you, my darling Nicky, with all my heart all the best things and success in everything. — Your fondly loving old Mama.[17]

This note is particularly poignant in hindsight as it was written in 1916. As the Dowager Empress wished her son success in everything, the Bolshevik revolution was approaching and the ruling house was increasingly cut off from the revolt fermenting in the streets.

156. A silver-gilt and enamel tankard, Fabergé, workmaster Antti Nevalainen, St Petersburg, 1899–1908. Height 9cm.

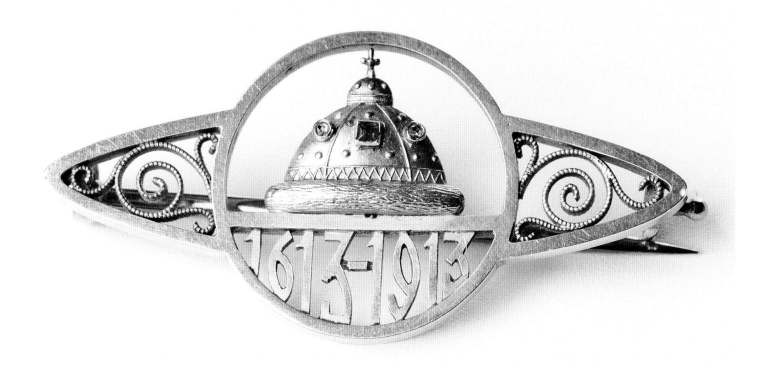

If the popularity of the Imperial Family was waning, then so was Fabergé's success which had reached its zenith during the tercentenary jubilee of the Romanov family in 1913. At that time, unlike Alexander III's intense involvement in the creative process or Nicholas II's apparent disinterest in the preparatory stages, Alexandra Feodorovna herself designed a brooch to commemorate the event, hundreds of which were executed by the firm. The anniversary of Romanov rule was marked by a multitude of balls and galas where the presence of Fabergé objects was pervasive. Each event was an opportunity to exchange Fabergé gifts, to wear one's own Fabergé tiara or cufflinks, to powder one's nose from a Fabergé compact, to accept the last quadrille on one's Fabergé dance card, or to offer a Turkish cigarette from a Fabergé case.

A rapid decline in business followed with the onset of World War I, and later through the October Revolution of 1917, after which the workshops were seized by the new government. Karl Fabergé fled Russia and eventually settled in Switzerland where he died, shortly after, in 1920. The most successful years of the firm therefore correspond roughly with the rule of Nicholas II – both suffered during the war and were annihilated by the Revolution. This serves to further parallel the Fabergé firm as a symbol of the fallen house of the Romanovs.

157. Imperial presentation pin of gold, diamonds and rubies. Fabergé, workmaster Albert Holmström, St Petersburg, 1912. These were made in large numbers to commemorate the 300th anniversary of Romanov rule, 1613–1913. Here the Monomack cap surmounts the dates. The original crown of Monomack was used by the Princes of Muscovy and at subsequent coronations right through to that of Peter the Great. It is a symbol of long-standing Russian autocracy. Length 4.4cm.

FABERGÉ MUSEUM BADEN-BADEN

In today's competitive auction market, Fabergé objects are sold at a premium. The brand carries a cachet that ensures higher prices are reached for this firm's output than for that of any of its contemporaries. This is rarely a reflection of the intrinsic value of the materials employed but rather how the various parts of an object have been worked and assembled. Here, precious stones cede to enamelled surfaces enhanced by seed-pearls, while silver-mounted native woods or carved stones

reminiscent of the hinterland are celebrated above precious resources. It was very much the vision of the Fabergé 'artist jeweller' to elevate form to the extent that the function of an object became a delightful pretext for the item's existence. Technical virtuosity is apparent throughout and no detail is overlooked – the inside of a box being no less pleasing in craftsmanship than the exterior; the back of a frame or the strut of a table clock displaying the same crispness of finish – supporting the firm's insistence that an object of virtue should be attractive from all angles.

The details of the finishes are the signature of the firm. Before even glancing at what the hallmark purports the object to be, it is in the *touché* or feel of a piece that its attribution is secured. Crude metalwork, uneven settings or shallow enamel are unacceptable and suggest a spuriously marked pastiche. The peculiarities of the scrolling struts employed in Fabergé pieces and the attributes of ribbon-tied laurel motifs inform the eye as well as the touch.

Opposite and above. 158. A jewelled gold, silver-gilt and guilloché enamel vanity case. Fabergé, workmaster Henrik Wigström, St Petersburg, 1908–1917. The lid set with plaque *en camaïeu*, a rose-tinted translucent enamel painted here with a scene of Venus assisted by a cupid at her toilette. The mirrored interior fitted with two spring-hinged lipstick holders flanking a central lidded compartment. This piece serves to remind us how the sober and restrained exterior can belie a delightful interior exquisitely crafted with miniature compartments. The opening and 'great reveal' of a Fabergé piece was meticulously conceived with an ear to the theatrical gasp. To surprise and delight a blasé client was surely a driving force for the firm's designers who strove to provide novelty for the market. Length 7.3cm.
BONHAMS/FABERGÉ MUSEUM BADEN-BADEN

159. Here, the back of a Fabergé clock shows the tidy backplate and scrolling strut. 1904-1907, height 12.5cm.
FABERGÉ MUSEUM BADEN-BADEN

Opposite far right. 162. A three-colour gold and guilloché enamel lorgnette by Fabergé, Moscow, 1899–1908. Length 12cm.
BONHAMS

Opposite. 161. Fabergé enamelled silver and gold calling-card case (workmaster Henrik Wigström, St Petersburg, 1899–1908) with a gold and enamelled pencil holder, c.1900. Length of pencil holder 12.7cm. Height of card case 9.2cm.
BONHAMS

Opposite below. 163. Fabergé gold bonbonnière, workmaster Mikhail Perkhin, St Petersburg, c.1900. The bulbous agate body surmounted by a gem-set gold collar and cover. Width 3.5cm.
BONHAMS

160. The characteristic Fabergé scrolling catch terminating in a bead.
FABERGÉ MUSEUM BADEN-BADEN

The characteristic hinged pin that hooks into a scrolling catch at the back of a brooch supports authenticity, but the absence of such a mechanism can indicate that the object was adapted or repaired. An early mentor of mine, who thankfully did not live to have to negotiate politically correct office guidelines, taught me that a Fabergé piece should never ladder a lady's stocking because all of the finishes are impeccable.

The quality of craftsmanship almost supersedes matters of taste. Even those who find the overall effect of Fabergé's output 'kitsch' must appreciate the superb handling of materials. While the average collector is unlikely to discover an Imperial Easter egg presumed missing for nigh on 100 years on an auction website, he or she will learn to hone their understanding of fakes from the study of such 'Fauxbergé' – a term coined

by the indefatigable Fabergé specialist Géza von Habsburg. That said, the playing field is more level for amateurs than one would expect and auction houses generally advise potential consignors regarding authenticity over the counter and without charge.

It is supremely satisfying to confirm a Fabergé attribution on a piece brought in by a client on a hunch, particularly when the piece in question was purchased in a flea market on the basis that it had 'good bones', 'pretty enamelling' or a 'funny Greek-type' hallmark. Selling a Fabergé object for £8,000, £15,000 or beyond can be a life-altering sum of money to a person who so easily might have second-guessed themselves and not popped by the front counter of an auctioneer such as Bonhams. For specialists, much time is spent visiting a wide network of regional and

164. A Fabergé silver-mounted thermometer and case, Antti Nevalainen, St Petersburg, 1899–1908. Length 14cm.
BONHAMS/COLLECTION MIRABAUD

165. A silver-mounted marble table barometer. Fabergé, workmaster Antti Nevalainen, St Petersburg, 1899–1904. Width 9.5cm.
BONHAMS/FABERGÉ MUSEUM BADEN-BADEN

166. A silver photograph frame. Fabergé, work-master Viktor Aarne (previously known as Johan Viktor Aarne), St Petersburg, 1899–1908. The double ogee in the Moorish taste was favoured by Nicholas II for use in his own apartments. Note the image of Grand Duke Alexander Mikhailovich (Sandro) in boyar costume, a disguise for a ball in 1903. Height 10cm.

BONHAMS/COLLECTION MIRABAUD

167. A rock crystal, gold, jewelled and guilloché enamel *kovsh*. This miniature piece is unmarked but attributed to Fabergé as similar examples are documented. Length 7.5cm.

BONHAMS/FABERGÉ MUSEUM BADEN-BADEN

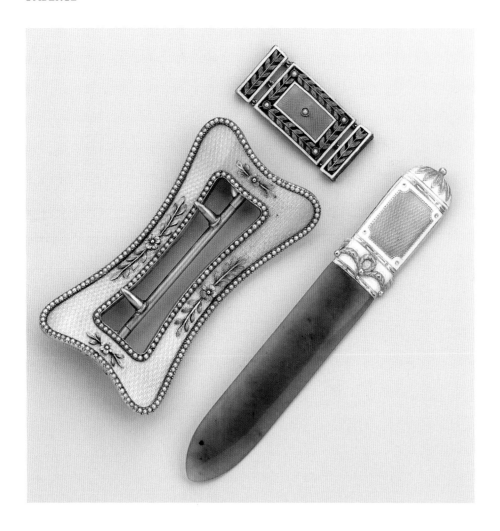

168. A Fabergé silver, gold, pearl-set and enamel buckle, workmaster Henrik Wigström, St Petersburg, 1899–1908; a Fabergé gold-mounted guilloché enamel neck ornament, workmaster August Holmström, St Petersburg, 1908–1917; a Fabergé gold enamel and nephrite paper knife, c.1900. Length of knife 9.7cm.
BONHAMS/PRIVATE COLLECTIONS

169. A Fabergé gold, enamel and diamond magnifying glass, workmaster Henrik Wigström, St Petersburg, 1908–1917. Length 10cm.
BONHAMS/ANDREY CHERVICHENKO

international offices on 'valuation days'. Back at headquarters, a constant flow of postal and email inquiries, accompanied with enough background details and images, enables valuers to draw an initial conclusion. Follow-up appointments are then scheduled in the hope that we too will sense the adrenaline rush that our colleagues on the BBC's *Antiques Roadshow* seem fortunate enough to experience with enviable regularity.

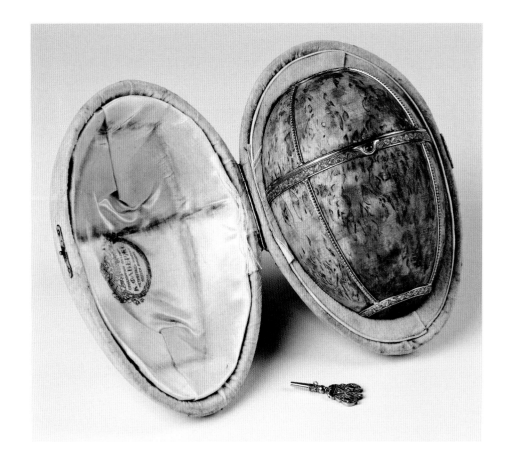

171. Easter egg of gold-mounted Karelian birchwood panels. Fabergé, workmaster Henrik Wigström, Petrograd, 1917. A birch egg was commissioned by Nicholas II for his mother but it was never delivered as the February Revolution intervened. Assumed to have been unfinished or lost, the piece resurfaced in 2001 when it was acquired from a private collection. The simplicity of design and sparing use of a common material, Karelian birchwood, befitted the austerity of the First World War.
Height 10.6cm.

FABERGÉ MUSEUM BADEN-BADEN

HARDSTONE

HARDSTONE CARVING FLOURISHED briefly in the Russian decorative arts from the mid-eighteenth century onwards. Stone-cutters were just as attracted to furnishing the grand apartments of newborn St Petersburg as the representatives of other crafts. As a result, the growth in demand for hardstone objects to complement interior decors prompted widespread exploration for supplies of both and existing specimens. The Ural mountains running through Russia and into Kazakhstan, delineating the eastern and western parts of the Russian Empire, and the Altai mountains of north-west Mongolia revealed rich deposits.

With the envy of other European courts and immense potential for national prestige hanging in the balance, the lengthy and potentially ruinous process of prospecting for home-grown minerals required the most powerful patronage. Ultimately, progress was made as a result of the endorsement of the Imperial administration. In the 1870s, native quarries supplied jasper, rhodonite, lazurite, porphyry, aventurine and marble to three main centres of production.[1]

Opposite. 172. Russian nineteenth-century gilt-bronze and malachite veneered guéridon. The design of the ormolu-mounted base is particularly fine and unusual as the baluster-shaped support and the base are malachite veneered. Height 79cm.
BONHAMS

Above. One from a parade of hardstone elephants in various materials showing the wide range of natural resources available to Fabergé. See Plate 193.
FABERGÉ MUSEUM BADEN-BADEN

173. Marble tabletop with lapidary relief bouquet, Imperial Lapidary Works in Peterhof, 1842. The splendid bouquet comprises flowers carved from agate, jasper, coral, onyx, turquoise and opal surrounded by a white Greek key border set against deep-blue lapis lazuli. Height 77cm; diameter 72.5cm.

BONHAMS

The oldest of the main stone cutting factories was located a few miles from St Petersburg at Peterhof. Stone polishing in this location had evolved from the glass polishing that had begun operating in a watermill on the site earlier in the eighteenth century. Some of the original craftsmen probably came over from Florence to teach Russian apprentices a gamut of skills, from basic grinding to the technique and art of creating

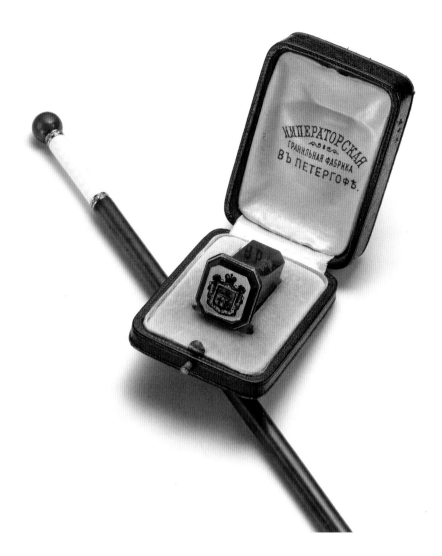

174. Nephrite seal, Imperial Lapidary Works, St Petersburg, late nineteenth century. Crochet hook, also nephrite, by Henrik Wigström, Fabergé, St Petersburg, 1899-1908. Seal 3.7cm; length of crochet hook 31.4cm; BONHAMS/IAKOBACHVILI COLLECTION

fine objects.[2] Peterhof became the principal training ground for master stone-cutters in Russia until the end of the nineteenth century.

For most of the eighteenth century, Peterhof produced smaller-scale objects measuring under a metre such as bowls, vases and decorative obelisks. This was a direct result of the costly and time-consuming process of transferring roughly hewn blocks of stone from quarries thousands of kilometres away to the cutting factory. Once the stone had survived transport, the transition from rough to finished object was centrally administered by the Imperial Cabinet. This institution's principal purpose was to oversee the care of the crown jewels, the contents of the treasury, and the commissioning of presentation gifts.

Hardstone production was intended for Imperial palaces or for official gifting, so the Cabinet was fundamentally involved in the creation and execution of decorative objects designed by court-sanctioned architects. The dimensions of the available block, its intrinsic strength and natural striations were all considered before signing off on a drawing. Close communication was required between Cabinet, factory director and master lapidary.[3]

175. Malachite box, nineteenth century.
Dimensions 15 x 29 x 18cm.
PRIVATE COLLECTION

The demand for decorative objects fashioned from native hardstone increased, prompting the exploration of new techniques to compensate for the limitations of the raw materials. Producing hardstone furniture, for instance, was inconceivable due to the fact that the scale and weight of such projects was beyond practical scope. The appearance, however, of a tabletop could be achieved once the method of veneering was perfected. Based on mosaic techniques, multiple blocks of malachite, for example, could be sliced and then laid out on a smooth surface. This would have to be of a stable material such as metal or stone in order to mitigate any swelling and separating of the veneer. The mosaic pattern was cemented down carefully, so as not to reveal the joins, and then sanded and polished. Any vacant spaces or flaws could be filled with a paste composed of green cement and ground malachite fragments to create a uniform surface.[4] The rich, green, marbled effect was thus preserved without breaks interrupting the striations.

176. Malachite paperweight with gilt-bronze handle, inset with view of St Petersburg's Palace Square, nineteenth century. Dimensions 3.8 x 16.5 x 33cm.

PRIVATE COLLECTION

Malachite was famously used to greatest effect in the late eighteenth to mid-nineteenth centuries. In all, twenty-four monumental vases were placed in ballrooms and large halls within noble palaces. A great many were specially created for the Imperial Museum in the New Hermitage which was inaugurated in 1852. The sheer size and weight of these commissions assured their survival to the present day as neither war nor government-backed change in fundamental ideology could damage or shift them from their original locations. These, together with the architects' plans and period watercolours, remain some of the most pivotal references for Russian design of the nineteenth century. When stepping into these palace interiors, we have a tangible link to the original design and decoration of these large spaces. Smaller objects, such as boxes, clocks and desk garnitures, made malachite accessible to larger segments of the buying public. This material was further enhanced by the use of bronze doré mounts.[5]

During the first half of the nineteenth century, stone cutting became highly developed at Ekaterinburg, the second important factory in Russia. Due to the ongoing transport problems inherent in the supply of raw materials for the Peterhof location, the Imperial administration resolved to create a new factory in 1765, in the heart of the Ural mountains at the site of the mineral deposits. Rather than bring the material to the masters, it was thought that the reverse should be workable.[6]

Training for the workers began at the age of fifteen and apprentices would be instructed in all aspects of the process from mining to polishing. Count Alexander Sergeievich Stroganov (1734–1811), an extraordinarily influential figure who served as President of the Imperial Academy of Arts in St Petersburg and as Director of the Imperial Lapidary Works between 1800–1811, is credited with restructuring the training process for stone carvers. It was during his tenure that the Imperial administration assumed responsibility for the education of the factory's most promising

177. Paperweight modelled with an assortment of hardstone fruit over a malachite base, nineteenth century. Dimensions 3.8 x 30 x 20.3cm.

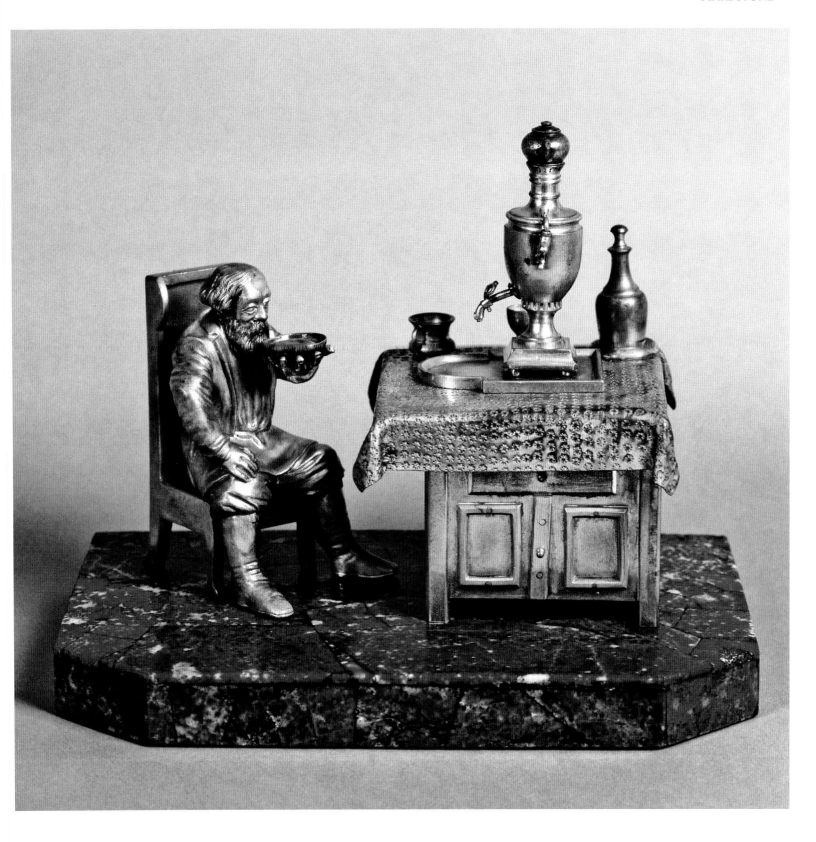

trainees. Stronger links between stone cutting factories and prominent architects were also fostered through his initiative. The sons of lapidaries were sent away to the Imperial Academy of Art, St Petersburg on scholarships, an investment that was more than recouped when their training was applied upon their return to Ekaterinburg.[7]

178. Gilt-bronze figure at tea, on a lapis lazuli base, nineteenth century. 19 x 23 x 15cm.
PRIVATE COLLECTION

179. Pair of nephrite tazzas, probably from the Ekaterinburg Lapidiary Manufactory. Height of each 28cm.

BONHAMS/FABERGÉ MUSEUM BADEN-BADEN

Opposite. 180. Kalgan jasper tazza and pair of candlesticks, probably from the Ekaterinburg Lapidary Manufactory, nineteenth century. In the Neo-classical style. Vase height 32cm; height of candlesticks 18.5cm.

BONHAMS

One notable characteristic of Ekaterinburg hardstone pieces was their combination with bronze mounts. The architect Andrei Voronikhin produced extremely fine works which were displayed at the Winter Palace as well as the residences of the most prominent Russian families. Voronikhin is a legendary figure in Russian history. Born a serf and granted 'freedom', the illegitimate son of Count Alexander Sergeievich benefited from a spectacular education and a network of commissions under Stroganov's watchful eye. His hardstone pieces enriched with bronze mounts carefully enhance one another and are thought to have evaded the ponderous qualities often associated with this combination of materials.[8]

The third factory worthy of mention is Kolyvan which was re-established in 1802 in western Siberia. It was decided by the Imperial Cabinet that large-scale objects made from stones local to the Altai mountains should be the focus of production. Technical improvements to the carving and polishing of monumental pieces allowed for beaded, gadrooned and fluted forms.[9] The factory supplied the New Hermitage building with bowls and torchères between 1840 and 1850. In 1851, the Great Exhibition in London awarded Kolyvan first prize for a square bowl, the technical excellence of which was compared by the jury to items from classical antiquity.[10]

Each of the three famous factories developed their own specific features but they shared much as well. Initially, the objects were not decorated and the resulting forms were simple and strict. By the late eighteenth century, dark bronze, ormolu and rich carvings were used to enhance them. At the close of the century and into the nineteenth, works in

Opposite. 181. Early nineteenth-century tazza comprising a shallow rhodonite dish mounted upon an ophiocalcite support. Height 22.5cm. PRIVATE COLLECTION

Above left. 182. Early nineteenth-century tazza comprising a shallow jasper dish mounted upon a rhodonite support. Height 10.5cm. PRIVATE COLLECTION

Above right. 183. Russian nineteenth-century hardstone tazza with faceted standard supporting a rhodonite dish. Height 28cm. PRIVATE COLLECTION

184. Gold-mounted and enamel bowenite box.
Fabergé, unmarked. Width 6.5cm.

carved stone were influenced by classical forms and ornaments were in the antique taste. The Empire period was characterised by grace and refinement when the carving technique flourished. The Gothic revival style used in the architecture of the 1830s–1840s did not impact the work of stone carvers although the solemn stateliness of the interior architecture of the 1840s and 1850s did lead to the creation of large decorative ensembles. As the second half of the nineteenth century was a time of economic uncertainty, the large-scale ambitions of the factories could not be sustained.[11]

The reality of this medium was that it sometimes took decades between creating a design, matching it to the appropriate stone sample, executing the work and then safely transporting it to the ultimate delivery point. These time-consuming processes, coupled with the massive investments required to prospect for new mineral deposits and the prolonged training of a highly specialised workforce, provided the massive challenges that led to the eventual decline of the discipline.[12]

185. Gold, silver-gilt and nephrite frame, Fabergé, Hjalmar Armfelt,
St Petersburg, 1899–1908, with scratched inventory number 13581. This frame was
acquired by a French diplomat at the 1932 Palace of Livadia sale and it had previously
belonged to Tsar Nicholas II's sister, Grand Duchess Xenia. This example distills
some of Fabergé's best known design preferences, from the plain wooden fitted case
(not illustrated) to the varicolored gold ribbon-tied swags punctuated with
cabochon stones, and the tidy backplate affixed with a scrolling strut to benefit the
viewer whose gaze should not be offended by inferior workmanship to the reverse of
the frame. The nephrite panel with its rich spinach-green tones would have been
specially selected from the stock of Siberian jade for evenness of colour and would
have suited a position near a light source so as to reveal its translucency and set off
the gold and jewelled accents to their best advantage. Height 12.9cm.

BONHAMS/FABERGÉ MUSEUM BADEN-BADEN

186. An amusing hardstone figure of a
hippopotamus by Denisov-Uralski,
St Petersburg, c.1900. Length 9cm.

Whilst the production of large-scale objects was no longer viable, the
Fabergé firm reinvigorated the Russian market for small carvings and
bibelots. These objects showcased native hardstones and became so
popular that specimens from Idar-Oberstein in Germany and other
locations were imported to fulfill demand.

The firms of Sumin, Denisov-Uralski and Britzin also supplied lapidary articles to the court, but it was Fabergé's signature use of materials such as gold-mounted enamel and the firm's unequalled craftsmanship that headlined in this collecting category. At the very top end of the spectrum are the fifty or so hardstone figurines of people capturing their national

187. A finely carved chalcedony figure of a snail, Denisov-Uralski, St Petersburg, early twentieth century. Length 9cm.

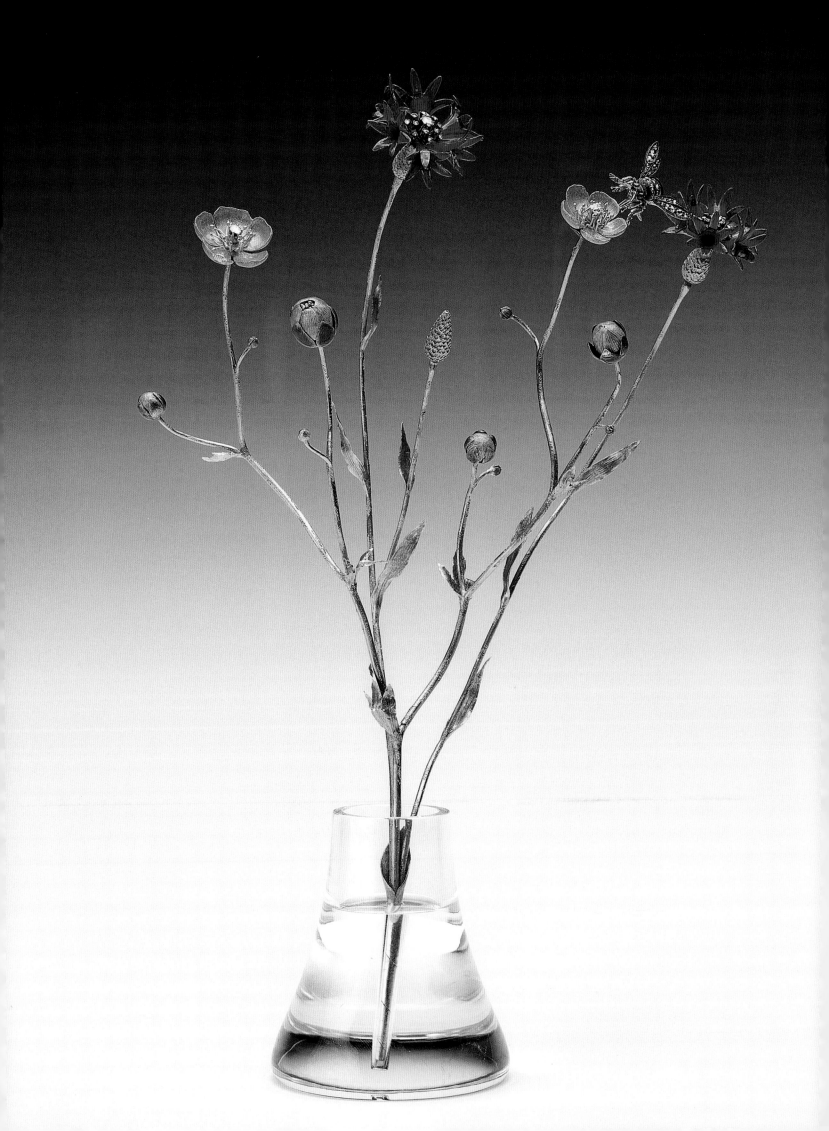

costume and attributes in painstaking detail. In a rare departure from
Russian themes, the firm created a Chelsea Pensioner in 1909, which is
now in the Royal Collection thanks to King Edward VII, who purchased it
during his last visit to Fabergé's London branch in 1909.[13]

The rare flower studies, which capture delicate stems placed in a rock
crystal vase in minute detail, generally evoke springtime or wildflowers
which the beholders must have longed to see throughout the endless
Russian winters. Unusually, the study of cornflowers and buttercups
comprises two floral varieties and is further enriched with a jewelled bee.
Originally owned by Maria or Alexandra Feodorovna, it was purchased by
Queen Elizabeth II from the fine jewellery retailer Wartski in 1947 for £375.[14]

189. Hardstone study of a Chelsea Pensioner.
Fabergé, 1909. Purpurine, aventurine quartz,
jasper, gunmetal, gold, enamel, cabochon
sapphires. 11.2 x 4.5 x 2cm.
SUPPLIED BY THE ROYAL COLLECTION TRUST / © HM QUEEN
ELIZABETH II, 2013

Opposite. 188. Study of cornflowers and
buttercups. Fabergé, c.1900. 22.3 x 14 x 8cm.
SUPPLIED BY THE ROYAL COLLECTION TRUST /
© HM QUEEN ELIZABETH II, 2013

190. Jewelled hardstone and gold-mounted parasol handle. Fabergé, unmarked. The rose-quartz handle is enriched with enamel tapering to tortoiseshell with applied diamond monogram of Maria Rosset Desandré who commissioned the piece from Fabergé. The materials, ornamental details, workmanship and fitted case all support the Fabergé attribution despite the lack of any hallmarks. Length 35cm.
BONHAMS/FABERGÉ MUSEUM BADEN-BADEN

In rare cases where metal mounts are present, hallmarks can help support a Fabergé attribution, but with pieces that are purely stone, such as the wide variety of animal carvings that survive, the final truth remains in the eye of the beholder. Cartier purchased hardstone carvings from some of the same suppliers as Fabergé, which were then retailed through the French firm, so there continues to be a sizeable 'gray area' closer to an art than a science which must be negotiated when evaluating this particular area of collecting. Experience dictates that for Fabergé pieces, the carved animals appear lively, and their coats, skin or pelts are convincingly rendered, often in a stone appropriate to the natural colouring. For example, a black seal laying upon a block of ice is convincingly rendered in obsidian upon rock crystal. That said, elephants sometimes appear in rich blue lapis and other colours which would only normally be seen in Disney reels. Finally, the little models feel exquisite to the touch, just like the Japanese *netsuke* carvings which inspired them.

191. Gold-mounted aventurine quartz card box. Fabergé, workmaster Mikhail Perkhin, St Petersburg, c.1890, with the scratch inventory number 49168. This is similar to an example originally belonging to Grand Duchess Xenia and acquired by Queen Mary. (See: The Royal Collection, RCIN 9126.) Height 8.8cm.
BONHAMS/WARTSKI

192. Fabergé topaz seal. St Petersburg, late nineteenth century. Height 7.5cm.
FABERGÉ MUSEUM BADEN-BADEN

The miniature Russian carvings so delighted their recipients that their fame spread quickly to the English royal cousins. In 1907, Fabergé fulfilled a special commission for King Edward VII and Queen consort Alexandra, sculpting animals on their Sandringham estate.

Countless boxes, desk seals, cane handles and frames were created to flaunt the rich varieties of Russian stones. Perhaps the most closely associated with Fabergé's lapidary output is a Siberian jade termed nephrite. Its rich spinach-green colouring was attractive on its own merits and anything beyond a small gold mount, a touch of red enamel or a diamond thumb-piece would only detract from the natural beauty of the stone. Pale green bowenite, transparent rock crystal, jet-black obsidian, toffee-coloured agate, pink rhodonite and purple amethyst were also widely used to great effect, as can be seen in the parade of elephants below.

193. A parade of hardstone elephants in various materials showing the wide range of natural resources available to Fabergé. Late nineteenth- to early twentieth-century, ranging in size from 2cm (smallest) to 9cm (largest).

FABERGÉ MUSEUM BADEN-BADEN

194. Hardstone snuff box with jewelled gold mounts,
Bolin, Stockholm and Moscow, 1916. Length 9cm.

BONHAMS/FABERGÉ MUSEUM BADEN-BADEN

195. Rhodonite and silver-gilt dish. Fabergé, First
Silver Artel, St Petersburg, 1908–1910. Length 39.4cm.

FABERGÉ MUSEUM BADEN-BADEN

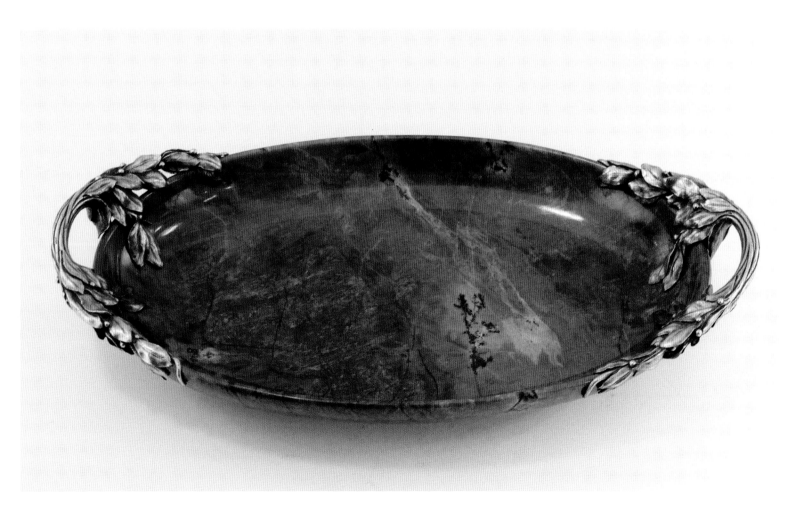

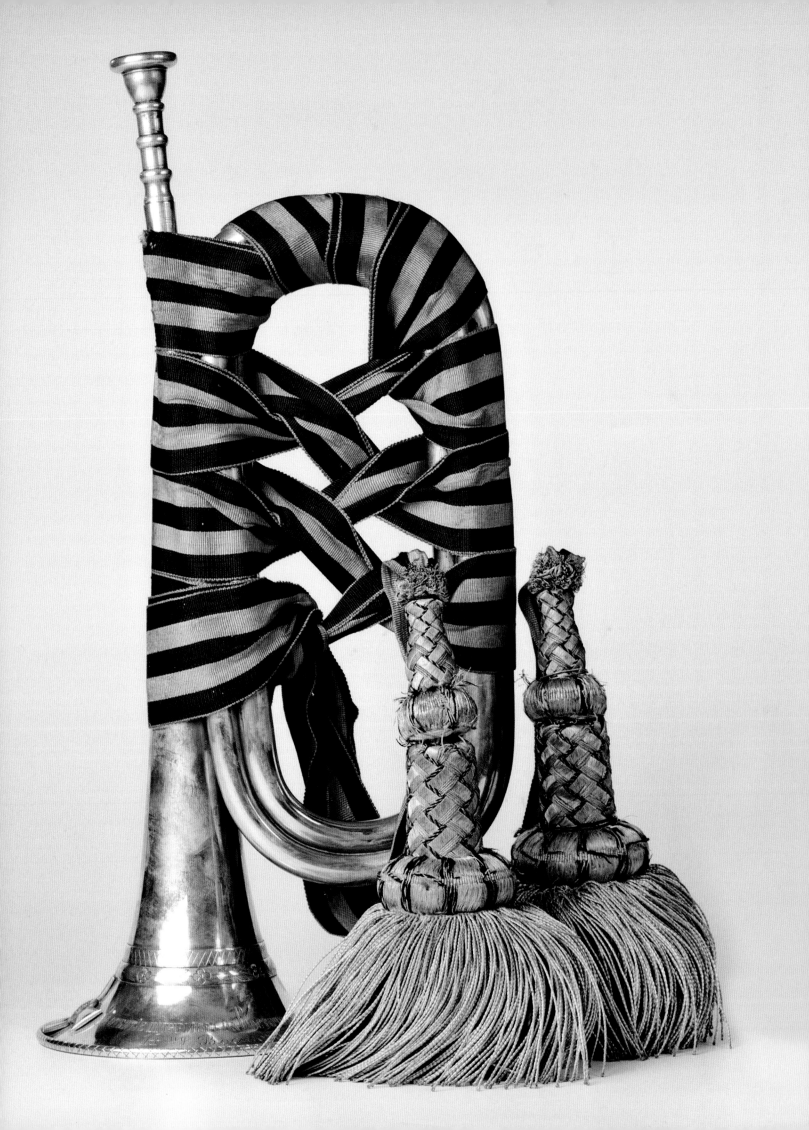

AWARDS
AND
DECORATIONS

IN KEEPING WITH THE SWEEPING reforms undertaken by Peter I, a system of ranking subjects into a meritocratic hierarchy based on service to the military, church, state and court was established. This effectively replaced the old boyar method which had been largely ensured by noble heredity. The minutiae of the revamped ranking system was then modified over the next two centuries until the fall of the Empire at the end of Nicholas II's reign in 1917.

During the last decades of the Imperial period, the gradations of Russian knighthood were defined in a tightly regulated sequence of eight hierarchical orders. Awards for merit in military or civilian life were further subdivided into classes that the recipient would progress through as years of service were accrued. The lowest rung was the Imperial and Royal Order of Saint Stanislas, rising to the Imperial Order of Saint Anne, the Imperial and Royal Order of the White Eagle, the Imperial Order of Saint Alexander Nevsky, the Imperial Order of the Apostolic Saint Prince Vladimir, the Imperial Military Order of Saint George the Victorious

Opposite. 196. Silver Saint George bugle. Unrecorded maker, St Petersburg, 1908–1917, 36cm. The 14th East Siberian rifle regiment were presented with this bugle, which is applied with a silver Saint George cross and entwined with a ribbon of the Order, in 1904 for their achievements during the Russo-Japanese War.
FABERGÉ MUSEUM BADEN-BADEN

Above. 197. Gem-set and enamel presentation gold box by Koechli, St Petersburg, 1908–1917, with a gold and enamel Order of Saint Stanislaus, Civil Division, Third Class neck badge, by Albert Keibel, St Petersburg, c.1900. Box height 4cm; order height 4.7cm.
BONHAMS/FABERGÉ MUSEUM BADEN-BADEN

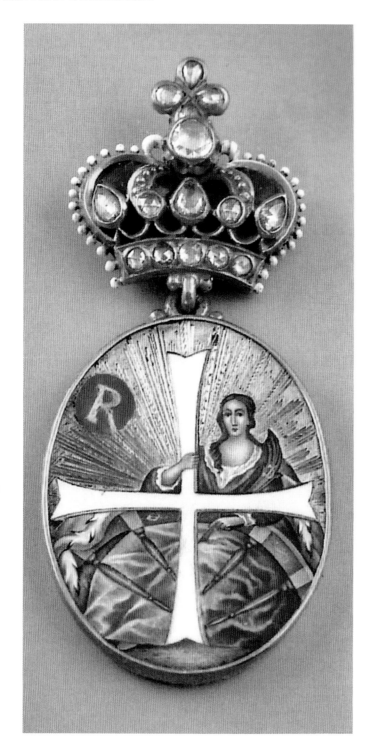

198. The Order of Saint Catherine created by
Peter the Great in honour of his wife, Catherine I,
and reserved for women of the highest ranks.
Gem-set gold and enamel, Moscow 1877. Length
6.9cm.

FABERGÉ MUSEUM, BADEN-BADEN

Great Martyr, the Imperial Order of Saint Catherine the Great Martyr, and
finally the Imperial Order of Saint Andrew the First Called. Emblems of
these orders survive in the form of badges (or crosses), stars, medals,
ribbons, linked chains, and ceremonial weapons such as swords.[1]

Women carried their husbands' ranks unless they served at court in their
own right. The Grand Mistress and also the Mistresses of the Court were
drawn from the highest echelons of the aristocracy, rewarding long years

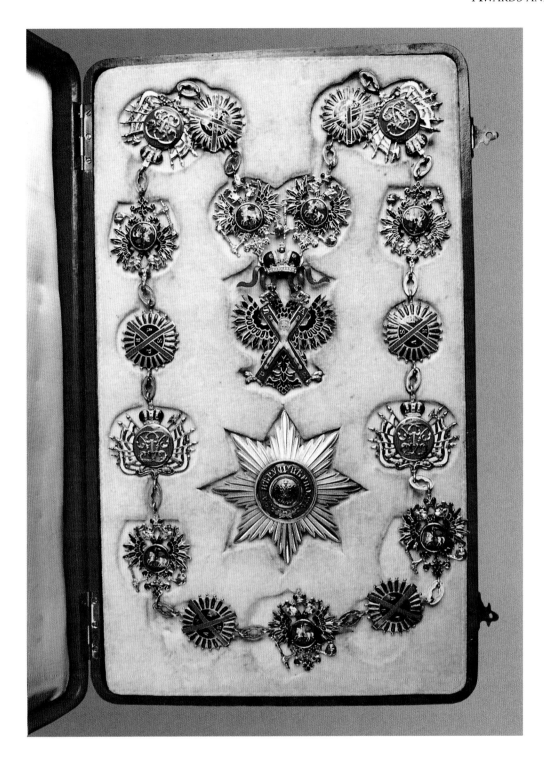

of service to the Crown. As female advisers entrusted with handling the most important tasks of an empress' household, the chosen few in this inner sanctum were required to be loyal and discreet confidantes, a critical role in helping to mentor foreign-born princesses into their roles as Imperial empresses. The highly selective ranking below this was awarded to married Ladies of Honour and Maids of Honour of the Bedchamber followed by Maids of Honour, 'Maids' being the unmarried counterparts of the 'Ladies'.[2]

199. The Star of the Order of Saint Andrew the First-called. Gold, enamel, stamped, engraved, 8.2 x 8.3, mid nineteenth century. Also shown is the insignia of the Order of Saint Andrew the First-called. Gold, enamel, cast, chased, engraved, 1861. (See p.175 for an image of the case.)

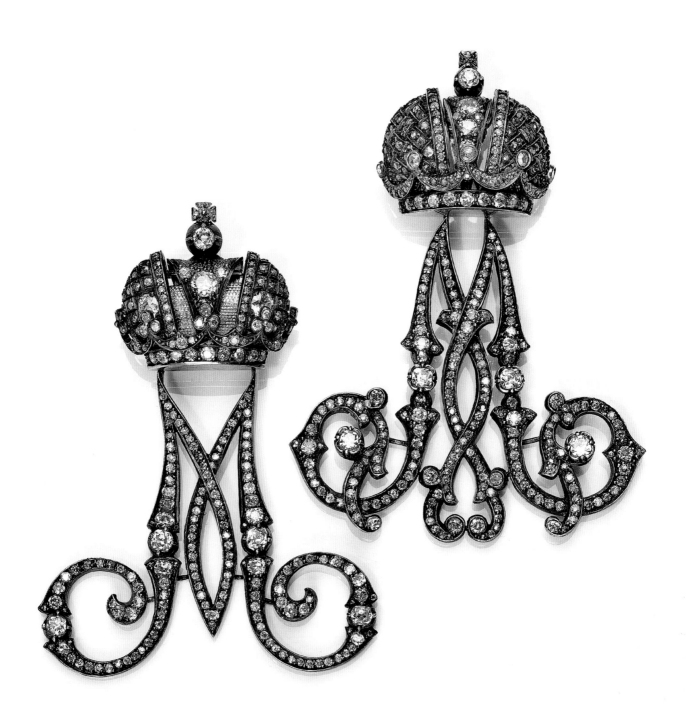

200. Two diamond-set lady-in-waiting ciphers.
The 'M' is for Maria Alexandrovna, presumably
during her time as consort between 1866–1894.
Height of largest 9.2cm.

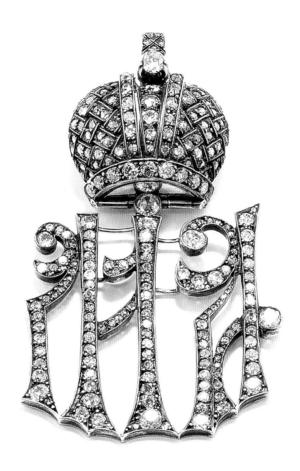

Strict regulations governing court dress required the jewelled portrait of an empress to be worn suspended from a ribbon of the Order of Saint Andrew and pinned to the left shoulder for the top three categories of service. The Maids of Honour in court attire wore the diamond-set crowned initials of the empress they served, also suspended from the ribbon pinned to the left shoulder. The cipher comprised both the reigning and dowager empresses if the former empress or mother-in-law of the consort was still alive. This was usually set with the consort to the left of the dowager empress.[3]

201. A diamond-set silver and gold Maid of Honour cipher c.1900. The initials refer to the Dowager Empress Maria Feodorovna and her daughter-in-law Alexandra Feodorovna. The piece would have been worn on the left shoulder, suspended from the ribbon of the order of Saint Andrew at official functions when court dress was prescribed. Height 8cm.

BONHAMS/EASTERN EUROPEAN PRIVATE COLLECTION

202. Gold-mounted jewelled hardstone cigarette case. Fabergé, workmaster Henrik Wigström, St Petersburg, 1899–1909. The hinged cover is gem-set with the Romanov eagle, suggesting that it was an Imperial presentation piece. Length 9.2cm.

BONHAMS

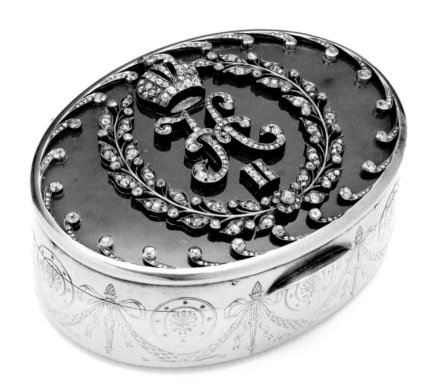

203. A jewelled gold and nephrite Imperial presentation snuff box. Friedrich Koechli, St Petersburg, c.1890. Width 7.8cm.

BONHAMS/JOHN ATZBACH

Further afield from the highest echelons of court life, an enormous number of small gifts, often incorporating the double-headed eagle and Imperial crown, were presented by the Imperial Cabinet as gifts to Russian subjects for service to the state or to the arts, as well as to foreigners during official visits. These gifts most commonly survive as jewellery, watches or cigarette cases.

The Finnish scholar Ulla Tillander-Godenhielm has studied the awards system closely and recounts that over a two-day period in 1909, the Imperial couple travelled to Poltava to celebrate the 200th anniversary of Russia's victory over Sweden. For every stage of the journey, staff who had assisted in every practical way in planning and protecting the logistics were recognised. Everyone, from railway employees to telegraph operators, including security detail, policemen, firemen, clerks and couriers, was presented with a token. These gifts totalled 144 items at a cost of 9,323 rubles, comprising eighty-three watches, dozens of cigarette cases and pairs of cufflinks, eight rings, and five brooches.[4]

204. Hermitage brooch from the Imperial Cabinet. Fabergé, St Petersburg, early twentieth century. Such brooches were given out to commemorate performances at the Hermitage Theatre. 3.4 x 3cm.
FABERGÉ MUSEUM BADEN-BADEN

205. A Paul Buhre gold open-face pocket watch made for the Russian Court, c.1900. 48mm.

While rings appear rarely on the market, stickpins, cigarette cases and pocket watches are more common. A premium is demanded for items in their original red leather fitted cases. These are usually handsomely decorated with gold borders and the Imperial Eagle features centrally on the lid.

It should be noted that presentations to the Imperial Family marking a particular event also sell at a premium. If an object in itself can offer context tying it to the royal diary, it then has an added pedigree akin to documented provenance.

The tangible remains of this hierarchical system evoking court life in St Petersburg appear at auction. Higher ranking military orders and Maid of Honour ciphers are rare, while the small tokens of appreciation produced in such high numbers also fared proportionately better through revolutions and world wars.

206. The fitted case for the Order of Saint Andrew, plate 199.

207. A parcel-gilt silver and enamel presentation plaque. Pavel Ovchinnikov, Imperial Warrant, St Petersburg, c.1891. Finely engraved with a river view of the city of Samara on the Volga, the centre applied with an Imperial Eagle within an enamelled shield and chain of the Order of Saint Andrew, the border inscribed with a dedication inscription from the Samara Civic Society and presented to Grand Duke Nicholas Alexandrovich (later Nicholas II). 30 x 36.3cm.

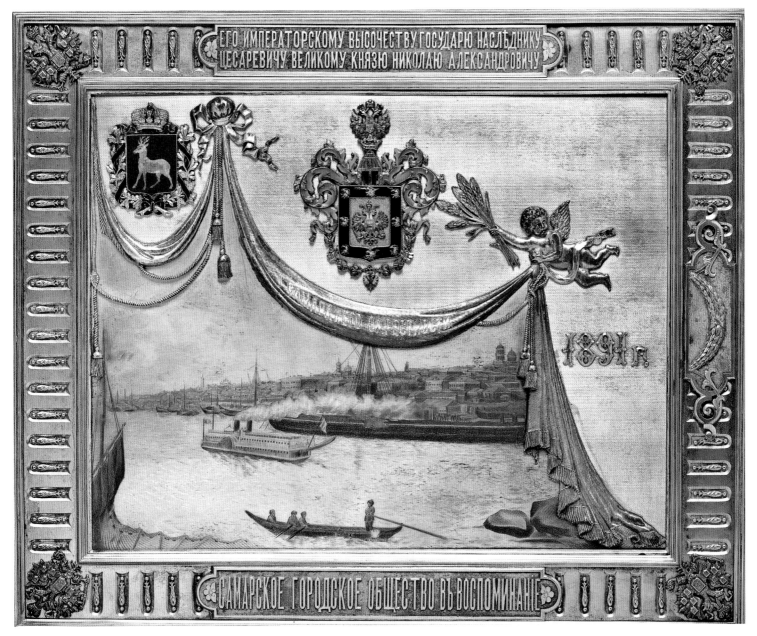

An overview of items relating to Imperial presentations in Russia would not be complete without touching on diplomatic gifts presented abroad. These are absolutely crucial to our understanding of Russian craftsmanship as they are sometimes the only extant examples to have survived the rather brutal nationalisation and systematic deaccessioning of Russian art during the nascency of the Soviet era. In an effort to raise foreign currency, items of value were either sold abroad or melted down, resulting in a vast number of artifacts having been liquidated. Works of art that had already been gifted to foreign dignitaries survived untouched abroad.

208. Silver presentation horn commemorating the 1883 Imperial Hunt. Sazikov, St Petersburg, 1883. Length 36cm.
FABERGÉ MUSEUM, BADEN-BADEN

Opposite. 209. A monumental Imperial presentation jewelled, silver punch bowl and ladle by Fabergé, Moscow, 1899–1908. Legendary medieval knights forging ahead in battle were repeatedly depicted in the epic paintings of Victor Vasnetsov. They typify the late nineteenth-century revival of interest on the part of the Russian intelligentsia and artists in glorifying their own past rather than continuing to refer to Western Europe as the barometer of good taste. Fabergé interpreted the theme in silver, borrowing the strapwork and foliate motifs from woodcarving and other peasant crafts. It is particularly fitting that a presentation by Nicholas II in recognition of the assistance offered to the *Variag* and *Koreitz* crews following Chemulpo would carry a traditional warrior theme.
LIEUTENANT COMMANDER DAVID COSTIGAN, R.N. TROPHY ROOM

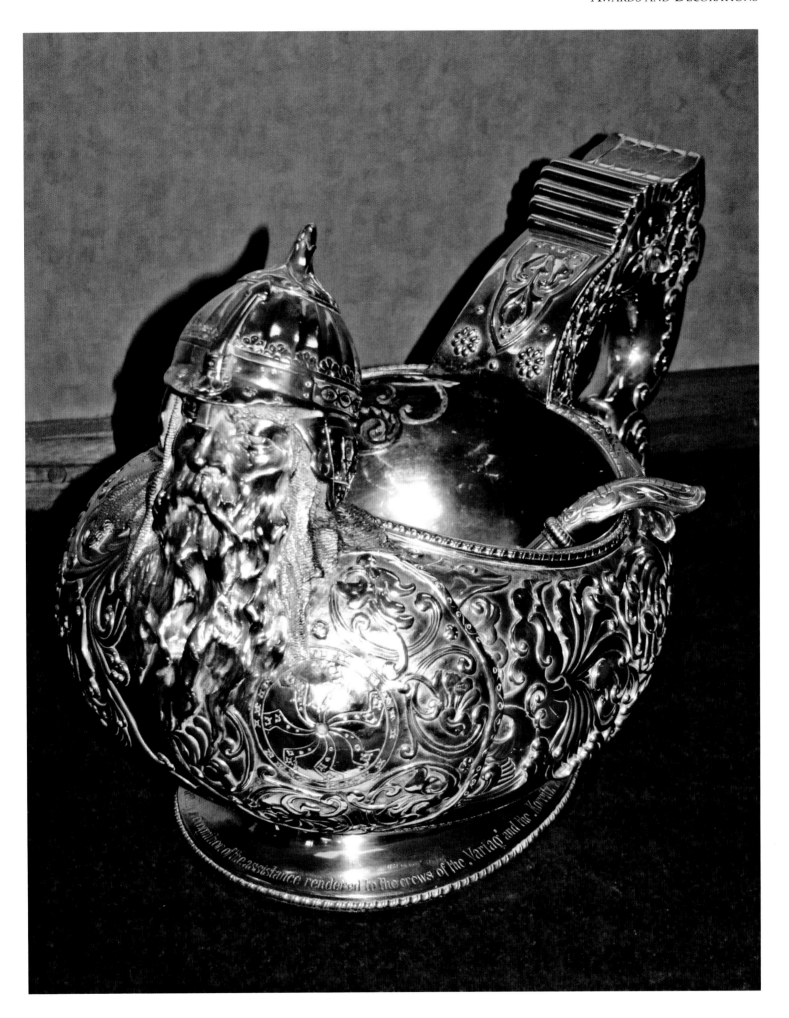

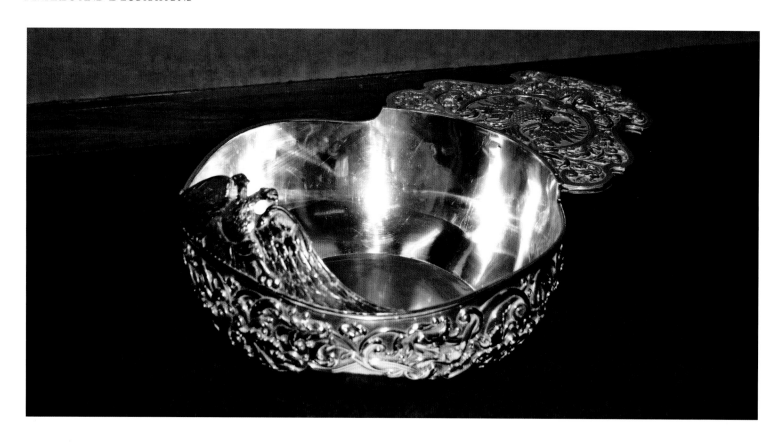

210. Large silver and enamel *kovsh* by Morozov, Moscow, c.1900. Diameter approx. 65cm.
LIEUTENANT COMMANDER DAVID COSTIGAN, R.N. TROPHY ROOM

A study of pieces commissioned by the Imperial household for exchange at state occasions such as military ceremonies outside of Russia makes a fascinating pendant to our understanding of the miniature objets de vertu belonging to the feminine *salon*, so commonly associated with Russia's output. These were the small portable items in soft lilacs, powder blues and salmon hues that, legend would have it, crossed borders sewn into the sable-lined coats of fleeing white Russians. Many were later bartered by pioneer Western antiques dealers such as Armand Hammer, or sometimes gifted as nostalgic exchanges between aristocratic cousins.

The systematic purging of decorative arts relating to the church and crown for ideological reasons by the nascent Soviet state, and or their conversion into hard currency to fund pressing needs such as agricultural equipment, resulted in the widespread destruction and melting down of pieces with intrinsic value. These tended to be large-scale commissions which were not produced as prolifically as the countless bibelots and needed to be put to work for the good of the nation, a fate from which the miniature trinkets of the drawing room were spared. The dichotomy recalls Tolstoy's epic novel, *War and Peace*, set approximately one hundred years ago, depicting a realm divided between the drawing rooms of fashionable St Petersburg and the traditionally masculine pursuits of war firmly rooted in the battlefield, high seas and officers' mess.

Examples of monumental silver created by the Fabergé workshops in Moscow illustrate Russian Revival themes executed on a gargantuan scale. As was the fate of French royal silver after the Revolution, we are left with case studies in various museums outside Russia where diplomatic gifts reside. The male realm is tangibly evident in the holding of the British Navy Trophy Rooms. Several examples of monumental presentation silver held within their inventory are of royal heritage. These command a high premium by virtue of their scale and impeccable provenance. A documented pedigree tracing back to a royal presentation has an added cachet and will almost invariably lead to fierce bidding.

211. Large Imperial presentation covered silver beaker by Fabergé, workmaster Julius Rappoport, St Petersburg, 1899–1908. The wasted tapering body in the Rococo taste is set with coins commemorating members of the Romanov dynasty. This particularly large example borrows from the Scandinavian and north German tradition of setting coins into silver vessels. It is a style which became particularly popular in eighteenth-century metalwork and was successfully revived in the Fabergé workshops.

LIEUTENANT COMMANDER DAVID COSTIGAN, R.N. TROPHY ROOM

Chapter 7
PORCELAIN

THE IMPERIAL MANUFACTORY

The history of porcelain in Russia echoes that of other Western countries in that its roots came from a desire to emulate the elusive hard paste produced in China. In the sixteenth century, porcelain was still considered a rare and expensive riddle of alchemy that conveyed prestige upon the very few wealthy enough to own examples. This technological advance was a carefully guarded national secret, aggressively sought after throughout the courts of Europe for its whiteness and durability. The only way to exhibit it in the West was to trade it with the Chinese and thus the status symbol held its exotic patina for centuries.

Those not satisfied with collecting Chinese porcelain embarked on a fierce competition to discover its mysterious recipe. This led to extensive experimentation and finally a breakthrough in 1709 at Meissen.[1] As the epicentre of European porcelain, Saxony and its wares would not have escaped the attention of Peter the Great when he toured European countries noting and absorbing their customs. In his reforms of Russian

Opposite. 212. A rare *famille verte* apothecary jar for the Russian market, Kangxi (1662–1722). Believed to have been produced for Peter I's apothecary. Height 17.2cm.
BONHAMS/MR J. REIS FERNANDES

Above. Detail from a cabinet plate made by the Imperial Porcelain Manufactory. See Plate 223.
BONHAMS/IAKOBACHVILI COLLECTION

court life, he would have appreciated the importance of furnishing state rooms with trappings of power, as well as emulating European dining rituals requiring multiple courses and serving implements. Thenceforth, the glittering state rooms and diplomatic galas in St Petersburg were to be equally impressive.

Peter the Great attempted to discover the secret for Russia but it was not until 1744, during the rule of his daughter, Empress Elizabeth, that a manufactory was established for the purpose of producing Saxon-type

213. Coffee service of Elizabeth Petrovna (1741–1762), produced under Vinogradov. Height of tallest jug 14cm.
BONHAMS

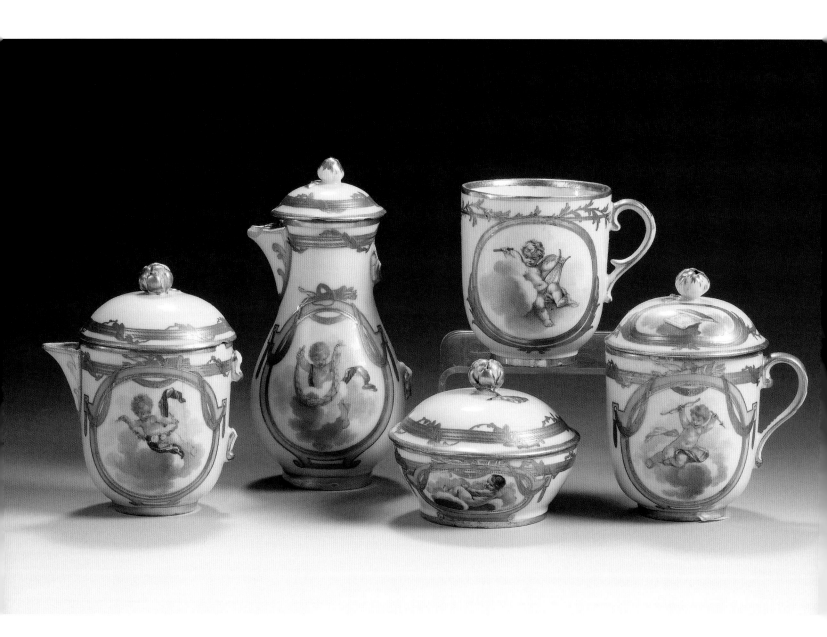

porcelain.[2] In 1750, the investment was deemed a success when the Empress was presented with snuff boxes to mark her birthday.[3]

The buying public's insatiable appetite for snuff boxes in the eighteenth century dovetailed well with the porcelain factories' ability to successfully produce small-scale presentation pieces. Used as household items, sometimes enhanced by presentation inscriptions or symbolic wording, they were prolifically gifted and collected. These fashionable accoutrements were usually silver- or gold-mounted and shaped in an endless variety of amusing forms – everything from shells to shoes. Exposure to print sources inspired artists to integrate miniature portraits, mythological subjects, flora, fauna and all manner of inscriptions on to snuff boxes.[4]

214. An important Birmingham enamel snuff box for the Russian market, c.1760–1765 commemorating the Battle of Kunersdorf which took place three years into the Seven Years War, on 12 August 1759. The interior is painted with an oval portrait medallion of Empress Elizabeth Petrovna based on a print by Georg Friedrich Schmidt after Louis Tocqué, framed by trophies of war and a ribbon inscribed in Russian 'God save Elizaveta I the Empress of all Russia'. The sides of the box are also painted with military trophies. Width 8.2cm.
BONHAMS

215. A Wedgwood plaque of Catherine II, c.1786, adapted from a c.1762 medal by T. Ivanov. Height 16cm.

BONHAMS

During the early years following the accession of Catherine the Great (1762–1796), elaborate Meissen-inspired Rococo forms continued to dominate the output of the Imperial Porcelain Factory, with increasingly complex decorations. As her reign progressed, Sevres porcelain from France became more influential than prototypes from Germany.

Having forcibly wrested the crown from her husband, Peter III, through a coup d'état, the young German-born princess set out an aggressive agenda to publicise her enlightened leadership of Russia's vast territories. Turning to the French court for inspiration, it was clear to her that Louis XIV had firmly grasped the unifying and propagandistic importance of ritual, ceremony and etiquette. Emulating the Sun King's carefully orchestrated 'arising', Catherine instituted her own 'lever' which reinforced the message of her divine authority

on a daily basis, and from the very moment of her own rising. Morning meetings scheduled around the ritual of her toilette and breakfast led into elaborate lunches, teas and glittering ceremonial banquets which carried on late into the night. Porcelain in forms adapted for dozens of guests being served multiple courses provided a golden opportunity to disseminate the supposedly indisputable wealth and taste of the Empress, with items sometimes featuring her likeness in the guise of Minerva, Goddess of Wisdom.

Further into her reign, as the classical style established itself at court, design became lighter and more rectilinear, and dining services were enhanced by statuettes and porcelain groups. The French sculptor Jean-Dominique Rachette was brought to Russia in 1779, and as Master Modeller for the factory, he oversaw production until 1804. His lasting influence was first felt in the Peoples of Russia series (see pp.206-7) based on illustrations of the native costumes which could be encountered within the Russian Empire and which had only recently been published. Classical figures drawn from ancient mythology also found favour as neoclassicism took hold.

216. Examples of the Everyday Service from the Imperial Porcelain Manufactory during the period of Catherine II (1762–1796), alongside a Gardner platter with flowers and blue ribbon, c.1780. Length of serving dish 28.5cm.
Bonhams

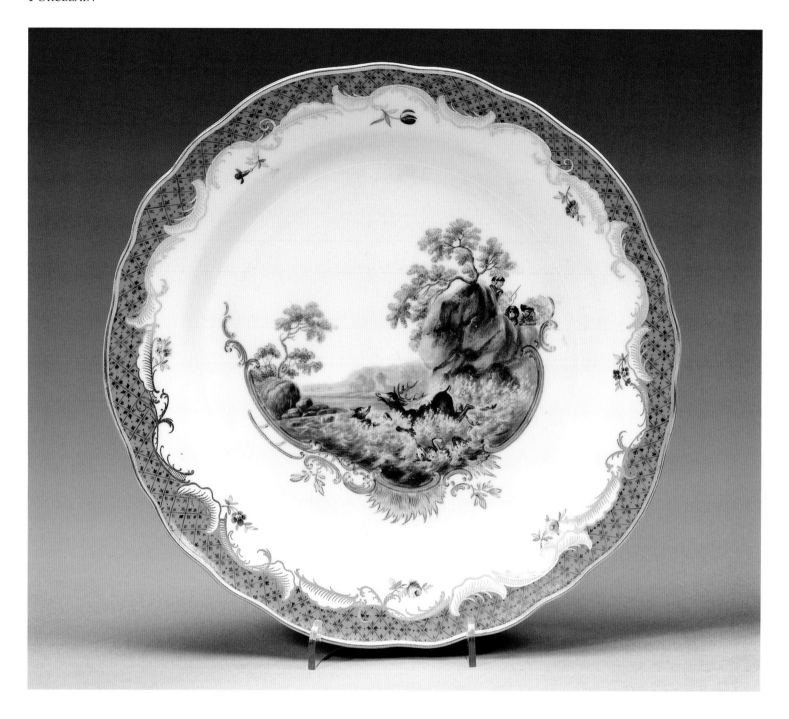

Large-scale gala services commissioned under Catherine the Great prompted the porcelain factory to evolve stylistically, hence ensuring its fame. The Arabesque Service, drawn from the classical frescoes discovered at Pompeii and Herculaneum, extended to an allegorical *sourtout de table* featuring symbols of the Empress' might. The Yacht Service, decorated with similar devices, celebrated Russia's power at sea and the thriving of her trade.[5] The enormous Cabinet Service, comprising 800 parts, was created in 1795 and enriched with medallions depicting architectural monuments of classical Italy, the remains and print sources of which are, in many cases, lost to us.[6] Replacement pieces for the

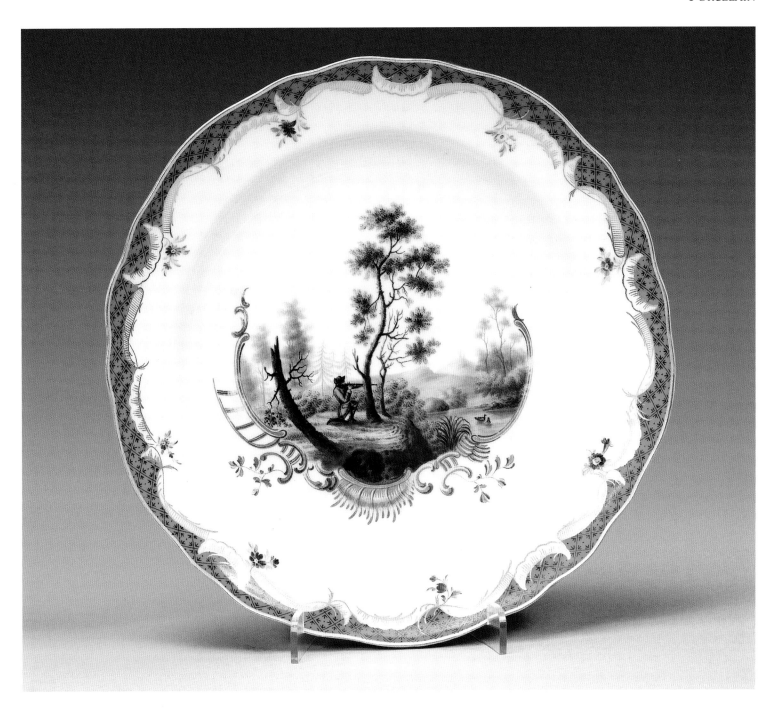

Hunting Service originally made by Meissen, various tea-sets, vases, gifts for Catherine's favourite, Count Grigori Orlov, as well as dowry pieces for her granddaughters ensured a constant flow of work for the factory.

In the eighteenth century, the factory became a victim of its own success as supply outstripped demand, producing far more stock than the Imperial warehouse could dispose of. Porcelain was made available beyond court walls in the shops of Moscow and St Petersburg, while provincial buyers were served by regional fairs conceived to promote Russian wares. These efforts were bolstered by an 1806 ban on the import of foreign china.

217. Two replacement plates from the Imperial Porcelain Manufactory, nineteenth century. They are from the Hunting Service originally ordered by Catherine II from Meissen in the eighteenth century and much extended in later years. Diameter of each 21.1cm.
BONHAMS

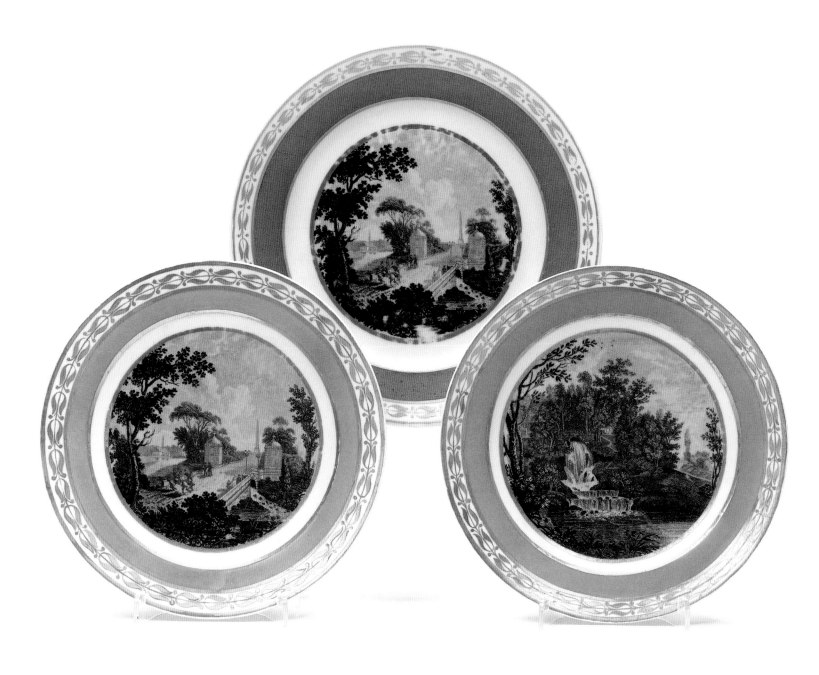

218. Three transfer-printed plates after drawings by Shchedrin, two showing the stone bridge at Gatchina and the third depicting the garden at Pavlovsk, nineteenth century. Diameter of each 21.6cm.

BONHAMS

However, this 'democratisation' of a patrician decorative art was an extremely challenging task as the factory was seemingly unable to supply both public demand and private commissions. In a further effort to popularise its wares, the factory returned in 1814 to the production of watercolours of Imperial palaces and parks commissioned in 1798 from the academician Semen Shchedrin. Drawing upon the technique of transfer-printing, the engravings could be reproduced more economically within brightly colored rims and bands of gilt ornament. This project enjoyed only limited success as the public who could access wares from the Imperial Factory preferred them to be hand-painted.[7] The production

of goods which should have eaten into the build-up of surplus stock, in fact encouraged the formation of small private factories whose wares were more affordable than the Imperial porcelain.

Stylistically, porcelain made during the reign of Alexander I (1801–1825) reflected the height of Russian neoclassicism as expressed in the flourishing of the Empire taste.[8] The beginning of the nineteenth century marked Russia's victory against Napoleon's forces.

219. Count Feodor Tolstoy commemorated the 1812 war with a series of unglazed porcelain plaques which were reproduced by the Imperial Porcelain Manufactory until 1917. Diameter of each 17cm.
BONHAMS

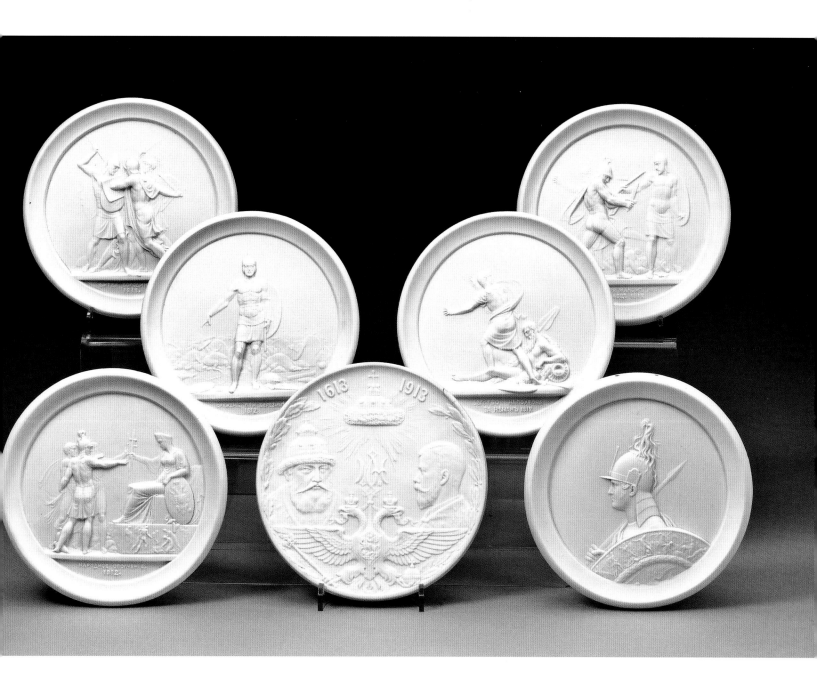

220. A replacement piece from the Guriev Service made by the Imperial Porcelain Manufactory, late nineteenth century. The service was originally produced between 1809 and 1917, incorporating folk scenes celebrating the varied people of the Empire. Diameter 24.7cm.

BONHAMS

Military scenes faithfully recording war heroes and regimental life decorated vases, plates, and cups. The resulting patriotic zeal was partly expressed in the Guriev Service featuring the people and architecture of Russia. It was an enormous banquet service comprising over 4,500 pieces and one to which more items were added through the end of the nineteenth century. This

marked a turning away from Italian scenes as the preferred subject and featured the earlier Rachette figures engaged in their daily occupations. Where statuettes or figural groups appeared as a centrepiece, they were no longer purely decorative but instead performed a function such as supporting a bowl. The drudgery of the working classes was replaced by a more romantic conception of an elegant and brightly attired peasantry captured in classical poses.[9] By the second quarter of the nineteenth century, the Empire taste was in decline and revival styles dominated.

The following monarch, Alexander's brother, Nicholas I, came to be associated with an eclectic array of revival styles. Porcelain and glass services intended for the Gothic-style Cottage Palace at Peterhof bore the mock-medieval shield enriched with white roses inspired by the childhood nickname (White Rose) of the Prussian-born consort Alexandra Feodorovna.[10] Following this Cottage Service (1827–1829), the Gothic Service was designed for the Winter Palace in 1832. Its ornament drew from the stained glass rosettes of Gothic cathedrals.

221. The Etruscan Service made by the Imperial Porcelain Manufactory, was originally commissioned by Nicholas I in 1844 for the private retreat of his consort, Empress Alexandra Feodorovna. Diameter 23.8cm.
BONHAMS

In 1832, before Westernisation sought to supersede native culture, Nicholas I commissioned a porcelain service which drew upon Russian design history. At a time when the Decembrist movement had challenged the legitimacy of Romanov authority with a revolt in 1825, it seemed propitious to turn to pre-Petrine decorative arts for inspiration. A young graduate of the Imperial Academy of Art, Feodor Solntsev, had been tasked in 1830 with copying the treasures in the Kremlin Armoury as well as church ornamentation throughout Russia (see p.58 where a more complete description of Solntsev is detailed).[11] The resulting visual reference points became pivotal in defining the way in which Russia revived her aesthetic past as interpreted through the prism of a nineteenth-century academic. The influential project led to further commissions for drawings to restore the Old Terem Palace and the large banqueting set which came to be known as the Kremlin Service.

222. Two Kremlin Service plates based on seventeenth-century enamel work, Imperial Porcelain Manufactory, period of Nicholas I. Diameters 22cm and 21.5cm.

BONHAMS/DR REINHARD JANSEN

The trajectory towards a full Russian revival was not linear. In 1844, Nicholas turned his interest towards an Etruscan revival. As with other parts of Europe, the influence of Pompeian excavations shaped the decorative arts of the 1840s, spreading a renewed interest in classical art.

Military themes depicted on plates continued to find favour beyond the Napoleonic victories and into the twentieth century, although production reached a high point under Nicholas I who, through marital alliance, was well-versed in Prussian cabinet porcelain in a similar vein. The artists and regimental units are often inscribed on the reverse of each plate, while the obverse features a Prussian-style eagle with dropped wings on finely tooled gilt rims. This eagle was a conceit introduced with Nicholas I's reign and served, once again, to underline his affinity for his consort's birthplace.

223. Two cabinet plates from the Imperial Porcelain Manufactory, dated 1828 and 1829, depicting elite regiments. Military themes drawn from lithographs were particularly popular following the Napoleonic Wars and Nicholas I commissioned cabinet pieces for presentation both at home and abroad for his Prussian father-in-law. Diameters 24cm.
BONHAMS/IAKOBACHVILI COLLECTION

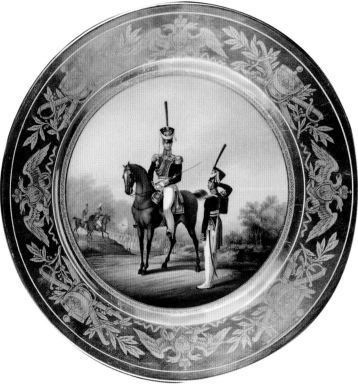

224. The Ropsha Service, originally created in 1823, featuring the eagle with dropped wings, a device introduced by Nicholas I. Imperial Porcelain Manufactory, period of Alexander II and Alexander III. Diameters 23.8cm.
BONHAMS

The second half of the nineteenth century saw Imperial patronage change from Nicholas I to his son Alexander II (1855–1881) who did not share his father's interest in the arts. More immediate financial concerns had to be reckoned with as the country emerged from the Crimean War. Social reform such as the 1861 abolition of serfdom redefined the relationship between workers and the Porcelain Manufactory. The expensive and cumbersome workshops experienced a period of artistic decline as the

Manufactory was severely restrained by the tastes of the Imperial patron, requiring his approval for all of their lines. The output during this period was therefore largely limited to replacement pieces for existing services, and necessary investment in infrastructure was not authorised. Large vases were produced as an exception and primarily to represent Russia abroad in international exhibitions. Clearly, value was placed on the West's perception of Russia even as the Manufactory fell further into disrepair.

225. These nautical services were created for the Imperial yachts *Zabava* and *Niksa* during the reign of Alexander II, Imperial Porcelain Manufactory. Diameter of each 22.6cm.
BONHAMS

226. This egg is finely painted with youthful portraits of Christ the Saviour and John the Baptist depicted in the European taste, c.1880, Imperial Porcelain Manufactory. Height 12cm.
BONHAMS

Amongst the smaller pieces that survived the relative austerity of this period are a rich variety of Easter eggs. These had a longstanding tradition in the Orthodox Church as a symbol of resurrection and were widely distributed in porcelain form by reigning monarchs from the time of Catherine the Great onwards. Examples lavishly enriched with Old Master paintings, detailed topographical scenes or depictions of saints were popular, as were more restrained examples introduced under Alexander III decorated with Imperial ciphers against plain ground. Eggs with loose floral motifs reflecting the taste for Art Nouveau also appeared towards the end of the century.

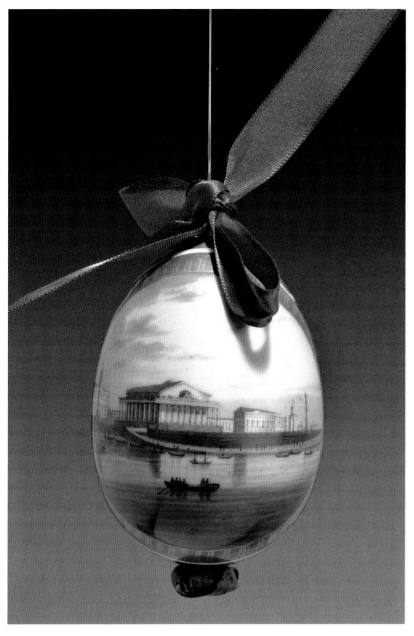

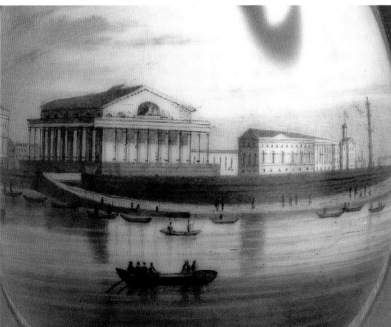

227. The central reserve of this egg is decorated with a finely painted view of the St Petersburg Stock Exchange and the Rostral Columns, c.1860, Imperial Porcelain Manufactory. Height 9cm.

BONHAMS

228. This egg from the Imperial Porcelain Manufactory is enriched with the cipher of Empress Maria Feodorovna against *sang de boeuf* ground, late nineteenth century. Height 11cm.

BONHAMS/JOHN ATZBACH

Opposite. 229. This vase by the Imperial
Porcelain Manufactory, dated 1909, continues
the taste made popular by Maria Feodorovna for
designs in the Copenhagen style painted in
muted tones. Height 42cm.
BONHAMS/IAKOBACHVILI COLLECTION

The Art Nouveau style was also witnessed in the fashion for vases with underglaze designs painted in muted tones. Alexander III's consort was originally Danish and links with her native country must have fostered the Emperor's interest in the Royal Porcelain Manufactory of Copenhagen which, by 1889, was creating a sensation with technical advances in high fire painted scenes. Subdued landscapes, flora and fauna were depicted to great effect, sometimes appearing through a clearing of branches reminiscent of Japanese woodblock prints.

The final reign of the Russian Empire saw a far more retiring style of court than those which had preceded. Nicholas II and Alexandra Feodorovna preferred to remove themselves from the increasing ferment in St Petersburg. The state concerned itself with the Battle of Port Arthur, pogroms, and popular revolt as it progressed towards the First World War and Revolution. This was hardly the time for financial resources to be siphoned into meaningful patronage of the arts. The Danish-style vases, Easter eggs and figurines in national dress continued to be produced, as did additions for existing banqueting services as necessary, but the Imperial fascination for porcelain had largely faded.

230. The Raphael Service was the largest produced by the Imperial Porcelain Manufactory during the reign of Alexander III and was eventually completed in 1903. It was originally inspired by the Raphael frescoes in the Vatican loggias which had been reproduced by Quarenghi during the reign of Catherine the Great. This example dates from the era of Nicholas II. Diameter 24.2cm.
BONHAMS

Opposite. 231. This vase of campana form flanked by Classical masks/handles and enriched with a view of the Alexander Column in Palace Square dates from the period of Nicholas I and was made by the Imperial Porcelain Manufactory. Height 27cm.
BONHAMS

Prior to its dissipation, the Imperial Porcelain Manufactory flourished in the eighteenth century under the patronage of a succession of Russian rulers, when its primary function was to supply the lavishly opulent Russian court. The manufactory's output largely mirrored the designs in vogue in Western Europe thereby fulfilling an important function in illustrating Russia's cultural aspirations. This was not the last occasion when porcelain manufacture echoed the state's message, however, as by 'fast-forwarding' over the next 150 years of Russian history, we can see this medium again being used to great effect after the Revolution, when it served to illustrate the propaganda of the emerging Soviet state. In the Soviet era, the State Porcelain Manufactory was renamed the Lomonosov Factory until 2005 when it reclaimed its pre-Soviet name, though our discussion here is limited to the period up until 1917.

Private Porcelain Factories

With the needs of the court being served almost exclusively by the Imperial Manufactory, the aspirations of the aristocracy and other wealthy patrons were met by Western makers or by small private workshops until the middle of the eighteenth century. In 1766, Francis Gardner, an Englishman based in Russia, established a successful manufactory producing a volume and quality of wares which were largely based on European prototypes and captured the attention of a wider Russian public. An early design of floral

sprays on a plain white ground became so popular and relatively affordable that this accessible line of porcelain came to be known as 'Gardner Rose'. The range was within the reach of a far larger customer base and the appetites of the aspiring middle classes could finally be met by the firm.

Depending on the prominence and budget of the patron, the addition of a monogram or a touch of gilding could further enrich the porcelain forms. We see examples at auction attesting to the wide variety and prodigious quantities that must have been produced.

232. A tea service from the Gardner Manufactory, Moscow, c.1880. Height of teapot 12cm.
BONHAMS

Below. 233. Porcelain basket from the Service of the Order of Saint Vladimir, Gardner Manufactory, Moscow, c.1785. The pierced sides are enriched with the moiré ribbon and cross of the order. Diameter including handles 29.8cm.
BONHAMS/EUROPEAN PRIVATE COLLECTION

Opposite. 234. Soup plate from the Service of the Order of Saint Alexander Nevsky, Gardner Manufactory, Moscow, eighteenth century. The cavetto with the star of the Order is surrounded by ribbon and badge to rim. Diameter 22.7cm.
BONHAMS

Gardner's firm did not escape the attention of the Imperial Court. Indeed, the German-born Catherine the Great was eager to encourage the domestic industry of one of her most prominent manufacturers whom she was eager to rebrand as a 'native' son. Between 1777 and 1785, Gardner was commissioned to supply four separate services for the use of the honorary societies of Saint Andrew, Saint Alexander Nevsky, Saint George and Saint Vladimir.[12] These elite Imperial orders were named after important saints and awarded for service to the Empire. Their members gathered annually at the Winter Palace to celebrate each of their patron saints' feast days and used dining wares depicting the ribbons, stars and badges worn by the members of each order.

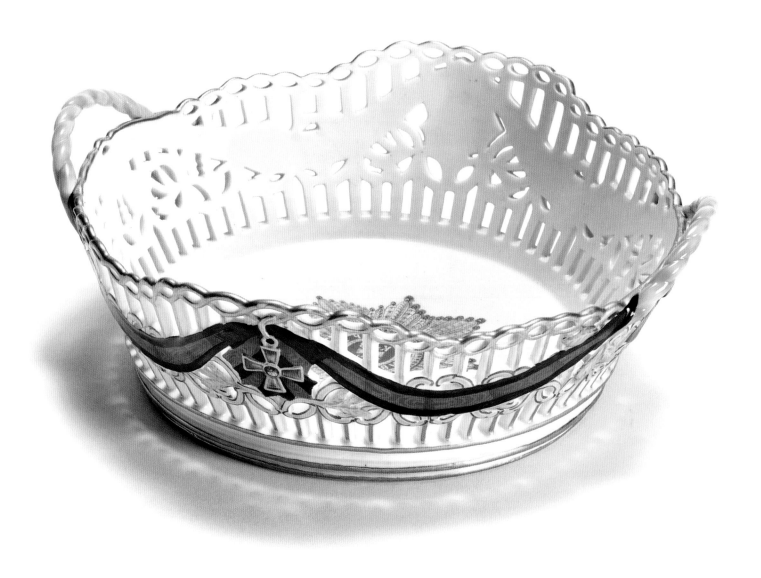

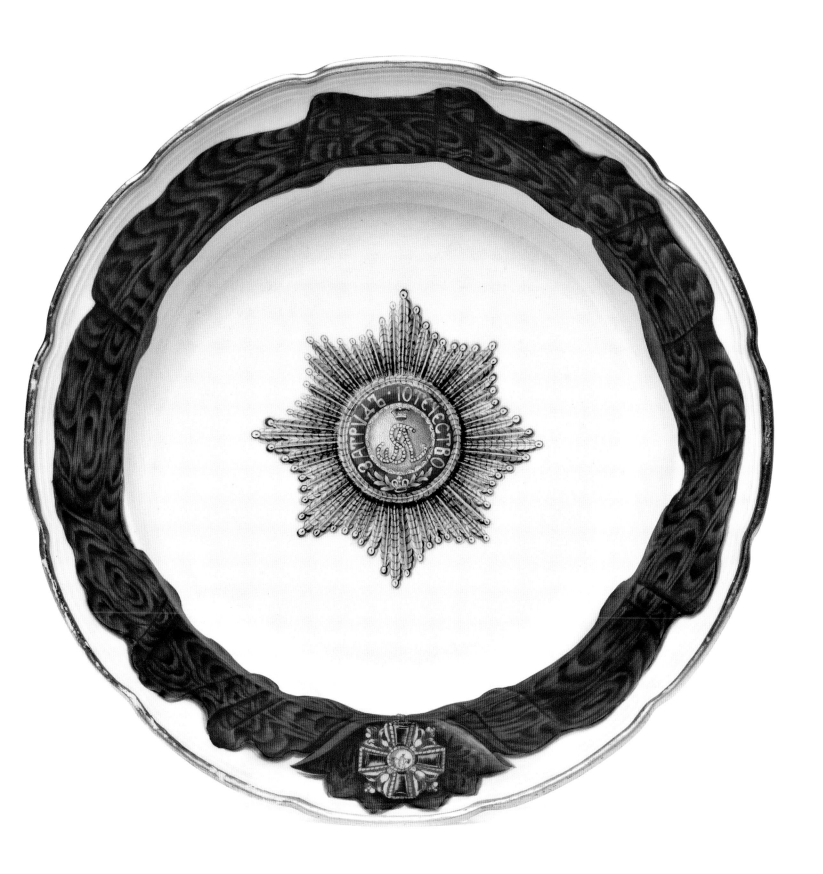

Opposite above. 235. Various cups and saucers from private factories including two floral examples with Popov stamps; one with musical trophies with impressed Safronov mark; the fourth with hunting scene; a saucer, also by Safronov but associated with a Kremlin Porcelain Manufactory saucer; and a mug in the form of a Turkish head with underglaze mark for Khrapunov-Novii, nineteenth century. Height of mug 12.7cm.
BONHAMS

Opposite below. 236. Gardner figures, mostly from the Peoples of Russia series, nineteenth century. Height of tallest 27.5cm. Details of two of these figures are shown above on this page.
BONHAMS

The Gardner factory also responded to fashions that came about as a result of historical events. Following the Russian victory in the Russo-Turkish War of 1774, mugs formed as Turkish characters were in vogue. Military subjects depicted on cabinet plates and based on French drawings evoked national pride. The Napoleonic War of 1812 spurred further patriotism and appreciation for the common man, as illustrated in the popular engravings of the day. These were interpreted by the porcelain factory as figurines of characters engaged in various trades or representing their regional costumes. With the earlier Rachette examples of the Imperial Porcelain Manufactory being well out of reach of the buying public, these became highly collectable.

Other private firms also supplied these wares and the name of Popov is perhaps the most often mentioned alongside that of Gardner. The span of this firm was shorter but it, too, was prolific in its output of figurines and porcelain wares. Rather finely painted cups and saucers appear on the market from time to time.

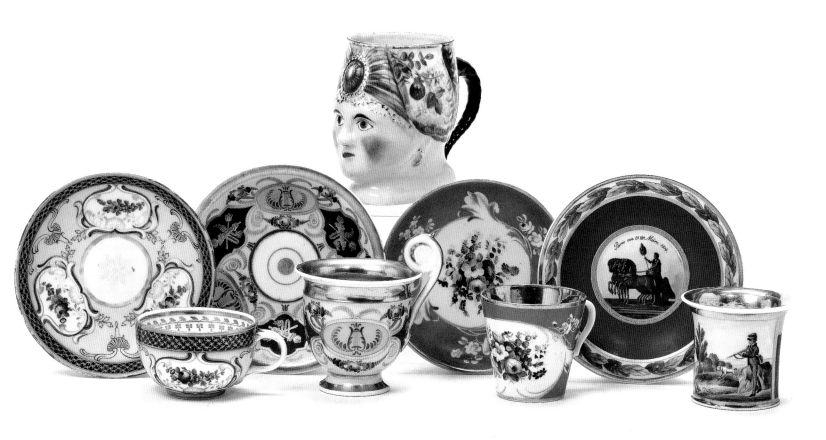

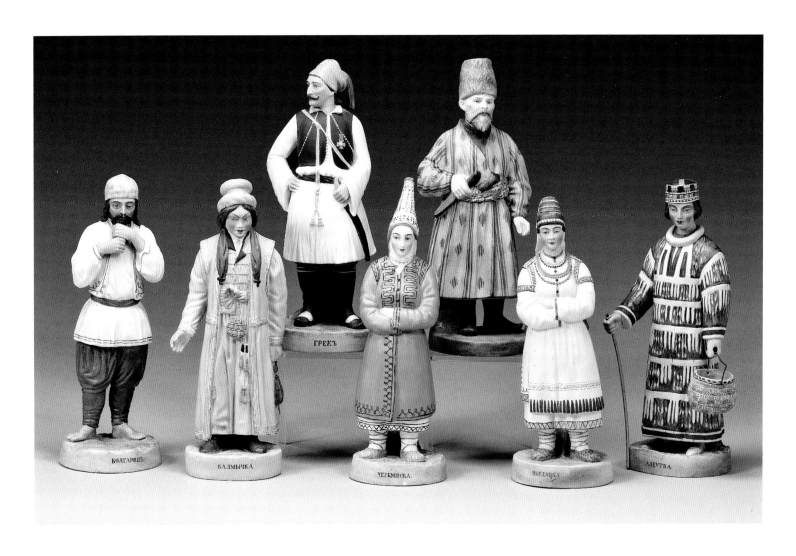

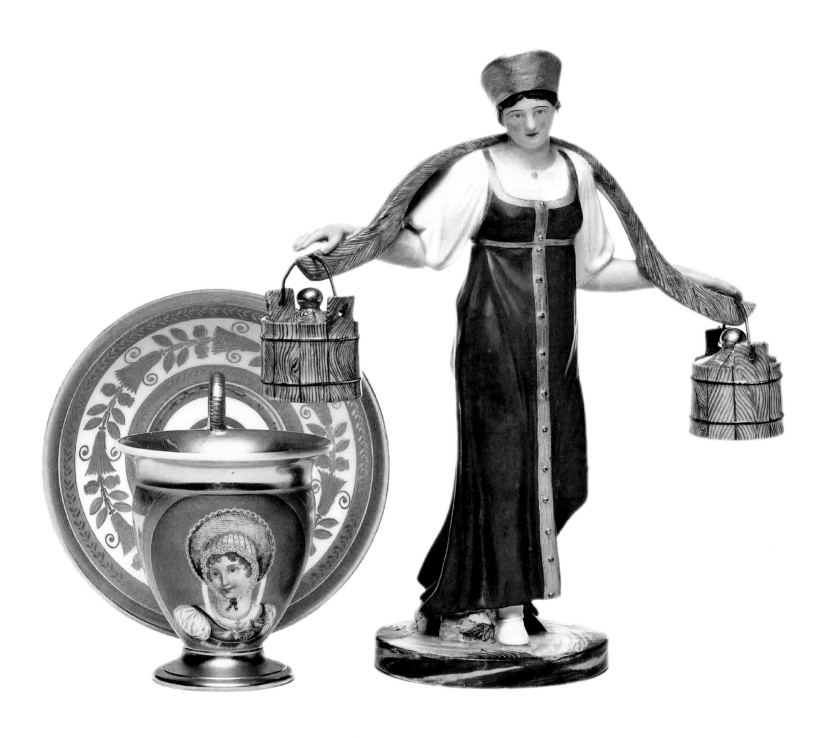

237. A nineteenth-century Popov cup and saucer, enriched with a lady's portrait, and a private factory figure of a water carrier modelled after Pimenov's *Vodonoska*. Height of cup 10.2cm.

BONHAMS/EASTERN EUROPEAN PRIVATE COLLECTION

Although slightly tangential, as it was not a commercial manufactory in the strictest sense, another important private concern was founded by the aristocratic Yusupov family on their estate at Arkhangelskoe. Plates came into the studio as blanks and were then decorated characteristically with large blossoms against white grounds within a gilt border. These were solely for use and gifting within the family.

Various firms such as Batenin, Novy, Fomin, Safronov and many others also flourished in the short time before the liberation of the serfs in 1861 freed workers from their enforced ties to private workshops. The end of the nineteenth century therefore saw most of these private concerns being unable to keep up with technical developments. Unless they were able join together in cooperatives or networks of enterprises (much like the silver artels) and then maintain their strength in numbers, their activities tapered off.

238. One from a series of early nineteenth-century plates decorated after illustrations of roses by Redouté, 1824–1826. The Yusupov factory limited production to the personal use or gifts of Prince Yusupov. Approx. diam. 23cm.
PRIVATE COLLECTION

Opposite. 240. Two vases by Safronov (left) and Batenin (right), c.1835, with views of the Moscow Kremlin and St Petersburg Stock Exchange flanked by the Rostral Columns. These examples show how vases from the Imperial Porcelain Manufactory of the Nicholas I period inspired private factories to market similar objects to aspiring middle-class buyers. Safronov vase height 23.5cm; rim 22cm.
BONHAMS

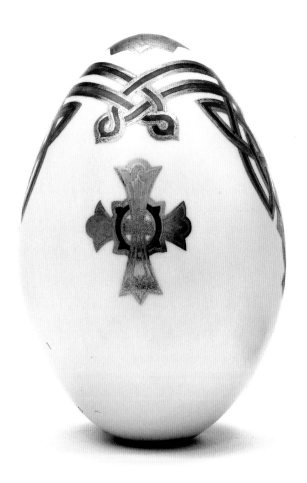

239. A porcelain Easter egg and napkin ring in the Russian Revival taste from a private factory, c.1900. Height of egg 10.5cm.
BONHAMS

One of the most prominent surviving concerns was the factory of the Kornilov brothers which hired experienced artists, invested in up-to-date mechanical techniques and represented Russia in international exhibitions abroad. This foreign exposure, in turn, gave the firm an understanding of the demands of an international market and helped forge commercial links with retailers such a Tiffany and Co.[13] Highly stylised Russian Revival pieces are still found on the market bearing the stamp of the Kornilov firm as well

as the words 'Made in Russia by Kornilow Bros. for Tiffany & Co. New York'.[14] The success of the firm provided funding to acquire failing factories until it became a virtual monopoly, ensuring its survival through the 1918 Revolution to the present day. It was renamed 'Proletarian' and converted its production to electrical insulators.

The Kuznetzov combine, located 100km from Moscow in the village of Dulevo, also managed to adapt itself into a network of enterprises in various Russian locations, becoming sufficiently commercially viable to absorb the Gardner factory in 1892.[15] With a firm grasp of the Russian market and a flair for catering for the needs of foreign consumers, Kuznetzov was awarded the prestigious Imperial Warrant in 1902.[16] Brightly coloured wares with floral sprays on white oval reserves against pink or blue ground were produced in prodigious quantities for export to the Middle East. Complete tea services of this type survive in large enough quantity – sometimes made from spare Gardner blanks – that demand has not stimulated significant prices in this sector. The firm's success story extends to the present day as it continues to operate as the Dulevo Porcelain Manufactory.

Opposite. 242. This porcelain solitaire by Gardner is in the style that was to be so successfully exported abroad, c.1850. Tray 25 x 24.5cm.
BONHAMS

241. A pair of *kovshes* from the factory of the Kornilov brothers, c.1895. Each traditional form is decorated with old Russian motifs and a strapwork adage relating to food and drink. Length of each 19cm.
BONHAMS

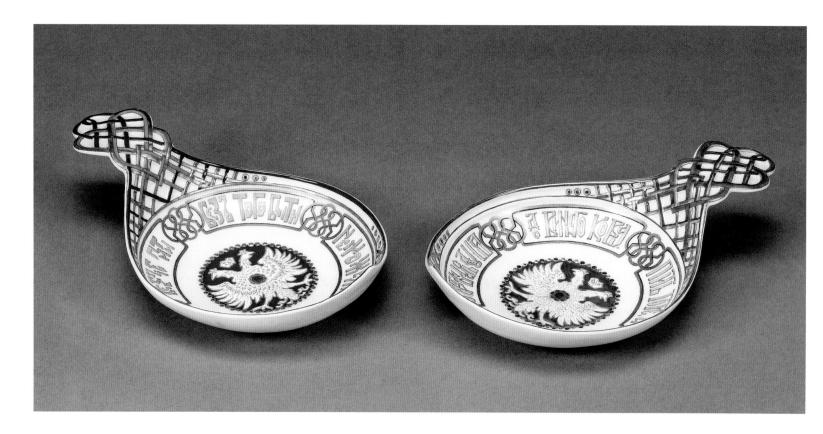

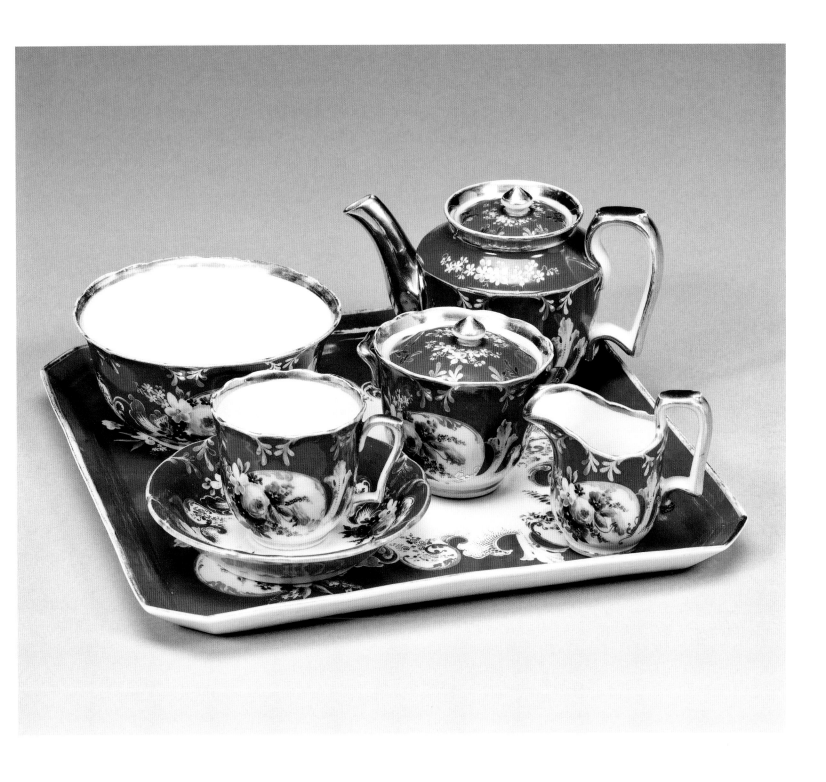

Chapter 8
GLASS

THIS COLLECTING CATEGORY IS sadly underestimated and often considered as one of the most derivative of the Russian arts. Similarly to its porcelain cousins, it is thought of as another ambitious parvenu elbowing its way into Imperial court life as a poor imitation of Western prototypes (in this case German or Bohemian). It would imply that when Russia had her eye on Paris and Berlin, those models were not, themselves, evolved of earlier forms.

Western scholars now finally accept that the Russian output was in fact an adaptation – even a distillation – of various influences that often resulted in technically superb pieces. Emmanuel Ducamp, the passionate author on Russian decorative arts, discusses with great warmth in his engaging lectures how Russian craftsmen, in a sense, had the freedom to emulate and adapt in order to delight home-grown patrons. Pointing to the noted designer Thomas de Thomon, a Parisian-born architect who graduated from the French Academy in Rome and adapted neoclassicism to suit Russian taste under Alexander I, Ducamp explains how the variant became established and just as 'valid' on its own merits.[1]

Opposite. 243. Russian goblet and cover, c.1730. The round bowl is engraved with the Russian Imperial Eagle and crown. Height with cover 21.5cm.
BONHAMS/PRIVATE COLLECTION

Above. Detail from Plate 264. Daum glass decanter with silver mounts by Lorié.
BONHAMS/FABERGÉ MUSEUM BADEN-BADEN

The development of glass in Russia follows certain parallels with the other disciplines that evolved in that particular national context. Early glassmaking flourished between the eleventh and thirteenth centuries in Kievan Rus until the invasion by the Tartar Mongols. By the fifteenth century, Moscow had extricated itself from the Golden Horde and forged trade links with Western Europe in its own right.

When Ivan III took Sophie Paleologue as his second wife in 1472, she brought a series of glass plates enriched with double-headed eagles in her dowry from Constantinople.[2] This powerful Byzantine symbol of East and West resonated with the Tsar, whose mission had been to unify disparate principalities and consolidate his power into an absolute monarchy. Apart from the Soviet period, the all-seeing eagle remains synonymous with the coat of arms of Russia.

Venetian glass, famed for its transparent quality, entered Russia through trading ports and also reached the court via ambassadorial gifts.[3] Efforts were made to establish glassworks inspired by foreign models but a dearth of journeying craftsmen coupled with financial difficulties prevented any long-term flourishing of the medium until 1668, when Tsar Alexei Mikhailovich (1645-1676) founded a factory in Izmailovo near Moscow.[4] The glass from here was transparent yet sturdy enough to withstand engraving, so that a matt white pattern could contrast against the clear form. These techniques were popularised by Bohemian engravers working in Moscow in the late seventeenth century.[5]

During the reign of Peter the Great, his closest advisor, Alexander Menshikov, founded a factory at Iamburg near the new capital. This glasshouse was nationalised after the death of Peter and his wife, and in 1730 it was leased to William Elmsell, a British merchant. Some of the Iamburg staff and materials were moved to new premises in the capital city where the company prospered and eventually came to be known as the St Petersburg Glassworks.[6]

The importance of glass cannot be overlooked. It was not an inanimate object to be relegated to decorating shelves but a powerful prop. With finely etched Imperial portraits and monograms further enriched by martial trophies and allegorical symbols, a ceremonial toast to the monarch's health at court underlined the ruler's claim to be recognised as an emperor on a par with European heads of state and not merely the king of relatively newly conquered dominions.[7] At a palace banquet, this was a deeply symbolic visual aid proclaiming the gravitas of the ruler.

244. A set of five small, facetted urn-shaped glasses with gilt decoration and covers from the Imperial Glass Manufactory, St Petersburg, c.1800. Height of each 13.4cm.
BONHAMS/IAKOBACHVILI COLLECTION

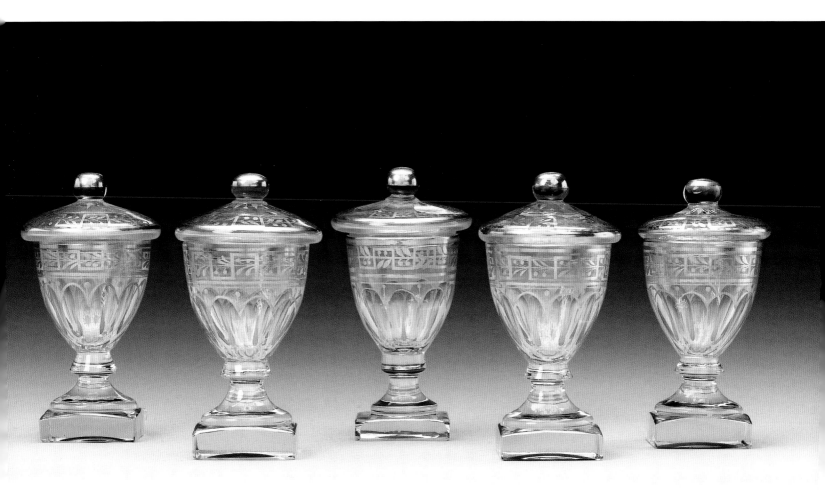

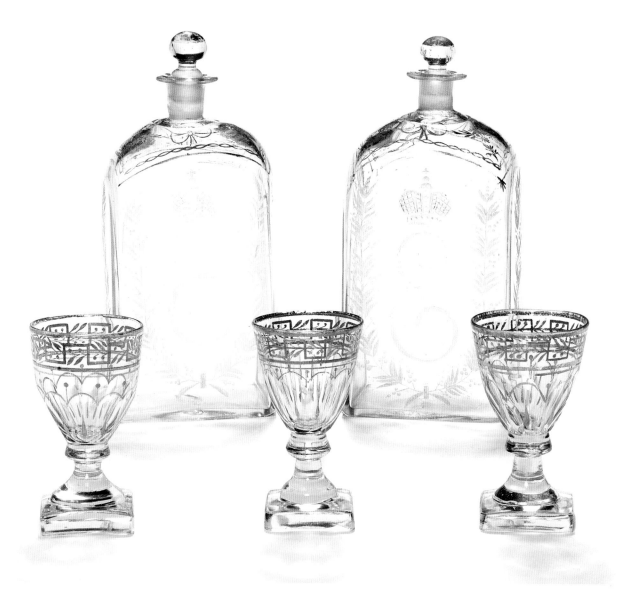

245. A pair of eighteenth-century vodka flasks with the crowned cipher of Empress Elizabeth Petrovna surrounded by laurel and berry branches, the sloping shoulders with gilt foliate scrolls, surmounted by gilt ball finial stoppers. They are shown together with three wine glasses from the Imperial Glass Manufactory, c.1800. The rims with gilded laurel garlands are super-imposed by a Greek key border. Height of flasks 23.5cm.

BONHAMS

Opposite. 246. An engraved and gilt glass covered goblet, probably from the Imperial Glass Manufactory, St Petersburg, c.1741–1762. This presentation piece for Peter the Great's surgeon, John Bell, commemorates the reign of Empress Elizabeth, with her monogram flanked by martial trophies and the Imperial Eagle. Height 42.5cm.

BONHAMS

The glass industry came into its own more fully under Peter's daughter, Empress Elizabeth, with the introduction of gilding and niello work to engraved surfaces in the baroque taste. This era was characterised by astonishing displays of opulence at court. Theatrical banquets required vast services of porcelain, glass and silver to serve the lavish foods and wines. Carafes were produced for pouring and receptacles for wine, water and champagne were commissioned.

As Dr Karen Kettering, former Curator of Russian Art at the Hillwood Museum, points out, the military achievements of the Empress were overshadowed by subsequent rulers. However, it was Elizabeth who consolidated her father's territorial legacy by successfully concluding the Russo-Swedish War; she also expanded the nation's borders by gaining a strip of southern Finland in 1743. Such a triumph merited the depiction of Elizabeth's portrait set in profile against military trophies.[8]

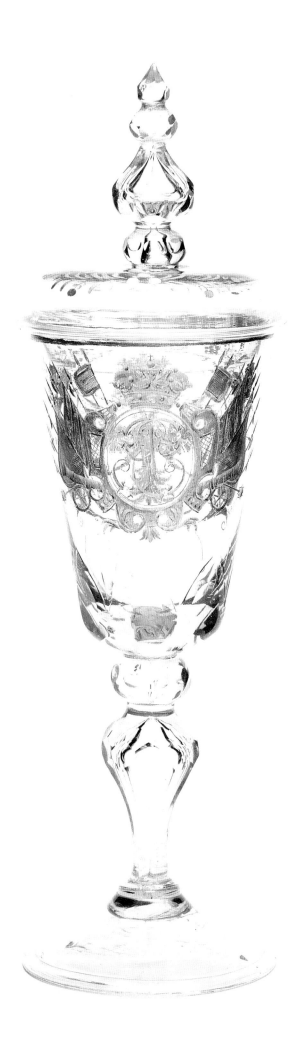

The scarcity of markings on glass makes firm attributions to Russian workmanship challenging. This is particularly true for the times when Western European styles prevailed, such as the Silesian prototypes typically formed with conical bowls, baluster stems and engraved ornamentation which were interpreted by the St Petersburg factory in the middle of the eighteenth century. The addition of Romanov ciphers and emblems on to Imperial portraits often helps to attribute the cutting, polishing and engraving to Russia but not always the blown glass itself.

In the mid-eighteenth century, technical skills had improved enough to enable the engraving of landscapes and genre scenes. The difficulty lay in executing perspective given the limitations imposed by a section of curved glass.[9] The inscriptions that enrich the opposite surface of the bowl indicate that glass was still a luxury item reserved for only the wealthiest collectors. These items also demonstrate that clear goblets had largely overtaken their coloured glass predecessors.

Elizabeth's successor, her nephew Peter III, was quickly overthrown by his ambitious, German-born wife, who came to be known as Catherine the Great. Biding her time at Elizabeth's court had exposed her to the pageantry of official dining and its importance in trumpeting propagandistic messages abroad, particularly to France. Having replaced Peter III, Catherine needed to affirm her wisdom and military might in order to establish foundations for the legitimacy of her rule. Her cipher coupled with the double-headed eagle on drinking vessels provided visual clues similar to those used by Elizabeth.

Further into Catherine's reign, interest in coloured glass returned. The most astonishingly rich room in the Chinese Pavilion at Oranienbaum is the Glass Bead Room designed in the taste of Jean Pillement. It seems to be decorated with glistening silk hangings featuring exotic birds and landscapes and within Chinese rococo frames. Upon close inspection, the background of the hangings reveals itself to be made up of tiny silvered glass beads. Three tables of coloured glass mosaic were designed to complement a glass floor which was replaced in the 1850s. The ensemble

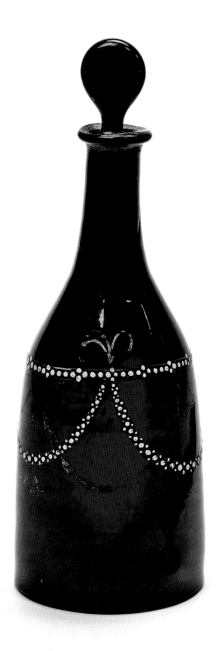

247. Blue glass decanter, eighteenth century.
Unknown maker. Height 26.4cm.

BONHAMS/IAKOBACHVILI COLLECTION

must have created a startling effect when candlelight bounced from the walls to the floor and back again.[10]

The noted scientist Mikhail Lomonosov had already been tasked with developing coloured beadwork under Elizabeth but it was well after his death that Catherine transferred control of the St Petersburg Glassworks to her favourite, Prince Grigori Potemkin. He then developed blue, violet, green, ruby and opaque white glass for use in tableware and interior decoration.

The principal characteristics of late eighteenth-century neoclassical glass are cylindrical or conical forms in coloured glass, enriched with restrained gilt garlands.[11] Medallions featuring the owner's initials in Latin, as opposed to Cyrillic, script showed the aristocracy to be far more fluent with the French language, sometimes even being unable to communicate in Russian.

248. Glass tumbler, possibly from the Imperial Glass Manufactory. Heavily cut with scrolling feet and sulphide profile of Alexander II, nineteenth century. Height 9.8cm.
BONHAMS

Coloured glass was also incorporated into large-scale objects such as chandeliers, mirrors and panels used for the decoration of palace interiors. The legendary classical architects of the nineteenth century, namely Thomas de Thomon and Carlo Rossi, were engaged in creating large-scale unified designs for St Petersburg palaces. This meant coordinating extravagant glass lighting and enormous decorative vases with bronze mounts.

The war of 1812 served as an inspiration for design well into the century. As with the other decorative arts, Russia's victory in the Napoleonic Wars inspired a vast array of commemorative wares. With glass, the vogue for classical historicism translated into deeply cut vessels adorned with white glass medallions enriched with triumphant inscriptions or portraits of war heroes. The style is sober and restrained, the words jubilant. Feodor Tolstoy, vice president of the Imperial Academy of Art, designed a series of medallions depicting the battles in allegorical terms. Figures draped in classical garb symbolise the event described and dated below. The popularity of these figures was such that they were translated into engravings, medals, hardstone, architectural decoration and biscuit plaques intended for display in the cabinets of middle-class homes.

As the French Revolution and Napoleonic Wars turned Russia against France politically, she instead found inspiration in the British luxury glass industry. Thicker, heavier glass vessels cut by steam-powered lathes

allowed for elaborate cutting. When applied to lead glass, known as crystal, the newest techniques produced large services which sparkled upon the candlelit tables they graced. Once again, clear glass dominated with various patterns being cut into it for decoration.

In 1824, Nicholas I presented his wife with a birthday service encasing small enamelled gold foil ermine mantles. This technique was considered extremely refined and thus often copied. The designs for heavier cut-glass vessels with tiered rims evolved into another service related to the Empress.

249. Glass plate after a design by Fedor Tolstoy of the Imperial Glass Manufactory, St Petersburg. Lead glass with silver chloride stain, 1836–1840. Diameter 24.5cm.

HILLWOOD ESTATE, MUSEUM & GARDENS; PHOTO BY ED OWEN

Above left. 250. Glass tumbler from the Cottage Palace Service, made by the Imperial Glass Manufactory, St Petersburg, nineteenth century. The front is affixed with a blue glass shield painted with the coat of arms of the Cottage Palace, Alexandria Park at Peterhof and the Cyrillic motto 'For Faith, Tsar and Fatherland'. Height 8.3cm.

BONHAMS

Above right. 251. Mustard cup from His Majesty's Own Service in the Cottage Palace by the Imperial Glass Manufactory, St Petersburg, nineteenth century. The blue shield with the arms of Alexandria was originally commissioned around 1830 for the location of Nicholas I's summer residence by that name in Peterhof. Lacking lid. Height 10.5cm.

BONHAMS/IAKOBACHVILI COLLECTION

The extensive porcelain service designed for the Cottage Palace at Peterhof around 1830, was complemented by a coordinating glass service with each form divided into three bands: a diamond pattern against a hatched ground around the rim; a swirling foliate design for the middle section; and heavily cut diamonds near the base. The coat of arms applied to the porcelain Cottage Service was also used as an applied shield on the wine and champagne glasses, decanters, tumblers, cruets and various dishes. The 1830s technique of faceting layered glass was best expressed in the Gothic Service. This design benefitted from clean lines and strong contrast between coloured and clear glass.

With glass objects within reach of middle class aspirations, supply had to adapt to demand. Romantic subjects offered a welcome respite following the war years.

252. Pair of gilt-brass and cut-glass candlesticks, c.1830. The band of arches evokes the Gothic taste that enjoyed a brief revival in the 1830s, particularly under the patronage of Nicholas I and his consort Alexandra in the design of their private refuge, the Cottage Palace at Peterhof. Height of candlesticks 30.5cm. Also shown is an engraved and cut-glass goblet, decorated with a palace view and engraved 'Pavilion á Pavlovsk', Russia or Bohemia, c.1815. Height 13.5cm.

BONHAMS

253. Russian cut-glass goblet, early nineteenth century. Height 14.4cm.

During the second quarter of the nineteenth century, coloured glass was once again back in vogue, this time enriched with transfer-printed images of Nicholas I and Alexandra Feodorovna drawn from famous portraits, as well as other images from print sources that had recently become available to the urban buying public.

As with other industries, the emancipation of the serfs in 1861 dramatically increased the cost of labour thereby placing workshops in severe financial straits. De-regulated working conditions and remuneration of staff had to be re-structured in order to incentivise talented craftsmen to remain loyal to a particular manufactory.

The middle of the century had also seen a creative flourishing, partly due to the revocation of an earlier ban on foreign imports. Craftsmen and goods flowed more easily through customs into Russia and native crafts were exhibited in foreign countries. Many disciplines of the Russian applied arts, including glass, exhibited their finest accomplishments abroad in international exhibitions. The Russians returned home with gold medals as well as design inspiration. The resulting cross-fertilisation of creative influences fed right into the taste for such historical revival styles as the Gothic, Renaissance and Rococo. Russian interpretations of Japonisme, Chinoiserie, or Turkic motifs were celebrated in the decorative arts. Russia was not only inspired to revive historical styles, but also to

254. Decanter, liqueur glass and two tumblers with transfer-printed portraits of Nicholas I and Alexandra Feodorovna, Imperial Glass Manufactory, 1840–1840. Decanter height 20.8cm.
HILLWOOD ESTATE, MUSEUM & GARDENS; PHOTO BY ED OWEN

make their wares attractive to the Persian market which had long been known to have a large appetite for Russian goods.

The stylistic exchange was accompanied by exposure to techniques which were then assimilated in mid-nineteenth-century Russia. References to earlier styles could be interpreted in a variety of ways beyond simply decorating the surface of an object. Cased glass, in which different colours are placed over one another, was already developed by Roman times and served as another reference point in the wide spectrum of revival styles. Layers of coloured and clear glass with patterns were then cut away to reveal clearly delineated patterns of contrasting hues conveying volume and depth.

This, in turn, inspired breakthroughs in painting enamel onto glass. The palette of colours available to artists widened considerably during the third quarter of the nineteenth century, as did the development or rediscovery of new materials such as an opaque red glass called purpurine. This was used to create massive-scale and award-winning objects emulating carved stoneware.

In order to remain in operation, even the Imperial Glass Manufactory needed to run a leaner operation and make its wares accessible to a greater buying audience through transfer-printing, turning from lead crystal to the more economical soda-lime production.

Opposite. 255. Carafe and tumbler set in green, white and colourless cased glass, Imperial Glass Manufactory, St Petersburg, 1835–1850. Carafe height 19cm; tumbler 9.8cm.
HILLWOOD ESTATE, MUSEUM & GARDENS; PHOTO BY ED OWEN

256. Purpurine model of a hippopotamus, Fabergé, St Petersburg, c.1900. Realistically carved with characteristic loose skin. Length 3.5cm.
BONHAMS/MIRABAUD COLLECTION

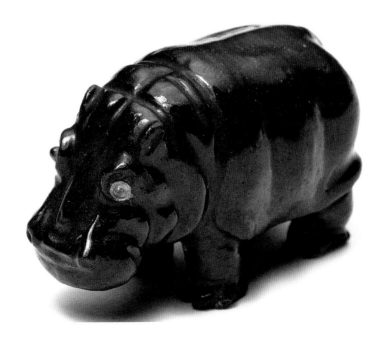

257. Russian enamelled beaker with strapwork and stylised lotus motifs within beaded and gilt bands, c.1882. Height 13.3cm.
BONHAMS

Opposite above. 258. Glass and porcelain from the formal service of the Imperial yacht *Derzhava*, designed by Monigetti; Imperial Glass and Porcelain Manufactories, St Petersburg, 1871–1873. Height of carafe 32cm.
HILLWOOD ESTATE, MUSEUM & GARDENS; PHOTO BY ED OWEN

Opposite below. 259. An opaline glass bratina extensively decorated with gilt Imperial Eagles and further enriched with the Cyrillic proverb: 'Whoever drinks from this cup will be healthy'. Possibly Khrustalny Glassworks, nineteenth century. Height 17cm.
BONHAMS

During the second half of the nineteenth century, the exploration of historicism fixed on Russia's own native folklore. Stylised lettering and strapwork inspired by Slavonic manuscripts were used to enrich glass. Motifs drawn from woodworking and embroidery appeared, as did fantastical creatures and characters from traditional fairy tales.

The Derzhava Service, conceived by the court architect Ippolit Monigetti in the 1870s, was one of the most important services created for an Imperial yacht. Here, the designer conceived a heavy-based decanter surmounted by onion-domed stoppers enriched with nautical-inspired strapwork (suggestive of the chain and knots suspending anchors) terminating as orbs. In keeping with the trajectory of porcelain in Russia, glass was also produced in private factories to satisfy the appetites of the thriving middle class who desired objects of beauty and could not access the rarefied output of the Imperial Glass Manufactory.

A playful group of works created by Elizaveta Bohm for the private Maltsov factory in the 1890s was enriched with drinking proverbs and joyful creatures. The shapes recall the *shtoff* or traditional rectangular vodka bottle. She also designed objects drawn from traditional forms such as the *kovshes* or *charkas*.

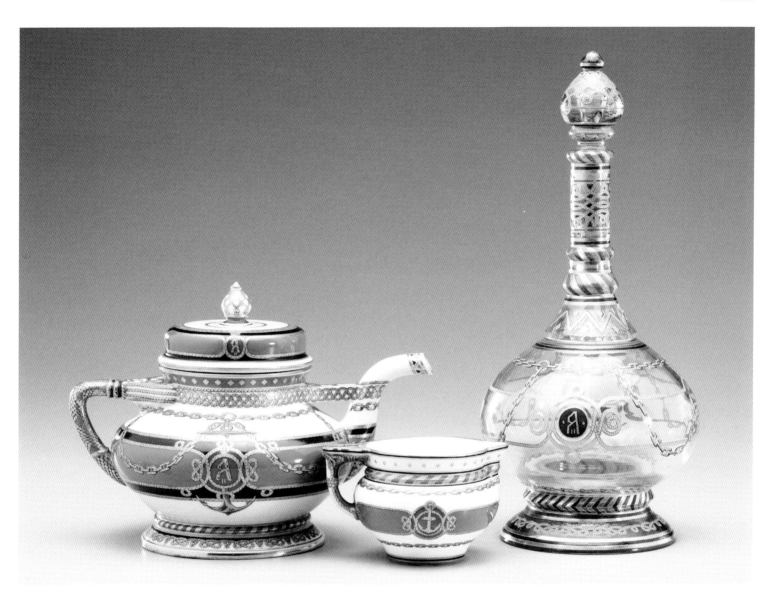

In 1890, it was considered more economically viable to combine the Imperial glass and porcelain works. Their survival until the Revolution was thus secured although production was limited to supplies for the court. Under Nicholas II, the factories mainly stocked additions to existing services or one-off decorative items, such as monumental vases in the Art Nouveau taste. These were deeply etched with languid shapes derived from flora and fauna.

The final large-scale commission for the Imperial Porcelain and Glass Factory was for a service to be delivered in time for the 1913 tercentenary celebrations. Large numbers of several types of drinking vessels consisting of knopped stems rising to partially faceted bowls enamelled with Imperial Eagles and royal devices formed a tribute to the glass produced under Empress Elizabeth. In this way, the output of the factory had essentially come full circle as the Court returned to displaying propagandising glass at its most regal celebration, vessels designed to toast the Romanov dynasty and impress guests from abroad.

As was the fate of the other decorative arts, the output created by the glass factory for the Romanov tercentenary was to be its final flourish before the austerity and requisitioning of the war redirected various crafts to meet the needs of the military. After the Revolution, these same resources instead had to service the needs of a burgeoning state, supplying basic consumer essentials such as jars, bottles and drinking glasses.

It follows that pieces created for the court were on view and inspired designs which then trickled down through the social ranks. Designs which were appropriate for the urban aristocracy were equally desirable for the rising middle class and so on. However, by virtue of its delicate nature, glass, as opposed to some of the other decorative art forms described in this book, was less likely to withstand the passing of time, a factor compounded by revolution, war and occupation. Basic supply and demand logic dictates that we are unlikely to see at auction one of just a few monumental vases that

Opposite. 260. Vase from the Imperial Glass
Manufactory, dated 1909. Of tapering
cylindrical form, decorated with flowers in the
Art Nouveau taste. Height 55cm.
BONHAMS

261. Vase from the Imperial Glass Manufactory,
St Petersburg, 1906. The colourless glass is acid-
etched with a fanciful selection of marine
subjects. Height 42.8cm.
BONHAMS

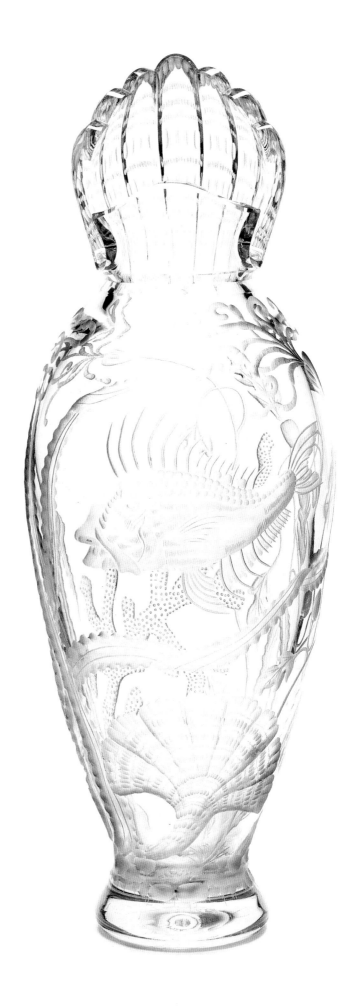

262. Three wine glasses from the Imperial Glass Manufactory, St Petersburg, 1896–1915. Each with black eagle and gilt monogram of Emperor Nicholas II and his consort Alexandra Feodorovna. Heights 19cm and 16.8cm.
BONHAMS

Opposite above. 263. Four Fabergé silver-mounted cut-glass forms. Moscow, early twentieth century. Tazza height 19.5cm; bowl diameter 20.5cm; claret height 20cm.
BONHAMS

Opposite below. 264. Daum glass decanter with silver mounts by the prominent firm of Lorié flanked by a pair of Fabergé examples in the Art Nouveau style. Moscow, 1899–1908. Central 23cm; each of pair 22.3cm.

BONHAMS/FABERGÉ MUSEUM BADEN-BADEN

were commissioned by an emperor. Generally, the works which have survived to the present day are examples from large stemware services, as well as occasional decanters and cabinet dishes. Wares produced by the Imperial Glass Manufactory may be better documented but there were plenty of commissions executed in private factories which also survived.

Periodically, the auction market sees a resurgence of interest in early twentieth-century silver-mounted glass, or in items with thematically linked technical elements of the underwater world etched with mounts as reeds. A premium is paid for Fabergé decanters comprising diamond-cut glass in the characteristic hobnail pattern.

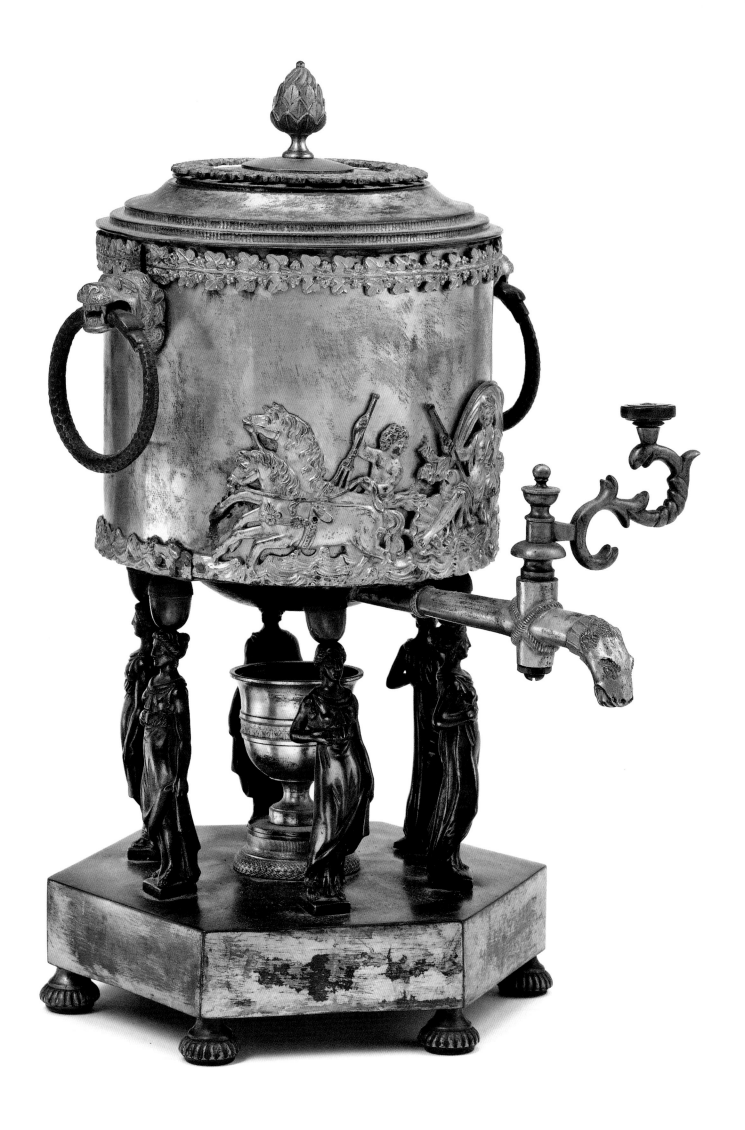

Chapter 9
METALWORK

METALWORK OTHER THAN SILVER deserves a mention here as the gun metal manufacturers of the Tula region evolved their craft, taking inspiration from faceted jewellery to create furniture, mirrors, and more portable items such as chatelaines, particularly under the patronage of Catherine II.

During the eighteenth century, an important place in the history of Russian decorative arts was occupied by work in steel. This is mainly associated with the town of Tula, located some 200 kilometres from Moscow, along major trade routes in proximity of iron ore deposits. By the Tsar's decree in 1595, thirty blacksmithing families were transferred from Moscow to this district and a system of perks evolved: exempting these valued artisans from the draft, permitting them to sidestep various taxes, and allowing them to sell their wares privately. The 'arquebusier craftsmen', as they were known, drew their appellation from the forerunner of the musket which was known as an arquebus.[1]

Opposite. 265. Gilt metal nineteenth-century hot water urn applied with frieze of Amphitrite driving a chariot drawn by infant tritons supported by caryatids; illustrating the increasingly elaborate ornament that was in vogue. Height 42cm.
BONHAMS

Above. 266. A parcel-gilt steel étui and chatelaine, Tula, eighteenth century. Note the polished faceting imitating precious stones, used typically in this period in bands of beading and fringes. Étui length 10cm; chatelaine height 17.7cm.
BONHAMS/PRIVATE COLLECTION

267. Daghestani miquelet-lock pistol, silver, gold, brass and wood. Mid nineteenth century with arabesque parcel-gilt niello work. Barrel 34.5cm.

BONHAMS/EASTERN EUROPEAN PRIVATE COLLECTION

268. A rare Russian 1811-pattern naval officer's sword, c.1820. Steel and brass etched and gilt with classical motifs against a blued ground. Blade 79.3cm.

BONHAMS/EASTERN EUROPEAN PRIVATE COLLECTION

Previously, a Kremlin fortress had been built at Tula with the strategic mission of guarding the southern-most frontier of the Muscovite state. Blacksmiths then settled nearby to supply the military needs of this important defence against the Turks. In 1700, Peter the Great signed a peace treaty with Turkey and turned his attention to conquering the Baltics. When the Swedish army threatened to capture Moscow, the capital's master armourers were transferred to Tula, where their services were additionally required following renewed conflict with Turkey. The State Armoury, today the site of the Kremlin Armoury Museum, was no longer used as an arsenal and thereafter became a repository for state treasures. By 1712, a permanent Imperial Armoury had been established in Tula.

During times of relative peace, armourers could devote their attentions to other pursuits, thus allowing them to diversify into the creation of hunting weaponry and even everyday objects. The chasing, blueing and overlay techniques normally applied to arms were employed with great effect to sewing instruments. The traditional skill set was expanded to include elaborate wrought-iron work which, by the 1730s, was used to create folding chairs loosely inspired by campaign furniture.

The applied decoration became increasingly elaborate as relief work evolved from flat encrustations into garlands, rosettes, and tracery.[2] Additional contrast was achieved by stippling, gilding or combining varicoloured base and precious metal motifs. By the middle of the eighteenth century, the blacksmiths had found inspiration in jewellery techniques and translated faceting into their steel objects. When the blueing itself was executed in tones varying from lilac to green and pink, the diamond facets lit by candlelight must have sparkled. The intricate craftsmanship involved in producing Tula furniture made it an expensive collectable only within reach of the Empress and the most wealthy aristocrats.

Catherine the Great was fond of this technique and visited the Tula workshops personally in 1775 and 1787.[3] Her interest in promoting this very native craft encouraged the establishment of a yearly Saint Sophia fair dedicated to Tula ware near her summer palace at Tsarskoe Selo. Court archives apparently indicate that the steel objects available for purchase were costly.[4] During the last quarter of the eighteenth century, smaller pieces such as bobbins, needle cushions, money boxes and chatelaines became more affordable and therefore more widely disseminated.

269. Three steel buckles displaying cut facets, blued mounts and scrolling foliage enriching the frames, nineteenth century. Height of largest 7cm.
BONHAMS

The fashion for ornate Tula ware was, however, curtailed as Catherine's successor, Paul I, sought to differentiate himself from his mother in every way possible, including his aesthetic choices. Although his reign was short-lived, the following ruler, Tsar Alexander I, was hardly in a position

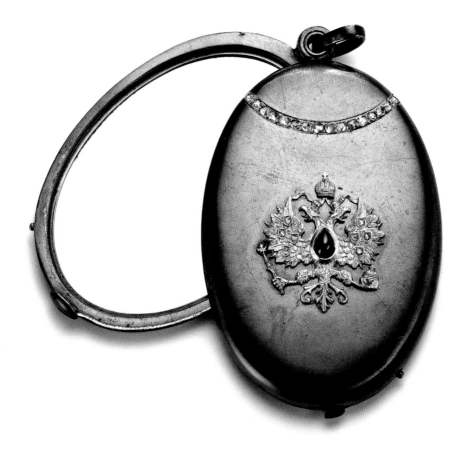

270. Jewelled gun metal locket sliding open to reveal mirrored section, c.1900. Length 8cm.
BONHAMS/GREGORY KHURTORSKY ANTIQUES

to promote the artistic pursuits of the armourers when the demands of the battle against Napoleon created a far more pressing return to the manufactory's original purpose of creating instruments of defence.

Warfare production took priority and by the time the embargo limiting the armourers to creating weaponry only was lifted in 1824,[5] those who could supply the finest peacetime wares had disappeared. The town instead became associated with everyday objects, churning out stove doors, irons and scissors to meet the demands of ordinary households.[6] The skills required for supplying cart parts and engraved branding plates could be traced back to gunsmithing.

Perhaps the most famous by-product of the Tula tradition, owned by practically every household, was the samovar. This was as intrinsically linked to tea making as our present-day kettles. Basically, the samovar was a water urn heated via a coal funnel, which delivered warm water through a tap. As they were produced prolifically, many examples survive by the firm of Batashev. Some have been preserved to this day with an original tray and pot

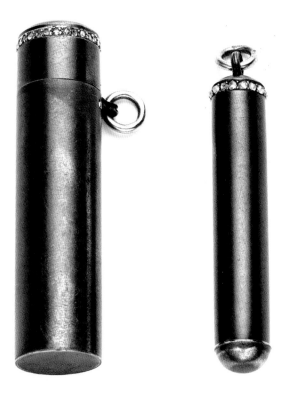

that would have constituted a service bearing the Imperial warrant of Alexander III or Nicholas II. While these are collectable, they are not terribly valuable from a sales point of view. As these marks cause a great deal of confusion for budding collectors and dashed hopes for would-be consignors, it is worth reiterating here that the warrant stamp does not indicate that an item was either in the personal collection or that it served as an Imperial presentation of the ruling house. It simply refers to status conferred to purveyors of the Russian court.

271. Diamond and gold-mounted gun metal retractable pencil and bodkin holder, Samuel Arndt, St Petersburg, c.1890. Length of largest 6cm.
BONHAMS

272. Fabergé silver-gilt, gem-set commemorative beaker in the style of a more austere military item and meant to take on the essence of brass. Moscow, 1908–1917. Height 8.5cm.
BONHAMS/COLLECTION MIRABAUD

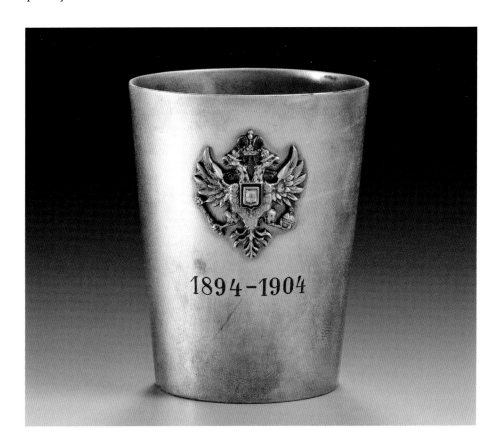

The industry's importance as a symbol of Russian pride was incorporated into *The Tale of Cross-eyed Lefty from Tula and the Steel Flea* published in 1881 by Nicholai Leskov. Here, Tula craftsmen are tasked with bettering a crumb-sized mechanical flea acquired in England and successfully fitting it with horseshoes or their own design. Behind the charming tale lay apt metaphors used to great effect by debating Slavophiles and Westernisers.

Opposite. 273. Brass samovar of cylindrical form with various stamped seal marks and twin wood-insulated handles, nineteenth century. Height 66cm.
BONHAMS

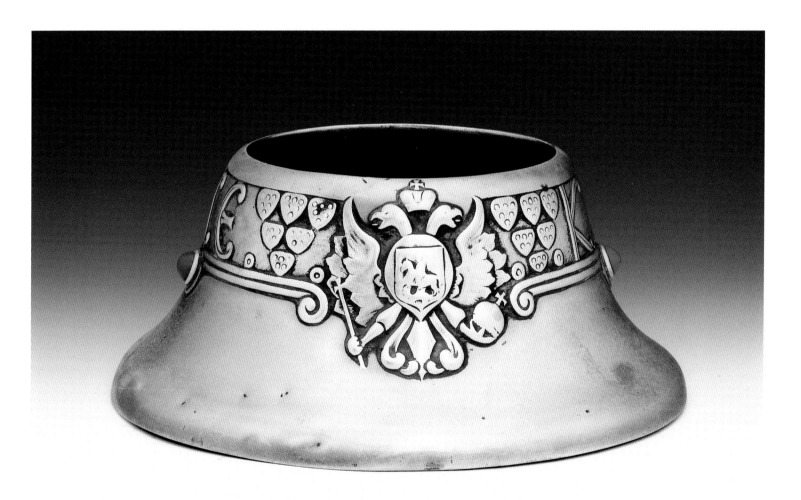

Later still, base metal was no longer limited to use in provincial manufacturing, as gun metal was incorporated into cigarette cases and other objects by the most famous urban manufacturers. Fabergé employed copper and brass in a line of objects created during World War I, remembered today mainly as austerity bowls. These are now sold as ashtrays or small bowls on the market and appear with some regularity.

274. A Fabergé brass ashtray, c.1900. The neck of the flaring body is respoussé and chased in the Art Nouveau taste, bearing the Imperial Eagle, and set with three cabochons. Height 7cm.
BONHAMS/FABERGÉ MUSEUM BADEN-BADEN

275. Copper austerity bowl by Fabergé, Moscow, c.1914. The base is inscribed 'War 1914'. Diameter 11cm.

BONHAMS

Opposite. 276. Copper-coated brass and glass table lamp. Fabergé, Moscow, 1914–1915.

FABERGÉ MUSEUM BADEN-BADEN

Whether as a simple nod to wartime frugality or whether the real shortages of precious metals made these a sensible marketing option, they remain today a relatively accessible way for collectors to get in 'on the ground floor' of Fabergé collecting.

Chapter 10
BONE

ALTHOUGH ARCHAEOLOGICAL REMAINS date the bone carving tradition of the northern Russian as far back as medieval times, its popularity only gathered widespread momentum in the seventeenth century. Walrus ivory was in abundant supply in the Arkhangelsk region bordering the White Sea. The area's most important hub for hunters and traders exchanging goods intended for southern Russia and the regions towards Europe was Kholmogory, whose reputation for home grown ivory spread to Moscow. As a result, sanctions were imposed in 1649 limiting the trade of ivory, and skilled carvers were invited to work at court.[1]

The carving of walrus and mammoth ivory gained further recognition under Peter the Great when he showed a personal interest in developing it as a hobby during his visit to Arkhangelsk in 1693.[2] With the flow of craftsmen between major city centres at home and abroad, stylistic and technical influences travelled broadly. While local hunting lore and *lubki* provided rich subject matter from which to draw, print sources from further afield, such as the Piscator Bible, de la Feuille's *Symbols and Emblems,* or the German engravings that inspired the eighteenth-century silver snuff boxes, also served as design inspiration for genre scenes on ivory artefacts.[3]

Opposite and below. 277. An ivory portrait of Paul I, after medal based on a print prototype, c.1780–1780. 6.5 x 6.5cm with frame.
PRIVATE COLLECTION

Above. 278. A gaming chip depicting a mammoth-type creature. Northern Russia, second half of the nineteenth century. 3.5 x 3cm.
PRIVATE COLLECTION

279. Catherine the Great as Minerva, after Ador, late eighteenth century. Diameter of plaque 8cm.
PRIVATE COLLECTION

Opposite above. 280. Walrus bone box with courting couple, Arkhangelsk, eighteenth century. Width 28.5cm.
BONHAMS/PRIVATE COLLECTION

Opposite below. 281. Walrus ivory case and sewing box, Arkhangelsk, late eighteenth to early nineteenth century. Width 20cm.
BONHAMS/PAUL PETERS

By the eighteenth century, bracelets, small bowls and boxes, combs and portrait plaques were in wide demand. The forms appeared traditionally northern but their ornament was increasingly westernised in order to comply with trends in the capital and further abroad. In this way, the dividing lines between traditional folk art and court-sanctioned decorative arts became less noticeable.[4]

Surviving examples suggest that the technique was particularly prized within the feminine realm, as hinged boxes enriched with courting couples against lacy openwork panels open to reveal paper or fabric-lined compartments now faded to *rose buvard* (blotting paper pink). Of the sewing baskets and miniature dressers that must have delighted urbane clients, perhaps the most characteristic output remains the *teremok-*shaped casket. These architectural boxes, shaped as truncated pyramids, suggest *terem* palaces due to their sloped lids. Here, a veneer of small plaques is created to cover a relatively large surface.

Apart from the profusion of boxes, carved bone combs were widely produced with a variety of detailing, ranging from exquisitely delicate double-sided examples to the more commonly affordable. With teeth more or less finely spaced, the main body offered a surface for carved openwork scenes in relief. Hunting and courtship scenes were popular subjects.

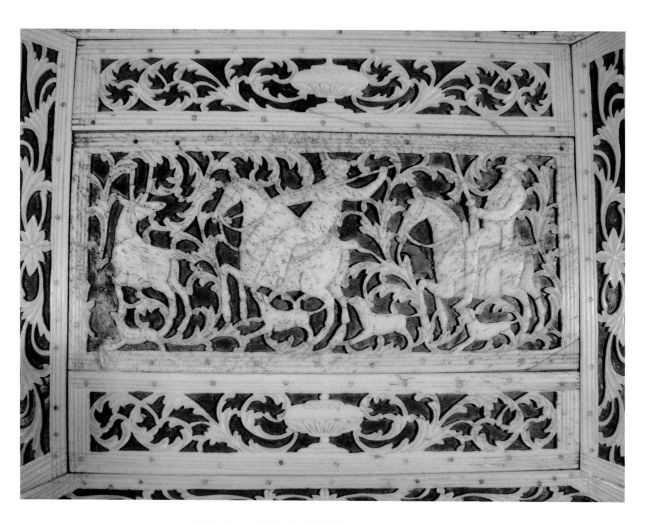

282. Hunting box from Yakutsk, first half of the nineteenth century. 21 x 17 x 17.5cm.
PRIVATE COLLECTION

283. Gaming chip with a dog chasing a hare. Northern Russia, second half of the nineteenth century. 6 x 1.5cm.
PRIVATE COLLECTION

Kholmogory bone carvers produced boxes for snuff in keeping with the craze which spread from Europe and was embraced by men, women and even youngsters who were eager to benefit from the supposed medicinal qualities of this import.[5] Other traditional outlets for the bone carvers were chess pieces and gaming counters reflecting popular pastimes.

If intended for card playing, the counters might be contained in a box designed *en-suite* with one for cards. The craft extended further still to small icons intended for personal use, mainly commemorating saints who were worshipped in northern Russia.[6]

The technique of ivory carving was meticulously slow and prone to damage as

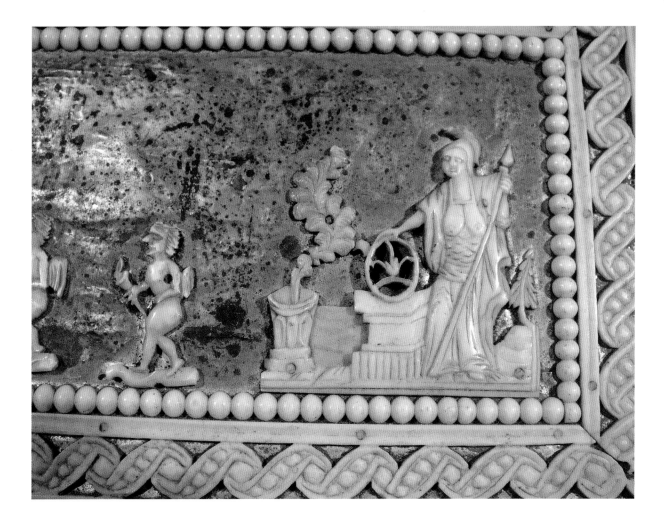

284. Detail of a box from northern Russia, c.1800, showing the foil backing. 22 x 18 x 7.5cm.
PRIVATE COLLECTION

the brittle plaques cut from bone or tusk had to be shaped, filed, engraved or perforated, and then pinned to a foil or tinted surface that shone through the openwork designs. To make the process more efficient, two plates could be carved through simultaneously, creating mirror images of a design that could then be finished with more precise tools. Themes were therefore echoed along the sides or hinged lid of a box with a scene being repeated in reverse.[7] A master carver would work with the grain of the segment so as not to compromise the strength of the material.[8] For further effect, the ivory plates were rubbed with green or red pigments to provide contrast. Natural stains varied from berry to saffron to sorrel in order to achieve a varied palette of dyes.[9]

The craft was handed down from father to son it seems. With the rare exception of masters such as Ossip Dudin, or others whose work was appreciated in the capital and even at court, the great majority of accomplished carvers remain anonymous as pieces were unsigned. Comparing extant examples allows for similarities to be noted amongst ornamental details which may indicate the design hallmark of a maker in the absence of his signature.

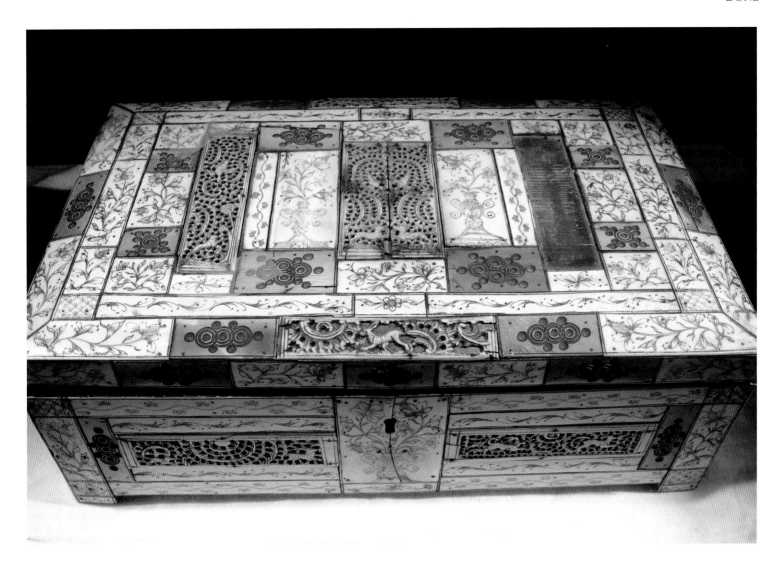

Opposite and above. 285. Northern Russian box with dyed sections, c.1750–1770.
31 x 18.5 x 10.5cm.
PRIVATE COLLECTION

Stylistically, the first half of the eighteenth century was influenced by the Rococo taste for scrolling foliate and shell motifs worked exuberantly around central portraits or allegorical scenes. The carving and relief work became increasingly detailed and the lacy openwork ever more delicate as the century elapsed. The second half of the eighteenth century saw stronger architectural lines and the use of coloured plaques creating bolder contrasts. During the nineteenth century, bone carving followed the classical trajectory characterised by rectilinear forms enriched with even borders as well as leaves, garlands and beading inspired by antiquity.[10] As the century progressed, the narrative or figural elements were supplanted by foliate enrichment, possibly in an effort to make items cheaper to produce and more marketable. Factory production, as with so many other disciplines in the decorative arts, sounded the death knell for independent masters and the craft had declined steeply by the end of the nineteenth century.

286. Detail of the hunting box in plate 282, showing early-nineteenth-century foliate pierced work surrounding a classical urn.
PRIVATE COLLECTION

Kholmogory, although the oldest and most widely known centre for bone carving, was by no means the only location where this technique flourished. The seventeenth and eighteenth century administrative centre for Siberia was located in Tobolsk. With its strategic location at the confluence of two major rivers, the city acted as an international trade hub and outpost for colonisation. The Russian bureaucracy demanded taxes from the native tribes and these were duly paid in kind with furs and fossil ivory. The bone carving tradition was brought to Tobolsk in the early eighteenth century with exiled Swedish prisoners of war. Their snuff boxes appealed to the local administrators, and the indigenous people soon learned to turn bone themselves in order to satisfy demand. Craftsmen eventually switched to woodwork but in the 1860s, Polish exiles revived bone carving by producing small objects such as brooches,

snuff boxes and paperweights. The work was largely figurative, illustrating the tribal people and their customs.[11]

In the seventeenth to eighteenth centuries, Russian frontiersmen settled further into the northern territories, bringing stylistic influences to the Yakut people who adapted their work in fossil ivory to create their own variation of northern bone carving. This can be broadly characterised as naturally coloured white, yellow or brown toned without dyed sections, engraving or coloured backings. The relief work is crisp yet shallow. Openwork nets surrounding genre scenes, illustrating Yakutian legends or tribal living, offer the distinguishing nuances attributing a particular work to this region.[12] Other centres sprang up amongst the Chukchi and Inuit people with output reminiscent of the scrimshaw familiar to North Americans.

The importance of bone carving in the history of Russian decorative arts lies in the way that a native craft, borne of traditional lore and using local materials, was refined. Furthermore, the craftsmen consulted Western print sources and digested their influence without slavishly complying with the edicts of St Petersburg. The output obviously appealed to the urban gentility of the capital and created demand from abroad. More importantly, it serves as a tangible reminder that northern Russia was astonishingly prosperous in its own right, that its cities were booming economic centres, and that its highest social echelons were also generous patrons who were engaged in promoting traditional crafts on a local level.

287. Gaming chip with birds. Northern Russia, second half of the nineteenth century. 6 x 1.5cm.
PRIVATE COLLECTION

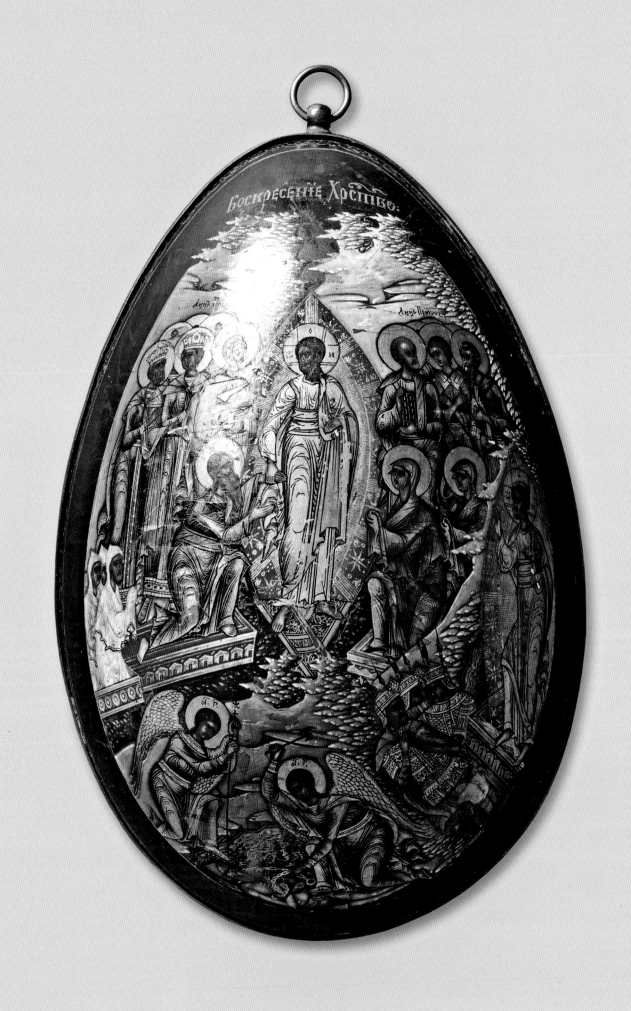

Chapter 11

LACQUER

LACQUER BOXES ARE AMONGST THE BEST known Russian collectables. Their omnipresence in souvenir shops is a testament to the tenacity of the craftspeople who assimilated the technique from its introduction into late seventeenth-century Russia and nurtured it through to the present day.

While Peter the Great is usually credited with bringing Russia out of isolation and establishing foreign relations, a route running parallel and north of the Silk Road was used during the Middle Ages to link Muscovy with China.[1] Due to political upheavals in the late Middle Ages, traffic was interrupted until fresh attempts were made by Westerners in the sixteenth century. They appealed to the Tsars to allow them to establish another route to Cathay. Where Genoese, Polish and English attempts failed, a delegation of Cossacks sought permission in 1616 and finally succeeded, returning with enthusiastic reports of people clothed in satin.

Opposite. 288. One side of the fine papier-mâché and lacquer egg from the Lukutin Manufactory in Moscow, late nineteenth century. Height 18.5cm. See also Plate 293.
BONHAMS

Above. 289. A papier-mâché box from the Lukutin Manufactory, nineteenth century. Length 9.5cm.
BONHAMS

With the groundwork established, Tsar Alexei and subsequent Russian rulers continued to strengthen Sino-Russian trade relations until the first treaty between a Western power and China was signed by Peter the Great at Nertchinsk in 1689. The document, written in Russian, Latin and Mandarin, established Russo-Chinese borders and protected the freedom to travel and trade within China.[2] The resulting increase in commerce must be credited for the appearance of Chinese porcelains, fabrics, spices and lacquer at the Tsarist palaces.

During Peter the Great's visit to the Netherlands in 1697, he would surely have imbibed the European appetite for Chinese-style lacquers, as well as both the English and Dutch efforts to emulate the technique. It is entirely possible, therefore, that it was he who endorsed the craft of lacquer making through the lens of his taste for all things Dutch.[3]

Beginning in the eighteenth century, lacquer in Russia was mostly applied to domestic items. This somewhat rustic craft known as *Khokhloma* is better known today as being epitomised by the red and black wooden bowls and spoons purchased in Russian souvenir shops.

At the other end of the spectrum, the lacquer technique was integrated into Russian palace interiors such as Montplaisir, built at Peterhof between 1715 and 1725 as the Tsar's summer residence. It incorporated a Chinese hall comprised of over ninety lacquer panels executed by Russian craftsmen working under a Dutch master. The chinoiserie wall panels were so well-executed that they were later mistaken for authentic oriental work. Only four panels survived the Second World War, but they did provide curators with models for restoration.[4] Extensive research revealed that the panels had originally been created by a master from the Palekh school, using the typical Russian icon painting technique on limewood.

Exotic wares which had been sold at successful annual fairs in the White Sea port of Arkhangelsk drew merchants from across Europe who were enticed by the Persian, Tartar and Chinese goods on offer. The Western European

290. A selection of papier-mâché boxes,
Vishnyakov, late nineteenth to early twentieth
century. Height of largest box with Kremlin lid
21.5cm.
BONHAMS

competitors at Arkhangelsk were the English and Dutch who possessed the ships that the French did not. As the century progressed, it was they who took control of the market for Chinese export goods until, in 1743, Empress Elizabeth banned the import of all Chinese merchandise from the West. Trade was thereafter resumed directly with China, and the ban on imports from the East India Company within Russia may explain the flourishing development of Russian crafts in the Chinese taste during the second half of the eighteenth century.

291. A group of lacquer objects including a plate and circular box by Vishnyakov, nineteenth century. Width of largest box 28cm.
BONHAMS

By the 1820s, the firm of Lukutin had become synonymous with the production of lacquered snuff boxes. Lukutin achieved a reputation in Russia akin to that of the Martin brothers' virtual monopoly on japanning in eighteenth-century France. Cardboard sheets were pressed around a wooden block, dried and soaked in vegetable oil. This surface was baked for several days at around ninety-three degrees centigrade. The resulting wood-like material was then lacquered and painted, often to imitate tortoiseshell, and coated with oil to give the object brilliance.[5] The technique was applied to album covers, tea caddies and desk accessories which appealed greatly to the wealthy classes.

Lukutin continued to be officially recognised as Purveyor to the Court until the firm's closure in 1904. The Imperial Eagle, found usually on the inside of Lukutin objects, signifies the firm's raised status and relationship with the Empire. This is analogous with the endorsement 'By Appointment to Her Majesty the Queen' on a present day product in the

UK – it does not indicate that the item was an official gift or a one-off presentation piece as is often inferred. The firm eventually re-opened taking the name of its locality – Fedoskino.

The pendant to the prominent firm of Lukutin was the main competitor, Vishnyakov. Whereas Piotr Lukutin, a savvy businessman, married into an established business founded by his father-in-law, Osip Vishnyakov was a former serf on the Sheremetev estate. Papier-mâché lacquer wares produced by Vishnyakov and Sons included boxes for tea and snuff, match boxes, Easter eggs and eyeglass cases. The company flourished in the mid-nineteenth century.

Both enterprises capitalised on the rising tide of Slavophilism, drawing upon existing popular imagery depicting countless troika and peasant scenes rather than creating original compositions. Artists are known to have gravitated between the two principal firms, bringing stylistic and thematic similarities to both Lukutin and Vishnyakov. Seasonal permutations such as winter horse-drawn sleighs or varied costumed figures engaged in selling their wares – toiling or perhaps resting at the

292. A gold-mounted and jewelled lacquer cigarette case. Fabergé and Lukutin, St Petersburg, 1899–1908. It has a hinged cover and vesta compartments, as well as a tinder cord chained to a suspension loop. Length 10.2cm.
BONHAMS/FABERGÉ MUSEUM BADEN-BADEN

village well – offered endless possibilities for the bestselling themes. Countless anonymous artists depicted meticulously detailed figures against a specially primed ground of metal powder, resulting in a particular luminescence that often seems to light a scene from within. By the mid nineteenth century, the firm of Vishnyakov had evolved into the production of the lacquered metal trays that are associated today with the firm's present name taken from Zhostovo, its locality.

Three further centres of lacquer production must be mentioned. Palekh, Mstera and Kholui were historically linked with icon painting, a medium which thrived until the twentieth century. At that point, the relatively short-lived demand for mass-produced oil renditions of religious images in the Western taste supplanted the painstaking and highly prescriptive traditional approach using egg tempera. The 'industry' was quashed altogether after the Revolution of 1917 as it was considered to be contrary to Soviet ideology; the technique, known under the umbrella term 'Palekh', was only revived in the 1920s. The finely painted boxes depicting fairytale scenes with striking tones of gold and red against pitch black ground remain a popular souvenir and export item.

293. A fine papier-mâché and lacquer egg from the Lukutin Manufactory in Moscow, late nineteenth century. Height 18.5cm. The other side of the egg is shown on page 256.
BONHAMS

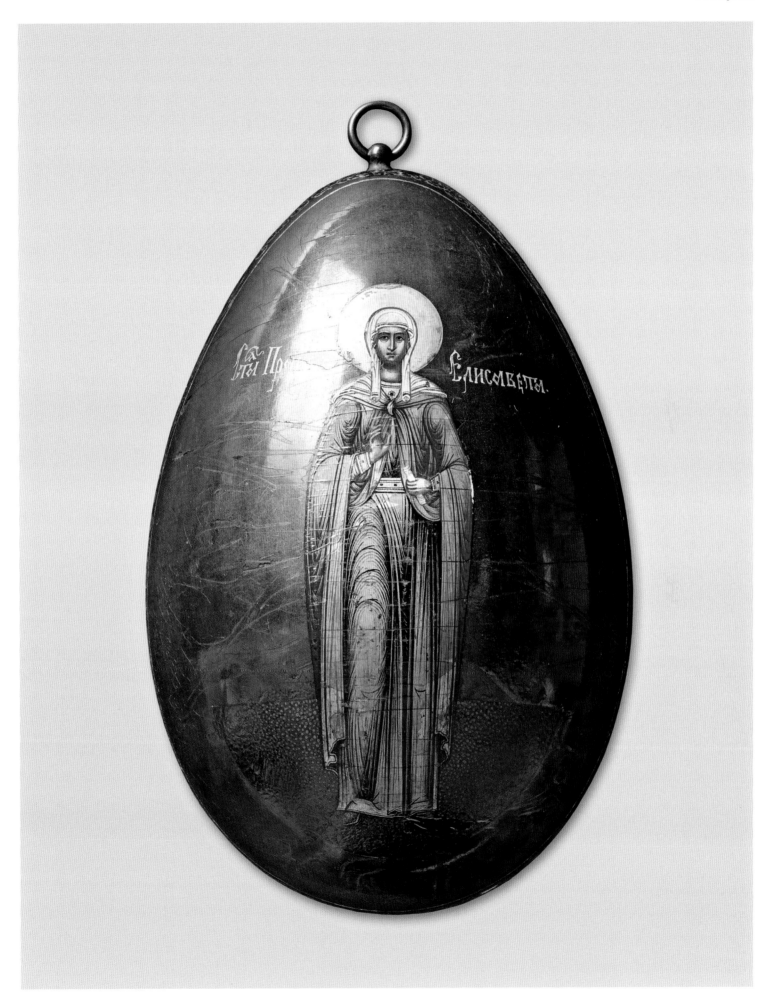

Chapter 12

WOODWORK

MY MOTHER'S UPBRINGING AT the French Embassy in Moscow, the former Igumnov Mansion, anchored her childhood in a Russian Revival confection that appeared to be created from marzipan and gingerbread. During my own childhood, I remember day trips to our relatives' *dacha* in the Moscow countryside and travelling past rows of houses adorned with elaborate window frames and gabled roofs. These were surely inhabited by the Russian storybook characters of *Terem Teremok*.[1]

My mother's nostalgia for the Russia into which she had been born nurtured my interest in Russian folk art. This in turn took root once I had access to the publications of Wendy Salmond and Alison Hilton with which I could contextualise the broader subject. As a critical component in Russia's search for a cultural identity, it is fitting to complete this book with a return to the rural traditions that have survived and evolved through generations to define artistic ideals despite the great westernising efforts of Peter the Great.

Opposite. 294. Inlaid wooden mirror, Nizhny Novgorod, c.1913. 86 x 58.5cm.
BONHAMS

Above. Detail from a carved and stained cabinet after design by Yelena Dmitrievna Polenova (1850–1898), Abramtsevo, c. 1880. See Plate 298.
ICONOSTAS

Opposite. 295. An eighteenth-century wooden
bread mould. Height 17.8cm.
ICONOSTAS

In the late Imperial period, a revived interest in peasant handicrafts left a firm imprint on the evolution of Russian decorative arts. 'Kustar' was a specifically Slavic strain of the Arts and Crafts movement, encouraged by influential patrons. It manifested itself as a force against factory-produced mass-marketed goods and the ensuing social changes as the Industrial Revolution gathered momentum and the young sought work in increasingly congested cities. It was hoped that supporting cottage industries would revive village cooperatives and national identity.

The movement was driven by those with power and wealth, and not always as a purely altruistic effort. For some, the motivating force was a way of giving back, a penance for being born to the landowning or industrialist classes that they felt had subjugated the working man. These isolated patrons and their instances of charity required more widespread official backing if they were to impact the plight of the Kustari.

Following the Emancipation Act of 1861, when serfs were freed, the provincial governing body, termed a zemstvo, had to take over from landowners in the day-to-day administration of rural affairs.[2] In the late nineteenth century the peasants, who were barely subsisting from their seasonal income provided by the land, were hardly in a position to debate the relative merits of donating their whittling or embroidering skills towards the good of a burgeoning national identity. In an often uneasy alliance between patron and supplier, a financial incentive had to be guaranteed in order for the product to be delivered. The mercantile outlets also required steady demand from a fickle buying public in order to encourage renewed supply.

296. A set of painted wooden skittles and ball,
c.1900. Heights ranging from 15cm to 18cm.
ICONOSTA

The Russian crafts which were successfully promoted, therefore, were
those that fulfilled the supply and quality control standards of the
distributor, be it patron or local zemstvo. These, in turn, had to meet the
demands of retail outlets catering to the capricious buyers, both at home
and, eventually, abroad. This could mean that wares had to be sufficiently

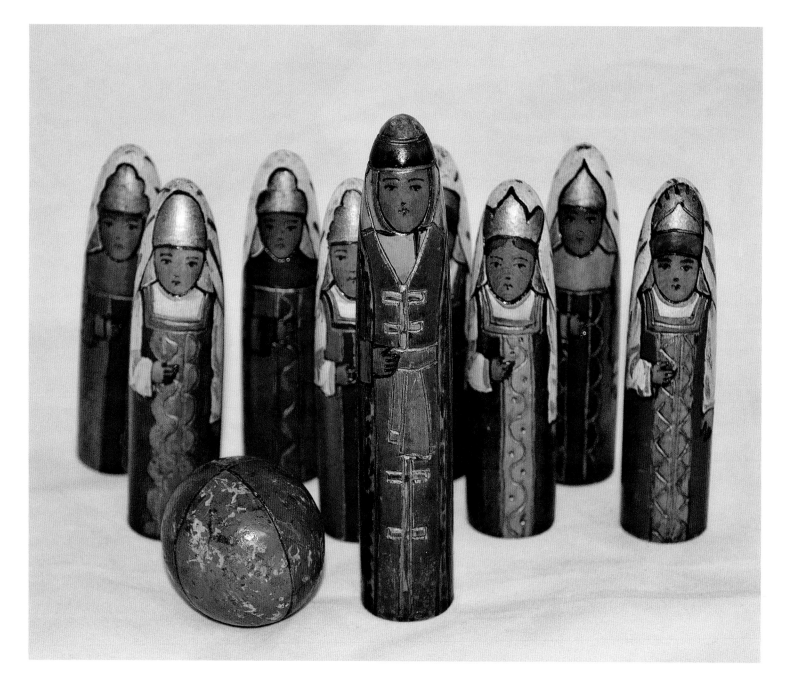

refined in order to fit into a drawing room and were therefore only vaguely reminiscent of their rustic prototypes. In some cases, a complete fabrication sparked the public's imagination, as in the case of the Matryoshka, a series of nesting dolls which evolved in the 1890s from a Japanese toy, becoming an iconic example of Russian folk craft.

297. A brass-mounted wooden laretz, c.1900. 14.5 x 17.5cm.

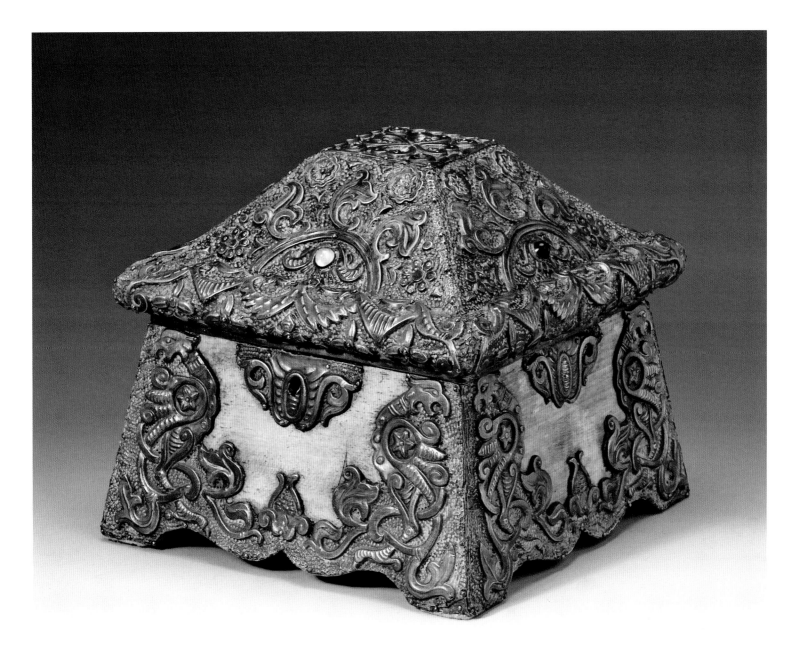

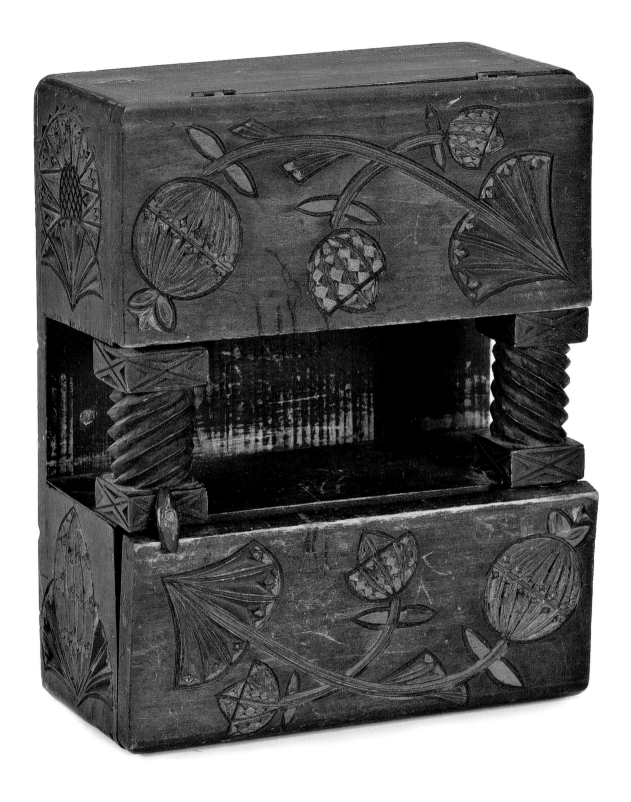

298. Small carved and stained cabinet after design by Yelena Dmitrievna Polenova (1850–1898), Abramtsevo, c. 1880. 45.7 x 15.2cm.

ICONOSTAS

A very small handful of wooden forms appear at auction and are received with mixed results. Small cabinets, frames, *kovshes* and, occasionally, chairs represent the principal offerings. The cabinets tend to be in the style of Yelena Polenova, tying them to a design dating from about 1880, when she ran the joinery workshops for the Mamontov family's art colony at Abramtsevo near Moscow.

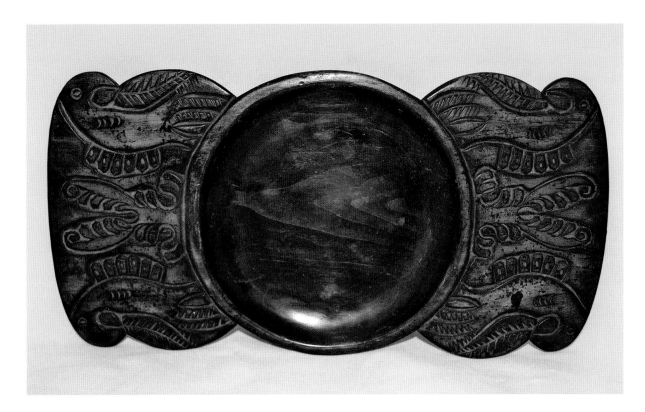

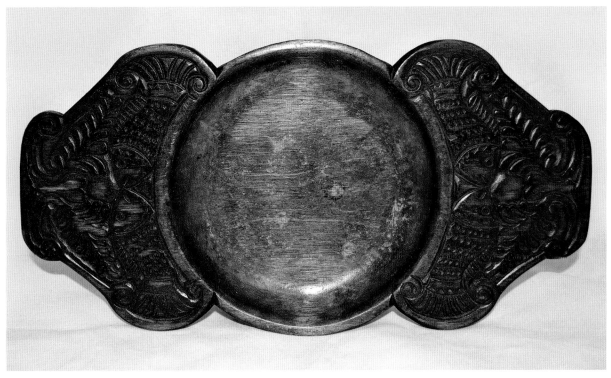

The Mamontovs were wealthy industrialists who had committed themselves to enlightening local peasants through art and to serving social needs of the rural population.[3] Wooden architecture and craft was best placed to channel the vernacular forms, techniques and materials specific to Russia. The raw materials were free from duty and plentiful. Polenova's background in the womanly decorative arts was a good fit for the Kustar

299. Two wooden platters, Abramtsevo, c.1900. Both 30.4 x 15.2cm.

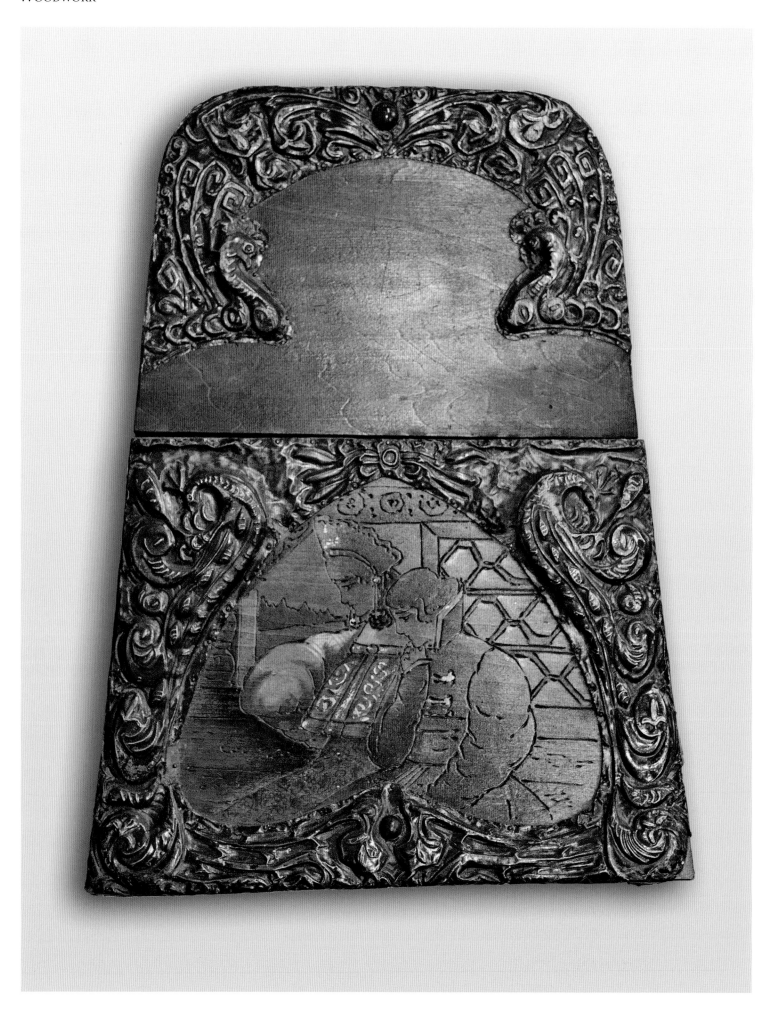

workshops being established on the Mamontovs' private estate to revive embroidery, joinery and ceramic work. Tasked with documenting traditional ornamental forms and motifs, and then updating them to make objects more marketable, Polenova was ideally placed to rework traditional craft in a sensitive manner which would both honour a common heritage and make it commercially viable. Her iconic column cupboard, based on storage cabinets created by her pupils, came to incorporate architectural details and ornamental references to traditional woodwork and local flora.

Wooden *kovshes* shaped as traditional ladles enriched with stylised flora and fauna or inset with contrasting materials also found favour as gifts. The reference to pre-Prefine forms combined with decoration found on early presentation silver was not lost on nineteenth-century revivalists. The handles and prows terminating in fantastical bird or horse forms would surely have found a willing audience abroad happy to interpret from their own references to Nordic heroes and Viking ships. References to mythical beasts and legendary heroes drawn from traditional fables conveyed strength and pride in the country's own heritage. A drinking maxim carved or painted around the rim in Viaz script provided the finishing touches in Cyrillic letters to underline the cultural provenance.

Opposite. 300. Letter stand, Abramtsevo, c.1900. 33 x 25.4cm.
ICONOSTAS

301. Wooden and silver piqué inlaid *kovsh*, c.1900. 20.3 x 64cm.
ICONOSTAS

302. A studio photograph of Empress Maria Feodorovna and her daughter Grand Duchess Xenia Alexandrovna, early 1880s. This nostalgic image of the Empress gazing through the stage-set frontage of a traditional log house supports the notion that the return to Russian roots and peasant craft was embraced at the highest echelons.
BONHAMS

Opposite. 303. Talashkino table, c.1900. 22.9 x 17.8cm.
ICONOSTAS

Frames and mirrors reminiscent of traditional windows and decorated with marquetry or inlay were entered for prizes at prestigious fairs. A mirror created for the 1913 Kustar Exhibition in St Petersburg was representative of mosaic work from Nizhny Novgorod. The accompanying catalogue identifies it as being 'made from designs by the artist D.N. Durnovo by the Kustari Grigorii and Mikhail Mairov of Vasil'skii district... Efforts to raise the artistic aspect of the wares have been made by the St Petersburg Kustar Museum and by the Nizhny Novgorod Provincial Zemstvo, where the Kustar department sells a variety of wooden wares at a total of around 4000 rubles per annum.'[4] Here, the artistic source and commercial viability could be seen as working hand in hand.

Another important centre for Kustar work was at Talashkino, the country estate near Smolensk owned by Princess Maria Tenisheva. The Abramtsevo ideas of workshops, learning facilities and gathering of material culture were present here without the backdrop of the well-established artistic network which was so central to the success of the Mamontovs. Wendy Salmond also points out that Talashkino operated without the same regard for financial solvency and therefore was not aimed at a considerable and uniform output of goods.[5]

The creative outlets provided by estate workshops such as Abramtsevo, Solomenko and Talashkino found favour with a bohemian buying audience in the city centres. Adding folk art to an urban home must have transmitted the idea that the owner was progressive and in touch with his or her roots. Ironically, of course, Kustar stock had to constantly evolve to feed the interests of mercurial clients and in so doing, had to adopt methodologies of mass production in order to keep costs down and quality of output uniformly high.

As part of a larger political movement, the local Kustar industries dovetailed into the broader context offered by the rising tide of Russian nationalism. At the state level, Alexander III advocated the unifying force of a pan-Slavic aesthetic. Imperial patronage bolstered the legacy of

304. Distaff, a tool used for spinning, c.1870.
Length 81.3cm.

ICONOSTAS

Opposite. 305. Carved and stained *trompe l'oeil*
oak chair with gilt inscription, after a design by
Vasili Petrovich Shutov, twentieth century.
Height 102cm.

BONHAMS/FRANK DE BIASI INTERIORS, NEW YORK

Baron Stieglitz, a wealthy banker who endowed a museum and applied art institute to foster home-grown talent and help bridge the divide between fine and decorative art. One of the lecturers there, Vasili Shutov, captured the nation's fascination for traditional folk imagery in the design for a *trompe l'oeil* chair which was exhibited at the All-Russian Manufacturing Exhibition in St Petersburg in 1870. An example is preserved in the Hermitage Collection (no. ERMB-481). The design, which inspired other versions and remained popular over the course of the following decades, incorporated a horse's yoke, woven matting, a pair of coachman's gloves and a worker's axe. A Russian proverb carved into the wood added a Cyrillic note of authenticity to the overall piece.

These chairs and other wooden pieces representative of the Slavic revival period crop up at auction periodically. Because they do not reach the hammer prices of more established markets, objects linked with peasant handiwork such as brightly painted distaffs are often relegated to the category of collectables. Speculators would not see these as an investment opportunity, but they certainly offer good value and a point of entry into the field for collectors who are attracted to the works.

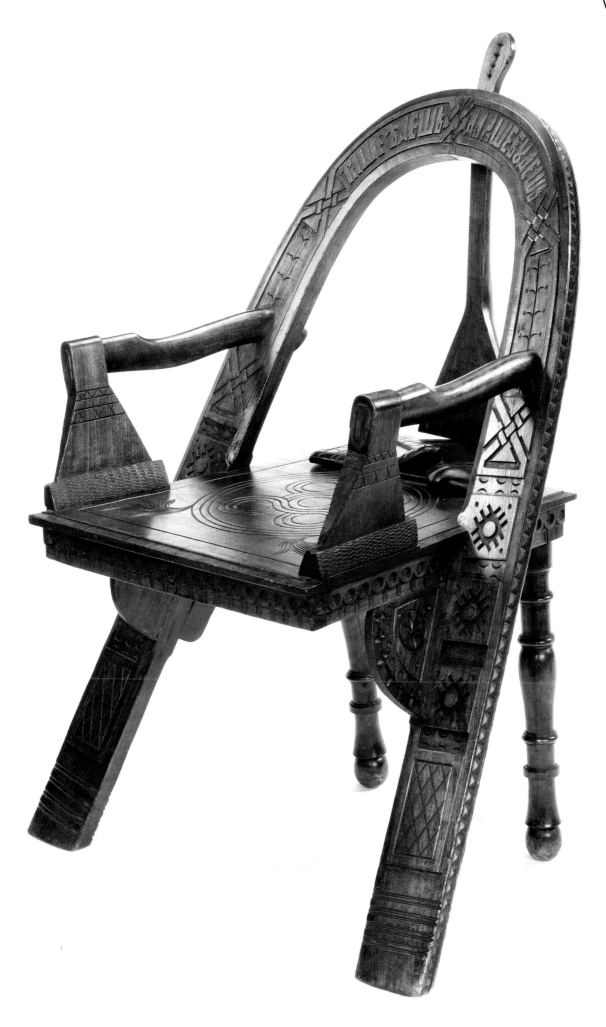

CONCLUSION

I CANNOT COUNT THE NUMBER of times I have been asked by befuddled dinner companions "Why do you do it?", or "What does it mean?", or better yet, "Why is it important?" In England, the more genteel "Sorry, but" precedes the query, whereas in the more direct Manhattan, I am challenged half way through my response by "And?", meaning "Your point is?".

Decorative arts are our tangible link to bygone eras. As archaeological finds, they reveal clues about the society that created them. Their material, form and usage serve as evidence of the people who tooled and owned them. While it is not nuclear physics, nor does it save young lives, it *is* important, particularly when the people that the objects recall so dramatically redefined themselves that they sought to wipe out all traces of their class structure and faith. The items they left behind, whether nationalised by a government in transition or preserved under floorboards within the folds of an old handkerchief, each has a story.

The process of evolution that adapts and hones an object through time mirrors a society's search to define itself. The Russian traditional coat of arms does not depict just any bird, it is a noble eagle, a supposed messenger of God and symbol of might. The mythical creature's head is cleaved, enabling it to concurrently survey both East and West. It speaks of a country with a land mass so large that it traverses continents. As a propagandistic tool, the image etched onto wine glasses or painted on porcelain cavettos at an Imperial banquet affirms a monarchy yearning to distinguish itself as a forceful player on a world stage. The decorative arts output mirrors the tension between native traditions and the imposition of widespread foreign influence. It shows how these outside influences were enforced by decree or eagerly embraced until they became something other than the repetition of

306. *Monastyr* by Sitnikov, 1967. 60.5 x 98.4cm.
BONHAMS

an earlier prototype. Thus, we see how the Baroque was eventually integrated into something that is nuanced from the way it was interpreted in France, Italy or Germany. Russia, too, found her own stand-alone style which was just as valid as that of her neighbouring countries.

The manner in which that legend is created, reinterpreted and redefined also speaks volumes. During the twentieth century, Russia disowned a large amount of its material culture, trading it abroad for much-needed currency, only for the State to then romanticise its lost patrimony and encourage its repatriation. An extremely wise mentor of mine, Anne Odom (Curator Emeritus at Hillwood Museum) who sadly died during the writing of this book, shared her wonder at the changing landscape of the broader picture. I hope that this introduction to the subject is worthy of her belief in me as a budding student of Russian Decorative Arts.

GLOSSARY

Abramtsevo: The name of the country estate near Moscow owned by the Mamontov family, who were wealthy railroad magnates and committed patrons of the arts. This location is synonymous with the Arts and Crafts colony that flourished there in the late nineteenth to early twentieth centuries and was committed to documenting the folk traditions of medieval Russia that were perceived to be threatened with extinction by industrial machinery. Ceramic, textile and carpentry workshops were established there in the hopes of keeping local peasants from migrating to city jobs. The artistic director Yelena Polenova created an Arts and Crafts industry based on her interpretation of local folk art and adapted to urban middle class tastes.

Ador, Jean Pierre: Geneva-trained court jeweller active in St Petersburg from the early 1860s and known for enamelled gold boxes.

Arkhangelsk: Russian for Archangel, a town in northern Russia located near the mouth of the Dvina River which was the principle trading artery to Moscow from the White Sea. Although it prospered as a commercial hub, the region maintained a strong tradition of folklore and craft, supported by wealthy local merchant patrons. Bone carving, particularly from Kholmogory, an historic trading post located to the south along the Dvina River, was highly developed as a craft.

Artel: in the context of Russian decorative arts, usually referring to early twentieth-century co-operatives formed by craftspeople who banded together in an attempt to counteract mass production.

Assay master: person who oversaw the identification and weighing or calculation of the precious metal content of an object before hallmarking it with a number denoting its proportion to alloy; this was expressed as a silver or gold 'standard' rather than carat weight.

Bast shoes: termed *Lapti* in Russian. Traditional footwear woven from tree bark.

Bilibin, Ivan (1876–1942): prominent illustrator and stage-designer who was deeply inspired by Russian folklore, rising to prominence in 1899 with his illustrations of fairy tales.

Bolin: Russian court jewellers originally founded in St Petersburg in 1791. It was renamed Bolin and Jahn by the 1830s, and simplified to Bolin in the 1850s, before expanding to Moscow and operating as Shanks and Bolin. The firm was considered a close competitor to Fabergé and gained acclaim for the precious gem-set tiaras and

other fine jewels it supplied to the Imperial Family and their circle. With dual Russian and Swedish nationality, the founder's descendent, Wilhelm Bolin, was able to transfer stock abroad at the onset of World War I, opening a branch in Stokholm in 1915. Although the Russian operation was suspended in 1917, the firm still operates today as Jeweller to Sweden's Royal Court.

Boyar: hereditary title given to high-ranking members of the feudal nobility. These ultra-conservative and anti-Western advisors to the Tsar wielded great influence throughout government and the military. Peter the Great abolished the medieval tradition in favour of a 'Table of Ranks' in 1722, devising a complex hierarchy of grades awarded for loyalty and distinction in the military, government and court. This new bureaucracy rewarded merit over noble birth.

Bratina: a spherical vessel traditionally for mead or beer and associated with ceremonial occasions. The form appears usually with bombé sides, a short circular foot and sometimes a conical lid. Gold and silver examples with lavishly engraved designs and viaz inscriptions were used as early as the sixteenth century and revived in the late nineteenth century as presentation awards.

Bread and salt ritual: included in a traditional welcoming ceremony with bread placed on a dish and salt in a cellar. The ceremonial presentation of highly valued bread warding away hunger and prized salt for flavouring and curing is synonymous with generous hospitality.

Butovski, Victor: *See* Stroganov Institute.

Cameo: created from stone, glass, ceramic or shell carved in relief above the surface (*see also* Intaglio).

Caravaque, Louis (1684–1754): French-born artist who executed royal portraits at the Russian court.

Rossi, Carlo (1775–1849): Italian-born architect whose work in Russia was characterised by the refined rhythm of the Neo-classical style.

Cathay: Anglicised version of a medieval European term for China.

Champlevé enamel: channels are incised into a metal plate and the resulting depressions are then filled, usually with opaque enamel.

Charka: originally a unit of liquid measure equalling ⅟₁₀₀ of a Shtoff, but commonly refers to a vessel for spirits comprising a shallow bowl fitted with a flat handle and originally termed a

'chara'. It resembles a winemaker's *tastevin*. The Russian form appears with angled or lobed sides chased with rocaille ornament in the eighteenth century, sometimes further enriched with coins in the northern European taste. Later, in the nineteenth century, the form was revived.

Cipher: single or interwoven letters of a name indicating a specific identity. A monogram, however, melds one part of a letter with another and is therefore a favoured device for expressing unions such as marriages.

Cloisonné enamel: walls (or *cloisons* in French) of soldered metal are built up from the base to form small cells which are then filled with enamel. In Russian cloisonné, the borders are often created out of twisted wirework which is more correctly termed filigree but is commonly referred to under the umbrella term cloisonné.

Cold enamel: term used to mean a coloured varnish applied to silver objects in the late Imperial period.

Coronation album: a lavishly illustrated commemoration of the ceremonial rituals associated with a particular monarch's ascension to the throne. Published in limited numbers for the highest-ranking guests and foreign elite.

Coronation cup: during the 1896 coronation celebration of Tsar Nicholas II and Alexandra Feodorovna, a riot erupted in the Khodinka Field in Moscow when a rumour spread that there would not be enough souvenir mugs and mead to satisfy the crowds. Thousands were killed or injured in the catastrophic stampede and a foretelling of the end of the Romanov dynasty can be interpreted, but that does not deter collectors from appreciating the lively graphics of the souvenirs. Referred to sometimes as 'Khodinka mugs' or 'Cups of Sorrow', these enamelled metal beakers are not uncommon on the market, although finding them without damage to the rim and base is rare.

Crossed anchors: often refers to the coat of arms of St Petersburg comprising two anchors layed across one another below a sceptre placed vertically. *See also* St George.

Cupola: in Russian architecture, a domed structure surmounting a narrower collar and terminating in a point. Sometimes referred to as an 'onion dome'.

Cyrillic: term for the Russian alphabet, which is a variant of Cyrillic script. Differing methods were used to transliterate Cyrillic into English, so proper names can take multiple forms to express the same sound. For example, 'Tolstoy' might appear elsewhere as 'Tolstoi', 'Romanov' as 'Romanow' or 'Romanoff', and 'Xenia' as 'Ksenia'.

Denisov-Uralski: hardstone carving workshop in St Petersburg thought to have supplied Fabergé's overwhelming demand for finely carved objects c.1900–1917.

Duval, Louis-David: Geneva-born jeweller originally trained as a silversmith. Moved to St Petersburg in 1753 and rose quickly to Court Jeweller under Catherine the Great, collaborating at times with another renowned court jeweller, Jérémie Pauzié.

Ekaterinburg: city located in the Ural mountains. An important mining centre benefiting from rich natural deposits. Renowned for stone-carving at the Ekaterinburg Lapidary Works, which flourished in the eighteenth century, permitting stone to be cut locally rather than being transferred in block form to Peterhof (the oldest stone-cutting factory which was located near St Petersburg). A third factory was established at Kolyvan in western Siberia capitalising on stones mined in the Altai mountains.

Enamel: glass flux ranging from translucent to opaque and used to enrich precious metal objects. It adheres better to gold than silver so a gilt wash may be applied to a silver base rather than using the more costly metal.

Ewing: usually referring to Nicholls & Ewing who supplied the court with jewellery. The firm, along with Fabergé and Bolin, submitted drawings and produced a parure for Grand Duchess Xenia's wedding jewellery, indicating the maker's standing at court in 1894.

Fabergé: firm founded in 1842 by Gustav Fabergé, a descendent of French Huguenots, in St Petersburg. In 1872, his son, popularly known as Karl, succeeded him, having completed his studies and training abroad. In addition to his responsibilities to the family firm, Karl ingratiated himself to the Imperial Cabinet by volunteering to restore ancient artefacts in the Hermitage for several years. The firm was eventually granted the Imperial Warrant in 1885 and two years later opened a branch in Moscow; this was followed by expansion to Odessa (1901), London (1903) and Kiev (1906). Karl Fabergé developed his father's business into an international luxury brand but did not craft pieces himself, instead entrusting the technical side to head workmasters Erik Kollin (1870–1886) Mikhail Perkhin (1886–1903) and Henrik Wigström (1903–1918).

Fersman, A.E. (1883–1945): a noted mineralogist, he began an annotated photographic inventory of the Russian Crown Jewels in 1922. It was eventually published by The People's Commissariat of Finances, Moscow, in 1925–6 under the title *Russia's Treasure of Diamonds and Stones*.

Filigree: *see* cloisonné.

Finift: miniature painting on enamel over copper plate. This tradition was particularly revived in the city of Rostov during the eighteenth century and is thus also termed 'Rostov' enamel.

Gilding: process of applying gold, generally to silver (*vermeil*) or bronze (*ormolu*). Where only portions of the surface are coated, the item is termed partly or parcel-gilt.

Grachev: St Petersburg firm founded in 1866 by Gavril Grachev and inherited upon his death in 1873 by his sons Michael, Simon and Gregory who re-branded the firm 'The Grachev Brothers'. The firm was granted the Imperial Warrant in 1892 and known until its closure in 1918 for fine silver in various European historical styles and enamel work in Russian Revival taste.

Greek-cut stone: Russian term for 'table-cut'.

Gregorian calendar: *see* Julian calendar.

Guild: organisation of Russian gold and silversmiths along the German model into craftsmen who adhered to certain standards of training and quality control. Masters who accepted commissions directly from the court or church were not required to adhere to guild restrictions.

Guilloché enamel: method of engraving a repetitive pattern by engine-turning onto a metal surface which is then fired with translucent enamel. The pattern remains visible through the colour, often forming a moiré effect when the object captures the light.

Hahn: firm founded by Austrian-born Karl Hahn in St Petersburg during the late nineteenth century. Held the Imperial Warrant and completed a coronation crown for Empress Alexandra Feodorovna. Produced fine jewellery and objets de vertu namely in the workshops of Alexander Treiden and Carl Blank.

Hermitage: refers to the Hermitage Pavilion at Peterhof, begun in 1721, in addition to the Palace complex in St Petersburg comprising several buildings incorporating the appellation. Specifically, the Hermitage Theatre opened in 1785, the Old Hermitage completed in 1787 (both under Catherine II), and the New Hermitage opened to the public in 1852 as a purpose-built art museum, the design of which was influenced by Nicholas I's penchant for historicism.

Imperial Academy of Art, St Petersburg: originally founded in 1757 and re-located to a purpose-built riverside Palazzo completed in 1789. The sumptuously decorated building promoted the court-sanctioned Neo-classical style in its architectural features as well as the techniques and aesthetic vocabulary imparted within. The most promising students competed for coveted placements abroad and graduation from the Academy was a virtual pre-requisite for a successful career as an artist.

Imperial Eagle: the coat of arms of the Russian Empire featuring a crowned double-headed eagle with spread wings, holding an orb and sceptre in its claws.

Imperial Porcelain Manufactory: founded in the mid eighteenth century to establish prized foreign expertise in hard-paste porcelain manufacture in St Petersburg. Its main function was to supply the Russian court and it was patronised by the reigning monarch.

Imperial Warrant: awarded to suppliers of goods and services to the Imperial court and permitting the use of the double-headed eagle on the firm's hallmark and branding as a mark of cachet. Recognition of these court purveyors could be renewed but not inherited.

Intaglio: a surface enriched with incised or engraved designs so that an impression yields an image in relief.

Julian calendar: Russia maintained the Old Style or Julian Calendar until 1918 when it adopted the New Style Gregorian system which was, by that point, thirteen days ahead. The conversion should be borne in mind when considering dedication inscriptions, anniversaries or other dating, as the Russian calendar maintained this discrepancy with the commonly used Western calendar through the late Imperial period. In certain publications, both systems are documented and sometimes appear as OS and NS.

Keibel: firm founded in 1797 by Otto Keibel in St Petersburg producing gold snuff boxes and jewellery. His son Johann inherited the firm and was awarded the Imperial Warrant, reworking the Imperial crown for Nicholas I's coronation. The firm continued primarily to produce Orders and other presentation awards under the leadership of Albert Keibel, until its closure in 1910.

Khlebnikov: Founded in 1870 in Moscow by Ivan Khlebnikov who ran the firm until his death in 1881, after which his sons Mikhail, Alexei, Nikolai and Vladimir took over and rebranded it as 'Khlebnikov Sons and Partners'. The same year, the firm was named Purveyor to the Court. Khlebnikov was known for enamel and silver articles and particularly adept at *trompe l'oeil* pieces.

Khodinka: *see* Coronation Cup

Kholmogory: *see* Arkhangelsk

Kievan Russ: medieval Slavic state which was a precursor to modern Russia. It centred around Kiev, encompassing parts of Ukraine, Belarus and Russia, flourishing from the ninth century until it fell to Mongol invaders in the thirteenth century. Its mythology and folklore fuelled the Russian Revival movement in the nineteenth century as a source of pre-Petrine vernacular identity.

Koechli (Köchly), Feodor. Father and son, of Swiss descent, were active in St Petersburg from the 1870s, supplying the court with gold jewellery and objects such as gold boxes and cigarette cases. The firm sometimes appears with the name 'Friedrich' as it was only later changed to the more Russian 'Feodor'.

Kokoshnik: a traditional Russian head-dress worn by women comprising a high crescent-shaped headband with an open back, fastened together by ribbons. This is analogous in appearance to the French hood popular in Tudor times. The Kokoshnik was used in profile for the hallmarking of precious metals between 1899 and 1917.

Kolyvan: *see* Ekaterinburg.

Kornilov: *see* Private Factory Porcelain.

Kovsh: traditional cup evolved from drinking vessels formed as wooden dippers and resembling a ladle with a short handle.

Kremlin: fortified complex used throughout the Russian Empire to defend its cities, although commonly referring to the walled inner city at the heart of Moscow. Also a generic term for the government operating within its building complex.

Kustar: term for a craftsperson involved in a cottage industry as opposed to an industrial setting; typically working in the home to create folk art to supplement income from seasonal labour.

Kuzmichev: firm founded in Moscow in 1856 producing silver, particularly enamelled wares in the Russian Revival taste which found a successful outlet in America when partnered with the legendary retailer Tiffany & Co.

Kuznetsov: *see* Private Factory Porcelain.

Lacquer: in a Russian context this term generally refers to papier-mâché or wooden objects enriched with finely painted miniatures of troikas or typical Russian scenes which are then lacquered and polished. The best known makers during the late Imperial period are Lukutin and Vishnyakov.

Laretz: an ornamental chest often shaped as a hinged casket with a flat-topped roof.

Lomonosov, Mikhail (1711–1765): prominent scientist commissioned by Empress Elizabeth to build a laboratory in 1748. Amongst other discoveries was the development of coloured glass. This in turn led to the factory production of glass rods used in mosaics and beading whose manufacture was eventually integrated into the St Petersburg Glassworks.

Lubok: a form of popular Russian print, first created from woodcuts during the seventeenth century, later evolving into engravings, etchings and then lithographs. They were relatively inexpensive to duplicate into booklets and therefore accessible to the lower classes when disseminated through marketplaces. Combining graphics with narratives, they compare to the modern-day comic book.

Lukutin: *see* lacquer.

Maltsov Glass: private glassworks located in Gus Khrustalny and Diatkovo which sold products in Moscow and St Petersburg thus bringing goods to aspiring middle classes who could not access output from the Imperial Glassworks and whose buying appetite was stifled by early nineteenth-century decrees banning the import of foreign goods.

Mamontov: *see* Abramtsevo.

Matryoshka: a series of nesting dolls in decreasing size which originated in Russia at Abramtsevo in the 1890s and were based upon a Japanese prototype. The figures usually depicted women in variously coloured traditional dress and headscarves, leading down to the smallest figure of a swaddled baby. The charming wooden models quickly delighted audiences abroad earning a bronze medal at the Paris Exposition Universelle of 1900 and surviving today as a popular export and souvenir.

Mecca stone: mauve or blue cabochon chalcedony with underlay of rose foil used in Fabergé objects.

***Mir Iskusstva* (World of Art):** Russian publication and artistic movement founded in 1898 aimed at countering the collective vision of Russian realism and industrial progress with a more individual approach embracing the Art Nouveau movement.

Monomack cap: usually referring to a jewelled gold cap dating from the late thirteenth to early fourteenth century, surmounted with a cross and trimmed with fur, now preserved at the Kremlin Armoury Museum. This form of regalia was in use from the coronation of Michael Feodorovich Romanov in 1613 to Peter the Great. According to legend, it was originally a gift from the Byzantine Emperor Constantine Monomachus to his grandson, Prince Vladimir of Kiev, after which it passed through the Princes of Kiev and Vladimir to Moscow, underlining the Russian capital's ambition to become the 'Third Rome' (Constantinople having been the 'Second').

Morozov: firm founded by Ivan Morozov in St Petersburg in 1849 that became a Purveyor to the Court in 1884. A year later, the founder died and his descendents ran the firm until 1917; known for the output of jewellery and fine silver.

Nicholls and Plincke: English partnership operating between 1829–1898 in St Petersburg. The firm's success was in capitalising on the Russian taste for English silver and reproducing finely modelled, weighty silver retailed through its 'Magasin Anglais'. The Imperial Warrant came early to the firm and helped to secure lucrative Imperial commissions.

Niello: technique of blackening an engraved pattern onto a precious metal object. An alloy of sulphur, copper, lead and silver is applied to the low relief carving and fired in order to adhere to the metal. After polishing, the surface reveals a strongly contrasting black design against brilliant metal. Cigarette, snuff, tobacco and card boxes are available on the market with prices dependent upon the intricacy of the design. Cartographic examples enriched with local maps and statistics are particularly sought after.

Oklad: a pierced metal cover for an icon, exposing various elements of the holy imagery such as face, hands and feet.

Ovchinnikov: founded in Moscow in 1853 by Pavel Ovchinnikov and expanded to St Petersburg in 1873. Upon his death in 1888, the founder's sons Michail, Alexander, Pavel and Nikolai took over the firm. It ceased trading in 1917 and is known for fine silver and enamelling, particularly in the Russian Revival style, winning prizes at Russian exhibitions and world fairs and earning the Imperial Warrant.

Parcel-gilt: *see* Gilding.

Patronymic: personal names in Russia contain the patronym placed between the first and family names. The father's name is carried through to his children and modified depending on gender, thus Ivan's children will carry 'Ivanovich' and 'Ivanovna' respectively to mean son and daughter of Ivan.

Pauzié, Jérémie (active 1740–1765): Geneva-born master goldsmith present in Russia from 1729 serving both Empress Elizabeth and Catherine the Great. Known for finely chased jewelled snuff boxes.

Perkhin, Mikhail: *see* Fabergé.

Peterhof: palace complex established by Peter the Great outside his capital city. The architectural ensemble includes the Hermitage Pavilion (not to be confused with the Winter Palace), as well as the Grand, Montplasir, Marly and Cottage Palaces in addition to the various gardens and fountains featuring the Grand Cascade and Samson fountains. For lapidary, *see* Ekaterinburg.

Plique-à-jour: subset of cloisonné enamelling where certain cells are filled with translucent enamel. The backing is subsequently removed, allowing the light to shine through, rather like a stained-glass window.

Podstakannik: tea-glass holder consisting of a cylindrical handled sheath, into which the glass itself was inserted. A late nineteenth century form and popularly in the Russian Revival taste, lending itself to sets with spoons and saucers en-suite. Often these were enriched with champlevé designs borrowed from the textile world imitating embroidered teacloths.

Polenova, Yelena: *see* Abramtsevo.

Potemkin, Grigori (1739–1791): Russian statesman and favourite of Catherine II (the Great).

Pre-Petrine: referring to a time before the Westernising efforts of Peter I (Peter the Great) took hold.

Private Factory Porcelain: a term for the private enterprises that were established to bring the highest quality porcelain produced at the Imperial Porcelain Manufactory to a wider market. Catherine the Great commissioned dining services from Francis Gardner, operating outside of Moscow, endorsing the firm with her royal cachet. Following an 1806 ban on the importation of foreign porcelain, private ventures were able to respond more swiftly to the growing appetite for porcelain goods than the cumbersome bureaucracy and expensive output of the Imperial Manufactory. The Gardner factory, later acquired by Kuznetsov, is perhaps the best known alongside Popov, Batenin, Kornilov, Fomin, Safronov, Khrapunov-Novy and others that briefly flourished.

The Yusupov factory near Arkhangelsk presents an interesting parallel as it was a privately owned concern created by the prominent patron of the arts Prince Nikolai Yusupov for his own personal use or gifting and not as a commercial venture.

Purpurine: a dark red vitreous material originally employed in seventeenth-century Italy and rediscovered at the Imperial Glass Manufactory in the mid nineteenth century. This opaque glass was revived by Fabergé.

Quatre-couleur: also termed varicoloured. Literally meaning four-coloured, an eighteenth-century technique of mixing gold with copper to produce a red tint, silver for green and nickel or palladium for white and placing these hues alongside natural yellow gold to great effect.

Rachette, Jean Dominique: French sculptor invited to Russia in 1779 to work as master modeller in the Imperial Porcelain Manufactory where he remained responsible for the sculptural section until 1804.

Revolution: in the Russian context, a series of revolts in 1917 that led to the overthrow of the Russian monarchy and the foundation of the Soviet Union.

Rostov enamel: *see* Finift.

Rückert, Feodor: active in Moscow late nineteenth century to 1917 as an independent maker, retailed through select firms such as Fabergé and Ovchinnikov. Output characterised by a rich palette of colours applied to designs in the Russian Revival taste. In larger pieces, the manipulation of wirework to delineate stylised foliate motifs, grids and mythical creatures, surrounding a miniature plaque after a contemporary painting are signatures of this craftsman.

St George: traditionally portrayed on horseback slaying a dragon on the heraldic emblem of Moscow. (The coat of arms for St Petersburg depicts crossed river and sea anchors below a vertically placed sceptre.)

St Petersburg Glassworks: founded originally in the mid 1730s on the banks of the Fontanka in St Petersburg by an English merchant named William Elmsel, producing work for the Imperial Court and the wider public. By Imperial decree, the factory was then moved to a location outside the city and limited to supplying the Court. In 1777 Catherine the Great gifted the works to her favourite, Prince Grigori Potemkin.

Samorodok: process whereby a heated silver or gold object is plunged into cold water resulting in the metal seizing into a random pattern resembling a topographical map. This technique was widely used in cigarette cases.

Samovar: traditional copper or brass kettle formed as a large vessel filled with water and fitted with an internal chimney compartment for conducting heated coal or other fuel. The body was surmounted by a pierced collar upon which a pot of concentrated tea was placed. Boiling water could be released through a tap near the base of the urn to dilute its strength. Services including a samovar, teapot, drip bowl placed under the tap and conforming tray used to catch stray embers can still be acquired. These can be profusely stamped with the firm name, further coin-shaped seals awarded at an international exhibition, or the Imperial double-headed eagle and reigning emperor's likeness if an Imperial Warrant had been granted to a Purveyor to the Court. While extremely attractive, these were as common as present-day kettles and do not command important prices at auction.

Sazikov: founded in Moscow by Pavel Sazikov in 1793 and continued by his son Ignaty, who opened a St Petersburg branch in 1842 and received the Imperial Warrant. The firm were important suppliers to the Imperial Court and regular exhibitors at international exhibitions. From 1868 grandsons Sergei and Pavel ran the firm in Moscow and Valentin controlled the branch in St Petersburg.

The head enameller in 1882 was Feodor Rückert who went on to establish his own firm in Moscow supplying Fabergé, Ovchinnikov and other retailers with his legendary enamels.

Schtoff: unit of measure equivalent to 1.23 L and the term for a large bottle usually containing vodka.

Semenov: Moscow firm founded in 1852 by Vasily Semenov and gained notoriety for its niello work. The business was taken over by the founder's daughter, Maria Semenova, whose work is characterised by finely rendered scrolling foliage using subtly shaded enamel cloisons.

Shaded enamel: a subset of cloisonné enamel whereby the individual cells are further defined with gradations of colour and painted hatching.

Silver Rows: so named due to the fact that the crafting and trade of precious metals in seventeenth-century Russia was restricted to approved workshops traditionally arranged in rows within a town's principle marketplace.

Slavophile: follower of a mid-nineteenth-century intellectual movement advocating a return to pre-Petrine, Slavic values as opposed to Westernisers who advocated Western Europe as a model for progress.

Solntsev, Feodor (1801–1892): artist, archaeologist, and professor at the Imperial Academy of Art. As an expert on Russian antiquities, he drew on his vast knowledge to restore the Terem Palace in the Moscow Kremlin in the seventeenth-century style. Originally driven by A.N. Olenin, then President of the Academy of Art and Director of the Public Library, and with financing from Nicholas I and the support of Count S.G. Stroganov, Solntsev provided extensive illustrations of church, Imperial, and everyday objects and ornaments. These were published in the monumental *Antiquities of the Russian State* in a limited edition of 600 copies released 1849–1853. This remains the pivotal visual resource that it became for the Russian Revival movement.

Solvychegodsk (Usolsk): The name of a town in northern Russia associated with the powerful Stroganov family and an important trading link between Moscow and the White Sea port of Arkhangelsk. Late seventeenth-century enamels from this region are often termed 'Usolsk', the ancient appellation of the town, and are characterised by bright flora and mythological fauna painted against white ground and set with medallions. The hatchings found on the foliate designs relate to shading in the engraved prototypes that inspired these works. The ground is not subdivided into the multitude of enamelled cells of cloisonné work but certainly inspired the taste for shaded enamelling during the late nineteenth century revival.

Stieglitz, Baron Alexander von (1814-1884): Russian financier and philanthropist who funded the Central School of Technical Drawing in the 1820s to provide training in the applied arts.

Stroganov, Alexander Sergeievich: *see* Voronikhin.

Stroganov, Sergei: *see* Stroganov Institute.

Stroganov Institute for Technical Design: term for a school of icon painting named for the wealthy merchant family of patrons. Distinguished for minutely rendered and exquisitely detailed figures. Not to be confused with the Stroganov Institute for Technical Design, originally established in Moscow in 1825 by Sergei Grigorevich Stroganov (1794–1882) to encourage design and the decorative arts. In 1870, the institute's director, Victor Butovski, published a collection of medieval ornaments reproduced from illuminated Russian manuscripts. This document fed the nation's appetite for a revival of traditional motifs in the arts.

Not to be confused with the Stroganov School of icon painting named for the wealthy merchant family of patrons and distinguished stylistically by minutely rendered and exquisitely detailed figures.

Styl' Modern: Russian term for Art Nouveau.

Sumin: St Petersburg firm active in the late nineteenth to early twentieth century with a stone-carving workshop that sourced minerals from Siberia and the Urals. Producers of finely carved animals, often confused with Fabergé's output.

Talashkino: artistic colony located near Smolensk on the estate of the same name belonging to Princess Maria Tenisheva (1867–1928), a prominent artist, collector and patron.

Tenisheva: *see* Talashkino.

Tercentenary: in the Russian context this refers to the 300th anniversary of Romanov accession to the throne. This was celebrated in 1913 with great fanfare and was to be the last of the lavish displays of Imperial pageantry before the austerity of World War I.

Terem Palace: formerly the principal palace of the Russian Tsars, it was extensively restored under Mikhail Romanov in the seventeenth century. Located in the Moscow Kremlin it has a distinctive tiled exterior. The interior, though extensively destroyed by fire, was restored in 1837 in the exuberant Russian Revival style.

Thomas de Thomon, Jean-Francois (1760–1813): French Neo-classical architect active in St Petersburg bringing austere monumentality to various designs, including the Stock Exchange, as well as decorative works such as bronze-mounted vases integrated into palace interiors.

Tillander, Alexander: prominent St Petersburg jeweller, born in 1837, who established his firm in 1860 and was awarded important commissions by the Imperial Court in the early twentieth century. Following the Revolution, the Tillander firm was re-established in the founder's native Finland.

Tobolsk carving: variant of northern Russian mammoth ivory carving characterised by group compositions reflecting the lives of the native population.

Tolstoy, Count Feodor (1783–1873): born in St Petersburg and studied at the Imperial Academy of Art, eventually distinguishing himself as a leading medallist, amongst other accolades. He produced a series of bronze medals commemorating the Russian war against Napoleon that were translated into plaster placques in the Wedgwood taste. He was a member of an accomplished and prominent family and should not be confused with the author of *War and Peace* and *Anna Karenina*, Lev (Leo) Tolstoy (1828–1910).

Troika: literally meaning a set of three, but often referring in popular imagery to a sleigh or other vehicle drawn by three horses.

Trompe l'oeil: literally meaning 'to fool the eye'. In the late nineteenth century, silver designs inspired by basket weaving gained popularity. As part of the Revival vocabulary, references to birch weaving and woodcarving were translated into a variety of forms. Cigar boxes with imitation tax bands or bread baskets covered by a loosely folded napkin frequently appear on the market.

Tsar: title used for a Russian monarch and derived from the Roman title Caesar. The tsar's consort was a tsaritsa and later tsarina in common usage. The heir was the tsesarevich although tsarevich is often used here. The title of Tsar was changed to Imperator or Emperor by Peter the Great in 1721. After that time, children and grandchildren of the ruler were referred to as Veliky Knyaz or Knyaginya meaning Grand Duke or Duchess.

Tsarskoe Selo: A complex of royal buildings, gardens and follies outside St Petersburg used as summer retreats by the Russian Imperial Family and courtiers, including the Catherine and Alexander palaces. The estates and surrounding town were renamed Pushkin during part of the Soviet period, so guide books and tourist information sometimes carry this reference.

Tula: the steelworks located south of Moscow in Tula were primarily famous for the arms factory founded there in 1712.

Their highly developed metalworking techniques reached beyond the making of armour and flourished in Catherine the Great's reign when applied to decorative parcel-gilt steel objects. During the course of the eighteenth century, the virtuosity of the Tula craftsmen continued to evolve as they borrowed polishing and faceting techniques from jewellery making. Characteristic flat surfaces enriched with contrasting coloured metal swags, ribbons or foliate designs delighted the elite at home and abroad through diplomatic gifts.

Objects found on the market today are distinctive for the colours achieved in designs combining unworked steel with burnished tones of green and blue, further highlighted with details in gilt and bronze. Examples survive primarily as pistols, caskets and snuff boxes, although dressing table mirrors, candelabra, sewing or writing instruments and buttons also appear from time to time.

Veliky Ustyug: a town in the Russian north and an important hub for trade with China. Known for enamel and niello wares.

Viaz script: an ornate form of calligraphy with cyrillic letters abbreviated and partly overlapping, seemingly woven into continuous bands. Used to enrich seventeenth-century Russian drinking vessels and revived during the nineteenth century.

Vinogradov, Dmitry Ivanovich (c.1720–1758): chemist responsible for uncovering the secret of hard-paste porcelain for Russia and the founder of the Imperial Porcelain Factory.

Vishnyakov: *see* lacquer.

Voronikhin, Andrei: born a Stroganov serf who was educated and liberated by Count Alexander Sergeievich Stroganov, an influential patron, long-time president of the Imperial Academy of Art and purported father of Andrei. As an accomplished artist, designer and architect, Voronikhin designed various public buildings in the Neo-classical style and is perhaps best known for the Kazan Cathedral in St Petersburg which was completed in 1811. Voronikhin is also credited for his innate understanding of interiors, marrying designs for monumental vases, lamps, furniture and works of art to the ornamentation of the architectural ensemble.

Westerniser: *see* Slavophile.

Wigström, Henrik: *see* Fabergé.

Winter Palace: official residence of Russian monarchs from 1732 until 1917, located in the centre of St Petersburg along the embankment. The Imperial Art Collection was opened to the public in 1852 and the palace complex continues to operate as the Hermitage Museum today.

World Fair: also termed 'Universal Exposition' or 'Great Exhibition', showcasing industrial, technological and artistic achievements represented by international exhibitors. The Russian exhibitors played an important role in exporting luxury goods and understanding foreign trends for integration into design at home. The Crystal Palace exhibition of 1851, Columbian Exposition held in Chicago in 1893, Exposition Universelle in Paris 1900, and the Louisiana Purchase Exposition in Missouri in 1904 are mentioned in this context.

The world fairs were a separate circuit from the Pan- or All-Russian exhibitions that took place in the major cities of Moscow, St Petersburg and Nizhny Novgorod where Russian-made products could compete for awards and then be nominated to represent the country at the international fairs.

Yusupov: *see* Private Factory Porcelain.

Zemstvo: form of provincial self-government in Russia created in 1864 to provide economic and social services in rural areas.

Zolotnik: originally a small unit of gold weight and coinage used as a metal standard to define purity of precious metal with 56 zolotniks being equivalent to 14 carat gold; 72 to 18 carat; and 96 to 24 carat. 56 was the most commonly used, while 72 was reserved for export articles.

Regarding silver, 96 zolotniks correspond to pure silver which is too malleable to be of practical use. 84, 88 and 91 represent increasing proportions of pure silver to metal alloy equivalent to 875, 916 and 947/1000 standard silver in the West. While most enamel work was produced with 84 standard silver, the 91 standard was deemed an acceptable alternative to Sterling and was therefore reserved for exports to England.

Platinum did not carry hallmarks.

NOTES

INTRODUCTION

1. Refer to Ulla Tillander-Godenhielm in *Fabergé ja hänen suomalaiset mestarinsa* ('Fabergé and his Finnish Workmasters'), 2008, pp.18-19 for the latest available research into the original names as per their birth certificates.

CHAPTER 1. PRECIOUS METAL

1. Katrina Taylor, *Russian Art at Hillwood*, Hillwood Museum, Washington D.C., 1988, p. 90.
2. Alexander von Solodkoff, *Russian Gold and Silverwork*, Rizzoli, New York, 1981, p. 35.
3. Ibid.
4. Anne Odom, *Russian Silver in America: Surviving the Melting Pot*, D. Giles Ltd, London, 2011, p. 216.
5. Ibid.
6. M.M. Postnikova-Loseva, *Zolotoe i serebrianoe delo XV—XX vv: Territoriia SSSR*, Nauka, Moscow, 1983.
7. Solodkoff, p. 20.
8. Odom, pp. 216–217.
9. Valentin Skurlov in Géza von Habsburg (ed.), *Fabergé: Imperial Craftsman and His World* (Exh. cat.), Booth-Clibborn, London, 2000, p. 405.

CHAPTER 2. ENAMEL

1. Anne Odom, *Russian Enamels*, Philip Wilson Publishers, London, 1996, p. 36.
2. Ibid., p. 46.
3. Evgenia Kirichenko, *Russian Design and the Fine Arts*, Abrams, New York, 1991, pp. 78–82.
4. Ibid., p. 131.
5. Wendy R. Salmond, 'Design Education and the Quest for National Identity in Late Imperial Russia: The Case of the Stroganov School', *Studies in the Decorative Arts* 1.2 (Spring 1994): 2–24.
6. Anne Odom, lecture on Russian enamels, Hillwood Museum Files.

CHAPTER 3. JEWELLERY

1. A. Fersman, *Russia's Treasure of Diamonds and Precious Stones*, People's Commissariat of Finances, Moscow, 1925, pt II, p. 9.
2. N. Riasanovsky, *A History of Russia*, Oxford University Press, New York, 1984, p. 230.
3. *St Petersburg Jewellers of the 18th–19th Centuries*, Oct. 2000–April 2001, State Hermitage Museum, St Petersburg, Slavia, p. 6.
4. G. Medvedova, *Russkie Iuvelirnye Ukrasheniia 16–20 Vekov: Iz Sobraniia Gosudarstvennogo Ordena Lenina Istoricheskogo Muzeia*, Sov. Khudozhnik, Moscow, 1987, p. 76.
5. M.V. Martynova, *Precious Stone in Russian Jewellery Art in the XIIth–XVIIIth Centuries*, Moscow Isskustvo, 1973, p. 13.
6. Ibid., p. 15.
7. Irina Polynina, *The Regalia of the Russian Empire*, Red Square, Moscow, 1994, p. 114.
8. Fersman, pt. II, p. 10.
9. Richard Wortman, *Scenarios of Power: Myth and Ceremony in Russian Monarchy*, Princeton University Press, Princeton, 1995, p. 69.
10. Alexander von Solodkoff, *Russian Gold and Silverwork*, Rizzoli, New York, 1981, pp. 68–69.
11. Ibid.
12. The illustration is reproduced in Polynina, plate 98.
13. Medvedova, p. 20.
14. von Solodkoff, p. 68.
15. Ibid.
16. Fersman, pt II, p. 11.
17. Polynina, p. 124.
18. *St Petersburg Jewellers of the 18th–19th Centuries*, p. 12.
19. Ibid., p. 14.
20. von Solodkoff, p. 69.
21. Ibid., p. 70.
22. Pauzié's accounts of life at court and detailed descriptions of Imperial commissions can be found in 'Zapiski Pridvornogo Brilyantshchika Pozie o Prebyvanii ego v Rossii', *Russkaya Starina I*, 1870, pp. 16–27, 77–103, 197–244.
23. Ibid.
24. Marina Martinowa, *Der Kerml*, VEB E.A. Seeman Verlag, Leipzig, 1989, p. 39.
25. *St Petersburg Jewellers of the 18–19th Centuries*, p. 22.
26. von Solodkoff, p. 80.
27. State Museum of the Moscow Kremlin, *Treasure of the Czars*, Booth Clibborn Editions, London, 1995, p. 32.
28. von Soldokoff, p. 82.
29. Ibid.
30. Ibid.
31. Ibid.
32. Medvedova, p. 20.
33. Ibid., p. 135–136.
34. Fersman, pt III, p. 29.
35. Polynina, p. 184.
36. John van der Kriste and Coryne Hall, *Once a Grand Duchess: Xenia, Sister of Nicholas II*, Sutton Publishing, 2002, pp. 17, 20.
37. Fersman, pt III, p. 9.
38. Ibid.
39. Ibid., p.12.
40. Ibid.
41. Robert H. Davis and Edward Kasinec, 'Witness to the Crime', *Journal for the History of Collections* 3.1, 1991, pp. 56–57.

CHAPTER 4. FABERGÉ

1. This figure was roughly equivalent to $125,000 at the time. Valentin Skurlov kindly offered the comparison to a Russian maid's wages in late nineteenth-century New York of $20 per month. He also cautioned that the total replacement value of the necklace as cited is likely to be inaccurate as there is no archival basis for this figure. The true value at the time might well have been far less as the Imperial family may have supplied some of the materials to be incorporated into the firm's design. It is probable that Alexander III's importance as a patron may also have earned him a special pricing structure. See: Géza von Habsburg, *Fabergé: The Imperial Craftsman and his World*, Booth-Clibborn Editions, London, 2000, pp. 229–30.

2. Alexander von Solodkoff, *Fabergé Clocks*, Ermitage, London, 1986 p. 23. The author mentioned that in 1901, a Fabergé jewellery designer earned 160 rubles or £17 per month. This was less than the price paid for the most modest enamel clock at Fabergé's London branch.

3. Géza von Habsburg et al., *Fabergé Revealed: At the Virginia Museum of Fine Arts*, Skira Rizzoli, 2011, pp. 25-6.

4. Robert Massie, *Peter the Great: His Life and World*, New York: Ballantine Books, 1981. p. 243.

5. Géza von Habsburg et al., *Fabergé: Hofjuwelier der Zaren*, Munich: Hirmer Verlag, 1986, p. 36.

6. Ibid., p. 22.

7. Henry Bainbridge, *Peter Carl Fabergé, Goldsmith and Jeweler to the Russian Imperial Court and the Principal Crowned Heads of Europe*, Batsford, New York, 1949, pp. 10–11.

8. Ibid., p. 8.

9. Ibid., p. 9.

10. Géza von Habsburg et al., *Fabergé: Hofjuwelier der Zaren*, p. 320.

11. Géza von Habsburg, *Fabergé: The Imperial Craftsman and his World*, Booth-Clibborn Editions, London, 2000, pp. 393–394.

12. Ulla Tillander-Godenhielm et al., *The Era of Fabergé*, Tampere Museums, 2006, p.127

13. Ibid.

14. von Solodkoff, *Masterpieces from the House of Fabergé*, New York: Abrams, 1984.

15. Géza von Habsburg and Marina Lopato, *Fabergé: Imperial Jeweller*, Exh. cat., St Petersburg: State Hermitage Museum and Washington D.C.: Fabergé Arts Foundation, in association with Abrams, 1993, p. 19.

16. Géza von Habsburg, *Fabergé: Fantasies and Treasures*, Fabergé Co., New York 1996, p. 23.

17. Ibid., p. 35.

CHAPTER 5. HARDSTONE

1. Antoine Chenevière, *Russian Furniture: The Golden Age 1780–1840*, London, 1988, p. 259.

2. Ibid., p. 264.

3. Ibid.

4. Ibid., p. 266.

5. A.N. Voronikhina, *Malachite Dans la Collection de l'Ermitage*, Editions du musée de l'ermitage, Leningrad 1963, p. 23.

6. Chenevière, p. 270.

7. Ibid.

8. Ibid., p. 274.

9. Ibid.

10. Ibid.

11. E.M. Effimova, *Russian Stoneware in the Hermitage Museum*, Hermitage Museum, Leningrad, 1961, p. 31.

12. Chenevière, p. 278.

13. Caroline de Guitaut, *Fabergé in the Royal Collection*, London: Royal Collection Enterprises, 2003, p. 187.

14. de Guitaut, p. 116.

CHAPTER 6. AWARDS AND DECORATIONS

1. Ulla Tillander-Godenhielm, *The Russian Imperial Award System*, 1894–1917, Helsinki, 2005, p. 59.

2. Ibid., p. 31.

3. Ibid., pp. 38–42.

4. Ibid., p. 193.

CHAPTER 7. PORCELAIN

1. Anne Odom, *Russian Imperial Porcelain at Hillwood*, Hillwood Museum and Gardens, 1999, p. 9.

2. Galina Agarkova and Natalya Petrova, *250 Years of Lomonosov Porcelain Manufacture, St Petersburg 1744–1994*, Lomonosov Porcelain Manufacture Co., St Petersburg, 1994, pp. 6–9.

3. Ibid., p.10

4. Tatiana Kudriavtseva, *Russian Imperial Porcelain*, Slavia, St Petersburg, 2003, p. 17.

5. Agarkova, p. 18.

6. Ibid.

7. Ibid.

8. Agarkova, p. 39.

9. Odom, p. 49.

10. Ibid., pp. 55–56.

11. Odom, p. 57.

12. *Porcelain in Russia: The Eighteenth and Nineteenth Centuries, The Gardner Factory*, Palace Editions, St Petersburg, 2003, p. 5.

13. P. Schaffer, ed., *An Imperial Fascination: Porcelain: Dining with the Czars*, A La Vieille Russie: New York, 1991, p. 150.

14. Marvin Ross, with a foreword by Marjorie Merriweather Post, *The Collections of Margaret Merriweather Post: [vol2] Russian Porcelains: The Gardner, Iusupov, Batenin ... Factories*, University of Oklahoma Press, 1968, p. 425.

15. Porcelain in Russia, *The Gardner Factory*, p. 13.

16. Schaffer, p. 149.

CHAPTER 8. GLASS

1. Emmanuel Ducamp, lecture on Imperial patronage of the decorative arts 1750–1850, Courtauld Institute, February 2001.

2. Marina Bowater, *Collecting Russian Art and Antiques*, Hippocrene, New York, 1991, p. 86.
3. N.A. Asharina, *Russian Glass of the 17th–20th Centuries*, Corning Museum of Glass, 1990, p. 12.
4. Ibid.
5. Karen Kettering, *Russian Glass at Hillwood*, Hillwood Museum and Gardens, Washington D.C., 2001, p. 16.
6. Ibid., pp. 18–19.
7. Ibid., p. 16.
8. Ibid., p. 25.
9. Ibid.
10. Giles Worsley, 'The Chinese Pavillion at Oranienbaum', *Country Life*, November 16, 1989, p. 70.
11. Corning, p. 24.

CHAPTER 9. METALWORK
1. B. de Montclos et al., *Imperial St Petersburg from Peter the Great to Catherine II*, Skira/Grimaldi Forum, Monaco, 2004, p. 223.
2. Antoine Chenevière, *Russian Furniture: The Golden Age 1780–1840*, Weidenfeld & Nicholson, London, 1988, p. 245.
3. Montclos, p. 229
4. Montclos, p. 231
5. Chenevière, p. 255
6. Ibid.

CHAPTER 10. BONE
1. Alison Hilton, *Russian Folk Art*, Indiana University Press, Bloomington, 1995, p. 102.
2. Robert Massie, *Peter the Great: His Life and World*, Ballantine Books, New York, 1981, p. 127.
3. These sources are discussed in greater detail in Chapter 1: Precious Metals.
4. Hilton, p. 88

5. Natalia Vyshar et al., *Ivory Carving in Northern Russia*, Interbook Business, Moscow, 2003, p. 10.
6. Ibid., p. 11.
7. Ibid., p. 10.
8. Irina Ukhanova, *North-Russian Bone-Carving, 17th–19th Centuries*, The State Hermitage Publishers, St Petersburg, 2005, p. 11.
9. Ibid., p. 12.
10. I.N. Ukhanova, *Rezba po kosti v rossiii by ukhanova khudozhnik*, 1981, pp. 218–219.
11. Vyshar et al., pp. 87–88.
12. Vyshar et al., pp. 113–114.

CHAPTER 11. LACQUER
01. Michel Beurdeley, *Porcelaine de la Compagnie des Indes*, Fribourg: Office du Livre, 1962, p. 124.
2. Ibid.
3. Elizabeth Gaynor, *Russian Houses*, Workman, New York, 1991, pp. 67–68.
4. A. Yonemura et al., *Lacquer: An International History and Illustrated Survey*, Abrams, New York, 1984, p. 208.
5. Ibid., pp. 208–209.

CHAPTER 12. WOODWORK
01. *Terem Teremok* is a popular Russian fairy tale in which a succession of animals request entry into a little log cabin.
2. Salmond, Wendy, *Arts & Crafts in Late Imperial Russia*, Cambridge University Press, New York, 1996, p. 81.
3. Ibid., p. 21.
4. Illustrated as 'encrusted woodwork from Nizhny-Novgorod' in *Russkoe narodnoe iskusstvo na vtoroi vserossiisskoi kustarnoi vystavke v Petrograde v 1913*, Petrograd, 1914, pl. LXXIX, p. 72.
5. Salmond, p. 115.

BIBLIOGRAPHY

GENERAL

Allenov, Mikhail. *Moscow: Treasures and Traditions*. Washington D.C.: Smithsonian Institution Traveling Exhibition Service in Association with University of Washington Press, 1990.

Alyoshina, T.S., ed. *History of Russian Costume from the Eleventh to the Twentieth Century*. New York: Metropolitan Museum of Art, 1977.

Biriukova, Nina. *Decorative Arts in the Hermitage*. Leningrad: Aurora, 1986.

Boele, Vincent, ed. *Art Nouveau During the Reign of the Last Tsars*. London: Lund Humphries, 2007.

Bowater, Marina. *Collecting Russian Art and Antiques*, New York: Hippocrene Books, 1991.

Bunt, Cyril. *Russian Art, from Scyths to Soviets*. London: Studio, 1946.

Blumay, Carl, and Henry Edwards, eds. *The Dark Side of Power: The Real Armand Hammer*, New York: Sirnon & Schuster, 1992.

Chenevière, Antoine, with Emanuel Ducamp. *Russian Furniture: The Golden Age 1780–1840*. London: Weidenfeld & Nicolson, 1988.

Coppleston, F. *Philosophy in Russia*. Indiana: University of Notre Dame, 1986.

Cross, Anthony, ed. *Engraved in the Memory: James Walker, Engraver to Empress Catherine the Great, and his Russian Anecdotes*. Oxford: Berg, 1993.

Davis, Robert. 'Witness to the Crime', *Journal for the History of Collections*, 3.1, 1991.

de La Feuille, Daniel, *Symbola et Emblemata*, Amsterdam, 1705.

Forbes, Isabella, ed. *Catherine the Great: Treasures of Imperial Russia from the State Hermitage Museum*. London: Booth Clibbom, 1990.

Galeries Nationales du Grand Palais. *La France et la Russie au Siecle des Lumieres*. Ministère des affaires étrangères: Paris, 1986.

Gaynor, Elizabeth. *Russian Houses*. New York, Workman: New York, 1991.

Goubanov, Guennadi, et al. *Leningrad, Art et Architecture*. Leningrad: Aurora, 1990.

Hamilton, George. *The Art and Architecture of Russia*. New York: Penguin, 1983.

Honour, Hugh. *Chinoiserie: The Vision of Cathay*. New York: Dutton, 1962.

Huth, Hans. *Roentgen Furniture: Abraham and David Roentgen*. London: Sotheby's, 1974.

Hutt, Julia. *Understanding Far Eastern Art: A Complete Guide to the Arts of China, Japan and Korea*. Oxford: Phaidon, 1987.

Ioannovna, Anna. *Opisanie Koronatsii e. v. imp., I Samoderzhtsy Vserosiiskoy Anny Ioannovny*. Moscow, 1730.

Jacobsen, Dawn. *Chinoiserie*. London: Phaidon, 1993.

Jarry, Madeleine. *Chinoiserie: Chinese Influence on European Decorative Art, 17th and 18th Centuries*. New York: Viking, 1981.

Jorg, C.J.A. *Porcelain and the Dutch China Trade*. The Hague: M. Nijhoff, 1982.

Kasinec, Edward. 'The Mythology of Empire: Imperial Russian Coronation Albums', *The Bulletin of the New York Public Library*, 1.1, 1992.

Kirichenko, Evgenia. *Russian Design and the Fine Arts*. New York: Abrams, 1991.

Kochan, Miriam. *Life in Russia under Catherine the Great*. New York: Putnam, 1969.

Koliazina, N.V. *Dvorets Menshikova*. Moscow: Sovietski Khudojhnik, 1986.

Komelova, Galina. *Masterpieces of Russian Culture and Art: The Hermitage, Leningrad*. Moscow : Sovetsky Khudozhnik, 1981.

Korshunova, Tamara, et al. *Russian Style 1700-1920: Court and Country Dress from the Hermitage*. London: Barbican Editions, 1987.

Kraatz, Anne. *La Compagnie Francaise de Russie: Histoire du Commerce Franco-Russe aux XVlle et XVlile Siecles*. Paris: Bourin, 1993.

Krivenko, V.S. *Nicholas 11, Koronatsionnyi Sbornik: Koronnovanie v Moskve 14. maia 1896*. St Petersburg, 1899.

Krog, ale Villumsen, et al. *Treasures of Russia – Imperial Gifts*. Exh. cat. Copenhagen: Royal Silver Room, 2002.

Kurth, Peter. *Tsar: The Lost World of Nicholas and Alexandra*. Boston: Little, Brown, 1995.

Lawrence, J. *History of Russia*. New York: Penguin, 1978.

Martynowa, Marina. *Der Kreml*. Leipzig: VEB E.A. Seeman Verlag, 1989.

Maskell, Alfred. *Russian Art and Art Objects in Russia*. London: Chapman and Hall, 1884.

Massie, Robert. *Peter the Great, his Life and World*. New York: Ballantine Books, 1981.

Massie, Suzanne. *Land of the Firebird*. New York: Simon and Schuster, 1980.

Mc Connell, Allen. *Catherine the Great and the Fine Arts in Imperial*

Russia: 1700–1917. Illinois: Northern Illinois Press, 1988.

Michael, Prince of Greece. *Imperial Palaces of Russia*. London: Tauris Parke, 1992.

Montclos, B. de, et al. *Imperial St. Petersburg from Peter the Great to Catherine II*. Skira/Grimaldi Forum: Monaco, 2004

O'Connell, Lauren M. 'A Rational, National Architecture: Viollet-le-Duc's Modest Proposal for Russia', *Journal of the Society of Architectural Historians*, 52, 993.

Onassis, Jacqueline, ed. *In the Russian Style*. New York: Viking Press, 1976.

Riasanovsky, Nicholas. *A History of Russia*. New York: Oxford University Press, 1984.

Rovinsky, D.A., *Russkaya Narodnaya Kartinki*, c.1881

State Hermitage Museum, The. *Catherine the Great: Treasures of Imperial Russia from the State Hermitage Museum, Leningrad*. London: Booth Clibborn, 1990.

Stroganov, Sergei Grigorevich and Feodor Gregorevich Solntsev. *Drevnosti Rossiskogo Gosudarstva*. Moscow, Alexander Semen, 1849–1853.

Sutcliffe, Mark, ed. *Treasures of the Czar: from the Sate Museums of the Moscow Kremlin*. London: Booth Clibborn, 1995.

Taylor, Katrina. *Russian Art at Hillwood*. Washington D.C.: Hillwood Museum, 1988.

Troyat, Henri. *Catherine the Great*. New York: Doubleday, 1984.

Viollet-le-Duc, E.E. *L'Art Russe: Ses Origines, ses Elements Constitutifs, son Apogee, son Avenir*. Paris, 1877.

Whitehead, John. *The French Interior in the Eighteenth Century*. London: L. King, 1992.

Wiedererstanden Aus Ruinen: Petrodworez, Puschkin, Pawlosk. Leningrad: Aurora-Kunstverlag, 1990.

Williamson, David. *Debrett's Guide to Heraldry and Regalia*. London: Headline, 1992.

Vollmer, John. *Silk Roads, China Ships*. Toronto: Royal Ontario Museum, 1983.

Wortman, Richard. *Scenarios of Power: Myth and Ceremony in Russian Monarchy*. Princeton: Princeton University Press, 1995.

GOLD, SILVER AND METAL

Bäcksbacka, L. *St. Petersburg Juvelerare Guld-och Silversmeder 1714–1870*. Helsinki, 1951.

Ivanov, Aleksandr Nikolaevic. *Gold and Silversmiths in Russia (1600-1926): A Guide for Experts*. Moscow: Russian National Museum, 2002.

Miller, Yuri. *The Art of 18th-19th Century Tula Arms in the Hermitage Collection*. The State Hermitage Publishers: St Petersburg, 2005.

Postnikova Loseva, M.M., et al. *Zolotoe i Serebrianoe Delo XV–XX vv: Territoriia SSSR*. Moscow: Nauka, 1983.

Odom, Anne. *Russian Silver in America: Surviving the Melting Pot*. London: D. Giles Ltd, 2011.

-- and Wendy Salmond, eds. *Treasures into Tractors: The Selling of Russia's Cultural Heritage, 1918-1938*. Seattle, Washington: University of Washington Press, 2009.

Solodkoff, Alexander von. *Russian Gold and Silverwork, 17th–19th Century*. London: Trefoil Books Ltd, 1981.

ENAMEL

Butovskii, V.L. *Histoire de l'Ornement Russe du Xe au XVIe siecle d'Apres les Manuscrits*, 2 vols. Paris: A. Morel et Cie, 1870–3.

Odom, Anne. Lecture on Russian enamels, Hillwood Museum Files, 1995.

-- *Russian Enamels*. London: Philip Wilson Publishers, 1996.

Pisarskaia, L., et al. *Russkie Emali XI-XIX vv: Iz Sobranii Gosudarstvennykh Muzeev Moskovskogo Kremlia*. Moscow: Isskusstvo, 1974.

JEWELLERY

Bolin, Christian, ed. Bolin in Russia: *Court Jeweller late XIX – early XX Centuries*. Exh. cat., Moscow Kremlin Museums. Moscow: Novy Ermitazh-odin, 2001.

Clarke, William. *Hidden Treasures from the Romanovs: Saving the Royal Jewels*. Edinburgh: National Museums of Scotland Enterprises, 2009.

Fersman, A.E. *Russia's Treasure of Diamonds and Precious Stones*. Moscow: People's Commissariat of Finances, 1925.

Kostiuk, Olga. *St. Petersburg Jewellers: 18th–19th Centuries*. St Petersburg: State Hermitage Museum, 2000.

Martynova, M.V. *Precious Stone in Russian Jewellery Art in the XIIth–XVIIIth Centuries*. Moscow Isskustvo, 1973.

Medvedeva, G. *Russkie Iuvelirnye Ukrasheniia 16-20 Vekov: Iz Sobraniia Gosudarstvennogo Ordena Lenina Istoricheskogo Muzeia*. Moscow: Sov. Khudozhnik, 1987.

Michael, Prince of Greece. *Crown Jewels of Europe*. New York: Harper and Row, 1983.

Morel, Bernard. *The French Crown Jewels: The Objects of the Coronations of the Kings and Queens of France*. Antwerp: Fonds Mercator, 1988.

Papi, S. *The Jewels of the Romanovs: Family and Court*. London: Thames and Hudson Ltd, 2010.

Polynina, Irina. *The Regalia of the Russian Empire*. Moscow: Red Square, 1994.

Ribbing, M., et al. *Jewellery & Silver for Tsars, Queens and Others: W.A. Bolin – 200 Years*. St Petersburg, Moscow, and Stockholm: Bolin, 1996.

Russian Jewellery of the 16th–20th Centuries From the Collection of the Historical Museum Moscow. Moscow: Sov. Khud. Pub 1987.

Solodkoff, Alexander von. *The Jewel Album of Tsar Nicholas II*. London: Ermitage, 1997.

State Hermitage Museum, The. *St. Petersburg Jewellers, 18th–19th Centuries*. St Petersburg: Slavia, 2000.

Zapiski Pridvornogo Brilyantshchika Pozie o Prebyvanii ego v Rossii. In: Russkaya Starina I, 1870.

FABERGÉ

A La Vieille Russie. Fabergé. Exh. cat. New York: A La Vielle Russie, 1983.

Bainbridge, Henry. *Peter Carl Fabergé, Goldsmith and Jeweller to the Russian Imperial Court and the Principal Crowned Heads of Europe; an Illustrated Record and Review of His Life and Work, A.D. 1846–1920*. New York: B.T. Batsford, 1949 (1966, 1968).

Curry, David Park. *Fabergé: Virginia Museum of Fine Arts*. Richmond: Virginia Museum of Fine Arts, 1995.

Forbes, Christopher, and Robyn Tromeur. *Fabergé: The Forbes Collection*. New York: Hugh Lauter Levin, 1999.

Guitaut, Caroline de. *Fabergé in the Royal Collection*. London: Royal Collection Enterprises, 2003.

Hill, Gerard. *Fabergé and the Russian Master Goldsmiths*. New York: Wings Books, 1989.

Habsburg, Géza von. *Fabergé: Fantasies and Treasures*. New York: Fabergé Co., 1996.

–– and Marina Lopato. *Fabergé: Imperial Jeweller*, Exh. cat. St Petersburg: State Hermitage Museum and Washington, D.e: Faberge Arts Foundation, in association with Abrams, 1993.

–– ed. Fabergé: *Hofjuwelier der Zaren*. Munich: Hirmer Verlag, 1986.

–– ed. *Fabergé: Imperial Craftsman and His World*. Exh. cat. London: Booth-Clibborn, 2000.

–– ed. *Fabergé in America*. Exh. cat. San Francisco: Fine Arts Museums of San Francisco, in association with Thames and Hudson, 1996.

–– et al. *Fabergé: Court Jeweler to the Tsars*. New York: Rizzoli, 1979.

–– et al., *Faberge Revealed: At the Virginia Museum of Fine Arts*. Skira Rizzoli, 2011.

Hawley, Henry. *Fabergé and His Contemporaries: The India Early Minshall Collection of the Cleveland Museum of Art*. Cleveland: Cleveland Museum of Art, 1967.

Johnston, William R. *The Fabergé Menagerie*. London: Philip Wilson, 2003.

Keefe, John Webster. *Fabergé: The Hodges Family Collection*. Exh. cat. New Orleans, LA: New Orleans Museum of Art, 2008.

Krairiksh, Busaya. *Fabergé in the Royal Collection*. Bangkok, 1984.

Lesley, Parker. *Fabergé: A Catalog of the Lillian Thomas Frail Collection of Russian Imperial Jewels*. Richmond: Virginia Museum of Fine Arts, 1976.

Lowes, Will, and Christel Ludewig McCanless. *Fabergé Eggs: A Retrospective Encyclopedia*. Lanham, MD, and London: Scarecrow Press, 2001.

McCanless, Christel Ludewig. *Fabergé and His Works: An Annotated Bibliography of the First Century of His Art*. Metuchen, N.J., and London: Scarecrow Press, 1994.

Muntian, Tatiana N. *The World of Fabergé*. Moscow: Red Square Publishers, 2000.

Snowman, A. Kenneth. *Fabergé, Lost and Found: The Recently Discovered Jewelry Designs from the St. Petersburg Archives*. London and New York: Wartski, in association with Abrams, 1993.

–– *The Art of Carl Fabergé*. London: Faber and Faber, 1953 (1962, 1968).

–– ed. *The Master Jewellers*. London: Thames and Hudson, 1990.

Solodkoff, Alexander von. *Faberge Clocks*. London: Ermitage, 1987.

–– *Faberge: Juwelier des Zarenbofes*. Exh. cat. Hamburg: Museum fur Kunst und Gewerbe, in association with Braus, 1995.

–– *The Art of Carl Fabergé*. New York: Crown Publishers, 1988.

–– and Christopher Forbes, eds. *Masterpieces from the House of Fabergé*. New York: Abrams, 1984.

Swezey, Marilyn P. *Fabergé Flowers*. New York: Harry Abrams, 2004.

Tillander-Godenhielm, Ulla, *Fabergé ja hänen suomalaiset mestarinsa*. Tammi, 2008
–– et al., *Golden Years of Fabergé: Drawings and Objects from the Wigström Workshop*. Paris: Alain de Gourcuff, 2000.

HARDSTONE

Effimova, E.M. *Russian Stoneware in the Hermitage Museum*. Hermitage Museum: Leningrad, 1961.

Kagan, Y.O. *Kameyone Khudozhestvo na imperatorskikh Kamnereznikh fabrikakh: Peterhof, Ekaterinburg, Kolyvan*. St Petersburg: State Hermitage, 2003.

Mavrodina, N.M. *Art of Russian Stone Carvers, 18th–19th Centuries :The Catalogue of the Collection*. The State Hermitage Publishers: St Petersburg, 2007.

Voronikhina, A.N. *Malachite Dans la Collection de l'Ermitage*. Editions du musée de l'ermitage Leningrad, 1963.

AWARDS AND DECORATIONS

Durov, V.A. *Russian and Soviet Military Awards*. Moscow: Vneshtorgizdat, 1989.

Tillander-Godenhielm, Ulla. 'The Russian Imperial Award System during the Reign of Nicholas II: 1894–1917', *Journal of the Finnish Antiquarian Society*. Helsinki, 2005.

PORCELAIN

Arapova, Tatiana. 'The Double-Headed Eagle on Chinese Porcelain: Export Wares of Imperial Russia'. *Apollo* 135:21–6.
Argarkova, Galina and Natalya Petrova. *250 Years of Lomonosov Porcelain Manufacture 1744–1994*. Lomonosov Porcelain Manufacture Co: St Petersburg, 1994.
Ayers, John, et al. *Porcelain for Palaces: The Fashion for Japan in Europe, 1650–1750*. Philip Wilson Ltd, 2001.

Beurdeley, Michel. *Porcelaine de la Compagnie des Indes*. Fribourg: Office du Livre, 1962, p. 124.

Carewell, John. *Blue and White: Chinese Porcelain and its Impact on the Western World*. Chicago: The Gallery, 1985.
Crossman, Carl. *The Decorative Arts of the China Trade*. Woodbridge: Antique Collector's Club, 1991.

Gruber, Alain Charles. *Chinoiserie: Der Einfluss Chinas auf die Europaische Kunst 17–19 Jahrhundert*. Riggisburg: Berlin, 1984.

Impey, Ayers, et al. *Porcelain for Palaces: The Fashion for Japan in Europe, 1650–1750*. London: Oriental Ceramic Society, 1990.

Kudriavtseva, Tatiana. *Russian Imperial Porcelain*. St Petersburg: Slavia, 2003.
–– and Harold Whitbeck. *Russian Imperial Rocelain Eggs*. London: Merrell Publishers Ltd, 2001.

Nikiforova, L., ed. *Russian Porcelain in the Hermitage Collection*. Leningrad: Aurora Art, 1973.

Odom, Anne. *Russian Imperial Porcelain at Hillwood*. Hillwood Museum and Gardens, 1999.

Popov, V.A. *Russian Porcelain: Private Factories*. Leningrad: Khudozhnik RSFSR, 1980.
Porcelain in Russia: 18th and 19th Centuries, The Gardner Factory. Palace Editions, St Petersburg 2003.

Ross, Marvin C., with a foreword by Marjorie Merriweather Post. *The Collections of Margaret Merriweather Post: [vol. 2] Russian Porcelains: the Gardner, Iusupov, Batenin ... Factories*. University of Oklahoma Press, 1968, p. 425

Schaffer, P., ed. *An Imperial Fascination: Porcelain: Dining with the Czars*. A La Vieille Russie: New York, 1991.
Staehlin, Walter. *The Book of Porcelain*. New York: Macmillan, 1966.

Wolf, N.B. von. *The Imperial Porcelain Factory 1744–1904*. St Petersburg, 2003.

GLASS

Asharina, N.A. *Russian Glass of the 17th–20th Centuries*. Corning: Corning Museum of Glass, 1990.

Dulkina, T.I. and N.A. Asharina. *Russkaya keramika i steklo, 18–19 vekov; Sobranie Gosudarstvennogo istoricheskogo muzeya*. Moscow: Isobrazitelnoe Iskusstvo, 1978.

Gorbatova, I.V. *Khudozhestvennoe Steklo XVI–XVII Vekov*. Moscow: Trilistnik, 2006.

Kettering, K. *Russian Glass at Hillwood*. Hillwood Museum and Gardens, Washington D.C., 2001.

Malinnina, T.A. *Imperatorsky stekliannyi zavod: XVIII–nachalo XX veka*. St Petersburg: Izd-vo Gos. Ermitazha, 2009.

Worsley, Giles. 'Chinese Pavilion at Oranienbaum', *Country Life*, 183: 68-73.

BONE, LACQUER AND WOODWORK

Guliayev, Vladimir. *Russian Lacquered Miniatures*. Leningrad: Aurora, 1989.

Hilton, Alison. *Russian Folk Art*. Bloomington: Indiana University Press, 1995.

Malchenko, M., ed. *Art Objects in Steel by Tula Craftsmen*. Leningrad: Aurora, 1974.

Odom, Anne, et al., *The Art of the Russian North*. Washington, D.C.: Hillwood Museum and Gardens, 2001.

Russkoe narodnoe iskusstvo na vtoroi vserossiisskoi kustarnoi vystavke v Petrograde v 1913. Petrograd, 1914, pl.LXXIX, p. 72.

Salmond, Wendy R. *Arts and Crafts in Late Imperial Russia: Reviving the Kustar Art Industries, 1870–1917*. New York: Cambridge University Press, 1996.
–– 'Design Education and the Quest for National Identity in Late Imperial Russia: The Case of the Stroganov School', *Studies in the Decorative Arts* 1.2 (Spring 1994): 2–24.

Ukhanova, I.N. *North Russian Bone Carving 17th–19th Centuries*. St Petersburg: The State Hermitage Publishers, 2005.
–– *Rezba po kosti v rossii*. Khudozhnik: Leningrad, 1981.
–– *Russian Lacquers in the Hermitage*. Leningrad: The State Hermitage, 1964.

Vyshar, N., et al. *Ivory Carving in Northern Russia*. Interbook Business, Moscow, 2003.

Yonemura, A., et al. *Lacquer: An International History and Illustrated Survey*. New York: Abrams, 1984.

INDEX

*Page numbers in **bold** refer to captions and illustrations.*

THE ANTIQUE COLLECTORS' CLUB

Formed in 1966, the Antique Collectors' Club is now a world-renowned publisher of top quality books for the collector. It also publishes the only independently-run monthly antiques magazine, *Antique Collecting*, which rose quickly from humble beginnings to a network of worldwide subscribers.

The magazine, whose motto is *For Collectors-By Collectors-About Collecting*, is aimed at collectors interested in widening their knowledge of antiques both by increasing their awareness of quality and by discussion of the factors influencing prices.

Subscription to *Antique Collecting* is open to anyone interested in antiques, and subscribers receive ten issues a year. Well-illustrated articles deal with practical aspects of collecting and provide numerous tips on prices, features of value, investment potential, fakes and forgeries. Offers of related books at special reduced prices are also available only to subscribers.

In response to the enormous demand for information on 'what to pay', ACC introduced in 1968 the famous price guide series. The first title, *The Price Guide to Antique Furniture,* now renamed *British Antique Furniture: Price Guide and Reasons for Values*, is regularly updated and in constant demand. Since those pioneering days, ACC has gone from strength to strength, publishing many of today's standard works of reference on all things antique and collectable, from *Tiaras* to *20th Century Ceramic Designers in Britain*.

Not only has ACC continued to cater strongly for its original audience, it has also branched out to produce excellent titles on many subjects including art reference, architecture, garden design, fashion, and textiles. All ACC's publications are available through bookshops worldwide and a catalogue is available free of charge from the addresses below.

For further information please contact:

www.antiquecollectorsclub.com

Antique Collectors' Club
Sandy Lane, Old Martlesham
Woodbridge, Suffolk IP12 4SD, UK
Tel: 01394 389950 Fax: 01394 389999
Email: info@antique-acc.com
or
ACC Distribution
6 West 18th Street, Suite 4B,
New York, NY 10011
Tel: 800.252.5231 or 212.645.1111
Fax: 212.989.3205
Email: sales@antiquecc.com